W9-CRU-020

THE A. W. MELLON LECTURES IN THE FINE ARTS

DELIVERED AT THE NATIONAL GALLERY OF ART, WASHINGTON, D.C.

Bollingen Series XXXV · 10

André Grabar

CHRISTIAN ICONOGRAPHY

A Study of Its Origins

The A. W. Mellon Lectures in the Fine Arts, 1961

The National Gallery of Art, Washington, D.C.

BOLLINGEN SERIES XXXV · 10

Princeton University Press

To the memory of my American friends

A. M. FRIEND, JR.

E. H. KANTOROWICZ

A. A. VASILIEV

Table of Contents

List of Illustrations

The original color illustrations have been converted to black and white for
this edition.

Information on sources not given in the captions is supplied here.
For abbreviations, see p. xxxvii.

from *Bulletin of the Museum of Jewish Antiquities* (Hebrew University, Jerusalem), III (1960).

ABBREVIATIONS FOR LIST OF ILLUSTRATIONS

Agraci Arts graphiques de la Cité, Paris; reproduction rights reserved.

Alinari Fratelli Alinari S.A., Rome; reproduction rights reserved.

Anderson Acquired by Alinari, *q.v.*

Arch. Vat. Archivio Fotografico Vaticano, Monumenti Musei e Gallerie Pontificie, Vatican City.

Babić G. Babić, "Les Fresques de Sušica en Macédoine et l'iconographie originale de leurs images de la vie de la Vierge," *Cahiers archéologiques: Fin de l'antiquité et moyen âge* (Paris), XII (1962).

Bendinelli G. Bendinelli, "Il Monumento sepolcrale degli Aureli al Viale Manzoni in Roma," *Monumenti antichi* (R. Accademia Nazionale dei Lincei, Rome), XXVIII (1922).

Besson Marius Besson, *Saint Pierre et les origines de la primauté romaine*. Geneva, 1929.

DAI Deutsches Archäologisches Institut.

Ecole des Collection chrétienne et byzantine, Ecole des Hautes Etudes, Sorbonne, Paris.
 Hautes Etudes

Freshfield, E. H. Freshfield, "Notes on a Vellum Album containing some original sketches
 Archaeologia of public buildings and monuments, drawn by a German artist who visited Constantinople in 1574," *Archaeologia* (London, Oxford), LXXII (1921–22).

Garrucci, Raffaele Garrucci, *Storia dell'arte cristiana nei primi otto secoli della chiesa*. 6 vols.
 Storia dell'arte Prato, 1873–81.
 cristiana

GFN Gabinetto Fotografico Nazionale, Ministero della Pubblica Istruzione, Rome.

Goodenough, Erwin R. Goodenough, *Jewish Symbols in the Greco-Roman Period*. (Bollingen
 Jewish Symbols Series XXXVII.) 13 vols. New York and Princeton, 1953–68.

Grüneisen, *SMA* W. de Grüneisen and others, *Sainte Marie Antique*. Text and atlas. Rome, 1911.

Hirmer Hirmer Fotoarchiv, Munich.

Kinch K. F. Kinch, *L'Arc de triomphe de Salonique*. (Publié sous les auspices de la Fondation Carlsberg.) Paris, 1890.

Mon. Ant.	*Monumenti antichi* (R. Accademia Nazionale dei Lincei, Rome).
Pont. Comm. di **Arch. Sacra**	Pontificia Commissione di Archeologia Sacra, Rome; reproduction rights reserved.
Sotériou	G. A. and M. Sotériou, *Icones du Mont Sinaï*. 2 vols. Athens, 1956.
Stern	Henri Stern, "Les Mosaïques de l'église de Sainte-Constance à Rome," *Dumbarton Oaks Papers* (Cambridge, Mass.), XII (1958).
Wilpert, *Katakomben*	J. Wilpert, *Die Malereien der Katakomben Roms*. Freiburg im Breisgau, 1903.
Wilpert, *Mosaiken und Malereien*	J. Wilpert, *Die römischen Mosaiken und Malereien der kirchlichen Bauten vom IV. bis XIII. Jahrhundert*. 4 vols. Freiburg im Breisgau, 1916.
Wilpert, *Sarcofagi*	J. Wilpert, *I Sarcofagi cristiani antichi*. 3 vols. Rome, 1929–36.

Acknowledgments

My thanks are due to the following, who have kindly helped me in securing the photographs reproduced in this book: Fred Anderegg, Supervisor, Photographic Services, University of Michigan, Ann Arbor; Dr. I. Antonova, Director, Pushkin Museum of Fine Arts, Moscow; Miss Alice Bank, Byzantine Section, State Hermitage Museum, Leningrad; Professor Hugo H. Buchthal, Columbia University, New York; Herbert Cahoon, of the Pierpont Morgan Library, New York; Emir Maurice Chéhab, Director General of Antiquities, Musée National, Beirut; Miss Joan M. Fagerlie, Curator of Roman and Byzantine Coins, American Numismatic Society, New York; Dr. George H. Forsyth, Director, Kelsey Museum of Archaeology, University of Michigan, Ann Arbor; Mrs. Erwin R. Goodenough, Cambridge, Massachusetts; Miss Rosalie B. Green, Director, Index of Christian Art, Princeton University; J. P. Lauer; Professor Doro Levi, Scuola Archeologica Italiana, Athens; Dr. George Miles, Director, American Numismatic Society, New York; Ernest Nash, Fototeca Unione, at the Accademia Americana, Rome; Professor D. Talbot Rice, University of Edinburgh; J. W. Salomonson, Vice Director, Istituto Storico Olandese, Rome; the late G. A. Sotériou; Professor Richard Stillwell, Princeton University; George Thompson, Paris; Hjalmar Torp, Norwegian Institute, Rome; Professor Kurt Weitzmann, Princeton University; and the Curator, church of S. Giustina, Padua.

I should like to express my sincere thanks to the Committee of the A. W. Mellon Lectures in the Fine Arts, who invited me to deliver these lectures at the National Gallery of Art at Washington in 1961. I should also like to thank Mr. John S. Thacher for his hospitality at Dumbarton Oaks during the time of these lectures.

I am indebted to my daughter-in-law Terry Grabar, who translated my lectures into English, and to my son Oleg Grabar, who helped me on various occasions. My friend and colleague Professor Sirarpie Der Nersessian assisted me in establishing the final text and in finding the solution to the numerous problems involved in the preparation of this long study. I should like to express to her my very sincere thanks.

I also wish to thank Miss Agnes D. Peters for expert editing of the manuscript and Mr. Joel A. Herschman for advice in preparing the captions, as well as Mr. William McGuire and his colleagues on the staff of Bollingen Series.

A. GRABAR

The Apocryphal Acts of John are quoted (pp. 66–7) in M. R. James' translation, from his *The Apocryphal New Testament* (Oxford, 1953). Eusebius' *Ecclesiastical History* is quoted (p. 68) in the translation made under the supervision of Philip Schaff and Henry Wace, in the Select Library of the Nicene and Post-Nicene Fathers of the Christian Church, ser. 2, I (New York, 1890).

Introduction

The heritage left us by Greco-Roman antiquity includes a large number of works of Christian art. These are not, it is true, the paintings and sculptures that come to mind when we think of classical art, but we must not forget that the art of late antiquity was a large family, to which the first Christian art also belonged. Further, we must remember that, because of the very great number of traditions that go back to it, this first Christian art plays a significant part in the history of Christian art of all times and all peoples.

Limiting ourselves to iconography, we will attempt in the following pages to show what can be observed of the manner in which the Christian images of late antiquity were created and what role these images played alongside other forms of Christian piety. In order to conform to the method of fixing the chronological limits of antiquity that is generally followed today, the monuments that will be considered will all be works that precede the rise of Islam.

This study is not meant to be a manual of ancient Christian iconography, where one would legitimately expect to find a systematic presentation of all the known types of images. Nor is it a history of iconography which would show the modifications these images underwent in time. My intentions are both more and less ambitious. Instead of considering all the monuments or all the categories of Christian images, I will cite only characteristic examples. But, on the other hand, I would like to say more about the nature of these images, about their form, and especially about their content. Let us pose the two questions that are at the basis of this inquiry: (1) Why do Paleo-Christian images look as they do, or, in other words, how were they composed? (2) On the religious level, what purposes did these images serve at the time of their creation?

To put these fundamental questions is to initiate two kinds of investigation: on the one hand, a study of the material creation of Christian iconography during late antiquity; and, on the other, an inquiry into the functions of these images in early Christian piety. The distinction between these two kinds of problems is evi-

dent, but in practice the investigator does not separate them, and the history of the elaboration of religious iconography is seldom distinct from the themes dictated by the piety of the faithful. Thus, in the present work, the motivations and procedures involved in the creation of Christian images will not be discussed in special chapters, nor will other chapters be set apart to deal with the religious purposes for which these images were adopted. Instead, these problems will be treated simultaneously with reference to different themes or to groups of monuments which will serve as examples. The examples will be chosen not so much to give complete illustrations of the themes or groups as to present some characteristic and important facts.

In all its parts this study has a historical character and, in consequence, is far from being an essay on Paleo-Christian iconography presented in the form of coherent and complete groups of images that would, taken together, be a mirror of Christian theology. Nor does it deal with those various quasi-mechanical procedures which, applied to Christian themes, would produce the Christian images that we know. Finally, without denying the role of spontaneous creation to the makers of images (generally, what we have are only workshop-produced stereotypes of sacred themes), we will leave to individual creativity only what our preliminary analyses do not oblige us to attribute to common motifs. Not long ago scholars had much more confidence in the creative faculties of the makers of Paleo-Christian images. The images seemed to be direct transpositions—or copies of such transpositions—of the words of Scripture into painting or sculpture, in terms that had, naturally, been invented by the artist. There appeared to be no need to assume intermediaries between the Scriptures and the artist. This view owed much to the Romantic idea of the inspired creator, but it also depended upon the undeniable fact that the very nature of Christianity as a revealed religion relates it—and its images—to the Book which contains its entire doctrine.

But to presuppose such a use of the Scriptures, and a considerable creative gift, in the obscure makers of images at any aesthetic level is to accord them tacitly what nobody would think of admitting for a theological or literary work, whatever the talent of its author. It would never occur to anybody to suppose that a writer invents the words and locutions he uses, and it seems normal that the originality of his work with regard to its very basis and form should be further limited by many other factors.

This is, of course, universally recognized today for every field of human endeavor, and the study of Paleo-Christian iconography has followed the general movement, although somewhat timidly. Without question the process of creating Paleo-Christian images was no exception and is comparable to what occurs in related fields of man's activities. The creative process is a series of steps—some conscious, others not—by which the artist sets out to compose an image and does

it with the assistance, deliberate or unsuspected, of all the memories that his task brings out: his education, reading, ambient ideas, personal experience, other images. Of all the influences that contribute to the creation of a new image, those of remembered images are among the most active, just as in literature the most prominent influence is often that of other literary works. It is this that makes it imperative that the historian of Paleo-Christian iconography consider with particular attention all the problems of possible relationships with common contemporary imagery, sacred and profane, in the formation of Christian images. It goes without saying that, at the beginning of the Christian experiment in iconography, the inspiration could have come only from the art of other religions or from profane art. Generally speaking, however, during the last centuries of antiquity the diverse images that had sprung up in an astonishing profusion in all forms of art and in all milieus within the Roman Empire were more than usually interdependent. The makers of Christian images could not have been ignorant of the multifarious figurations that surrounded them, nor could they have escaped being to some degree influenced by them. One could say, and we will return to this, that Christian iconography was born in this epoch thanks to the exceptional growth of figurative art in the Roman Empire.

Our study of Paleo-Christian images will be largely concerned with their sources in the visual arts; and it will lean heavily on the investigations and discoveries concerning Greek and Roman imagery, both Christian and non-Christian, that have been made in the last two or three decades.

Who has not been as much disturbed by the hermetic character of an Indonesian or a Mexican work of art as by a phrase in a language he does not know? In fact, any particular image of any period of history contains its share of motifs common to the society that produced it—commonplaces, in truth—just as a written text or any verbal expression contains words and locutions of current usage. The most inspired lyric poem, clearly marked by individual genius, is nonetheless the product of the specific language of a given society and owes to it the great majority of words, locutions, or turns of phrase that it employs.

Exactly the same thing holds for iconographic matters. And this leads us to the repetition of a fact that is indeed banal but must be pointed out in any attempt to define the bases upon which the original Paleo-Christian images were founded: that from its beginnings Christian imagery found expression entirely, almost uniquely, in the general language of the visual arts and with the techniques of imagery commonly practiced within the Roman Empire from the second to the fourth century. It is a bit embarrassing to repeat such obvious facts, but I do not believe it is superfluous, especially considering the attempts that were made—much later and in much more distant countries—to interpret the same Christian subjects

by using idioms entirely independent of the Greek and Roman systems of imagery. If we look, for instance, at the Christian images painted by the Chinese or the Arabs, which in their own way—but in a way that appears quite strange to us—evoke an evangelical scene or personage, we become aware how essential the contribution of the Greco-Latin iconographic language has been to Christian imagery at all periods, even down to our own; and we can realize even more forcefully how essential it was to the Christian imagery of late antiquity, which will be our principal concern.

This classical language—the most nearly perfect we know—opened infinite possibilities to the Christian image-makers. Naturally enough, they used it in a very unequal fashion, borrowing at times a varying number of its terms, sometimes using only a few simplified expressions, at other times taking over a whole rich repertory of motifs. But various as were their borrowings, all of them remained indebted to visual motifs common to the Mediterranean area at the beginning of our era, when Christian iconography began.

It seems to me that one further remark is necessary. Since we have compared the elements that compose a Christian image with the words and locutions of verbal language, it is useful to recall a fundamental fact, which is—once again—disturbingly banal, but which is unfortunately often forgotten, perhaps just because of its banality.

No one would think of classing as works of art—belles-lettres—everything that is expressed in words; in this field, art holds only a limited sector, which we think we can define fairly exactly. Most prose, whether oral or written, is manifestly removed from aesthetic or poetic concerns. The same thing holds true for all the other modes of expression that man has at his disposal, and notably for graphic and plastic techniques, for the construction of buildings, etc. A distinction is generally not made between works that serve practical ends—those which, in the realm of imagery, fix and transmit facts or ideas—and images that interpret these facts and these ideas in poetic fashion through procedures that are essentially artistic. We are wrong in thus confounding informative images and expressive images. The first appeal solely to the intellect (exactly like a technical text), while the others make an appeal to the imagination and the aesthetic sense. It is an abuse to include among works of art all those painted, drawn, or sculptured images which in large part are really only signs that stand for a human figure, an object, or an idea, whether those signs are of a descriptive or a symbolic character.

It would avoid a good deal of confusion if we were more often mindful of this primary truth, and did not consider every image from the past as a work of art. It is certain that a good number of Paleo-Christian and medieval images ought to be excluded: the artisans who made them were presenting personages and events in

order to make them known to their contemporaries; the simple fact that the images were painted or sculptured is not enough to make them works of art. There is one category of early Christian and medieval figurations in which informative images are more clearly separated than elsewhere from expressive images. This is the category of manuscript illustrations. The pictures that accompany treatises on mathematics, astronomy, or medicine are essentially informative. They serve to make the text more comprehensible. But the illustrations of books of the Bible or of classical tragedies rarely confine themselves to this function. They are parallel to the text and almost necessarily interpret it, and they interpret it always by turning to the methods of art.

It is difficult, of course, to trace a line that would distinguish absolutely between informative and expressive images. It is enough to remember the artistic qualities of certain illustrations of ancient scientific books such as the Greek manuscripts of the physicians Dioscorides or Nicander. On the other hand, a goodly number of Greek or Latin manuscripts with innumerable little stereotyped images hardly deserve to count as works of art.

It is nonetheless true that in itself the use of the techniques of painting or sculpture does not automatically make an artist of the man who uses them, nor does it make the result a work of art. Such painted or sculptured products, neither artistic nor poetic, have little or no interest for the history of art, and its methods of investigation ought not to be applied to them. The historian of iconography, however, can inspect them with as much profit as authentic works of art, because iconographic terms are equally present in any painted or sculptured image. Iconography is, after all, the aspect of the image that informs, the aspect that is addressed to the intellect of the spectator, and is common to prosaic informative images and to images that rise to poetry, that is, to art.

Thus we see very clearly how iconographic studies encroach on the domain of the history of art, especially for those periods which, like the one that interests us here, constantly used the image as a means of conveying information, for example, to convey the content of a religion and the various forms of piety. During such periods, iconography is an important and constant means of diffusing knowledge of the most diverse facts; and this is why it is entirely justifiable to consider this informative iconography as one considers a language, without connecting these activities with artistic enterprises.

I have just said that Christian imagery, at its birth, borrowed, and kept, the Greco-Latin iconographic language as commonly practiced at the beginning of our era everywhere around the Mediterranean. That this is undeniable can easily be verified by observation of certain of the most general and frequent features of Christian images: the presentation of the human figure, its posture, physical type,

costume, and habitual gestures and attitudes, its common accessories, and the architecture or furnishings that surround the figure. An incalculable number of features, inseparable from the Greco-Roman imagery of the Empire, passed into the Christian iconographic language just as naturally and inevitably as words, expressions, and syntactical or metrical constructions of the first centuries of our era—of Aramaean, Greek, or Latin—passed into the language of Christian theologians.

Christian iconography, it is true, came into being only about two centuries after the foundation of Christianity, when the religion had been defined and propagated by means of the word. But, except for the difference in time, the use commonly made of means of expression and diffusion by the Christian authors or by the Christian image-makers of late antiquity was the same: they expressed themselves in the language—visual or verbal—that was used around them.

This is only natural. But it means, a priori, that, with regard to Christian imagery, the great majority of its distinguishing features were neither created nor invented by the makers of the first Christian images. Almost everything in their work was dictated by the models they followed; and it was actually because of this that the new, Christian images they created were understandable to their contemporaries, and therefore effectively achieved the ends intended.

Against this background of a common repertoire of motifs—a koine of the Greco-Roman period—the Christian sculptors or painters had only to trace a few new features and details to transform an image of a type common in that period into a Christian image, that is to say, into one that evoked a Christian thought or a historical event charged with Christian meaning. Materially, this specifically Christian additive could be insignificant, taking only little space, and appearing only to the informed eye because it was expressed by allusion, not directly. For the Christians of the time, however, as for the image-maker, the detail was revealing: it gave the work its value and, though barely perceptible, was the ground on which the work could be accepted or rejected. There are, for example, sarcophagi with the figure of an orant or a Good Shepherd which can be attributed to the Christians or to the pagans only by virtue of details that, at first glance, may not seem significant.

Except for a few themes peculiar to itself, Paleo-Christian iconography has no terms of its own. In other words, the language of the Christian image-makers of late antiquity is not comparable to a complete language—the language of a people or a certain ethnic group—that has a vocabulary that answers every need, with an appropriate syntax. The Christian iconographic language is comparable rather to one of those special or technical languages that linguists call parasitic. Such incomplete languages with a special and limited vocabulary are parasitic because, like parasitic plants, they depend on another language—another plant—and take from it those terms which are needed for the special area involved.

Just as there is a language of electricians, sailors, or thieves—all languages of limited use, which are grafted onto the stock of a national language—there is a Christian iconographic language, which does not comprise a complete repertory of original signs appropriate to all possible uses but consists of a limited group of technical terms which, when added to the normal terms of Greco-Roman imagery of the time, give the image the desired Christian signification.

Whereas the general language is known to everyone and is constantly used, the specialist, speaking in the field familiar to him, introduces a certain number of technical terms. These terms are normally confined to the specialized field for which they have been created, but one or another of them is sometimes adapted to another field, and is made to refer to subjects of a different kind. Thus language creates substitutions, and new versions of those terms which were originally reserved to a technical field and to the language of specialists are adapted to new subjects. It is in this way that Christian image-makers utilized the theme, for instance, of the philosopher, which had originally been defined in the art of the philosophico-religious coteries of the Empire. The Christians repeated it, but gave the image of the philosopher taken from this special iconographic language a new value as a symbol of Christ, the "true philosopher."

In order to take account of this kind of procedure, and thus study one of the means most frequently employed for creating new Christian images, we will attempt to define a certain number of general themes—such as Death and Resurrection—which, at the period we are discussing, came into being in Christian iconography. In this way an iconographic typology can be established, a network of constants which, through individual works and in company with constants common to everything appearing at the time, reveal closer lines of kinship between works in related categories. In the case that concerns us, it is a matter of images which, whether they be pagan, governmental, Christian, or Jewish, treat related themes. In fact, this community of ideas imposes on images of different origins similar formulas.

For example, there were several religions that liked to represent visually everything touching upon the great power of their respective gods; in its turn, Christianity took this theme into its iconographic program. The iconographic solutions of one group act on those of the others. But in order to perceive this network of interdependence, one must first recognize what linguists call the semantic fields, that is, the sum of words (for language) or subjects (for iconography) that form semantic families, that is, families of words or subjects that are related to each other by their meaning. Words of very different roots and forms can belong to the same semantic family: for example, conquer, conqueror, victory, trophy, glory, domination, and the corresponding defeat, prisoner, slave, struggle, hunt, circus, etc., are of the

same semantic field; and in iconography, the scene of a victorious combat, the trophy that is a symbol of victory, a crown of laurel, the figure who crushes the conquered, success in the hunt or in the amphitheater, an arch of triumph, or the subjection of barbarians present the same theme. Like words of the same semantic field of a language, terms of the same semantic field of imagery are connected with each other not by their form but by their content; and this is of great importance for our studies in iconographic creation.

A new image can have as its source another image which does not resemble it formally. The link between the two is of a semantic nature; that is to say, both (despite their different appearance) belong to the same semantic field of a given iconographic repertory—for instance, the repertory of late antiquity. Thus, for example, there are several types of images of the Resurrection of Christ. Each differs from the others, but all represent the same dogma, and all are borrowed from iconographic formulas for Triumph as presented in the imagery of the Roman Empire: the raised cross presented as a trophy, the type of Anastasis that shows Christ trampling down the Evil One, or Christ with the adder and dragon. Although they represent the same dogma, these images have nothing in common visually. But they are related because they all derive from types that had already served to represent Triumph in the monarchical and agonistic art of the period. The Christian image-makers went back to the same source: the images in the semantic field of the idea of victory or triumph. The iconography of Triumph showed the way to the iconography of the Resurrection. Theoretically the Christian image-makers could have found another means of expression for this dogma, but they do not seem to have done so at this time.

In considering the ways in which the earliest Christian images evolved, we should emphasize the importance for our purposes of the definition of these general themes under which we place the different concrete subjects. For, if the grouping of subjects by general themes is valid, there are better chances of grasping the manner in which dissimilar iconographic formulas are applied to subjects of the same semantic family and similar iconographic formulas are applied to subjects which, although they seem to be unrelated, are really concerned with the same general theme. Constants play a major part in many ancient Christian images. To recognize them is to understand better the manner in which these images were created.

I will not discuss here all the procedures of the early Christian image-makers. But it is important to keep in mind that creativity in this area consists in appropriating existing figurations by shifting the meaning of repeated formulas, by taking over known iconographic formulas, or composing similar ones by analogy. In one instance, and a rare one, we will see pre-Christian iconographic formulas applied in a sense diametrically opposed to the meaning they held originally. I have

in mind those images of Imperial art which served to glorify the power of Rome and its representatives by showing the defeat of Rome's enemies, who are bound, judged, condemned, and beheaded. Christian image-makers took over this imagery, but used it to glorify the judged and condemned—Christ, the apostles, the martyrs —and to stigmatize their persecutors—the princes, the judges, the Roman soldiers.

In attempting to observe the procedures of iconographic creation in late antiquity, we can, as I have indicated, benefit from the experience of linguists, and particularly from their studies of technical languages, because, within the Greco-Roman imagery of the Imperial age, Christian iconography had the characteristics of a technical language. Now in speaking of a technical language or a specific iconography, we recognize implicitly that the technical language or the special iconographic language has its own particular functions, which are its *raison d'être*. Of this I am, in fact, convinced: that in late antiquity there were no Christian images made for the sake of producing a pretty fresco or an appealing figurine or genre scene. Indeed, we know of no such Christian figurations, where creation is a gratuitous act—art for art's sake.

All the Christian images that we know had a definite religious purpose, and this is why we will investigate examples of these images by grouping them according to the religious need each group served. This method permits us to understand better the meaning of each image: taken in isolation, apart from a specific context, an image can be understood in many different ways; but its religious meaning becomes clear when it is considered as a part of a series of images, all serving the same purpose. For example, the orant in a catacomb and, later, the orant in a martyrium do not have the same religious meaning. Nor do the scenes of the miracles of Christ on a sarcophagus and those on the walls of a baptistery answer the same purpose.

In other words, the grouping and examination of images in related series permits us to establish the semantic fields in iconography of which we have been speaking. At the same time it shows, as dictionaries do for words, that the same iconographic term—the orant, the Good Shepherd—has different meanings according to the context (that is to say, according to the purpose of the given image). The first step can be compared to what happens when we establish lists of synonyms (separate terms that have similar meaning); the other step corresponds to a study of homonyms (terms that sound alike but have different meanings).

With regard to method, a last point merits attention at this place. In linguistics one often comes upon the problem of synchronism or its opposite, the problem of distinguishing in time the phenomena that are observed. There is, in fact, no question that certain phenomena belong to the language of one single period, while others represent steps in an evolutionary process or successive transpositions. In certain respects the situation is plainer in iconography, since the facts that one

observes all belong to dated, or more or less datable, monuments. But since iconographic terms do not change systematically or according to regular curves and the dates of many monuments remain uncertain, and since, moreover, as with languages, the same iconographic term can be employed simultaneously with different meanings, each of them invented at a different date, iconographic studies do not escape the problem of synchronism. Were the images we see created simultaneously, as elements of the same repertory of figurations? Or is it a question of different steps in the work of the same image-maker (successive phases of the same images)?

Since we are concerned here only with Christian antiquity, we have less chance of committing grave errors by confusing the simultaneous with the successive. But the danger exists: there were, in the Christian religion, a good many shifts between the third and the sixth century. The image of the orant, for example, had several meanings to the earliest Christians, but could have had all of them at once to a Christian of the fifth century. But these meanings were formulated successively, at different moments. Thus the historian who seeks to understand the material creation —the visible evidence—of Christian iconography will have to distinguish the meanings chronologically, and sometimes to take into account earlier meanings, because, for example, the initial significance of an image can clarify the meaning given to the same image at a later time. Excellent examples of the usefulness of this method will be offered by the works themselves when we attempt to explain the religious meanings of some types of Paleo-Christian images of the Virgin Mary.

CHRISTIAN ICONOGRAPHY

A Study of Its Origins

PART ONE

Preface

In general, the study of the origins of an image that expresses a religious concept leads to a better understanding of the reasons for its existence. By learning where, when, how, and for what end a certain image was created, we begin to apprehend the religious significance that the image may have had to its creators. It is therefore all the more pertinent to inquire further into the very first Christian images and the conditions under which they were created.

Figurations of a Christian character are normally endowed with a religious function, and this function is all the more certain for the first images created by Christians because of the circumstances under which they appeared. No extra-religious consideration could, at that time, have dictated the use of imagery to any Christian if he were not determined to possess an expression in paint or stone of some Christian truth or some personal attitude toward a serious problem of life. Neither the laws of the pagan Empire nor Christian custom—then nonexistent—can account for this adoption of imagery; thus the postulate that these first images are such figurations as those which at other periods are so often passively repeated, and about whose real religious value one can have reasonable doubts, is immediately eliminated. Those first makers of Christian images, who worked at their own risk and to their peril, would never have done so without serious religious reasons, especially since the first generations of Christians had worshiped without cult images. But the practices of the idolaters, who all made extensive use of paintings and sculpture, made it unavoidable that a change of principle with regard to images had to take place.

We must start our inquiry by a study of the beginnings of Christian imagery and the problems it poses with an awareness of what was being done—in the existing situation—outside the Christian communities, not only among the devotees of the great traditional religions of Greco-Roman paganism, but also among the Jews and the adherents of other non-Christian religions within the Roman Empire. We will have to examine the oldest Christian images, their form, and their content, by

placing them beside analogous and contemporary representations that are not Christian, in order to understand the religious purposes of those who created them. This necessitates undertaking two important excursuses (see pp. 8 f., 10 f.). The first will be devoted to the form of the first Christian images, which are remarkably concise and hold to the strictest essentials; it will also deal with the iconographic language of these schematic images, or image-signs, and the problem of the antecedents of similar Christian figurations. The second excursus will probe the reasons why these image-signs were used in the particular area of funerary art in the Christian catacombs and sarcophagi. These images for the most part represent the salvation or deliverance of one of the faithful, whom God has saved from the peril of death; but in some cases they recall the doctrinal merits of the deceased—his baptism, his communion. What was the religious purpose of these images and others —pagan ones—which present evident psychological analogies? The answer to this question will inform us better as to the religious intent of the makers of the first Christian images.

The second chapter will be chiefly devoted to some Christian images that make us feel the breadth of the influence exercised by the official art of the Roman state on the young Christian art at its beginnings. In recent years there has been much discussion of the art that flourished in Imperial Rome at the end of antiquity, but its effects have been studied only partially, and primarily with reference to the influence exerted by images of the Emperor. In reality, this influence was far more general, and it can be said that at its birth Christian iconography received no more powerful impact than that of the images of the "governmental" cycle, by which term we designate all the subjects that represent the political, military, and judicial powers of the Emperor and the agents of the Roman state and that show its activities. This is a whole area that has never been explored, as such, in its entirety.

Among the other areas of art practiced at the heart of Roman society, the semidecorative, semisymbolic imagery that flourished in the villas of the great landed proprietors must also be cited. We will see how, and under what conditions, the art of the latifundia lent itself as a source for the Christian image-makers of the end of the period we are considering.

I. The First Steps

The earliest Christian images appeared somewhere about the year 200. This means that during roughly a century and a half the Christians did without any figurative representations of a religious character. It almost seems a pity, since this rejection of images—never proclaimed *expressis verbis* by the theologians—leaves us without archaeological testimony as to the spiritual state and reigning disputes of the Christian communities before the year 200. We date the oldest Christian paintings of the catacombs to about 200, and the oldest representational sculptures on Christian sarcophagi to the first third of the third century, even though we know that this chronology is rather insecure, since it does not rest on dated written documents. In fact, a number of topographical, stylistic, and iconographic features indicate that the earliest subterranean mausoleums in Rome, those of Domitilla, Calixtus (crypt of Lucina), Priscilla, etc., are close in date and generally slightly later than the year 200. The first funerary frescoes of Naples and Nola are more or less contemporary with those in Rome. The first sarcophagi with Christian subjects, those of Rome and Provence, belong to about 230; and the mural paintings of the chapel (baptistery) unearthed in the little Roman garrison town of Dura-Europos, on the middle Euphrates, on the Persian frontier, are also of about 230. It is from these monuments that we will take our first examples of Christian images. I have said above, in the preface to this first part of our study, why it is important to look first at the earliest iconography of the Christians—even though the chronological order of the monuments will not be followed afterward.

Let us consider some examples of painting in the Roman catacombs, choosing them from among the earliest. What one notices first in these funerary hypogea is that the ceilings, and sometimes the walls, are divided into compartments by a pattern of straight and curving lines. This framework of decorative lines is aesthetically predominant in the paintings of the catacombs and is very characteristic of that art which, in the midst of the cemetery, tended to gaiety.

1, 2, 4

Some of the figures, generally very small (they were to become larger only in

the fourth century), are no less attractive; this funerary art goes beyond the fears and sorrows of death and puts on an air of gladness. The little figures isolated in the centers of their delicately framed fields represent orants or Good Shepherds whose decorative effect seems more important to the painters than the meaning, for they use them as motifs that they alternate within their designs. The figures are, however, allegories of the soul of the pious believer and of Christ as the shepherd (see below, pp. 10, 11, on the sarcophagi). But the catacomb painters have not deviated from a pleasing manner, and all of the figures show the imprint of this attitude. In the same agreeable tone they paint a Daniel in the lions' den, a resurrection of Lazarus, Noah in the ark, or the Adoration of the Magi: the protagonists are young and graceful, with elegant gestures and noble mien. And it is rare to find one of these paintings that does not reproduce a conventional scheme.

In catacomb painting, and on sarcophagi as well, the story of Jonah is told in the same gracious and fluent manner but in several successive episodes: Jonah thrown into the sea, Jonah vomited by the whale, Jonah resting in the shade of a pergola. Here again the decorative intent takes precedence; the artist responsible for these religious symbols has separated the diverse episodes of the story of Jonah and distributed them in the panels afforded by the general arrangement of the ceiling or wall decoration or the sarcophagus wall.

This art is an easygoing one, indifferent to detail, to the individual expression of the figure, to the precise traits of a face. One finds uncompleted architecture, and surprising negligence in Biblical images of a narrative character. But these paintings of the catacombs are not meant to represent events—they only suggest them. It is enough to indicate one or two salient features, in order to designate a specific person, event, or object. These few traits do not define the images at all, but the informed viewer is invited to make use of the summary indications to divine the subject. In other words, the paintings are schematic—that is, they are image-signs, which appeal above all to the intellect and which imply more than they actually show. Since the value of a sign is commensurate with its brevity, there are no limits to its use except those imposed by the necessity of remaining understandable. It is imperative that the sign be unequivocally decipherable. We know, of course, that the frequent use of any sign in a certain context permits surprising abbreviations. One may cite the famous paintings in the crypt of Lucina which show a fish that serves as a support for a small basket filled with white ring-shaped objects. The Christians who went there knew how to decipher such a painting: communion.

And they knew, too, that the image of the fisherman alluded to Christ and to the apostles, fishermen of souls. But in some cases the brevity is certainly excessive, as when, for example, a scene that represents a meal of some kind has no detail that would distinguish between the Multiplication of the Loaves, the Miracle of Cana,

the Last Supper, or the repast in paradise beyond the tomb. Those who planned the mural paintings in the catacombs were probably not entirely averse to a certain ambiguity in their image-signs, since the Multiplication of the Loaves, for example, was regarded as a symbol of the agapae of paradise or a figuration of the Last Supper. This deliberate ambiguity is evident in certain cases, as in the so-called "rooms of the sacraments" in the crypt of Lucina, where a communal repast is shown as the 6
Multiplication of the Loaves (indicated by the presence of twelve baskets), though the scene appears next to a scene of baptism, which would argue in favor of a 18
banquet representing the Last Supper. For it is this gospel episode that is the foundation of the sacrament of communion, which the adjacent image of baptism, another sacrament, would appear to call for. Of course, the matter is even more complicated than this, and more than one archaeologist, trying to identify this scene of baptism, has hesitated between the baptism of Jesus and that of a neophyte. This confirms what we have said before: image-signs, as found in the catacombs, fulfill their purpose successfully only in so far as they are clear; but the concept of clarity is a function of the training of the viewer.

It goes without saying that the clarity of the image-sign also depends on the degree of complexity of the subject that it is meant to communicate. We have lost the key to most of the scenes represented on the walls of the hypogeum of the 10
Aurelii, under the Viale Manzoni in Rome; so we cannot agree on the meaning of the very interesting scene in the catacombs at S. Sebastiano in Rome that shows a 11
person dressed as a soldier ascending into the heavens before a circle of amazed spectators. In Christian imagery, the representation of unusual subjects is rarely attempted. But who can provide any final solution to the puzzling scene in the catacomb of Priscilla, where one person seems to point to a star in the presence of 12
a woman and child? And who can identify with any certainty, in the catacombs of the Cimitero Maggiore, the mother and child who appear with a monogram of 13
Christ on either side and are flanked by two donors? Is this really the Virgin Mary, or is this some Christian woman with her child?

However, it is not only the laconic image-signs that are difficult of interpretation. The descriptive scenes, without inscriptions, in the catacombs discovered in 1955 under the Via Latina afford a whole series of subjects, beginning with the now famous image of a group of sages or doctors with a body, presumably dead, stretched 14
on the ground. In all these cases, and in a certain number of others of the same kind, the image-sign no longer fulfills the function for which it was created. It lacks clarity for us, either because the subject it is meant to translate is too complex or because our iconographic information is insufficient.

It is certainly not the task of the historian to judge the relative effectiveness of the image-sign of Paleo-Christian art as a means of iconographic expression. But

recognition of the limits of its effectiveness does indicate what functions could have been assigned to it. These functions are comparable to those of general ideas in language. Some of these general ideas are abstract in character, while others tend to become so as a result of extremely frequent use. In the series of abstract ideas there is, for instance, the notion of piety, which has as an image-sign the orant, or the idea of philanthropy, which—although it is less obvious to us because of the greater rarity of the iconographic term—has its iconographic counterpart in the figure of the shepherd carrying the lamb. In the series of ideas made banal by use, some examples that quickly come to mind are names of feasts: the Annunciation to the Virgin, Easter, the Epiphany of Christ's Baptism. The words, like the corresponding image-signs, are enough to recall the evangelical events commemorated by these feasts.

All the earliest Christian images belong to this category of pictorial signs whose characteristics have just been defined. It is in funerary art that we find the oldest examples (there was an analogous imagery made for the living, even though we cannot say whether or not it began as early as the sepulchral imagery). The image-signs that fill the Paleo-Christian catacombs and sarcophagi are of two kinds with respect to their semantic value. A limited number of iconographic signs represent the two major sacraments of the Christian Church, baptism and communion. The majority of the others serve as references to or citations of divine intervention for the salvation or preservation of certain believers: the preservation of Noah, during the Deluge; the deliverance of Isaac, when Abraham would have sacrificed his son; the deliverance of Daniel from the lions or the three Hebrews from the furnace; or, from gospel narratives, Lazarus restored to life by Jesus or the paralytic cured, shown carrying his bed.

When these highly schematized scenes are painted in the catacombs or carved on sarcophagi, their presence next to the body of the dead has the same meaning as the prayer of the burial office called the *commendatio animae*: they enumerate the precedents for divine intervention for one of the faithful, and express the desire that God may exercise the same benignity toward the person who is now dead: God, save him, as you saved Daniel, Noah, etc. The rituals that we know are not earlier than the ninth century, but the correctness of this interpretation cannot be questioned, since identical prayers for the living have come down to us, of which several go back to late antiquity. The extension to the living of prayers evoking the saving power of God in the Biblical past also explains the cycles of analogous images decorating objects in common use such as drinking glasses or engraved and painted cups decorated with gold leaf. Prayers of this kind, which seem to have served mostly for individual worship and even for magical invocations, probably go back to Jewish versions. It is even possible that the image-signs of some of these Biblical

Margin references:
1, 2, 15, 16

17, 19, 22

18

salvations or deliverances were first created by the Jews for their own use. Jewish examples of deliverance—Abraham, from sacrifice of his son Isaac; Noah; and Daniel—are known. But whether the Christians knew, at the beginning, image-signs of Jewish making or only Jewish prayers with the formula: Save me as you have saved Noah, etc., the great proportion of veterotestamentary salvations in the catacombs and on the sarcophagi, but especially in the catacombs, makes it very probable that there was some initial Jewish contribution. The images of salvation mean: God who in the past has saved all these pious men will do as much for the now deceased (or for the owner of the object on which the images appeared). 20

The psychological intent is slightly different when, instead of the precedents for salvation, one of the sacraments is represented—baptism or communion (see above, pp. 8 f.). Here, obviously, there can be no question about Hebraic influences, nor about the formula: Save me as you have saved others. These images, found only in sepulchral art, serve to point out that the deceased was a Christian by representing the two sacraments. It is no longer only the intervention of God but participation in the sacraments of the Church which assures the salvation of the dead.

The Christian imagery of allusive signs employed, astutely enough, only a very limited number of figures, and this saved it from confusion. Nevertheless, it is surprising, if we think of pagan usage at the time, and of funerary art in the Middle Ages, to see how small a place is devoted to Christ in the earliest Christian art or to symbols that would stand for Christ. This applies to Paleo-Christian art before the edicts of tolerance. At this early time, the Saviour appeared only in the guise of various allegorical images, which had remarkably few individual traits. There was chiefly the Good Shepherd carrying a lamb, which signified that the shepherd, an allegory for Jesus, saves the lamb, an allegory for the Christian soul. The image-makers made no attempt to be more specific. Like the ceilings of the catacombs (see above, pp. 7 f.), the façades of certain sarcophagi line up three Good Shepherds; 19 and these may have, indifferently, the features of an adolescent or a bearded man of ripe age. Without going into examples that show how the image of St. Peter was influenced by these allegorical images of Christ (see below, pp. 69 f.), it can be said that as a general rule these allegorical images were relatively abstract, on principle; for in pagan Roman art, as has been shown above, the figure of the shepherd carrying the lamb was a symbol of philanthropy—*humanitas*. As Theodore Klauser has recently observed, it was by starting from a symbol of moral philosophy that the Christians created the allegory of Jesus that was the most common one in the third and fourth centuries.

Christ as the Good Shepherd has a counterpart in the deceased as orant. This is evident in the earliest catacombs and on the façades of Paleo-Christian sarcophagi. The pagan symbolism of the Romans had used the same orant to signify *pietas*; thus,

here again, Christian art began by representing abstractions not only to designate
Christ but also to characterize the ordinary Christian. We will see that in both cases
the later history of Christian iconography involves an attempt to replace the
abstract symbols by concrete representations—portraits, in fact. But first let us turn
22, 23 our attention to a second allegorical figure for Christ (or his forerunner Job), the
philosopher, which occurs as early as the Good Shepherd. This allegory, unlike the
Good Shepherd, was afterward quickly forgotten, and this is why it is more dif-
ficult for us to recognize an allegorical representation of Christ in the figure of the
philosopher on the Christian sarcophagi. But modern exegesis leaves no doubt that
the bearded man with the nude or seminude torso in an exomis tunic, shown seated
on a stool, often reading a book, is certainly Christ as the true philosopher. Of course,
the deceased believer sometimes takes on the features of the philosopher, but as a
24 general rule this iconography is reserved for Jesus, and the deceased stoop before
the philosopher who has taught them the true philosophy.

In the oldest catacombs, images of salvation taken from the Old Testament
25 predominate; there are, however, a few instances of the Christ-Thaumaturge,
27 particularly in the representation of the resurrection of Lazarus. But the catacombs
and the sarcophagus reliefs of the fourth century freely multiply instances of the
miracles of Jesus. What seems to have happened is that the image-makers and their
clients grew increasingly conscious of the idea of a more personal image of Jesus,
this individualization developing through his thaumaturgical works. However,
before multiplying the miracles of Jesus, the early image-makers often reproduced
26 a single scene of his infancy, the Adoration of the Magi. The special place reserved
to this subject is surprising for us only because we have for centuries celebrated
December 25 in commemoration of the birth of Christ at Bethlehem. But the
ancients celebrated his birth either on the day of the Epiphany of Baptism (January 6)
or the day of the theophany of the Magi (January 5); and the paintings of the Paleo-
Christian funerary cycle retain the reflection of this latter very archaic usage. The
image of the Adoration of the Magi replaces the whole Christological cycle. It is
the iconographic sign that indicates the principal argument in favor of the salvation
of each believer: the fact of the Saviour's Incarnation and his work on earth.

The necessity of redemption is sometimes indicated by an image of Original
28 Sin, Adam and Eve, separated by the tree, with the serpent. But with a certain
negligence often characteristic of their work, or perhaps with the deliberate inten-
tion of representing only the promise of salvation (and not anything that could be
an obstacle to it), the men who made the images in the catacombs and on the sar-
cophagi did not often represent our original ancestors. There are, however, some
very early examples of this image (Naples, Nola); and in the fourth century it was
included in some of the more complete ensembles where the image-signs are

grouped systematically as a general demonstration of the scheme of salvation, as
on the sarcophagus of Junius Bassus (A.D. 359). Original Sin (*g*) serves here to
counterbalance a whole cycle of the Redemption developed especially to show not
only the Passion of Christ (*h, d–e, c*) but the martyrdoms of the two Roman apostles,
Peter and Paul (*b, j*). The Redemption cycle begins with an Entry into Jerusalem
(*h*), a scene of the coming of the Saviour that is an iconographic synonym of the
Adoration of the Magi. Thus the more developed cycle confirms that the Adoration
of the Magi was a sign of the Incarnation-Redemption. So far as I know, the Adora-
tion is the oldest image-sign for this central fact in the record of collective and
individual salvation; and this explains its frequent appearance in funerary art from
the beginning.

In their main outlines the iconography of the catacombs and the iconography
of Roman sarcophagi are the same. Nor is there an essential difference between the
iconography of Roman sarcophagi and that of the provincial sarcophagi of the
third and fourth centuries (southern Italy and Sicily, northern Italy, Provence,
Spain, Roman North Africa, and even Constantinople). But because of the progres-
sive enrichment of the repertory and the iconographic innovations that were made
everywhere, the unity of this iconography for sepulchral use appears only when the
chronology of the monuments is taken into account. There is greater unity, in the
beginning, in the paintings and reliefs of the third century. It diminished gradually
after the triumph of Christianity, each branch of Christian art tending to greater
autonomy and each undergoing different influences. We will return to this a little
later in speaking of the relationship between image-signs representing Biblical
subjects and descriptive images representing subjects analogous to or even identical
with those of the image-signs. Let us say now that the free exercise of the Christian
cult was not favorable to artistic activity in the catacombs, and painting in churches
and mausoleums above ground must have grown rapidly in importance. From the
second half of the fourth century on, the paintings in the catacombs—which were
given up completely in the fifth century at Rome (in Naples, vast subterranean
galleries of easy access were still used for several centuries after the Peace of the
Church)—appear either as repetitions of older frescoes or as reproductions of
paintings in above-ground buildings (the latter, for example, in the newly dis-
covered catacombs under the Via Latina). It is from this last point of view that these
later works ought to be studied, especially in matters of style but also with regard
to their iconographic program.

The iconography of the sarcophagi of the fourth century is more interesting
and original. Here, too, the monumental art of the great sanctuaries raised after the
Peace of the Church left a profound imprint, and we will take note of several
iconographic creations of this type on the sarcophagi, not only with regard to

29

images of Majesty (see p. 79) but in speaking of the iconography of Christ and the apostles Peter and Paul (see p. 68), and also in connection with the oldest figurations of the Resurrection or the Incarnation (see p. 123). In addition, the sarcophagi, like the frescoes of the fourth century, show the image-sign growing toward the descriptive image; and we will look at this in due course (see p. 93).

Before considering this evolution in the very nature of Christian imagery, the question should be asked: What was the exact religious value of the Christian images that we consider as initial, those which we designate by the term image-signs? One can obviously stop at the easy answer: These figurations of funerary art, like any other images, served to call to mind the events they represented. But to be content with this is to evade the real question. When the Christians abandoned their negative attitude toward imagery, adopting a repertory of images and using it in such sacred places as mausoleums and cemeteries, they had serious reasons for doing so. What exactly were their intentions?

We know that the images of the earliest cycles belonged to catacomb painting and sarcophagus decoration, the two categories of Christian art that we have discussed with respect to their religious meaning. Most of the images represent examples of salvation or preservation (especially deliverance from the danger of death) that God accorded to some of the faithful in the past; other images are concerned with the work of Jesus the Saviour or the Christian sacraments. These last meant, clearly, that the deceased, by virtue of his devotion, could hope to share after death the prospect of those who believe in Christ. But these definitions of the subjects of the images still do not entirely explain the grouping of precedents for individual salvation around a tomb or the presence of images signifying the work of redemption for all men or the merits of the deceased.

The psychology behind such a use of images becomes a bit more comprehensible if we compare the Christian funerary program to that of the pagans of the same period. On their sarcophagi, and sometimes on the walls of their mausoleums, the latter often represented scenes drawn from mythological stories, of which some had Death as a general theme—scenes of the death of a hero, Meleager, Endymion, etc.—while others represented the soul of the deceased transported to the beyond, to heaven or to the happy isles. In decorating sarcophagi with images of this kind, what the pagan sculptors did was to adapt the subjects furnished by prevailing religious iconography to the central themes of funerary art. In this respect the schemes of the pagan funerary cycles prepare us for the images of the cycles of the Christian cemeteries. The pagan cycles influenced the formation of the Christian ones.

There are, of course, essential differences between the pagan and Christian funerary programs. First, the theme of Death is absent from Christian funerary art,

31

30

whereas it is at the very center of the corresponding pagan program. The Christians systematically avoid Old Testament or gospel subjects that recount the death of anyone. It is seemingly the victory of Christ over death that excluded this theme from Paleo-Christian sepulchral iconography. Second, while Christian iconography continues the pagan tradition of images of life beyond the tomb, it does so much more discreetly. For a long time representation of the afterlife is limited to the allegorical figure of the orant or, even more abstractly, the lamb that the Good Shepherd carries on his shoulders; both are images of the soul of the Christian. It is only at the end of the fourth century, and even then only rarely, that there appears the image of the deceased led to paradise by a saint—a tardy and exceptional Christian version of an ancient theme of pagan sepulchral iconography. 32 33 34

Of all the pagan burial images, certain scenes of the labors of Hercules in the recently discovered private funerary hypogeum under the Via Latina are the most closely related to Christian funerary figurations—or at least to one of the major categories of those figurations, the images of salvation. The relationship is apparent only if the deeper religious meaning of the two cycles of images, pagan and Christian, is considered. For in both cycles the true sense of the images is an evocation of a divine power which works for the good of man. On the Christian side, it will be remembered, the episodes represented are those where God saves a believer from death; on the pagan side, they are the exploits of Hercules who, according to the beliefs of the time, was a "savior," a hero who devoted his life to working for the deliverance of men. In other words, the Christian images of salvation or deliverance and the pagan images of the labors of Hercules were both meant as demonstrations of a divine power working for men; and it was for this reason that they were used in funerary art.

The parallelism extends further. The Herculean cycle in the catacombs of the Via Latina is not limited to the exploits of Hercules but includes also those whom his efforts benefited (Alcestis, after her death, led by Hercules to her husband, Admetus, 35 who, now immortal, inhabits an ideal world beyond). It thus forms a real counterpart to the Christian images that represent God's deliverance of Abraham, Isaac, Noah, Lazarus, or the paralytic. The Christian images, like the paintings of Hercules in these catacombs, were effective because of this: they invited each and every man to see his own end in the enviable condition of the Biblical or mythological persons who had experienced an especial divine solicitude.

Recognizing the relationship of the early Christian images to pagan versions of contemporary funerary art helps us to perceive the religious meanings of all these images. But to grasp more fully the intention of those who grouped the two cycles together at the tombs, we can bring to bear the testimony of another category of images of the same period—the images inspired by the Roman games. These

were very common figurations at the time of the first Christian images, but their relationship to the Christian images has never been seen because the subjects appear to be too different. The importance of the games of the circus and hippodrome, which had innumerable consequences in every level of Roman society, is well known. The language of Christian worship borrowed much from the language of the circus, either comparing a martyr, or simply a believer, to a victorious athlete or designating the vicissitudes and triumphs of religious experience in terms of combat and victory in the arena. In parallel fashion, Christian iconography had recourse to the repertory of imagery created for the circus and borrowed more than one image, for example, that of the athlete standing beside a cippus where he will place his crown, the reward for his triumph, or the image of the fighter in the arena battling a wild beast. In short, Roman Christianity did not remain isolated from the world of the circus and hippodrome; and therefore, for this period, it is legitimate to propose other comparisons, such as those which we will now make, not of iconographic subjects but of another function of images.

It is thanks to the excellent study by the Dutch archaeologist J. W. Salomonson that I am able to propose such a comparison. In studying a pavement mosaic of the fourth century found at El Djem, Tunisia, he has produced evidence that it repre-

36 sents a banquet of five circus fighters (*venatores*) and that it belongs to the Roman cycle inspired by the spectacles of the arena. He has, furthermore, been able to explain the presence of not only the prophylactic motif of the sheaf of millet that is repeated several times on the border around the central image but also another prophylactic symbol, in the form of a scepter, that one of the five figures holds in his hands. In various ways, several other North African mosaics are related to the mosaic of El Djem. They also are scenes inspired by the circus, showing the combat of man and animal or of animals only, both types being represented in conjunction with familiar prophylactic symbols: the sheaf of millet, the scepter, or more abstract

37 motifs of Punic origin. Among the analogous images, a second mosaic from El Djem is particularly instructive in that it has—in addition to the images showing a fighter and some prophylactic symbols (the subjects mentioned occur together with an image representing protection against the evil eye)—inscriptions drawn from the acclamations shouted at the arena, exclamations by which the crowds expressed their admiration for the favorite gladiators: "You are alone" (in being able to accomplish such an exploit); "For eternity" (may your glory be eternal). The inscriptions reveal the triumphal character of the figurations.

These images thus represent the triumphs of the *venatores* of the circus. One might well include them among the iconographic commemorations of the past exploits of famous fighters if it were not for the fact that these images are accompanied by, or sometimes framed by, prophylactic symbols and acclamatory in-

scriptions which reveal that the men who commissioned them had in mind an eternal perpetuation of the exploits in question. For, since prophylactic symbols have no retroactive value, it would be superfluous to represent them in a simply commemorative image. The fact that they are present—even numerous and frequent—indicates that the compositions were meant to exert in themselves a beneficial influence in favor of those who owned the images or those who viewed them. In other words, because of these symbols and inscriptions in images of the circus cycle, we can be even more certain as to what was intended by an important category of contemporary images of the earliest Christian iconography; for these images reveal the same kind of intent as that of the Christian images of salvation or deliverance. That is, the motive for consecrating images to the victorious exploits of celebrated circus fighters, with emphasis on the purpose of inviting perpetual renewal of these triumphs, is psychologically very close to what the Christian image-makers intended by an image of the deliverance of Noah or Daniel, which also was created only for the purpose of inviting a similar divine action toward a contemporary.

Two groups of archaeological facts reinforce the connecting links between the pagan and Christian images that we have been discussing. On the one hand, there are the many other Roman works inspired by the circus which are manifestly apotropaic. Salomonson, using in part the older studies of Waldemar Deonna and other classical archaeologists, notes the frequent representations of a man fighting an animal, or of wild animals attacking other animals, on various objects in common use such as vases, plates, pitchers, or lamps. The prophylactic significance of these themes inspired by the circus games is confirmed by the use of the struggle against a wild animal in ancient books of oneiromancy. These works interpret this image as a favorable presage; and the same interpretation holds for the images of *venatores* in combat with a wolf, lion, or bull or of combats between animals. This fact is extremely important for the study of Christian iconography in late antiquity, and will be of use again later in regard to another chapter of its history (the images inspired by the cycles that we have called the cycles of the latifundia). At this point it is necessary to consider the prophylactic significance of representations of combat between man and animal or between animals because it throws a new light on the probable meaning of some of the primitive Christian image-signs.

There are pavements of the first centuries of our era with images other than those of the arena that lead in the same direction. It is at Antioch, in the private houses, that one finds most of them. They represent the feminine personifications Ananeosis, Ktisis, Soteria, Apolausis (restoration, foundation, preservation, well-being). Each of these personifications corresponds to something desired, including the acts of laying a foundation or restoring a dwelling: such acts are personified to invite a favorable future for the new house.

38

All the myriad motifs and subjects of pavement mosaics like that of the victorious *venatores*, which we have been considering, testify to the same intent: to wit, the *raison d'être* of this kind of composition was prophylactic. These images were thought to function actively.

Alongside the very numerous pagan pavements (whose location has saved them from destruction) we can place only a small number of analogous Christian figurations. But there is one most valuable example. It is a vessel of lead, possibly liturgical, which was found in Tunisia in the nineteenth century. Published at the time by G. B. de Rossi, it has since disappeared. The sides of this simple object are covered with *repoussé* reliefs which curiously juxtapose a large number of motifs drawn from Christian and pagan repertories. That the object itself is Christian there is no question, because of the use of the motifs of the lamb, the four rivers of paradise, palm trees, etc., but the motif of circus athletes with their crowns of victory is also present, as well as scenes of animal combat. The heteroclite group of images is accompanied by a Greek inscription, which wishes well to those who use the vessel. This makes it clear that the figurations, uniting Christian motifs and motifs of the arena, are prophylactic symbols: they are brought together on the base in order to contribute to the realization of the hopes formulated in the inscription. Finally, this object is a precious one in that, by juxtaposing images of the two cycles, it removes our last doubts as to the legitimacy of our comparisons with images inspired by the circus. The Tunisian vessel is material proof confirming the conclusion that the images of the cycle inspired by the circus had a prophylactic value and that Christian images, notably those which formed the cycle of salvation in the catacombs and on the sarcophagi, could be charged with the same function. There, too—without ever having stated it *expressis verbis* or even having formulated it for themselves— what the image-makers drew was not primarily images commemorative of former salvations but representations of the divine power that remained forever present.

In establishing this point we define one more area where the Christians started from an established tradition and then interpreted it in their own manner; and we also draw, from the comparison with related pagan monuments, some valuable observations on the probable religious and moral import of certain Paleo-Christian images.

It can also be suggested that Christians at the same period—the period of their first iconographic efforts—perhaps used images to express theological ideas. They were close to this when they represented the two principal sacraments of the Church, baptism and communion, in their funerary art at Rome, as noted above (pp. 8 f.). In speaking of these images, we included them among the subjects meant to distinguish the deceased as a believer who could confidently expect the salvation of his soul. But it is equally certain that images of the sacraments, whether purely symbolic

(fish and bread) or descriptive (scenes of the baptism of an anonymous neophyte and of meals taken in common) or Biblical, with allusions to the sacraments (the baptism of Christ, the Multiplication of the Loaves, the Last Supper), contain also in germinal form an affirmation of dogma.

The same thing is true of other Biblical scenes that we have classed among the images which, besides the sacraments, define the religion of the deceased; for example, Adam and Eve with the serpent, and the Epiphany (the Adoration of the Magi). For these evidently contain another affirmation of essential Christian dogmas, original sin and redemption.

Having pointed out these incursions that the first Christian iconography made into the area of dogma, we should stress the fact that the number of images of this kind, and the number of dogmatic themes that they referred to, was extremely limited in comparison with allegorical figures and representations of salvation. This is particularly true for the catacombs. The sarcophagi of the fourth century attempt more in the way of the iconography of dogma, and we will see some examples in the chapters devoted to the Paleo-Christian creations that are the most important in this domain (themes of the Trinity and the Resurrection). In fact, it is probable that this iconography did not arise within the bounds of the initial funerary art which concerns us at the moment.

Nevertheless, early Christian art in its Eastern branch furnishes one remarkable case, unique at the period, of a cycle of mural paintings in which both the subjects and their arrangement proclaim their dogmatic character. These are the mural paintings of a small baptistery of about 230, one of the group of rooms set apart for *40–44* the Christian cult in a private house in the town of Dura-Europos.

Discovered shortly after World War I, the portion of the baptistery that remains was moved to the Yale University Art Gallery, where, with its frescoes, it has been reconstructed. The date of this building and its paintings cannot be disputed, and thus we know, thanks to the Dura baptistery, that from the reign of Severus the Christians had cult buildings in Roman cities, even though their religion was unlawful, and that they had at their command a relatively rich religious iconography. It is not known whether the existence of such buildings was peculiar to the eastern provinces of the Empire, but there is no reason to assume that it was. We know that places of Christian worship, along with everything in them, were totally destroyed everywhere during the persecutions of the third century and the beginning of the fourth. It is pure chance that saved some portions of the baptistery of Dura; the building was buried deliberately, about 256, by the defenders of the fortified Roman town, on the eve of a Parthian attack, to reinforce the adjacent city walls; the burial, intended to be temporary, became permanent when the Parthians took the town in 256, and the building was not rebuilt.

The iconographic program of the baptistery of Dura is not necessarily one that was peculiar to the Semitic Christians of northern Syria. But whatever its place of origin, it is distinguished from the iconographic ensembles of the catacombs by the relationship that it establishes between its subjects and their arrangement on the walls, with certain subjects manifestly taking priority over others. The hierarchy established by the location of the images is emphasized by differences in proportions and in techniques. Thus the scene of Adam and Eve, which in the catacombs may be placed anywhere among the salvations and without any topographical relation-ship to the Good Shepherd, is treated differently in the baptistery of Dura. The most central spot in the room, the niche of the *chevet* (behind the font), is reserved for

40, 41 two images, Adam and Eve and the Good Shepherd with His Flock. In other words, images representing the essential dogmas of original sin and redemption are made central by their location; and furthermore, for obvious reasons, it is the image of redemption, in the form of the Good Shepherd and His Flock, that predominates. While the image of original sin takes up only a corner of the niche, at the bottom, the idyllic image of salvation stretches over the rest of the wall.

All the walls of the baptistery were covered with paintings, and as less than half of them remain it is impossible to know the scope of the entire iconographic program. Perhaps it is chance that, in the extant part, evangelical scenes predomi-nate (four to one), whereas in the earliest catacombs of Rome and the Campagna, it is clearly the Old Testament that is pre-eminent. But at Dura the remaining fragments testify that the images were intended to celebrate the baptismal rite: the

42, 43 Samaritan woman at the well and the miracle of Christ walking on the water evoke the theme of water essential to the office of baptism. We are also shown the victory

43 of David over Goliath, the healing of the paralytic, and, naturally, the Resurrection

44 of Christ (the theme being translated iconographically by the scene of the holy women at the tomb).

On this point a comparison is permissible with the catacomb paintings, which surely owe their numerous images of salvation to the office for the burial of the dead. The idea that inspired the Jewish and Christian prayers, as well as the Paleo-Christian liturgical offices which followed them, produced similar results in the catacombs of Rome and in the third-century baptistery at Dura. In praying for the dead or for the neophyte, the Christians constantly went back to evocations of salvation or deliverance and, consequently, to the idea of an appeal to divine power (at Dura: the victory of David over Goliath; the miracle of St. Peter, whom Jesus saves from drowning; the miracle of the paralytic cured). This is the reason for the use, both in the catacombs and in the baptistery, of images whose religious import is identical. As for the Resurrection of Christ, essential to the offices of both baptism and burial, though images of it are still wanting in the catacombs, they are frequent

and important on the sarcophagi from the fourth century on. On this point also, therefore, the practices of the image-makers of about 230 at Dura and of the third and fourth centuries in the West are fairly closely allied. One might even suggest that in the place reserved for the mystery of Christian initiation, just as in the burial grounds, the images were intended to do more than recall events of the past: they were intended in some sense to perpetuate the intervention of God, as seen in these instances, for the benefit of the neophytes, just as the sacraments did.

The scene of the Resurrection is a rare version, with no angel and with an enormous closed sarcophagus and the three holy women arriving, holding candles; two stars replace the acroteria of the sarcophagus. It is more than a half-century earlier than the other representations of the same subject at Rome, and more than a century earlier than other representations of the subject by the incident of the arrival of the holy women at the tomb (see below, p. 123). The painters who worked at Dura must have had an iconographic repertory that did not entirely correspond to that available to their Roman counterparts. And if we observe the interpretation of the gospel scenes, we have the same impression of a tradition that is certainly quite close, but distinct: the miracle of the paralytic is presented in two successive episodes (before and after the cure). These scenes, as well as the scene of St. Peter drawn from the waters of the lake, are treated in a more descriptive manner than the salvations of the catacombs, although, as we will see, this does not necessarily mean that they derive from detailed illustrations of manuscripts of the Scriptures. Finally, two different styles are used for the images in the nave, depending upon their location: those on the upper part of the walls (the miracles) are rapidly sketched on a white ground with small figures that are drawn rather than painted; those on the socle (the Resurrection can be identified) have monumental proportions and present large figures completely painted and worked into a solemn and majestic rhythm. These differences in the translation of subjects according to their position on the walls were inherited by the Christian painters of Dura from their pagan predecessors, perhaps from the mural painters of the eastern provinces of Europe, to judge from some examples of frescoes of a similar kind (of the third and fourth centuries) at Kerch, once the Greek colony of Panticapaeum, on the Black Sea. They have the same graphic sketches on a white ground at the top of the walls and sometimes the same monumental figures on the socle.

So far as we can judge from what remains of the baptistery of Dura, it reveals primarily the fact, unsuspected before this discovery, that rooms devoted to the celebration of the Christian cult and decorated with iconographic paintings existed almost a century before the edicts of tolerance. The style of these mural paintings and the manner of adapting figurative painting to the walls prove that their authors followed usages known from earlier pagan examples in the eastern provinces of the

45

Empire. But the painters of the baptistery of Dura followed a system in the choice and distribution of the Christian subjects that they represented, and this surely implies that there existed in the region of Dura slightly earlier Christian antecedents (perhaps coinciding in date with the earliest Christian paintings in the catacombs of Rome). The Roman catacomb paintings resemble the Dura frescoes in a general way, as much as contemporary works created within the Greco-Roman world resemble each other. But the relationship, as we have said, is not very close, since Dura's tendency is toward more descriptive figurations, while the Roman catacombs long held to image-signs that were as abbreviated as possible. But at Naples and Nola the Christian frescoes of the same period were more descriptive, closer to the type of Dura. Furthermore, the painters of Dura were entirely indifferent to the decorative effects which the Roman painters never lost from view. It seems reasonable to suppose that paintings in a room above ground, of easy access to the whole Christian community, might naturally tend to become more descriptive than would the paintings in funerary hypogea and that certain features of the art of Dura may not necessarily correspond to any regional feature.

The iconography of the funerary cycles of the third century at Rome and in Provence and that of the baptismal cycle at Dura are related, as we have said, by their common religious theme: the power of God which assures the salvation of true believers. In both cases, the Good Shepherd (taken from the Gospels) is depicted, and stories of salvation drawn from the Scriptures are also evoked, forming a counterpart to the prayers of the services. It would seem that in both cases the iconography says the same thing, or nearly the same; and, in spite of the difference in the offices which inspired the iconography, the images correspond to the respective offices. All of which means that the inspiration of the first Christian art is liturgical, and belongs exclusively to those offices which concern the individual rather than the entire community: the services of baptism and the burial of the dead.

It is thus that we can define the religious significance of this art, its field of action, and the period of its appearance. Its utilitarian character implies an impetus coming from the faithful, which means that it need not have been inspired or even approved by the clergy; and these considerations seem satisfactory to the mind which marvels at the sudden flowering of Christian art. Yet one may still wonder whether, after all, there was not some intervention by an ecclesiastical authority, even though all that separates the works of Rome from those of Dura—that is, their independent experience—argues against such intervention on a high administrative level. One group of works invents an iconography for funerary use; the other, an iconography for baptismal use. Each group has its own iconographic resources— on the Roman side, symbolical scenes of classical inspiration, like that of the philosopher who teaches to the Christian the truth revealed by the Gospels, or classical

motifs such as the shepherd and his flock in a natural setting. Whereas in Rome the first Christian artists were inspired by the forms created by their pagan counterparts, at Dura there is no direct carry-over from classical art. The absence of surviving antecedents in the region of Dura for the decoration of the baptistery makes it impossible to affirm that its paintings depended upon local tradition; the possibility that local antecedents once existed should not, however, be excluded. We have already mentioned the funerary mural paintings in Kerch, in the Crimea, which are very close in time to the paintings of the Dura baptistery and which show that certain traits of these paintings were familiar to the painters of the eastern provinces of the Empire (the socle with large personages and, over against this, very small scenes sketched higher up).

Briefly, then, there is some reason to believe that the first experiments in Christian iconographic creation—at Rome, on the one hand, and in Roman Mesopotamia, on the other—may have come about through local initiative, with the means available and even following the dictates of a slightly different religious thought. If this were true, it would not be surprising to find, for example, that these attempts did not spread throughout the Empire to the entire body of Christian communities.

But there are other considerations with which we can counter these observations, and they seem to argue in favor of a concentrated action. The most notable is the synchronism: for it is in the Severan period that, at Rome and at Dura, the first Christian iconographic ensembles were realized. And since this surprising flowering, for which nothing in the preceding two hundred years has prepared us, was not at all in the nature of things Christian, one can justifiably assume the intervention of ecclesiastical authority or, at least, a connection between the Western and the Eastern branches of this imagery. The two ensembles may have been created either as a result of the same decision or by the influence of one upon the other. These considerations have a tempting appearance of truth.

Such is the situation when one considers the question strictly within the domain of Christian iconography. It changes if the field of observation is enlarged, for, among traditionally aniconic religions, Christianity was not alone in providing itself with an iconography in the first half of the third century. If it is surprising enough to find Christianity creating a religious figurative art after being for two centuries a religion without images, it is still more astonishing to see a shift in the same direction among the Jews. Many centuries had passed, between Moses and Septimius Severus, during which the Jews rejected any figuration of a sacred character and even any image of living beings. But now, in the first half of the third century—that is, at the same time as the earliest Christian figurations—there appear, one after another, creations of Jewish religious iconography. The first

Jewish experiments are similar in character to the Christian: there are the symbolic reliefs of the synagogues of Capernaum in Galilee, followed by other analogous but later examples; the coins of Apamea, in Phrygia, struck by the Jewish community of that city and showing a scene of Noah and his wife praying before the ark which they have just left; and finally, before 243, the great cycle of religious frescoes on the walls of the synagogue of Dura, this same Dura where we saw the frescoes of the Christian baptistery.

Whatever the degree of relationship between the two iconographies, Jewish and Christian, may have been, and the causes of the interdependence of their images, the historian of Christian iconography is faced with the question: Why did the two traditionally aniconic religions, which existed side by side within the Empire, equip themselves with a religious art at the same period? In spite of all that separated them, these Jewish and Christian communities, though enemies, were far from being impervious to influences from one another. There are a thousand proofs of this. We know especially to what extent Christian liturgy, in its beginnings, was inspired by the liturgy of the synagogue in its form and content (aside from its sacraments). Moreover, the synchronism of the appearance of sacred iconography among both Jews and Christians would be most easily explained if it were admitted that these occurrences had the same origin. If this were true, the coincidence of the dates of the earliest Christian images at Rome and at Dura would not depend upon some decision of a Christian authority, but would reflect a movement in favor of religious iconography which affected Jews and Christians alike. To understand this development, one would have to consider the two iconographies together.

To undertake an analysis of the works of Jewish iconography of the third century would take us too far afield without sufficiently forwarding our study of Christian iconography. But since one cannot understand the beginnings of Christian iconography without knowing the contemporary Jewish works, let us pause over several of these Jewish images to get an idea of the religious intention behind them.

On the lintel reliefs of the synagogues of Jaffa and Capernaum (and on other later similar pieces), there are symbolic figurations: the seven-branched candlestick of the Temple, the star, the crown, and also the eagle, several quadrupeds, and the palms of paradise. Just as the Christian iconography of Rome showed the influence of Greco-Roman art, that of the synagogues of Galilee retained as a matter of course many of the decorative motifs of the neighboring temples of Baal. But let us note particularly the content of these first Jewish figurations. They are symbols which can be reproduced, isolated, in any location, to show the presence of the Jewish cult. In other words, it is the same principle whose Christian counterpart we know in the symbol-object: the anchor, dove, lamb, etc.

The image of Noah and his wife beside the ark, which one sees on the coins

of Apamea in Phrygia, presents no difficulty of religious interpretation: it is commemorative, since it evokes the celebrated relic of this city, a fragment of Noah's ark, which the very powerful Jewish community of Apamea had in its charge. The translation into iconographic terms of an event recounted in the Scriptures was in this case inspired by a tangible vestige of the event. Nothing similar occurs in Christian art before the fourth century; here the Jews are in advance of the Christians. They took their inspiration from the commemorative iconography of Roman numismatics, replacing the usual images of the local pagan sanctuary and its idols by the representation of the event commemorated through their relic of the ark.

The two Jewish experiments which we have mentioned are contemporary, but they are so different that it is vain, I think, to attempt to trace them to a single initiative. Like the Christians of the third century, the Jews were animated by a desire to create images, but the realizations, in Galilee and in Phrygia, due to local conditions, are quite dissimilar.

Finally, there is the major experiment, that of the frescoes of the synagogue of Dura, which Professor C. H. Kraeling is probably right in connecting with the strong upsurge of Jewish activities in more than one cultural domain in and around Edessa, capital of one of the small kingdoms situated between the Roman Empire and Persia. I will restrict my remarks to certain particularities of these paintings that have a direct bearing on Christian studies.

These frescoes combine certain symbols of the kind we have seen in the reliefs of Capernaum in Galilee and Biblical scenes comparable to that of the Apamean coins. In this respect the synagogue at Dura resembles the Christian catacombs and sarcophagi of Rome, which show an analogous combination of Christian symbols and scenes drawn from the Scriptures. However, in contrast to the great majority of the Christian scriptural images of the third century, which are abbreviated and summary, those of the synagogue at Dura are treated as large framed pictures which describe in much detail the scene represented. And there is another essential difference: the iconographic ensemble of the Dura synagogue is unfolded on the walls of a room used for the daily liturgical ceremonies of the religious community—an enterprise which has no Christian counterpart until long after the Peace of the Church. It should not be forgotten that at the beginning of the third century the Jewish faith was authorized in the Empire, whereas the Christian religion was not, and would become legal only under Constantine.

Still more important is the difference in the significance of this image cycle, compared with the Christian cycles of the third century. As we have said, these were always concerned with the salvation of the individual. But at Dura it is the destiny of the chosen people which is the subject of the ensemble. The choice and arrangement of images show this clearly, and in this respect, too, the Jewish iconography

of Dura is in advance of the iconographic programs of the Christian churches by more than a century. Without going into detail, let us recall a small number of scenes which leave no doubt of this. Among the symbolic subjects, the Temple with the Ark and the lion of Judah with Jacob's dual benediction on the tribes of Israel are predominant. Among the narrative scenes, there are: Moses leading the chosen people across the Red Sea; an entire cycle dedicated to the Ark and the Temple, which evokes a chapter in the history of God acting among his people; the story of Esther, the benefactress of her people (here, the triumph of her brother Mordecai); the resurrection of the dead before the eyes of Ezekiel; and finally, in the center of these scenes which have for their anonymous hero the chosen people as a whole, compositions showing David the king anointed by Samuel or David enthroned. Beyond all question the great iconographic program on the walls of the synagogue of Dura is concerned with the religious interests of the whole of Israel; and whether it envisages the past or the Messianic future, its subject is always the destiny of the chosen people.

What aspect of the religious history of Israel is brought to the fore by these paintings? It is the solicitude of God for his people, throughout the centuries, and, by contrast, the punishment inflicted by the God of Israel on the enemies of his chosen ones and on traitors. Nothing is more characteristic of Judaism than this assimilation of the people of God to Israel and of the final glory of God to the Messianic kingdom of Judah on earth.

But if Christian universalism set aside the national formula of the religious iconography of the Dura synagogue, iconography after Constantine, as we will see, was to seize upon the fruitful theme of the kingdom of God and to develop it in its own manner, which was not that of the Jewish paintings of Dura. However, these paintings, so different otherwise from Christian images of the third century, are at one with them in attempting to show, through each of the images, the power of God and the felicity of the faithful (here taken collectively, as the chosen people). Here, too, as for the paintings and funerary reliefs and the frescoes of the baptistery of Dura, one can cite prayers which appeal for salvation in enumerating the past favors of God (Jewish prayers such as Psalm 118). In other words, this iconography has a religious meaning very like that which we have seen in the Christian cycles of the same period, except that the salvation in question concerns the entire people chosen by Yahweh.

We can turn this conclusion around and express it the other way; an iconographic program of this kind signified, for whoever contemplated these frescoes, that the God of the Jews is great and the people who are faithful to him have not ceased to enjoy his blessings through the centuries. God has saved his people from many different calamities, he has raised the dead and blessed Israel since the begin-

ning of time. Here again we find the theme of comfort and assurance of protection and salvation which is the theme of the Christian images of the same period; and if one is concerned with the communal life on earth and the other with the salvation of the individual after death, still all these images, Jewish and Christian, are plainly intended to comfort the beholder, and either to strengthen him in his faith or to lead him into the Christian or the Jewish religion.

These observations may help us to see more clearly the reasons for the simultaneous birth of Christian and Jewish iconography in the Severan period. In both cases, the first imagery of which we have any record asserts salvation through reference to the experience of the past. An art which adopts this program serves to hold the faithful or to bring in new converts. Since one of them, the Jewish, seems much more evolved iconographically, and the other, the Christian, better adapted to impress different ethnic groups and at the same time more sensitive to the appeal of the growing spiritualism of the third century, it is surely the new Jewish iconography which seems to have been created first and the equally new iconography of the Christians afterward. And since each of these religions promises salvation, there is a strong possibility that the first Christian iconography came into being as a response or a counterpart to the concurrent Jewish iconography born a short while before.

Much of this is a hypothesis, which is perhaps destined never to be proved. But, whatever the exact order of their appearance may have been, the Jewish and Christian iconographies began at the same period and probably more or less simultaneously, at diverse points in the Empire, where Jewish and Christian communities lived side by side. One of these centers was Rome, where the Jews were far less active in iconography than the Christians, and the Christians much more open to classical influence. The two arts came into being side by side at the beginning of the third century in the eastern Empire, in the area between Palestine and the Persian border. In this region, it is the Jewish iconography which seems predominant and which draws more than one new element from its contact with local Semitic and Iranian art (the one flourishing in the eastern provinces of the Empire, the other practiced on the far side of the nearby Persian frontier and spreading into the neighboring regions of the Empire). The Christians of the East, less powerful and probably less numerous, began with an art imported from within the Empire, an art much less affected by Iranian influences than the art of their neighbors the Jews.

In the early third century the Roman East and Persian Upper Mesopotamia were experiencing a time of exceptional iconographic fermentation, which extended to the art of several different faiths. On the Roman side, we have just mentioned the Christian and the Jewish activity. On the Persian side, between about 240 and 270, a new religion, that of Manes, was spreading its propaganda with the

aid of images. Starting at Ctesiphon and moving from there into provinces that bordered the Empire, like the region of Dura, Manes was the first to apply this method, for which the Zoroastrians later reproached him; the method is of particular interest to us, since in late antiquity the Jewish and the Christian missions were accomplished with no recourse to images. Gathering the written testimonies, some contemporary and Manichean, others of later date and sometimes by the hands of enemies of Manes (for example, a Moslem like Firdausi in the *Shah Namah*), we can establish the following subjects for the pictures which Manes showed to his auditors: images of God; images of the Last Judgment showing the judge, the good rewarded, and the evil damned. It is amusing to think that the second occurrence of a mission which sought to impress possible converts through the spectacle of the Last Judgment concerns the Christian mission to England of St. Augustine, four centuries after Manes. We know that Manes' successors added other images to those which Manes used, notably that of the bema or throne, which symbolized his passion and his ascension, as well as the portrait of Manes, which indicated his invisible presence at the head of his church. Placed near the bema (I imagine, on the bema), the portrait of Manes was the object of veneration or of worship. To illustrate this Manichean iconography, there remain only some miniatures, much later in date and showing strong Chinese influence, made for a manuscript written in Turkistan.

55

As is well known, the mission of Manes, starting from Ctesiphon, spread rapidly (in spite of the persecutions which supervened) to Persia and toward Central Asia and throughout the Roman Empire, even to Africa and Italy. This iconography must have accompanied the installation of Manichean communities everywhere and provoked repercussions. The late Wilhelm Koehler thought that the great and scholarly iconography which was created at Rome at the beginning of the fifth century under the impetus afforded it by Pope Leo the Great was a response to the very effective propaganda of Manicheism in the West.

The arts of the West encountered Manicheism only around the year 400. In the eastern provinces of the Empire and in Persia, similar and equally violent contacts occurred in the second half of the third and in the fourth century. Modern scholars in the field of iconography in Iran (Nyberg, Wikander, Puech) admit that it is to the flowering of Manicheism, with its books of divine revelation, its church, and its propaganda, that we owe the codification of traditional Mazdaism and the organization of the Zoroastrian Church, which became the state church of Persia. Further studies will, I hope, show whether the official art of this state religion, as we see it under the Sassanians, also was a reply to Manichean iconography.

We have no reason to believe that the Manichean mission, with imagery as

a propaganda instrument, provoked the Jews and Christians of the Levant, inviting them to abandon their traditional rejection of figurative art. Such a hypothesis would have a very good chance of satisfying everyone and of providing an answer to the question still before us, that is: Admitting that the Christians followed the Jews and that both iconographies originated at the beginning of the third century, why did they do so *then*, rather than earlier or later? The Manichean factor would explain everything, especially since it introduced imagery as propaganda. But—happily for the truth to which this hypothesis would have done a disservice—the dates make this answer impossible: the first Jewish and Christian images occur certainly soon after or even slightly before the year 200, while the earliest Manichean images cannot be earlier than about 240.

The Manichean evidence can, however, be used in two ways. Manes could have been led to invent an imagery for the religion which he founded, and to make it an instrument of propaganda, because the Jews and the Christians, his closest neighbors in the domain of religion, had, both of them, just created one. If this was so, one should expect to find a similarity in the three systems of imagery, particularly (which interests us the most) in the religious value one could see in them and in the uses for which they were designed in the religious life of the three communities. But, in the present state of our knowledge, all that can be asserted is that Manes judged imagery to be capable of expressing ideas and of assisting the propagation of the religion which he had founded and which he preached, beginning in Upper Mesopotamia around the year 240. The imagery that he created was destined for the crowds, and the role that the Last Judgment played in it would confirm this.

The second way of using the Manichean evidence is even more prudent. Without presupposing a link between the creation of Manichean iconography and the slightly older Jewish and Christian iconographies, one would limit oneself to pointing out the purely chronological closeness of the beginnings of all these iconographies. Whatever the order of their appearance, there is no question that they followed one another at short intervals. Three iconographies of three revealed religions appear almost simultaneously, and in each instance some of the earliest of its works of art now known—all directed to the average spectator—are found in the same frontier region between the Roman Empire and Persia, in the area of the upper Euphrates. At the beginning of the third century, religions, sects, confessional and philosophical-religious groups, favored by the Pax Romana, lived freely together in the cities of the Empire, and in the eastern provinces in particular. Roman law and prosperity favored this, as well as the intense agitation within these groups which organized, dissolved, clashed, and tore from each other their not very stable membership. It was also Greco-Roman custom which, in this world more or less won over to Hellenism, favored a recourse to art as a means of expressing and

propagating ideas; and the competition among these religions which existed side by side spurred on the initiators and creators of iconographies for each of them. The more these religions competed with each other, the more the iconographies of which they availed themselves resembled each other, because each expressed itself in terms of the same iconographic language of Greek classicism, their differences being differences only of detail.

The excavations at Dura have provided an excellent material illustration of this state of affairs and particularly of the impressive proximity of several religious iconographies, different from each other but similar in form. One has only to look at the frescoes of the sanctuaries lined up one after another along the walls of Dura: the Christian baptistery has not only the synagogue as a neighbor but also a temple of the Palmyrene gods, a Mithraeum, and the sanctuaries of Atargatis, Artemis Azzanathcona, a Semitic Zeus, another local Artemis, and Adonis. Of different dates, but not very far apart, all the paintings in these sanctuaries existed simultaneously at the time of the destruction of Dura in 243. A few years later, there would have been a Manichean sanctuary, too.

The singular spectacle afforded by the view of the ruins of the ramparts of Dura is not only suggestive for a historian of Roman customs and the religions of late antiquity. It also explains the circumstances under which the religious arts, vestiges of which we see at Dura, were born and suggests the intentions of the initiators of these iconographies. The existence of imagery in the practice of some religious groups called forth the creation of other systems of imagery, all of them invented under conditions of competition and expressly for the adherents, either assured or possible, of the respective groups. The religions most firmly aniconic, Judaism and Christianity, did not resist the competition, which made its effects felt eventually in an emphasis on the distinction between the two faiths. In this respect, it is striking that at Dura the Christians gave priority to evangelical themes (whereas at Rome they emphasized motifs of the Old Testament, which they held in common with the Jews). At Dura, Christians and Jews were in competition, and their iconographic repertories underlined what was specific to each of them.

II. The Assimilation of Contemporary Imagery

In the Introduction, I spoke of the close relationship that iconography bears to language: iconography constructs an image as one builds up a sentence or a discourse, by using elements of different origin and combining them according to practices comparable to the rules of grammar. In the present chapter and the following ones, this general observation will guide us in the study of a certain number of examples of this kind of iconographic creation. Our particular aim will be to define the iconographic terms, corresponding to the words and locutions of language, that were employed in Paleo-Christian art. We will begin with the most common and banal terms of the period which saw the formation of the Paleo-Christian iconographic language. We will then turn to the borrowings that this imagery made from the vocabulary of the official art of the Roman state. Throughout, we will observe the adaptation of these borrowings to the Paleo-Christian context.

In any image that a painter or sculptor makes, the part that is properly his own is minimal. The rest belongs to the vocabulary of the current language of the visual arts, either the language in general use or, sometimes, a special technical language already established. It is on this condition that an image-maker is understood by others, the obvious aim of anyone who expresses himself whether it be in images or in words. Christian iconography in late antiquity follows the general rule, and the considerable portion of it that consists of clichés or of less banal but still common forms of the art of the time is particularly evident because all these features can be observed in pagan works, often works earlier than the first Christian images.

There is, first, the category of common forms and motifs, those which are used without reflection and which one cannot get along without. In the realm of iconography these are the equivalents of the commonplaces of moralists or theologians. To this category belong most of the forms which concern the representation of the human figure, which is the central subject of all ancient Christian images, including figurations of Christ, Mary, and the saints. Thus primitive Christian

iconography is peopled with figures that necessarily show one or another of the most common postures: standing, seated, or reclining. Pagan images and Paleo-Christian images of the standing, seated, or recumbent figure employ the same devices to represent these postures; the sameness is not a question of the Christian image-makers borrowing from their pagan counterparts, but of their using, in common with their contemporaries, a single language of visual forms. This observation holds for all the motifs that we will enumerate.

56

57

For the standing figure, this identity can be seen by a comparison of the row of figures at the bottom of the walls of the hypogeum of the Aurelii in Rome (Viale Manzoni, third century) with the very similar isolated figures of the philosopher type or the apostles and prophets in the catacombs. As for the reclining figures,

4

31

it was pointed out long ago that certain Jonahs lying under the pergola resemble the reclining figures of Endymion on pagan sarcophagi. Here the imitation is perhaps deliberate. But it is not because of deliberate imitation that other figures of the recumbent Jonah also resemble pagan sculptures of nude youths stretched out in the

58

21–24

sun—for example, those on Roman sarcophagi which represent a dead child. The unaccompanied seated figure is rarer, but one finds figures in a similar pose in various scenes of assembly and in compositions of the philosopher type. Whether such an image is pagan or Christian, the figure—frequently bald—is shown seated frontally or sideways, wearing an exomis tunic, and bent over a phylactery. Pagan or Christian, the image is practically the same, the resemblance going beyond the seated pose of the sage and extending to his physical type and his action (reading in the roll held before him).

59–61

The same thing holds for the figure in prayer with extended arms: Christian art made the orant one of its favorite subjects and quickly developed the type. But there exist pagan counterparts, orants that are allegories of piety; and nothing

57, 62, 63

distinguishes the two groups iconographically. The gesture of a single forearm raised can have the sense of prayer, but it is more often a gesture of surprise or, on the level of ritual, of acclamation or bearing witness (it is still the gesture that accompanies the taking of an oath). Pagan versions of this gesture, for example, on the Great Cameo of France, in the Treasury of the Sainte-Chapelle in Paris, on the base

62, 63

of the column of Antoninus Pius in Rome, or on consular diptychs (the gesture of the personifications of cities toward the consul), have their Christian counterparts

64

in, for instance, the Mother of God carrying the Child, in the papyrus of the Alexandrian Chronicle at Moscow, or on ivories like those on the throne of Maxi-

65

mian (prophets as "witnesses" of evangelical events). But it is the gesture of the orator, or simply that which accompanies discourse, that is the most frequent and the

66, 67

most banal, whether for the pagan sages, orators, and magistrates or for Christ and his

68

disciples or for the prophets in Christian iconography. It is this gesture which later

was confused with that of benediction and which, because of this interpretation, had a particularly lasting and illustrious place in Christian iconography.

Among the common iconographic locutions of the Paleo-Christian period one must also include the small *volumen*, or scroll, that is carried by so many figures, pagan and Christian: philosophers, authors, teachers. The exomis tunic, which leaves one shoulder and part of the torso bare, was used for representations of Christ and other persons shown as philosophers (the author of the "true philosophy" and his forerunners and disciples). But the nudity revealed by this garment must have limited its use in the Christian repertory of formulas. By contrast, the other method of representing a noble personage, whether sage, poet, or Roman magistrate, had unlimited service in Christian art of the period. In this convention the figure is covered with a toga or other mantle, its drapery arranged according to the usages of the classical period. Christ, the prophets, and the apostles were to retain this costume indefinitely as a kind of uniform that distinguishes them from all other figures in Christian images.

As there were no authentic portraits available, the image-makers gave their subjects noble and expressive faces, either beardless or with beards of different types. Examples occur in the catacombs and even more often on sarcophagi of the fourth century, where images of Christ among the apostles are frequent. Comparison with the pavement mosaics at Apamea (Syria), the mural paintings of the hypogeum of the Aurelii, including the figure of a *togatus*, the miniatures of the seven physicians in the Dioscorides manuscript at the National Library in Vienna, and also with the portrait heads of profane sculpture of the Roman Imperial period sufficiently demonstrates the origin of the noble and expressive heads of the apostles and prophets. The Christian image-makers endowed these personages with the heads "*habituées aux hautes pensées*" (Stendhal) that the sages of pagan art of the Imperial epoch inspired. Yet this did not prevent certain of these "pseudo portraits" from retaining some traits indefinitely while discarding others. This is the case for representations of St. Andrew, and especially of St. Peter and St. Paul, of which the earliest versions —profiles on bronze medallions—go back to the third century. A certain kind of pseudo portrait was created under these conditions, evolving from the noble and expressive heads (clearly not portraits) that we mentioned at the beginning of the paragraph.

In groups of such figures as the disciples with their master or the apostles with Jesus the arrangement is no less conventional. The apostles are placed according to age, and in principle all ages are represented, beginning with the old men and going down to the youngest, shown beardless. Thus Philip and Thomas as youths end the line of the twelve apostles. But meanwhile, and especially before these last images were established, the Christians made frequent use of another formula con-

61, 68

66–68

69, 70

71, 72

stantly found in the art of the time, that of making all the figures they represented invariably youthful, depriving them as it were of age: Moses or Noah or Isaiah, *73* Jesus or St. Paul thus appear as young, beardless men.

74 The pagans were very fond of images where young children or *putti* played the roles of adults in representations of the circus or of combat, the chase, or various kinds of work, or even in religious scenes. At the very beginning of Christian art, some of the Christian image-makers adopted this playful genre (which makes one think of eighteenth-century French art) for certain scenes of symbolic grape-

75, 76 gathering (in allusion to the "vine of the Lord" and to communion) such as are found, for instance, among the mosaics of S. Costanza at Rome; and on the sar-

77 cophagus of Junius Bassus *putti* are shown harvesting wheat. A very early fresco in

78 the catacomb of Domitilla in Rome shows Cupid and Psyche as *putti*, although here again the figures are symbolic (Psyche in paradise is the soul in the afterlife). One might cite also an enigmatic Christian painting in the newly discovered catacombs

79 of the Via Latina where five *putti* in tunics, holding palm branches, stand before a seated figure. But the *putti* genre was not very popular among the Christians, who quickly replaced the little children by adolescents. This version of the formula of youth must have seemed more acceptable; for its association with an abstract idea —in this case, the eternal—was in accordance with the image-signs of the Christian funerary cycles, while at the same time it did not oblige Christian imagery to put aside the predominantly serious air which is so characteristic of it. Thus, here at the beginning of Christian art, we have a phenomenon often observed by linguists in their area: in passing from one language to another or in transmission from one generation to another, a term, if it lives, changes its form and its semantic value, and we see in iconography, as in language, a shifting of form and of meaning.

 Youthfulness in all the figures of a scene places it outside of time: all the actors in the event remain eternally young. Many texts of the Middle Ages have retained this thought, which has a corollary in another notion that is at the same time like and opposite: the eternal can also be pictured in the guise of a mature man, since the full-bearded face, the abundant coiffure, suggest a long span of time and fullness of power. The image which corresponds iconographically to this formula was ascribed

80, 81 to Christ, especially where he is shown in majesty, as the omnipotent and omni-present lord forever. The similarity between these figurations of Christ and the

82 traditional images of the sovereign gods of late antiquity—Jupiter, Neptune, or Pluto—has long been recognized. There is certainly a relationship, and it appears likely that the Christian image-makers used this type of head to signify the all-powerful sovereignty of Christ. It may be difficult to envisage this borrowing in actual practice, since no Christian could have thought of Christ with the head of a pagan god. But, as we have frequently said in these pages, it is not a question of a

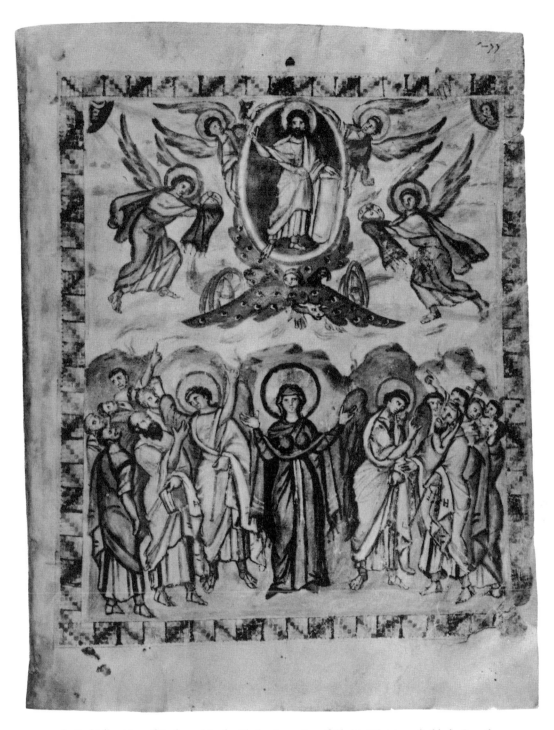

I Ezekiel's vision of God combined with the Ascension of Christ. Miniature, Rabbula Gospels, Biblioteca Medicea-Laurenziana, Florence [35]

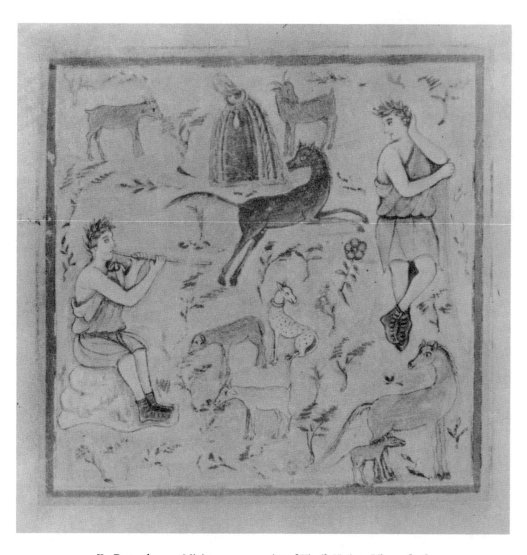

II Pastoral scene. Miniature, manuscript of Virgil, Vatican Library [36]

direct loan that Christian art received from a separate art, that of the idolaters. The powerful head with long beard and abundant hair was a part of the repertory of the art of the period, and both the Christians and the pagans used it, as one can use the same word in different senses. Christians and pagans did indeed use the same verbal terms, for example, to designate the omnipotence of God or of a god, but the meaning of the terms was not necessarily the same.

There is an analogous case in such familiar scenes of the art of the period as the ascension of a god or a hero, where fiery steeds carry his chariot obliquely across the heavens. The personified Sun and Moon and the emperor in his posthumous apotheosis were represented in this specific fashion, which was familiar to the artists of antiquity long before the Christian artists in their turn took it over in order to represent either the Ascension of Elijah or that of Christ. With certain inevitable adaptations, such as were also made for the ascensions in mythology and in Imperial imagery, Christian iconography adopted this formula for its own, once again making use of the common visual forms of its environment.

In connection with representations of ascension, Christian iconography also made use of another type of image—the triumphal chariot, shown frontally. The art of late antiquity knew many scenes of this kind, in which the victorious emperor was represented in the chariot as charioteer. Such scenes served as a point of departure for a figuration of Ezekiel's vision of God combined with Christ's ascension, a miniature in the Gospels of Rabbula. Ezekiel's description mentions the wheels of the chariot of God, four animals (instead of four horses), and the rapid movement of the divine chariot. Except for the detail that the four animals of the vision surround God in his chariot, instead of taking the places that were customarily reserved for horses, the Christian ascension is still an iconographic imitation—this time a representation of the chariot climbing vertically (and not obliquely) into the heavens. In the earliest Christian images of Ezekiel's vision—for instance, at Bawit —the axles and the wheels of the chariot, as well as the attendant prophet, are still represented, confirming the dependence of this type of Christian image on pagan figurations of ascension.

One branch of late classical iconography furnished a great number of motifs for the first generations of Christian image-makers: this was pastoral imagery, whose principal motifs are the shepherd, his dog, his flock of lambs or goats or, more rarely, his herd of cows, or a rocky landscape with a few decorative trees and sometimes a few rustic buildings. In the Roman period, such visions of pastoral calm were the delight of city dwellers, and in mural decorations in particular they were frequent. Paintings of this kind are preserved in the ruins of the Palatine and also in the elegant ancient stuccoes from a Roman house found at the Farnesina and in a great many frescoes, pavement mosaics, and reliefs going back to the first centuries

83

I

84

85
86

II after Christ. Illustrations for Virgil's works afforded Roman painters opportunity to treat the subject of the shepherd with his flock. And pagan funerary art took it up also, in its turn, and used it often in its evocations of the ideal sojourn in the afterlife. Connections between these figurations and the earliest Christian versions were all the more natural because Christianity in its funerary art—the most important branch of Christian art until the fifth century—itself reserved an important place

87 for the subject of the shepherd and his flock. Christian iconography was certainly led to this subject by the Scriptures, which compare Jesus to the Good Shepherd and Christians to the flock that he guards. But the existence of the same subject in

89 pagan sepulchral art made it inevitable that these idyllic pastoral images should frequently be transferred to Christian sarcophagi. Both the pagan and the Christian figurations are very similar, and it is sometimes difficult to distinguish one from the other. Visually, the vocabulary and the sentiment are the same. There is nothing

90 astonishing in the fact that a certain figure of a shepherd who leans on his staff amid his sheep in a miniature in a manuscript of Virgil in the Vatican reappears on the

90, 91 façade of a Christian sarcophagus. The Christian Good Shepherd naturally belonged to this iconographic family, and it is not uninteresting to find such a figure not only on pagan sarcophagi but in the paintings of non-Christian mausoleums like that of

88 Trebius Justus or in the hypogeum of the Aurelii—works contemporary with the earliest Christian images of the Good Shepherd, where the shepherd appears with other paintings that have nothing Christian about them.

On a pagan sarcophagus in the basilica of S. Sebastiano on the Via Appia, a more interesting motif is added to the usual pastoral image. Before a small cottage,

93 one sees a family of shepherds; the shepherdess, seated, holds a young child in her arms. The sculpture is of the third century. For the historian of Christian iconography it is very precious, because it furnishes an example of the image of mother and child as it must have been commonly represented at this time; such a composition, among others, was used by the first image-makers for Mary holding the Child Jesus. The version on the sarcophagus of S. Sebastiano is the one which was to give rise to the iconographic type of the Byzantine Theotokos Hodegetria (cf. below, p. 84). A pagan funerary stele in the Archaeological Museum in Aquileia shows us

92 another image of mother and child, but this time the two figures, represented frontally, with the child on the axis of the mother's body, are enclosed in a medallion and cut at shoulder height. Nevertheless, the group is quite natural. And here again the composition is of a type which served as a point of departure for a Byzantine

94 icon of the Virgin, the one called the Nikopea. At a more advanced stage in a similar evolution one comes across a third image of a mother and child—in a fresco of the fourth century in the catacombs of the Cimitero Maggiore at Rome: this time not only are the two figures placed one before the other frontally but the mother makes

the gesture of the orant. It is probable, if not certain, that they already represent Mary with the Child Jesus. Except for one detail (the child is not in the posture of an orant), the same image served as the iconographic scheme for the Byzantine icon the Blacherniotissa (the Virgin orant standing with the Child before her, whom she does not touch and who is often enclosed in a medallion).

One could easily extend this list of examples of Christian images, and even of entire categories of these images, which resemble pagan figurations of the same period. In most cases, these figurations were commonly employed in pagan art and belong to a repertory of commonplace forms which the Christians used as one uses the common words of daily language—without deliberately choosing them. In other cases—the pastoral images, the philosophers, the ascensions or apotheoses, the groups of mother and child—it is the subject chosen which led to the utilization of a particular form or motif derived from analogous pagan representations. It is not that the art of paganism made a contribution that came to form the Christian iconographic language; rather, all of these images show the normal effects of the employment of terms, or motifs, common to a single visual language, a language whose terms were used by all makers of images—sometimes in a new sense.

The examples that have been mentioned demonstrate that contemporary motifs and formulas played a large part in Paleo-Christian art, which was nothing else than one branch of the art of the Imperial epoch. There were as many comparable examples in the other branches of Imperial art, and this is just as normal as is the presence in the most accomplished literary work of a substantial quantity of words that are in daily use and common to any text or discourse composed in the same language and in the same period. But beyond this common ground shared by all the imagery of the age, Christian iconography in late antiquity shows more specific relationships to certain special areas of contemporary iconography, exactly as a particular technical language can furnish itself with special terms drawn by preference from a certain definite source (such as the military or erotic expressions in religious language). It is thus that Christian iconography drew largely on the conventional motifs of the repertory that previously had served the official art of the Roman state and on those of the secondary currents that flowed from this art.

Many of the preceding observations refer to Christian images before the Peace of the Church under Constantine. The Peace of the Church opened the door to increased activity in the field of Christian iconographic creation. But it seems that this flowering did not follow immediately upon the edicts of tolerance (A.D. 313) and that the first great burst of creation in this domain took one specific direction. Since Christian ideas or forms of devotion could now be freely expressed, one might

expect Christian iconography to have developed in all possible directions. But this did not occur.

It is, of course, true that the reigns of Constantine and his sons, which saw the foundation of the Christian Empire, are, for the history of Christian iconography, nearly a *tabula rasa*. One must not forget the massive destructions. However, if the texts justify this remark with regard to the Christian architecture in the grand style launched by Constantine, written testimony is as mute as the monuments with respect to Christian images which can be attributed to the initiative of Constantine and his court, or of anybody else, during the first half of the fourth century. Aside from the sarcophagi and the catacombs of this period—where the new is relatively unimportant beside the old, and where the Peace of the Church scarcely makes itself felt—one can mention only a few small Biblical images, probably taken from illustrated manuscripts, which, at the end of Constantine's reign, were worked in mosaic in the cupola of the mausoleum of the Emperor's daughter Constantina (S. Costanza, Rome). There is reference also at this period to a statue of the Haemor-rhoissa at the feet of Christ in a public square of the little Palestinian town of Paneas (see also p. 68).

The extreme paucity of evidence from the days just after the edicts of tolerance possibly reflects the actual situation. In this period, the walls of the churches do not seem to have been decorated with mosaics or frescoes; and nothing indicates the frequent use of Biblical images on portable objects, including the pages of manuscripts. Risky as it may be to draw conclusions from the absence of monuments, it is less dangerous here than in many other cases, because there have remained to us from the same period (the first half of the fourth century) an appreciable number of profane images: the frescoes of the Constantinian palace at Trier, including portraits (one of them identified as the Empress); the series of triumphal and military reliefs on the Arch of Constantine, near the Roman Forum, and on the numerous Constantinian medals; and the illustrated Calendar of 354.

Except for the Christian subjects in the vault of the ambulatory of S. Costanza in Rome, one can set over against all these iconographic monuments, profane and in part frankly pagan (for instance, the images of the Calendar), only the monogram of Christ, the letters chi and rho combined, that Constantine, after a dream, had placed on the shields of his soldiers and on the Imperial standard, the labarum. But let us note, in passing, that this monogram was the equivalent of a symbolic sign, not a representational image, and that this initiative of the Emperor is in reality a throwback to the first Christian attempt to create religious figurations, when a small group of new symbolic signs, the image-signs, was devised. Having broken with idolatry, Constantine could easily have wished to dissociate representational images from the religion of Christ. Moreover, the Chi-Rho monogram adopted by

Constantine was particularly appropriate to serve as a symbol of the religion whose destiny he consciously connected with the country of its founder, Christ, and especially with the city of Jerusalem. It is known how much attention Constantine paid to the Palestinian memorials of the earthly career of Jesus. At this time, at Jerusalem and everywhere in the Holy Land, the Jewish tradition of the symbolic sign was a living one and had its application in the art of the synagogue (see p. 25). But, above all, the unique and important contribution of Constantine to Christian iconography—the adoption of the monogram of Christ for the labarum and for the Imperial army—had a practical and military character.

This example of Imperial intervention interests us in two ways. First, we have here a case of Christian iconographic creation whose origins and initiator are known, as well as its place of invention (Rome) and its date (313: the battle of the Milvian bridge). Iconographically, the invention is hardly remarkable; and we can only regret its lack of distinction. Yet here, for once, both written sources and archaeological evidence are exceptionally explicit on the religious significance of the Christian device adopted by Constantine. The device which he put into circulation was a symbol of Christ—I say intentionally Christ and not the Christian religion —and, since its use was reserved for the army, including the Emperor, head of the Roman army—and, in particular, for the Emperor's helmet—this symbol had manifestly a prophylactic value. The army placed itself under the protection and the guidance of Him whose monogram it bore. In other words, the new symbol, born in the years decisive for the victory of the Church and adopted by the Imperial author of this triumph, still had, like everything previously invented and in use in the domain of Christian iconography, a specific function, and was abstract in idea and in this respect archaistic. One should add that, like earlier iconography, this symbol also in no way attempted to explain or reflect the dogmas or the high principles of Christianity. The salvation assured by Christ was still there (if not represented, at least implied) as the purpose of the display of this symbol, but with this difference—which anticipates the future of Christian art—that the preservation evoked by the symbol was no longer individual but collective. In the Christian view, collectivity means normally the Church and God's people within it; the formula was introduced after the victory of the Church over the Arian emperors and never disappeared. But in 313 Constantine did not see things with the eyes of the Christian clergy: for him, the collectivity to be protected by the Christian symbol that he had adopted was in fact his army, that is to say, the Empire.

According to a contemporary, Eusebius, this same Constantine had an image made in the vestibule of his new palace at Constantinople; this, while also symbolic, belongs more fully to the realm of iconography since it showed human beings. The personages were Constantine and his sons, represented triumphant over a dragon

stretched at their feet. The image showed the Christian victory of the Emperor over his vanquished enemy, paganism (perhaps especially the idolatry of Licinius, the last of his rival adversaries). In other words, this Constantinian iconography, like the symbol which he introduced into the army, also referred to the political concerns of the Emperor and was connected with military power—with, however, this difference, that it glorified a victory and showed the Emperor himself in the pose of victor.

In numismatics, Constantine and his sons gave impetus to triumphal iconography which, continuing and enriching a Roman tradition, served to fix in the memory of all the image of the invincible monarch, the most powerful on earth. The Christianity of the rulers of the Constantinian dynasty did not prevent them from favoring this ambitious art, which was as foreign as possible to the Christian virtue of humility. In fact, the Christian faith of the emperors gave way to the needs of the state, whose newly recognized Christian mission justified its institutions and its conquests. It is also under Constantine that an iconographic formula was found to define the hierarchy of universal power according to the doctrine of the Christianized Roman monarchy. The motif of a personage enthroned on a seat of gold, inspired by a motif formerly reserved for gods, was retained for the Emperor; although apparently the motif of Imperial majesty remained as before, often in compositions representing the Emperor in majesty or in his apotheosis there appeared above him a Hand, descending from the sky, which blessed or crowned him, thus showing that God in heaven was the celestial sovereign of the earthly sovereign. The motif of the Hand of God stretched from the sky toward a person represented beneath, and thus on earth, was not less well defined iconographically than the motif of Majesty. But if this latter was classical, the Hand came from Jewish art: a century before the Constantinian medals the frescoes of the synagogue of Dura already showed it (the scenes of Moses on Mt. Horeb and of Ezekiel). As I pointed out earlier with regard to the monogram of Christ in Christian iconography, Constantine was interested in Jerusalem and in Jewish antiquities perhaps because of his way of understanding Christianity through the person of Christ. The compositions on these coins and medals showing Majesty and the Divine Hand determined once for all the iconography of an essential idea, which was to remain alive for a thousand years: the idea of the Christian Empire as a reflection of the celestial Empire, the earthly monarch who holds his power from the divine monarch, the cosmocrator. Here, for the first time, attempts were made to define a central and universal fact through iconography, whereas formerly iconography had reflected only religious facts of limited and individual import. However, the underlying thought of the two superimposed monarchies which the Constantinian iconography was meant to illustrate was religious only in part—or was religious in the manner that the late Roman Empire saw such things.

97, 98

99, 100

It is extremely significant that the initiative for a Christian iconography of universal import, concerned with essential ideas instead of with the personal anxieties of individuals, comes from the government of the Empire, and follows closely upon its conversion. One could imagine the same initiative directed by the Church, and the probable consequences that such direction would have had in iconographic matters: the Christian community (and not the Roman state) would have been shown to designate the Christian whole; and the essential ideas to be captured in the image would probably have been chosen from those Christological ideas which then animated the best Christian minds—or else would have been taken, more generally, from the dogmas of the Church. But it was not before about the year 400 that the higher clergy of the Church became conscious of what they could attempt in the domain of iconography if they directed it and fashioned it so as to bring it closer to the dogma and at the same time to render it more edifying. In Constantine's time, the Christian clergy were not prepared for a task of this kind in view of the Christian art they knew—the narrow and utilitarian art which the Christians had practiced in the third century. The government of the Empire, on the other hand, had by tradition all the range of artists' workshops and the indispensable artisans at its disposal, as well as the habit of an official iconography, to interpret for general consumption the facts and moves of the reigning sovereign. It is not astonishing, then, that the great iconographic flowering had its beginnings in the Imperial palace, before control of Christian iconography gradually passed to the Church.

This first phase was important, for it gave an effective direction to Christian iconographic creation; in fact, during the fourth century and at the beginning of the fifth, at the very end of antiquity, some purely Christian subjects were interpreted with the help of iconographic formulas from palatine art. As we have seen, the earliest Christian iconography frequently employed motifs and formulas in more or less common use in all branches of contemporary art; what happened in the fourth century is similar, but distinct. All the "vocabulary" of a triumphal or Imperial iconographic language was poured into the "dictionary" which served Christian iconography, until then limited and poorly adapted to treat abstract ideas. The future of Christian iconography was profoundly modified, and what was created then has remained fundamental for Christian art. Still today, thanks to this tenacious tradition, most of us lend to the appearance of divine things the features, more or less confused, of forms that go back to the art of the late Empire. Christ sits solemnly on a throne; he makes the sign of benediction; he is surrounded by angels or saints standing on either side; he wears a crown, and crowns the saints, beginning with Mary, who has herself a throne and wears a formal costume with pearls and precious stones, etc. It is Christian art such as it was in the Empire after Constantine

that has furnished us all these familiar images, just as the usages of this period of the first flowering of Christianity endowed the clergy, later divided as Catholic and Orthodox, with their sacerdotal dress and defined for centuries the movements and gestures of the officiating priests, and left its unforgettable imprint on the liturgy, the rites, and the form of the prayers of the Church.

The mark of Imperial iconography in Christian art is recognizable everywhere and in different ways: appropriation of themes and subjects, borrowings of iconographic details, utilization of more remote models for the creation of analogous images. It is to the theme of the supreme power of God that Imperial art contributed the most, and naturally so, since it was the key theme of all the imagery of the government of the Empire. The official monuments of the late Empire furnished the Christian image-makers with a series of tested models, and they profited from them largely. It is, naturally, through the different applications of the general theme of God's omnipotence—as revealed through Christ—that the influence of Imperial art made itself felt. So far as one can see, the appearances in Christian art of subjects relating to this theme were not simultaneous. They must have been created as they were needed or as the occasion arose.

The oldest of the subjects inspired by this theme is that of Christ confiding the scroll of the Law to St. Peter in the presence of St. Paul. The group of three figures is symmetrical, their appearance solemn. A mosaic—unfortunately greatly restored —at S. Costanza in Rome (about 350?) preserves a very ancient version of this 101 symbolic image—the symbol of the Church in the form of the Law given into the hands of the most venerated of the apostles, St. Peter. The subject also appears in another mosaic, dated a century later, in the cupola of the baptistery of S. Giovanni 102 in Fonte at Naples. A curious detail of this image is the sphere of the universe, which supports the figure of Christ—an iconographic allusion to the universality of his power.

Imperial models for figurations of power are found in such various works as 103 Roman coins—for instance, coins of the Severi, one showing the Emperor crown- 104 ing a victor and one with the sphere of the universe serving as the Emperor's throne —and a large silver plate of the late fourth century in the museum of the Academy 105 of History in Madrid. In the center of the silver plate, one sees the Emperor Theodosius I giving a scroll to a high officer of the Empire, a ritual gesture which signifies the delegation of power to this dignitary. In other words, Christian iconography inherited from Imperial iconography not only formulas but subjects, and the priority of the Imperial models is proved by the fact that the Imperial images represent real ceremonies, while the Christian figurations are imaginary, their symbolism becoming understandable only because of the ceremonies of the palace.

The same observation is valid for such a scene as that in the apse of S. Vitale in

Ravenna: Christ is seated on the sphere of the world, as its universal sovereign. But this time he presents a martyr's crown to St. Vitalis and receives a model of the church from its founder, St. Ecclesius; the attendant angels present the saints to Christ. The scene is obviously inspired by court ceremonial, and the costume attributed to the martyr saints confirms this. Arbitrarily (without regard for historical fact in the lives of the saints themselves), in the art of the Christian Empire the martyr saints are dressed as dignitaries of the court in fine tunics of white silk covered by heavy cloaks held at the shoulder by a fibula, and with a rectangular ornament (the *tablion*) along the side. Images of martyrs conceived in this fashion are typical and frequent: two are visible in part of a row of saints in a mosaic dating from the seventh century in the chapel of S. Venanzio attached to the Baptistery of St. John at the Lateran. The official character conveyed by the ceremonial costumes is apparent also in the style of this mosaic and of all the mosaics of the period: their uniformity is not due to a lack of artistic skill on the part of the mosaic workers, nor to an Oriental influence on the style, but to a conscious intent to make the presence of the divine or the sacred felt. For in the fourth century, according to the testimony of Ammianus Marcellinus, rigidity, fixity, and stonelike inflexibility of mien were indispensable for representations of the Emperor, who thus expressed the superhuman impassibility of the man filled with divine grace. The symbolic rigidity of the sovereign was echoed in the immobility of guards and dignitaries and the calculated cadence of movements during the orchestrated ceremonies—and it is this that was imitated by the image-makers.

The inspiration of official Imperial art is seen in other Christian subjects: for instance, Christ in Majesty, in two variants, one of which is closely related to the subject of the Giving of the Law which I have already mentioned. In this version Christ is standing and holds the cross as the Emperor in his official effigies holds the lance; the apostles on either side make the gesture of veneration. The Giving of the Law is sometimes traced according to the formula that we know. A different version shows Christ enthroned, but the universe on which he sits is not the symbolic sphere, as at S. Vitale; instead, there is a kind of seat placed on the cloak of an allegorical personage who represents the universe exactly as the emperors are represented on the triumphal Arch of Galerius at Salonika. Christ presiding over an assembly of the apostles was one of the first subjects that brought echoes of official art into Christian iconography, for the façades of certain sarcophagi show the scene from the middle of the fourth century. Here, in terms of an iconographic remembrance of the universal Roman monarchy, Christ as cosmocrator is set against the background of a palace or a city. The apostles are seated around Christ, the ensemble taking on the appearance of a representation of a council at the Sacred Palace of the emperors, the *silentium*, or some other assembly where the emperor personally

106

107

108

109–111

112 presided. Certain catacomb paintings where Christ is seated alone (or with only a few disciples), while all or most of the disciples remain standing, are perhaps inspired directly by the particular usages of these assemblies.

113 An isolated work, the Barberini terra-cotta plaque now at Dumbarton Oaks, throws further light on the representation of a council of apostles presided over by Christ. This time the assembly is a judicial college, and the scene shows a meeting of the tribunal. The presence of the barristers' chancel, of litigants, and of objects which signify recompense, on the one hand, and punishment, on the other, makes it explicit that this is a scene in a Roman tribunal. But the identity of the judges and the monogram of Christ engraved on the purse that symbolizes recompense designate the tribunal as the Last Judgment. No monument is preserved, so far as I know, which would furnish a counterpart to this scene among purely Imperial works.

114, 115 But, lacking scenes of Imperial tribunals conceived in this manner—in those which we know, except in some late copies, the scene is viewed from the side—we may look again at the reliefs of the Arch of Constantine which show other official as-

116 semblies presided over by the Emperor, and notably that of the *largitio* or distribution by the sovereign of pecuniary aid to the crowds which surround him. It is the central part of the relief which is particularly instructive for formal comparisons. The lateral developments, which show officers executing the orders of the sovereign, are special to the subject of the *largitio*. In an earlier Roman relief, in the Archaeological Museum at Brescia, one can see another official assembly conceived and represented in the same manner.

All the scenes in church apses, especially in the Greek and Semitic East, which show a vision of God by a Biblical prophet represent these theophanies by adapting a formula of Imperial majesty to their particular subject. For the vision itself, only a

117–119 luminous aureole is added to the usual figure of majesty, and visionaries take the place of the acolytes of the sovereign. The most striking examples of images of this kind are at Hosios David in Salonika, which must be dated in the fifth century. Traditionally, the two personages who accompany the divine vision are recognized as Ezekiel and Habakkuk, although one may question this identification. In the monastic chapels at Bawit, in Egypt, visions of this kind were frequently represented in the sixth century and later, but with the details of the iconography changing almost every time. The aureole of light is always maintained, but the acolytes change. Sometimes Ezekiel fills this role, and sometimes the apostles with the Virgin, the latter group clearly evoking the Ascension.

Two other subjects often rendered in early Christian art reflect Imperial models: the Adoration of the Magi and the Entry of Christ into Jerusalem (the latter is iconographically close to the Flight into Egypt). In these images we are concerned with episodes described by the Evangelists. There is no doubt that here the artists

followed the texts. But in their fashion of interpreting them they are influenced by official iconography: that of the offering of crowns and other gifts by the Orientals conquered by the emperor during a celebration of the triumph, and that of the Hellenistic and Roman ceremony of the sovereign visiting a city of his Empire or a conquered (or "liberated") town.

Let us consider a few examples of these two subjects in relation to the corresponding figurations of official art. First, there is the group of Parthians carrying offerings, on the Roman triumphal Arch of Galerius at Salonika, or two groups of \quad 121 conquered barbarians before the Emperor, on the base of the Egyptian obelisk erected by Theodosius I in Constantinople. Over against these, one may place the \quad 120 sculptures of the ambo from St. George's Church at Salonika, including an Adoration of the Magi which resembles more particularly the reliefs of the triumphal arch \quad 122 in the same city of Salonika. The arched niches, the movements of the offering bearers, and their costumes are, in fact, very much alike in the two works. And, finally, let us cite the famous mosaic of the triumphal arch in S. Maria Maggiore, where all the details are direct reflections of official art.

As for the Entry into Jerusalem, it is enough to recall the scene on the Echmiadzin ivory, as well as a Coptic relief with Christ riding an ass between two angels, \quad 123 now in the Berlin Museum, and to compare these renderings with a scene of the *adventus* of Constantius Chlorus on a coin of his reign (305–6) and with the \quad 124 engraving on a plate found at Kerch which represents Constantius II (reigned 337– \quad 125 61) as a horseman between a winged Victory, at the right, and a footsoldier armed with spear and shield.

But what the official art of the Roman state brought to the new iconography of the Christians is not limited to the specific examples I have enumerated, to which many others could easily be added. Moreover, the presence of these impressive realizations had an effect on the general direction taken by Christian art. If Christian iconography reflected so scantily the Christological and dogmatic problems which were the central concerns of the Christian elite after the Peace of the Church, it was because the Christian image-makers had nothing on which to build images devoted to the illustration of these newer and more abstract ideas. Accessible precedents in Imperial iconography, however, gave the image-makers the means of representing symbolically the power of God. But this also meant that the principal object of their imagery was not necessarily the essential thing in the Christian experience, for they did what the iconographic antecedents at their disposal permitted them to do. In brief, Christian iconographic expression at this period was in large part channeled into an imagery familiar to the Imperial authorities who, after having decided upon the conversion of the Empire, governed the Christian state and its official religion.

The erection of the Arcadian columns in Constantinople and the realization of

the mosaics of S. Maria Maggiore in Rome afford a striking parallel, which helps us to understand better the unity of iconographic invention in the two branches of governmental and ecclesiastic art. Everyone is familiar with the two columns, of Trajan and of Marcus Aurelius, in Rome that are ornamented spirally with historical reliefs. These odd and costly triumphal monuments of the second century were repeated afterward only once, when about 400, in Constantinople, Arcadius had

126–131

two similarly decorated columns erected to the glory of his father, Theodosius I, and to his own honor, columns now destroyed and known chiefly through drawings of the Renaissance period or later. It would be difficult to find a more flagrant example of imitation: after three centuries, a Christian emperor repeats a type of pagan Imperial monument, and later the copies pass—understandably, by the way— as real Roman works.

One can guess what impression this *renovatio* must have made on contemporaries. For these historical columns and their bases revived a kind of visual presentation of historic events that had not been cultivated since the second century: in superposed registers they depicted historical episodes or symbolic ceremonies, scenes of war and military campaigns, with crowds and hilly landscapes and cities, the whole evoked with a laudatory and triumphal intent. Scenes of this kind, forming entire cycles on the shafts of these spiral monuments, cannot have been usual elsewhere. Doubtless, then, the reliefs of the two columns in Constantinople had an effect on their contemporaries. I even think that a material proof of this effect is to be seen in a great Christian monument of Rome, the mosaics of S. Maria Maggiore.

These mosaics were made in the reign of Pope Sixtus III (432–40), soon after 430, a little more than two decades after the Imperial columns of Constantinople,

130

and they are obviously inspired by triumphal art. The mosaics of the arch that stands before the apse, with single scenes distributed in superposed registers, do not represent successive episodes of a continuous story. They are artificially juxtaposed for the purpose of iconographic demonstration. In this respect the mosaics of the arch

128, 129, 131

form a counterpart to the similar compositions on the base of the triumphal column of Arcadius, where the compositions, in superposed registers, also form a thematic iconographic ensemble. On both the arch and the base the theme is supreme power —the supreme power of Christ or of an emperor—expressed according to the iconographic conventions of the Roman monarchy.

The mosaics of the nave, on the other hand, have a narrative character. The plan of the architectural decoration obliged the mosaicists to divide their work into a series of individual panels, but the composition of many of them is awkward, giving the impression that a continuous band of images has been cut into distinct parts. If something like this really happened, the relation of these mosaics to the

reliefs in spiral bands on the shafts of the Imperial columns of Constantinople— *126, 127*
and also to their models in Rome—becomes still more striking. The surprising
thing about these mosaics with Biblical subjects is that the stories of Abraham and
Moses are interpreted in terms of the military art of the Romans (see pp. 48 f.). *132, 133*
And the mosaicists also use the conventions of the reliefs to represent space: the
single plane which rises very high, and two superposed and independent planes.
In addition, in the mosaics there are scenes from a palace cycle, which are fitting
on the triumphal reliefs but which are unexpected when it is a matter of, for in-
stance, the life of Moses.

Iconographic examination of the mosaics of S. Maria Maggiore thus invites
us to recognize in them inspiration by the most recent and most impressive Imperial
monuments. These mosaics are probably the most extensive and most suggestive
example of the iconographic influence of Imperial art; and they enable us to grasp
the extent of what Christian art could be expected to take from this source and to
recognize that, on the plane of ideas, the contribution was quite limited. Of course,
some interesting religious intentions found expression in various unfamiliar figura-
tions in the mosaics of the triumphal arch. But we can mention them only in passing,
since the interpretation of these figurations is uncertain. It is important, however,
to bring up this difficulty of interpretation of the mosaics of the triumphal arch
because the difficulty is characteristic of any exceptional imagery, the exceptional
character of the mosaics of S. Maria Maggiore being the consequence of their
dependence on another art. The triumphal art of the emperors was not intended to
convey the Christian ideas with which Christians attempted to charge it, and their
efforts in that direction probably gave rise to obscure figurations (for example,
the identity of the female figure at the right of the infant Christ in the Adoration of *134*
the Magi). Sometimes the triumphal arch of S. Maria Maggiore is called—wrongly
—the "Ephesian arch," a name which is meant to indicate that this mosaic, which,
chronologically, follows immediately the third ecumenical council (which sat at
Ephesus in 431), reflects its canons relative to the Virgin. If the intention to make an
iconographic demonstration of a dogma were clearly evident (but this is far from
being so), the mosaics would furnish a proof that imagery inspired by Imperial art
was incapable of expressing the theological ideas discussed in this council.

Christian images of triumphal inspiration, on the other hand, always succeed
in expressing the idea of the power of God: since Imperial iconography furnished
a range of subjects and motifs evoking the idea of power, adaptation of each of these
conventional subjects to the Christian frame, to make them play the desired role,
that is, to proclaim the power of God, was relatively easy. Some of the motifs of
this official symbolism which the mosaicists of S. Maria Maggiore employed on the
arch are these: composition in superposed registers, where the highest is filled with

abstract signs of supreme power, the next shows the Emperor and his dignitaries, and the lower register (or registers) represents the foreigners who recognize the power of the Roman monarch, either by acclamation or by offerings, while at the very bottom of the panel the enemies of the state are portrayed as chained prisoners. The great mosaic of the triumphal arch of S. Maria Maggiore is a counterpart to a composition of this kind: the throne above (top, center) is the symbol of the power of God in heaven; in the same register is shown the recognition of the royalty of Christ by his people (the Hebrews and the Romans); in the second register the foreign kings do homage or present their offerings to the infant Christ; and, still lower, one sees the image of the hostility and defeat of the enemy king, Herod.

The transition from the Imperial triumphal model to the Christian replica is evident, and this enables us, here and in similar cases, to grasp the lesson of such works for our studies. The nature of this lesson can be defined unequivocally: from the Christian point of view these beautiful images on the church's triumphal arch could show to all beholders the great power of God or of Christ—power which extends from heaven to earth, and on earth embraces the Empire and the barbarian countries, that is to say, the entire inhabited universe. This is what the Christian image-makers could achieve by their method of integrating Christian images of a historical nature—that is, from the Scriptures—and a few symbols of abstractions into a well-developed iconographic language familiar to all. Naturally, this iconographic language was also able to inspire more properly Christian creations, more ambitious from the point of view of ideas. But this is another topic to which we will return. For the moment, what interests us is the fact itself of this recourse to the official art of the Empire and its importance for the process of formation of Christian iconography.

Only one iconographic repertory is usually mentioned in connection with the art of the Roman state, the strictly Imperial repertory which furnished the framework for the iconography of the various images of the power of Christ. In bringing the reliefs of the historical triumphal columns into this discussion, we have begun by pointing out figurations of power and their significance for the Christian iconography of the supreme power of God. But the lesson of these same reliefs is not confined to this strictly Imperial aspect of the matter.

The frieze sculptures of military scenes also had their influence on Christian art: and we can observe in the mosaics of S. Maria Maggiore the Biblical scenes conceived after the pattern of the military scenes of the Roman columns. This category of images includes not only scenes of combat but representations of armies on the march, sieges of fortified cities, and peaceful contacts with foreigners. In the *135–138* mosaics the armies and people advance and pass in compact crowds, as in the reliefs of the historical columns; and one is hard put to it to remember that these hosts

represent sometimes the Egyptians and sometimes the Hebrews—in fact, what one seems to see everywhere in the mosaics are Roman legions in battle with barbarians. Fortified Roman towns are frequent both in the mosaics and in the column reliefs. *139, 140* In other scenes in the mosaics, the chief men of Israel, Moses, Joshua, etc., are placed *141* on hillocks, thus dominating the mass of the people of Israel. In the reliefs of Roman *142* military campaigns, the same device serves to point out the emperor, the general, the centurion, or some other Roman officer. He often mounts a knoll or a podium to harangue the soldiers; and Joshua does the same when he stills the sun in a mosaic in S. Maria Maggiore. To the series of scenes representing peaceful contacts with foreigners belongs the S. Maria Maggiore mosaic in which Abraham astride a *143* charger, like a Roman general, meets the priest-king Melchizedek, on foot, bring- *144* ing Abraham bread and wine. Other mosaics show a leader of Israel seated, receiving the delegates of a neighboring tribe, just as a Roman official receives the representatives of a conquered people in the military reliefs. In these, in addition, appear winds, personifications of places or rivers, or celestial messengers (Victories) that intervene in the affairs of men—devices also found in the S. Maria Maggiore mosaics.

What military imagery offered to the Christian image-makers was often not usable in the customary program of ancient Christian art. It is principally in illustrated manuscripts of the historical books of the Old Testament that we see its imprint, when the illustrations are composed at a very early date, that is in the fifth century. To judge from medieval copies, Psalter illustrations at this period originated *145* in the same source of inspiration; and this is hardly surprising, in view of the importance of themes of armed battle and acts of violence in the Psalms.

It is necessary to point out in particular one area of Christian iconography that is entirely dependent on models furnished by the art of the Roman state: the iconography of tribunals, judgments, condemnations, and executions. Given that the judicial function is a prerogative of political power, it is the emperor, or a magistrate officiating in his name, who presides over scenes of judgment and who is shown conducting the interrogation of the prisoner, condemning him to corporal or other punishment, while his agents conduct the accused or condemned man, guard the door of his prison, strike him, or cut off his head. On the sarcophagi of Roman magistrates judgment scenes are frequent, and the iconographic formula is the same that was applied to the judgment by Solomon or of Daniel or the trials of Jesus or any Christian martyr. It was a standard formula, already seen in variant versions in the frescoes of a Roman house under the Farnesina (now in the Museo *146* Nazionale Romano in Rome), where the judgments involve mythological figures.

In the art of judicial themes the scene of execution by beheading is probably of the same period. It is the scenes of this type on the Imperial columns that most directly foreshadow the usual images of execution in Christian hagiographic iconog-

raphy: they surely come from triumphal imagery, for it is there—in order to glorify the performance of the "peace-making" Roman army—that there was most often occasion for representing executions (since executions decreed by an ordinary tribunal were unlikely to be honored by an image). The Christian borrowing of this model is particularly suggestive because it illustrates a "mutation" in the meaning of a borrowed term, going beyond a more or less marked "shift" in meaning and completely reversing the sense. Whereas the Roman state propagated these images in order to glorify the magistrate and the military, who, by cutting off heads, established Roman order, the Christian image-makers made use of the same iconographic scheme to exalt the memory of those who were executed and to proclaim the iniquity of the representatives of the Roman state. The first examples of these figurations which, inspired by the practices and the art of the government of Rome, served to condemn it appear before the Peace of the Church.

147 Three anonymous martyrs, kneeling, their eyes bound, ready to receive the executioner's sword stroke, are represented on the wall of a tiny *confessio* under the church of SS. Giovanni e Paolo on the Aventine in Rome. Several Roman sarcophagi of

148, 149 the fourth century show St. Peter and St. Paul, separately, in scenes of their judgment (the execution itself is not shown at this period). These first images of the passion of the apostles are summarily treated, and it is possible that the very vagueness of the action reflects the difficulty felt by the Christians in accepting the moral reversal just mentioned.

Since traditional art had shown condemned or executed persons only to point out their crime vis-à-vis Roman society, it took time to make the sacred image a testimony of sympathy for those who there occupied the traditional place of the enemy. This has often been affirmed, in order to explain the absence, then the rarity, of images of the Crucifixion of Christ in late antiquity and the contemptible quality of those which do exist. The hypothesis of moral reversal is not to be rejected, but it is more difficult to demonstrate it on the iconographic level than it is for scenes of execution by beheading. We do not know any figurations of crucifixions of those condemned to death by Roman civil law, whereas the military reliefs on the Imperial columns in Rome furnish, within the frame of Imperial

150, 151 triumphal art, scenes of the beheading of adversaries of the Roman state. For the hagiographic images of decapitation, there are thus the indispensable standards for comparison.

The themes and motifs that we have mentioned are not claimed to be the only ones taken from the art of the Roman state into Christian iconography. Many aspects of this art furnished models on different occasions and by various channels to Christian image-makers after the Peace of the Church. There will be opportunity later for referring briefly to a few of them in discussing Christian portraits; for

certain categories of these portraits adopt formulas used for portraits of dignitaries of the Empire, and others descend from them by way of assimilation or analogy.

Apart from the art of the Roman state (relating to the emperor, magistrates, army, and their respective official activities), there were other more or less circumscribed areas of iconography within the framework of Roman art at the time of the Peace of the Church which furnished Christian artists with useful elements of the iconographic vocabulary they were constructing. For instance, there should be mention of the much more limited but not negligible iconography which had as its principal provenience the villas or rural habitations of the great landed proprietors and which probably reflected their taste and ideas.

The very first Christian iconography, that of the funerary cycles and the paintings of Dura, the fruit perhaps of competition with the art of the synagogue, was thoroughly urban—an art of the city which carries within it the mark of the tastes and anxieties of the urban populace of late ancient times. The Christian iconography inspired by Imperial art depends upon models created by the government of the Roman Empire and used throughout its entire territory and in all social milieus. But, besides the government and the mass of the urban population, there was the powerful senatorial class, the class of the great landowners, particularly powerful in Sicily, North Africa, and Syria, and everywhere where there were latifundia. In a few instances Christians were established in the villas of these extremely wealthy and powerful proprietors, and the art of the landed estates of these aristocratic Romans seems to have contributed more to the repertory of images than has been generally recognized. The pavement mosaics that have been uncovered in a great number of the villas, and the continuation of this art in the vault decoration of the equally aristocratic Umayyad mansions in Syria, as well as several less important series of related monuments, afford us an idea of this art and its iconographic program. It happens that one group of subjects from these Roman villa decorations served as a model for a specific and important category of Christian images, and as we have the good fortune here to be able to observe both the point of origin and the final expression of this branch of iconography, the really Christian part of these figurations can be usefully measured.

At the point of departure is a pavement mosaic from Carthage, which comes from the property of a landowner who is represented and identified as "Dominus Julius." The panel shows the seignorial manor (in the center) and the proprietors, husband and wife (at the bottom). Slaves surround the proprietors of the domain. One slave holds before his master a scroll marked with his name. I take it to be an act of sale or a similar document certifying the rights of Julius over the estate. Around his wife, other slaves remind us of his riches: they carry jewels and viands.

152

At the top is a feminine personification (at her feet are a hen and her chicks in front of a coop—a symbol, possibly of the home). Two slaves approach, holding the products of the domain, while in the four corners of the panel archaic figures personify the four seasons and their occupations. Finally, on either side of the image of the manorial dwelling which forms the center of the composition, the favorite diversion of the country nobility is depicted in the preparations for the hunt and the return from it.

This mosaic represents a particular estate or domain belonging to a specific proprietor, and it portrays it conventionally by means of several subjects that are independent but grouped in a certain precise fashion: in the middle, the dwelling which is the symbol of the property of Julius; converging toward it, the bearers of the fruit of its cultivation, of which several details are seen; and, accompanying these, in the corners of the panel, the four scenes symbolizing the seasons. In other words, an estate is represented symbolically in its extent and its riches by means of the occupations of its inhabitants and the incessant movement of time. And one should keep in mind, too, the motif of the hen with her chicks, which I take to be a symbol of the home.

Although in North Africa and Europe Christian pavement mosaics are rarely iconographic in subject, in the Greek and Semitic East many of the churches of the fifth and especially the sixth century contain carpet mosaics with allegorical imagery. The same is true for the synagogues of this period in Palestine. It is in the Holy Land, including the Lebanon, that we find the preponderance of examples. Most often there is a decoration on a white ground of entwining vines that enclose human and animal figures. A comparison with later Islamic monuments in the same area points to the probable secular origin of such mosaics; in fact, two frescoes of the eighth century, in two different Umayyad palaces, utilize the essential terms: at Qasr el Heir, the scrolls with living things and, in the center, a personification of the Earth, as well as a hunt and musicians; at Qasr 'Amrah, the foliage sheltering in its turnings busts of persons, animals, musicians, and dancers. (In the second example, the composition is spread over a vault; at the end of antiquity, the themes of pavement decoration, on the one hand, and of ceilings and vaults, on the other, were frequently the same.)

Some of the pavements of the churches show only a more or less random choice of motifs from among those mentioned above. Others are systematic, and it is through them that it is possible to see the chain of relationship that ties them to the mosaic of Lord Julius from Carthage. The center of several of these mosaics (the section which in the Carthage mosaic shows the dwelling of the proprietor of the domain, surmounted by a personification of the home) is occupied by a personification of Earth, as the inscriptions show. Two personages present this figure with

(margin references: 153 · 154, 155 · 152)

baskets of fruit, bringing us back to another feature of the Carthage mosaic, the bearers of offerings, who extend them toward the "home." Certain Palestinian mosaics also show the motif of the hen and chicks, and where the motif is complete we see that it opposes the security that the mother hen provides for her chicks to the dangers encountered by the cock, the victim of the fox. In the same mosaics one also sees the images of work in the fields or gardens; and although I do not know any that are grouped according to the seasons, there are personifications of the seasons and of the months on other contemporary Palestinian pavements, showing that these pavements are all more or less related. The hunt, which the Carthage mosaic also shows, is sometimes added to the motif of work in the fields. But in the Christian versions of such pavements in Palestine, the hunt takes on a peculiar character: instead of killing the game, the hunters seem to content themselves with pushing back the animals. The intention, seemingly, was to show man's defense against the wild beast, an idea which can be associated with figurations of tamed animals in the same ensembles: animals trained to the sound of the flute, and saddled pack animals. The subject of these church pavements thus becomes the earth and the occupations of men who cultivate it and who defend it against savage beasts. From the conventional image of a certain part of the earth (that of a real and private domain), we pass to the image, not less conventional but modified, of the earth in general, the earth where God reigns and which is the domain over which the activity of the Church extends.

In order to formulate this idea iconographically, the eastern Christians used a model of the type of the Carthage pavement, modifying it in several respects—for instance, by replacing the juxtaposition of numerous small scenes (as in the pavements of the Great Palace at Istanbul) by a network of vine scrolls. The tracery of vines serves as a frame for figurations which are independent of each other but which, as they are superposed in almost regular rows, the spectator is invited to consider independently of the rinceaux as a single picture with several registers. This is the way, of course, that one considers the mosaic of Lord Julius, where, however, the scenes are brought together without the framing of the vine scrolls. *156*

Comparison of the Carthage mosaic with those of Madeba and Mt. Nebo (also known as Mt. Pisgah) shows how the secular symbolic image of a specific landed property becomes in the hands of the Christians the image of the earth in general and in particular the ideal land governed by God. The possibilities of this allegorical imagery for the interpretation of Christian truths were far more limited still than the means offered by Imperial art. But the art of the villas of the great provincial proprietors contributed, it seems, to the expression of the theme of the earth peaceful and calm under God. This theme had a certain success at the end of *155*

antiquity, and perhaps especially in Palestine and the eastern provinces of the Empire, where it met that of the expected Messianic Peace, a Jewish theme based on Old Testament prophecies. The motif of animals expelled as hostile to man after the original sin but assured of return, domesticated, at the time of the Peace is a part of this theme.

157

The question of narrative figurations does not concern us here. The difficulty in evaluating the Christian element in these allegorical mosaics is not in determining what parts of the images matter religiously but in defining the precise meanings of the allegories. As we know, at the end of the seventh century (Council of 695), the Byzantine Greeks renounced allegory in their Christian images, and precisely because of this: the shadow of truth, as they said (referring to allegories and to events of the Old Testament), is never as useful as the truth itself, that is to say, the events following the Incarnation. After a brief appearance in the sixth century among the Christians of the East, the allegorical iconography that we have been considering was discredited by this opinion, and it was abandoned a short time after the Islamic invasion of the eastern provinces of the Christian Empire in the seventh century.

PART TWO

Preface

In the preceding pages we have attempted to define the most general bases of the Paleo-Christian iconographic vocabulary, its fundamental constituent elements. In order to grasp them, we have analyzed the first Christian works in the area of imagery and the ancient Christian figurations that were inspired by the art of the Roman state and its derivatives. These two surveys, taken together, enable us to measure what ancient Christian art owes to the iconographic terms of current imagery and what it owes, after the Peace of the Church, to the art supported by the emperors and the administration of the Empire, an art which, by virtue of that fact, enjoyed great prestige.

In the two chapters of this second part of our study we must look at Paleo-Christian images from another point of vantage. We will isolate, successively, two important classes of subjects—portraits, and narrative scenes based on the Scriptures—in order to examine their origin and their relationship to the art of the environment. This method has certain advantages for a historical study when it deals with categories of images clearly enough defined and represented by a sufficient number of examples. Through the comparison of works of the same kind, pagan, profane, or Christian, one should be able to deduce what is to be ascribed to the invention or interpretation of the Christian image-makers.

We will see that there are particularly interesting and clear conclusions for the portraits, precisely because of the certainty with which portraiture can be classified, whether it be individualized or of some typological variety. It is more difficult to draw conclusions of general import from an analysis of the Biblical scenes. A scene is, obviously, a matter of sacred history only as its subject is related in the books of the two Testaments. The number and variety of possible Biblical subjects is, of course, immense. Even for the most important material, the story of Christ as told in the Gospels, there were so many possible choices of subjects from the Scriptures (and so many different choices were made) that a rigorous classification of Christian scenes from Scripture is precluded; and comparison with profane images or with pagan religious—that is, mythological—images is still less instructive.

In order to find solid ground on which to found some comparisons, I have selected from among the mass of Biblical scenes those which belong to cycles of a defined type and those (occasionally the same ones) that by reason of their location permit us to infer a specific religious function. These supplementary data—the composition of the cycle and the functions of the images—will allow us in certain cases to determine what must, in other cases, remain guesswork: that is, it will enable us to uncover the first steps in the creation of Christian scriptural narrative images and to designate the sources of inspiration of the Christian image-makers.

The choice of the portrait and the Christian scriptural narrative scenes may be surprising for an investigation of this kind. It may be asked whether these are not two areas where the image-maker is normally free from any influence from extant traditions, being guided exclusively either by the physical aspect of the person whose portrait he draws or by the text of the Scriptures for which he gives a pictorial equivalent. Because this has been—and still is—tacitly assumed, the Christian portrait and the narrative scene derived from the Scriptures have rarely been the subjects of comparative studies which go beyond the solely Christian domain. But this assumption is certainly an error. Far from being exceptions to the general rule, the images in these categories bear as many marks as images in other categories of diverse influences from current artistic usage, including the common iconographic formulas of the day. Our conclusions, although they are presented with caution, will set aside, or appreciably diminish the weight of, opinions that tend to regard all the early Biblical images as proceeding from direct illustration of the text of the Old and New Testaments. It is natural that it should be thought that the purpose of the narrative images was to illustrate texts, since they are the imagery of a revealed religion and the revelation is recorded definitively in the books of the Scriptures. Should not all Christian art therefore be the visual counterpart of the revelation that the texts of the Scriptures record verbally?

But the monuments do not support this view, however natural it may appear a priori; or, at least, they invite us to regard the iconographic translation of Christian narrative subjects as not primarily dependent upon direct illustrations of the text of the Scriptures and most certainly not as exclusively so. The validity of this approach is demonstrated in systematic examination of the paintings in the earliest manuscripts of the Gospels and of the Biblical images, isolated or grouped in cycles, that decorate the monuments and small objects of the early Christian period.

It would normally be expected that the proper place for images constituting a visual equivalent of a text would be among the illustrations of manuscripts of the Gospels. But, on the contrary, the earliest illustrated manuscripts of the Gospels afford no example of this. In them, instead, are found either image-signs, limited to evoking a Biblical episode by allusion, or narrative images that interpret, or present

a commentary on, an evangelical story. As to images of the same Biblical subjects which appear in late antiquity on the walls of funerary hypogea, then in churches, on sarcophagi, on liturgical furnishings, on the bindings of a book of Gospels, or on medicine boxes and amulets, we will see that they almost always belong to the category of image-signs, which call to mind but do not describe. The few facts of the gospel story that such schematic images retain certainly do not imply that the image-maker expressly consulted the text of the Scriptures (any Christian was expected to know as much), and it was even necessary that the maker of the work bear in mind the meagerness of the information possessed by the masses, since his images were destined for them. We will see that images in these categories—image-signs and narrative images—were selected according to the function of the location or the object where they appear. This statement is commonplace in itself. But it will help us to discern the motivations of those who created these images (motivations relating to function, which are far from the simple desire to establish visual equivalents of texts) and also the particular current usages that were adopted for these works that had special functions.

III. The Portrait

 This chapter will deal with the general theme of the Paleo-Christian "portrait." We will study it by classifying representations, as well as written documents, by categories, which in this particular case will be defined principally by the functions of the portraits that we have to analyze, the function being determined in its turn by two principal factors: the rank or social position of the person who is portrayed and the use for which the portrait was destined. Naturally—and this is of primary importance—we will be concerned always and only with the portrait as it was known at the period and in the milieu that produced the Christian images, specifically the Christian portrait images, and with those non-Christian portraits of the same time and environment that for one reason or another contribute to a better understanding of the Christian portraits.

 A distinct category of ancient portraits comprises the likenesses that were intended for private family use, as in our times, and that served to recall the features of some person, with all the many possible motives that could prompt the making of portraits of this type and all the possible occasions for which they could be created. Such private portraits could be limited to showing one person alone, or they could represent groups of persons, for example, several members of the same family. This vast category of private portraits can be divided into two branches, if we look at it from the particular point of view that is essential in dealing with portraiture. In representing the features of some person, every portrait is a silent souvenir of the person it portrays; it is thus, very naturally, a commemorative work. This is true of most portraits of the living for the living, but it means that the portrait as an artistic theme also extends, quite normally, to the vast area of funerary art, the portrait of the dead for the survivors, as well as the portrait of the dead next to his body, placed there on his own account, for his existence in the afterlife. The private portrait is, then, an immense category, and one that has never been abandoned.

 In addition to this first great family of portraits, which the last centuries of antiquity cultivated actively, there is another that is no less important. It includes

the many kinds of public portraits, that is, portraits meant to be seen by everyone or by some section of the society to which the person who is portrayed belongs. The initiative which underlies the ordering of these portraits may also be of a public character: a religious or professional community, the administration of the state, the army, the court, etc. In view of the social function of these portraits, the images themselves tend to identify the person or persons represented as members of their group, agents of the administration, magistrates, officers, emperors. This is, in fact, a peculiarity of portraits of this type. When the portrait goes beyond the simple end of representing the physical features of a person, as it does in the private portraits, in order to identify a man socially, by his class, profession, or some hierarchy, it makes use of a greater number of co-ordinates: typical accessories, costumes, actions, or the grouping of several persons (judges, poets, apostles).

In this category, too, the intentions of those responsible for the portraits may vary, and, along with these intentions, so may the functions of the images. In fact, public portraits could be put to funerary use, or at least they could be located in the place of burial. Furthermore, they are also to be found on the walls of certain public buildings, on furniture, on objects designed for some special use that is connected with public life—triumphal arches, columns, the furnishings of tribunals or offices —on the apparel of employees, dignitaries, or soldiers, and on the armor (the shields and helmets) of the soldiers.

It may be asked what profit there can be in examining this mass of documents relative to the Greco-Roman portrait, private and public, of Imperial times, in view of the fact that these innumerable portraits have nothing Christian about them and that we are concerned here with Christian iconography. Since there have always been portraits—at least since historic times—is it not true that, when one undertakes a portrait of someone, the essential source of the effigy is the person represented, anything else being secondary or nonexistent?

But, as a matter of fact, portraiture is not always thus practiced, and particularly not at the period that concerns us. Every portrait, or almost every one, bears the mark of a definable genre, that is, of the category to which it belongs by reason of the identity of the subject, the use to be made of the portrait, the intentions that lie behind its making, etc. Early Christian portraits share this characteristic with the other portraits of the period; like them, they were conceived and executed according to common usage. The scholar seeking a better understanding of the paths by which the first Christian images came to be created thus finds it much to his advantage to study the methods and conventions of Roman portraiture at the beginning of our era. He will find there the key to early Christian portraits and the explanation of many of their particular features, which would go unnoticed if he did not stop to examine the Roman examples attentively. These special features can generally be

explained if one can manage to establish the exact category of a Christian portrait—
a category that can be recognized by analogy with both earlier and contemporary
Greco-Roman portraits. It is then possible to reconstruct the path followed by the
Christian portrait's executant, starting from the typical formulas of the time, and
finally to note what is truly Christian in the Christian portrait—that is, what the
Christian artist was able to take from the formula at hand and what he added.

One observation of general significance demonstrates the utility of this method
of investigation or, at least, indicates the necessity of not assimilating the Christian
portrait of late antiquity to the modern portrait as regards its meaning and its func-
tion. If one thinks of early Christian imagery as a whole, one runs up against an
apparent contradiction. Reviewing mentally the figurative arts of the Paleo-
Christian period and the early Middle Ages, one notes, not without surprise, that
more than half of all Christian images are representations of historical figures, from
Christ and the apostles or the leaders of Israel in the Old Testament down through
the innumerable saints of the Church. The Christians were very obviously much
attached to the evocation, through an image, of holy persons and saints, bishops, and
the heroes of Biblical stories. However, these representations of historical persons
—portraits in the broad sense of the word—generally lack the characteristic which,
with some exceptions, almost until modern times defines the portrait: the physical
resemblance, the individual precise details which represent the face of the person
portrayed. Of course, we do not know the features of the face of Jesus or those of
the saints. Comparison of two or three "portraits" of these persons on ancient
monuments is enough to demonstrate that the physical type is too slightly defined
to correspond to an actual face and that it changes from one image to another;
consequently, it appears that there was no intent to reproduce the real appearance
of an individual head. Take, for example, the portrait heads of the popes at S. Paolo
fuori le Mura in Rome: there were dozens of them, but they are distinguished from
one another chiefly by the names inscribed beside the paintings.

Why, then, did the Christians set so much store by portraiture and at the same
time neglect what would seem to be the essential characteristic of the portrait? The
answer must be sought among the authors of these portraits and their patrons, who
must have seen other things in them than the desire that they record as accurately as
possible the exact appearance of the individuals portrayed. Our analysis will bring
out some elements of the answer to this question: What did the Christians of late
antiquity demand of a portrait?

It has just been said that many images that we classify as portraits manifestly do not
aim at what is generally one of the major concerns of the portraitist: the likeness or,
in other words, the imitation of the features of the individual portrayed. This is

certainly true, and it is true not only of the Christian portraits of the time but also of many pagan ones. Should we, then, call them portraits? I think that we should, and I will explain why.

First, because the ancients considered them as such. I have in mind images of persons who are shown not involved in any action but for themselves: their proper names are inscribed beside their effigies without regard to the sometimes very summary delineation of their faces; the names identify them as portraits. And the very early hagiographic stories reveal that these images (which seem so undistinctive to us) sufficiently identified to contemporaries the saint who appeared to them in a dream or a vision. This attestation of the identity of a saint by reference to a portrait previously seen is quite frequent in hagiography. The first examples that I know are from the first half of the seventh century (St. Cyrus, St. Demetrius), that is, from a period that has left us only portraits that are particularly summary.

It must, of course, be admitted that we can class as portraits images which do not do much in the way of plastic description of the face but aim, nevertheless, at bringing out an individual trait. The art of our own time often manifests the same tendency and, like the artists of late antiquity, retains from one portrait to another the same scheme. The painter Modigliani, known for his portraits, worked in this way. This is because he, like many of the painters and sculptors of our day, and like the portraitists of the last centuries of antiquity, attempted to represent the person that he portrayed by other means than the objective and detailed description of a physiognomy. These means are not the same among our contemporaries and among the ancient portraitists who concern us here. But the rejection of the descriptive portrait based on exact imitation of the features of the face is common to both and should not exclude the works of either group from being classified as portraits.

What, then, are the characteristics of these images that are portraits despite the absence of likeness to individual physiognomy? Before enumerating them or considering any of them in detail, let us state that, like other categories of images of this period, the portrait of late antiquity is typological. What it means to represent, and can represent, in the image of an individual is indicated plastically (or pictorially) by means of formulas. The typological character of the portrait of this period is its essential quality, the portrait being naturally subject to the same principles of interpretation as other branches of representation, where the typology, that is, the use of formulas to represent the human body, gesture, dramatic action, space, landscape, is well known.

One facet of the typology of the portrait of late antiquity is easily understood, and it is the one which will help us most in grouping Paleo-Christian portraits. These are formulas having to do with the manner in which the portrait is used, often with reference to the religious, political, or social function attributed to it. More

surprising, and sometimes less clear, is the application of typological formulas to the representation of the person portrayed. Such formulas exist, nevertheless, and their typological nature is unquestionable. But it would be difficult to draw from them any conclusions particularly useful for our study, since this typology applies almost indifferently to all effigies intended as portraits. Perhaps it will suffice to attempt here only a general explanation, applicable to all particular cases.

We must, first of all, recall a peculiarity that has to do with the customs of late antiquity: that images seem to have been used more frequently than at other historical periods and that an extraordinary importance was attributed to them. This is confirmed by certain categories of portraits such as those of the emperors, which were found—and had to be found—everywhere: on coins, on the scepters of consuls, on helmets, shields, the official robes of civil dignitaries, in the chambers of tribunals, on codes of law. It is known that legal sentences could not be pronounced in judicial chambers in the absence of an Imperial image. The meaning of this is clear: the portrait of the sovereign replaced the sovereign; the emperor was, by reason of his portrait, present in the room when the judge pronounced sentence in his name. The portrait of the emperor had a similar juridical value and was virtually obligatory on weights, stamps, coins, and later on seals: here, again, the presence of the emperor, replaced by his effigy, guaranteed the standard of the metal, the exactness of the weight, or the authenticity of the document. We are especially well informed, in this respect, on the subject of Imperial portraits. And for certain series of portraits connected with specific functions, the effigies of the great magistrates of the Empire, among which should be included the bishops of the Church, we have similar testimony: portraits of persons of such rank have the value of judicial testimony or of a signature.

Official portraits are more indispensable during the Roman Empire than at other periods or in other political or social conditions. But when we have recognized this, it is all the more striking to see how indifferent the image-makers were to any individual characteristic in their effigies and particularly in those which were surely employed as an assurance of the ideal "presence" of the sovereign (for example, the effigies on coins). In fact, contrary to the practice of the early Empire, they sometimes did not hesitate to reproduce the same features for the emperor from one reign to another, changing only the name of the sovereign. This is the rule for profile busts on *semisses* and *tremisses*. In coins the sameness might be explained as due to the small size of the effigies or to the decadence of the coiners' technique; but these arguments would not account for the curious generalization of the features of the emperors in their official portraits. The same conventional masks, for one thing, can be found in portraits of far greater dimensions, as in those of two consuls of the sixth century and as in the tenth-century mosaic in S. Sophia which shows

158

159, 160

Constantine and Justinian as symmetrical figures. Yet some of the most highly *161, 162*
schematized effigies have a surprising intensity of expression, which in itself would
seem to exclude any hypothesis of awkward execution or failing technique.

One way of explaining this phenomenon of acceptance of generalized effigies
might be to attribute it to the rather rudimentary perception of the early Middle
Ages, when much of the feeling for the salient features of an individual head that
made the Hellenistic Greeks and the Romans excellent portraitists seems to have
been lost. The artists of the early Middle Ages saw, as it were, fewer things in a face
than did their predecessors in late antiquity (in a comprehensive and extensively
illustrated work entitled *Études comparatives: Le Portrait,* Wladimir de Grüneisen
chiefly stressed this simplification, which he attributed to the influence of artisans
who came from the masses and to poorly defined "Oriental influences" that tended
to "simplify" the classical portrait; this simplification is considered a negative trait,
a sign of graphic impoverishment and decadence). To be sure, we must not under-
estimate the part played by the artisan-executants of the early Middle Ages (we
know, by the way, mostly reproductions of original portraits on coins, mosaics, or
objects such as liturgical vases). But I think that the principal reason for the generic
or typological character of portraits of this kind must be sought elsewhere.

Just as ceremonies and rites replaced spontaneous action at the Imperial palace
and, in official life from the third century on, the physical person of the prince gave
way to the august bearer of supreme power, so the image, when it is of the emperor
or a dignitary, aimed primarily at a representation of the sovereign, "count," or
silentarius that is recognizable not so much by his personal traits as by his insignia,
his posture, his ritual gesture. And as protocol forbade freedom of movement to
the prince and the dignitaries who surrounded him and insisted on perfect immobil-
ity of countenance, the art of portraiture, in attempting to represent this way of
conceiving the appearance of certain privileged human beings, devised an appro-
priate plastic formula. To make identification possible, the image-maker thus
limited himself to indicating what would permit recognition of the bearer of
authority: a few features of the face, including a small number of prominent traits
(such as the shape of the beard), hardly going beyond what one can find in a quick
sketch or in a child's drawing. To this was added the inscription of the name of the
person portrayed; and, finally, special care was taken in the representation of the
symbols and the conventional accessories of that person.

One might say, in summary, that the emperor, for instance, does not exist, or
hardly exists, as a theme of portraiture apart from his rank and his public functions,
aspects which are at the same time social and mystical. The first task of the portraitist
is to make the effigy convey the idea that the person portrayed is the real basileus,
consul, dignitary, or bishop by showing in the portrait that he possesses all the

essential characteristics: he has noble and grave features and a majestic mien, he makes the correct gesture, he holds in his hand the insignia or he wears the clothes appropriate to his social situation. We are tempted to say, when we see, for instance, an image of St. Theodore as a soldier, that it is an image of a Byzantine soldier which resembles other portrayals of Byzantine soldiers. But what we should say is that it is an image of St. Theodore defined iconographically as a Byzantine soldier.

I hope that the preceding pages, devoted to what I have called the typology of the portrait at the end of antiquity, will be helpful in examining specific examples of Paleo-Christian portraits of this period. I have said before that typological procedures apply not only to the portrait itself but also and perhaps especially to all that has to do with the way the portrait is presented at this period. The typical formulas for this outward presentation are at the basis of the classification of Paleo-Christian portraits in the following pages.

It is hardly necessary to mention that for the Christians of late antiquity the portrait constituted a problem of great moral import, for, more than any other image, it could be suspected of exposing Christians to the dangers of idolatry. The problem of the utility, even of the legitimacy, of Christian images was posed in particularly acute form by portraits of Christ, the apostles, or the saints. The historian should not forget this in considering these portraits.

The history of Christian portraiture begins with a few literary testimonies concerning very early portraits which have since disappeared. The first evidence occurs in the apocryphal Acts of the apostle John. It is a Greek text attributed by philologists to the second century and to Asia Minor. The account begins with a very vivid description of the circumstances in which a portrait of John was executed.

John had a disciple, Lycomedes. This disciple invited a friend, a painter, to the house, asking him to make a portrait of John, without John's knowledge (sec. 26). The painter worked two days. The first day was devoted to a sketch; on the second day the painter colored it and gave his work to Lycomedes, who received it joyfully. He took the portrait, put it in his bedroom, and crowned it with flowers.

Later, John noticed that Lycomedes frequently retired to this room, and he asked him: "My beloved child, what is it that thou always doest when thou comest in from the bath into thy bedchamber alone? Do not I pray with thee and the rest of the brethren? [meaning: you need not withdraw alone for prayer] or is there something thou art hiding from us?" Saying this in a rather playful way, John accompanied Lycomedes to his bedchamber and saw there the portrait of an elderly man, which was crowned with garlands, and had candles and an altar set before it.

The apostle called him and said: "Lycomedes, what meanest thou by this matter of the portrait? can it be one of thy gods that is painted here? for I see that

thou art still living in heathen fashion." Lycomedes replied: "My only God is he who raised me up from death with my wife: but if, next to that God, it be right that the men who have benefited us should be called gods—it is thou, father, whom I have had painted in that portrait, whom I crown and love and reverence as having become my good guide" (sec. 27).

Then John, who had never before seen his own face, said: "Thou mockest me, child: am I like that [like the portrait] in form, ⟨excelling⟩ thy Lord? how canst thou persuade me that the portrait is like me?" Then Lycomedes brought John a mirror, and when John saw himself in the mirror and looked at the painting, he said: "As the Lord Jesus Christ liveth, the portrait is like me: yet not like me, child, but like my fleshly image; for if this painter, who hath imitated this my face, desireth to draw me in a portrait, he will be at a loss, ⟨*needing more than*⟩ the colours that are now given to thee, and boards . . . and the position of my shape, and old age and youth and all things that are seen with the eye (sec. 28).

"But do thou become for me a good painter, Lycomedes. Thou hast colours which he giveth thee through me, who painteth all of us for himself, even Jesus, who knoweth the shapes and appearances and postures and types of our souls. But this that thou hast now done is childish and imperfect: thou hast drawn a dead likeness of the dead" (sec. 29).

The apostle John, it would seem, was not very sympathetic toward the art of portrait painting. At least this is what the second-century account affirms. But it is all the more interesting to find in the account testimony as to a portrait of St. John made from life, although without the subject's knowledge. And it is no less interesting to read that one of the apostle's disciples, who considered himself a Christian, found it natural to possess a portrait of his master and even to make of it the object of a cult of veneration which, according to this account, was practiced with images of benefactors by those who owed them gratitude.

The second text that refers to a Christian portrait of evangelical times is concerned with a portrait of Christ himself, and this time a sculptured one. The text is of later date—from the middle of the fourth century—but it is equally worthy of consideration. First, because its author, Eusebius, depended heavily on earlier sources, and because the statue in question must have been personally known to him, since it was not far from his home; and second, because his manner of explaining or justifying the presence of this Christian portrait is almost word for word the same as the explanation given by the apocryphon of the second century to excuse the man who made the portrait of the apostle John: that is, that it was the portrait of a benefactor, in accordance with a usage retained by Christians who came from among the ranks of the pagans.

Eusebius (*Historiae ecclesiasticae* VII xviii; cf. Migne, *PG*, XX, 680) describes

a sculptured group erected in the Palestinian town of Paneas and considered to be a representation of Christ curing the Haemorrhoissa. Opposite the kneeling woman was the upright image of a man, and Eusebius adds: "They say that the statue is a portrait of Jesus" (εἰκόνα τοῦ Ἰησοῦ φέρειν). And he continues: "Nor is it strange that those of the Gentiles (τοὺς πάλαι ἐξ ἐθνῶν εὐεργετηθέντας) who, of old, were benefited by our Saviour, should have done such things [that is, erected statues], since we have learned also that the likenesses of his apostles Paul and Peter, and of Christ himself, are preserved in paintings (τὰς εἰκόνας ... διὰ χρωμάτων ἐν γραφαῖς σωζομένας ἱστορήσαμεν), the ancients being accustomed, as it is likely, according to a habit of the Gentiles, to pay this kind of honor indiscriminately to those regarded by them as deliverers" (οἵα σωτῆρας ἐθνικῇ συνηθείᾳ παρ' ἑαυτοῖς τοῦτον τιμᾶν εἰωθότων τὸν τρόπον).

Let us now turn to the consideration of a group of the first Christian portraits that have been preserved. These are the portraits of apostles, and we will consider them first because the small series of them begins, if not in the second century as has been affirmed, at least in the third; it extends into the fourth century. We will go no farther. I am thinking of the very early images of the apostles Peter and Paul grouped together on certain bronze medallions, most of them found in Rome.

However astonishing it may seem, these images appear at a period which has left us no equivalent images of Christ. Is this a matter of chance? Or is it, rather, that the monuments that have been preserved testify to the actuality? In the latter event the monuments would be of considerable moment (corresponding to a first blaze of Christian portraiture, afterward extinguished, they would be comparable to written testimony on Christian portraits from the beginning of our era).

So far as the medallions with effigies of Peter and Paul together are concerned, they must have had the same function as other Roman medals of the kind (that is, medallions that are not coins). Being commemorative, they must have been distributed or sold to Christians who venerated the memory of Peter and Paul, exactly as Lycomedes, the disciple of the apostle John, venerated his master in the apocryphal text. His veneration led Lycomedes to order a portrait of the apostle John, whereas in Rome in the third and fourth centuries the faithful could contemplate the features of the apostles Peter and Paul at less expense by procuring one of these medallions which showed them together, in profile (the heads only), facing each other.

It might be thought that analogous pieces ought to have been found with the image of Jesus. But there are none, and I think that the text of the apocryphal Acts of St. John indicates that we ought not to expect it at this period. The text made this very plain distinction: Lycomedes' painting is not an image of God, but an image of a disciple of Christ, who is the master venerated by its owner. The portrait that Lycomedes has had made and that he venerates, in the manner of the time, with

candles, altar, and crown of flowers is the image of his master, the apostle, who is a man. It can very well be supposed that the medallions with effigies of Peter and Paul reflect a similar idea that goes back to a period in which an effigy of Christ (a portrait, as distinct from a figure in an evangelical scene) would have been unthinkable, while, on the contrary, portraits of "venerated masters" (philosophers, sages, enlightened thinkers) were normal, as was the kind of commemorative cult devoted to them.

The medallions showing the heads of the two apostles are copies of Roman medallions from the same period which show the facing profiles of two emperors or two gods or heroes (Dioscuri) in the same way. That the formula, which belongs to the medallion particularly, is identical in all three versions makes it especially clear how these Christian medallions originated; indeed they are closer to Imperial and pagan medallions than to later images of the apostles Peter and Paul. *164*

On Roman medals, one sometimes sees a symbol between the two profiles or a tiny figure which indicates by a gesture the relationship between the two persons represented. These accessory, explanatory elements have a counterpart in the series of medallions representing Peter and Paul, but only on examples that are slightly later (fourth century, or perhaps early fifth): between the apostles there appears the monogram of Christ as it was adopted at the time of Constantine. There is a parallel to this in gilded glasses decorated with the same image of these two apostles (but which date from about 400) and on certain funerary stones with engraved images, where the monogram is replaced by a crowning hand or a standing Christ who crowns the apostles. In other words, this little central motif—just as on the Roman medallions which served as models for the medallions of the apostles—characterizes the persons portrayed. It indicates, here, that they are Christians and martyred apostles. *165*
166
167

These medallions are extremely modest pieces, but I think that their testimony is of great significance, especially in view of the absence of similar pieces with an effigy of Christ. These works remind us that, during this early period, the portrait was essentially a commemorative image for Christians or for those around them and that therefore it was intended only to record physical appearance. Christians of the first generations could less easily have conceived portraits of this kind for Christ.

If portraits of the apostles had chronological priority over those of Christ and other saints (I am speaking of portrait images, which show the person apart from any scene, for Jesus appears quite early in representations of evangelical scenes), their priority vanished in the fourth century. From then on, it is the image of Christ that takes precedence, and the process reverses itself. I mean that we begin to see portraits of St. Peter (only St. Peter) that are copies of the portrait of Christ as it was then created under the influence of the imagery of the great official art. Like

168 Christ, St. Peter is shown enthroned in majesty or, rather, enthroned as a philosopher
 (as in the statue in the basilica of St. Peter). Like Christ, St. Peter is shown standing,
169 bearing the cross combined with the monogram of Christ as a Roman trophy. Like
170 Christ, St. Peter is represented as the Good Shepherd (on sarcophagi), the lamb on
 his shoulders.

 It might well be supposed, were it not for certain evidence, that the process of
creating this iconography developed in the opposite direction, that is, that in the
fourth century, as in the third, representational types were established for St. Peter
before they were used for Jesus Christ, and for the same reason—that the commem-
orative portrait was acceptable for an apostle but not for the Saviour. However,
this hypothesis will not serve for the famous monumental statue in St. Peter's or
for the bronze statuette in the Berlin Museum, and it is even less acceptable for
images of St. Peter as the Good Shepherd. In all these cases, the priority of the images
of Christ seems certain. These portraits are obviously copies of images of Christ; it
cannot be the other way around.

 On the other hand, it seems to be established that the scenes commemorating
the martyrdoms of SS. Peter and Paul on Roman sarcophagi of the fourth century
were made before the appearance of representations of the Passion of Christ. And
it is these latter that were adapted from images of the judgment of the two apostles,
and not vice versa. This necessarily presupposes the earlier existence in Rome of a
local iconography particular to SS. Peter and Paul, which would give it a priority
whose first manifestations are seen in the commemorative medallions. Not only
the portraits of the martyred apostles of Rome but also the images celebrating their
martyrdom must have been created then, that is, in the second or third century.

 The thing that seems to me as interesting as the very early invention of certain
types of images of SS. Peter and Paul, prior to images of Christ, is the close relation-
ship between images of St. Peter and Christ from the fourth century on. Moreover,
another image of St. Peter belonging to this Christian cycle of the fourth century,
one that shows him bringing forth a spring from a dry rock, is also a copy; but this
time it is the similar miracle of Moses that has been taken over and ascribed to
St. Peter (the same thing can be found in certain apocrypha). In short, the earliest
iconography of St. Peter (and, in part, of St. Paul) is very closely related to the
iconography of Christ (and in one case it utilizes a theme from the life of Moses).
This is perhaps not surprising, since St. Peter is the apostle who succeeds Christ as
the head of the earthly Church. Particularly in Rome, this iconographic closeness
is not unexpected, at least that part of it which gives certain priority to images of
Christ that show him enthroned, or as the Good Shepherd, or as bearer of the
Christian trophy.

 It is more surprising to observe that an inverse order of creation in relation to

images of Christ obtains for certain other images of St. Peter and of St. Paul in which the martyrdoms of both apostles are celebrated; for historically, and in doctrine, the passion of the disciples imitated the Passion of the Saviour, their Master. In this case, as in the case of the initial commemorative double portraits, local imagery, intended to perpetuate the memory of the martyrs of that place, must have been the origin of the iconographic interpretation. These images of the two Roman apostles correspond to a cult which venerated them as local martyrs, while those of St. Peter alone reflect an affirmation of his priority over the other apostles.

I have suggested above, more than once, why a portrait of Christ, showing him alone and apart from any scene, that is, a portrait in the usual sense of the term, might not have been included in the Christian iconographic repertory before the Peace of the Church (with the exception of the Christian portraits, possibly of the first century, recorded in the texts cited above and the effigies of Christ made by the Gnostics, etc.): it could have been avoided through fear of idolatry. A recent discovery at Ostia (hitherto unpublished) seems to raise some doubt as to this cautious attitude. For it is in fact a portrait bust of Christ which decorated the interior wall of a small building whose use is unknown. The walls of the room are covered in marquetry of multicolored marbles, and the portrait, which is a part of this decoration, is in the same technique. It is not, in other words, a painted portrait or even one in mosaic, but an imitation of a painting or a mosaic in a technique which is capable of only a summary resemblance to the model.

We might deduce from this that the model was appreciably earlier than the work found at Ostia, which in all likelihood goes back to the beginning of the fifth century. The hypothetical original thus would go back, at the latest, to the period of Theodosius I; and this conclusion does not help us at all, since it gives us no indication as to the existence of portraits of Christ at the time of the first portraits of Peter and Paul in the third century.

Physically, the head of Christ in the marquetry at Ostia (the long hair, rather abundant beard, and the general expression) is close to the Christ of the mosaic of S. Pudenziana and to one in a fresco in the catacomb of Commodilla, both Roman works of the first half of the fifth century. This is close to the period of the work at Ostia; and there is one further detail—the hand of Jesus in the gesture of benediction—which, in spite of a certain awkwardness due to the technique of marquetry, also argues in favor of this period and not of an appreciably earlier model.

This evidence would indicate that a portrait of Christ was in fact created sometime near the end of the fourth century and transposed into marquetry some decades later. Certain features of this image lead us to think that by the late fourth century, the idea must have been fairly generally held that a portrait of Christ was as acceptable as any other portrait and could be attempted by applying to Christ the current

formulas. At Ostia, the bust of Christ is given a very common rectangular frame. To show the benediction, one finger of the right hand is bent. Finally, there is an archaic detail: the bust is not shown frontally, although frontality was virtually obligatory from this period on, but the right shoulder is advanced so that Christ is made to appear before the spectator turned slightly to the right. This position, which strikes me as a rare one, at least for busts, is the only archaistic feature of the Ostia portrait. Perhaps it indicates a desire to give an air of authenticity to the portrait, but it is not enough, in itself, to prove the existence of a model earlier than the Peace of the Church.

Although we still lack a portrait of Christ alone from this early period, its characteristics emerge elsewhere. At the end of the third century there appears a composition, more common in the fourth, which can be described as a collective portrait. It appears on the walls of the catacombs, on sarcophagus façades, and then in the apses of churches built after the edicts of tolerance. It shows no action, but only Christ amid the apostles. The thirteen figures are aligned, and in the earliest and most common version they are all seated. This version shows the Master Catechist and the circle of disciples who listen. Later the rendering was slightly altered to give Christ a royal mien as the Panbasileus. Such collective portraits deserve attention. For it is in this form of collective portrait that the earliest portraits of Christ and the apostles together have come down to us. This is not surprising in view of the popularity of the group portrait in classical antiquity from Hellenistic times. Works of this genre show a group seated in a semicircle within an exedra or apse: poets, or sages, or doctors, or geometricians (*agrimensori*), or a teacher surrounded by his disciples. Such professional collective portraits were common. I will mention only a few: the earliest example and a few other little-known ones. The oldest and the most curious one was found during the excavation of Memphis. In a real exedra of a Hellenistic temple of Serapis, sages and poets are shown seated along the wall. A pavement mosaic in the apse of a villa at Apamea in Syria shows a similar group, with Socrates presiding. And a few years ago the catacombs discovered under the Via Latina revealed another similar group of sages, whom we cannot identify definitely, gathered around a body which the chief of the group (Aristotle?) touches with his stick.

Thus it was a theme of classical tradition that was taken up in the representation of the assembly of Christ and the apostles in the apse of a place of worship, as at S. Pudenziana in Rome or at S. Aquilino (adjoining S. Lorenzo) in Milan. These semicircular groupings of the seated disciples of Christ, shown in the apse, continued on into the later practice of the Church and well into medieval iconography in two parallel developments: first, it is in the apse, in the episcopal churches, that the clergy were usually seated on a semicircular bench; and, in iconography,

Byzantine images of the Pentecost and of the Councils went back again to this early formula, placing the apostles and the members of the synods on a similar semicircular *synthronos*.

The collective portrait of the apostolic college presided over by the founder of the Christian religion sometimes took on a different form, without changing its significance in the least. In certain churches of the sixth century—S. Vitale, Mt. Sinai, Cyprus—the portraits of Christ and the apostles appear again in or around the apse or the choir, presiding over the liturgical assembly, but now enclosed in individual medallions. They appear as if on shields hung against the walls. The series of thirteen *imagines clipeatae* of Christ and his disciples forming a single composition was already established in the fourth century, as on the well-known ivory casket called the Brescia lipsanotheca, where there are also two unidentified portraits. The series of medallions is a common motif in the sixth century. It is used on amulets and on certain ampullae of the Holy Land, where Christ and the apostles encircle the Cross, the symbol of the religion that they founded, or where evangelical scenes summarize in their own way the work of Christ.

Numerically, portraits in the form of the *imago clipeata* probably take first place in the vast domain of Christian portrait iconography. Their antecedents in Roman art and, earlier, in classical Greek art are well known. In origin, the *imago clipeata* is a funerary portrait and was still common as such in pagan art at the time of the beginnings of Christian imagery. There are innumerable examples on Roman sarcophagi, with one or two portraits enclosed within a circular disk or a shell. On Roman steles, in the tombs, whole families are thus represented within the same circular disk. On Christian sarcophagi, the formula is reproduced unchanged, as, for example, on the tomb of St. Prosdocimus at Padua (sixth century); while a vault mosaic of the martyrium chapel of S. Vittore adjoining S. Ambrogio in Milan uses it again for a triumphal portrait.

The Romans sometimes used *imagines clipeatae* to represent the holders of particular administrative titles, as was demonstrated in an office excavated at Dura on the Euphrates. Placed one next to the other on the ceiling, these medallions form a sort of gallery of portraits. The Christians continued the practice for emperors, empresses, and consuls (on ivory consular diptychs) and extended it to bishops, who, considered as high functionaries of the Empire, had the right to official portraits. This explains, among other things, why images of bishops occasionally suffered the traditional consequences of the *damnatio memoriae* that was imposed on heretics.

While the originals of the portraits of bishops were probably kept at the bishops' palaces, copies of them were sometimes reproduced on the walls of basilicas. Thus whole galleries of popes are shown as *imagines clipeatae* in Rome, at

175

176

177

178

179
180

181

182

S. Crisogono and at S. Paolo fuori le Mura (now in the museum of the monastery). But all the portraits of bishops that were kept in the bishops' palaces were not necessarily in the form of *imagines clipeatae*, it should be remembered. This is confirmed by what we know of the portraits of popes. At Ravenna and Milan full-length portraits of bishops must also have been made, for copies of portraits of bishops, depicted as standing figures, are represented in the apse decoration of S. Apollinare in Classe at Ravenna and in the fifth-century chapel of S. Vittore off the *chevet* of S. Ambrogio in Milan.

183

184

To judge from medieval Byzantine copies of bishops' portraits, the Greeks seem to have made use of all three common formulas of the ancient portrait: the standing, full-length portrait, the bust enclosed in a clipeus, and the bust in a rectangular frame. This last type is represented by several early examples: an icon on wood of St. Basil at Mt. Sinai, a Coptic painting on wood, and another icon of a bishop in the Berlin Museum. Some of the copies of bishops' portraits preserve the individualized traits of the originals. The most remarkable is certainly the mosaic portrait of St. Ambrose on the wall of the chapel of S. Vittore. Another example the original of which must have been excellent, and in which the individuality of the subject must have been forcefully brought out, is the portrait of St. Basil the Great which is preserved in two good copies, in an icon on wood, possibly of the seventh century, at Mt. Sinai, mentioned above, and in a painting of the ninth century on a wall of S. Maria Antiqua in Rome. These examples give us an idea how such portraits were transmitted—from the originals, which were easel paintings, to the copies reproduced on the walls of churches.

185, 186

187

There is one fundamental difference, a difference of principle, between all these portraits of bishops—whether saints or no, whether shown alone or in groups, full-length or as busts, within round or rectangular frames—and the series of *imagines clipeatae* enclosing busts of Christ and the apostles. The portraits of bishops go back (or purport to) to images taken directly from life, whereas the portraits of Christ and the apostles go back to a conventional genre of collective portraits, of which we have noted some early examples. This does not, of course, exclude the possibility that individual characterizations of the apostles were sometimes attempted, as they were for the bishops in the galleries of *imagines clipeatae*.

Another type of portrait that is frequent in Christian art at this period shows the subject standing, facing front, with his two arms raised symmetrically. Because this was the gesture of prayer, it was used first in allegorical figures. In the orant portrait, which is thus derived from a symbol, the person portrayed is shown without entire divorcement from action, since he is praying. To show someone in this manner was to offer evidence of his piety—hence the frequency of portraits of saints as orants, from the martyrs to the Virgin, interceding for man. In a general

way, the origin of the image of the orant in symbolism explains the ease with which the Christians endowed it anew with symbolic significance in portraits showing the subject as an orant. Thus, in the case of the Mother of God, the same gesture of the orant took on several symbolic interpretations having to do with the mystery of the Incarnation (by means of a specific iconography of the Annunciation and the Ascension), which made Mary the intercessor par excellence for man and also an image of the Church. We will return to such images of the Mother of God later.

The history of this type of portrait, which I will call the orant portrait, is particularly interesting to the historian because, by exceptional good fortune, art historians are familiar with several stages of its evolution and can see the same iconographic formula with different meanings. It is one of those very rare cases where historians can witness the successive adaptations of a single iconographic term, in a process certainly analogous to semantic changes in the history of languages.

According to T. Klauser, at the beginning there is the orant symbol, as it was known in the art of Imperial times, representing piety (*pietas*, εὐσέβεια). As we saw it (pp. 11–12), it is the orant *pietas* that figures on so many sarcophagi of the third century, some pagan, some Christian, where it is the counterpart of the shepherd carrying the lamb (at first, *humanitas*, or φιλανθρωπία, then the Christian and gnostic Good Shepherd). But the personification of piety soon became the symbolic image of the deceased (to show that he was pious), and on several sarcophagi the portraitlike features of the orants are very marked (for example, in the Lateran, the orant surrounded by doves). The same evolution, from symbol of *188* piety to portrait of the pious man, can be observed in the paintings of the catacombs. There also the orant portrait developed marked individual traits, with carefully rendered details of costume, as in two orant portraits of young girls, in the catacomb of Thraso and Saturninus in Rome and at Antinoë. In a third stage of the same *189, 190* evolution the simple Christian—whether deceased or living—is no longer represented as an orant, but the iconographic type is retained for portraits of saints, preferably martyrs. At Rome in the fourth century, it is thus that St. Agnes was *191* represented in the ancient subterranean confessional at the church of S. Agnese fuori le Mura and an anonymous martyr at SS. Giovanni e Paolo. At Salonika, in the fifth century, in the church of St. George several martyrs make the same gesture, *192* and the patron saint of the church of St. Demetrius, also in Salonika, repeats it in *193* his turn. Many other portraits of saints composed in late antiquity adopt the same formula: it is a specifically Christian type of ancient portrait.

This type of portrait, where the portrayal does not divorce the subject from action (since he is praying), comes from a symbol, as has been said. This derivation doubtless explains the ease with which the Christian orant portrait again became symbolic when it was used to show the sanctity of the person to whom it attributed

the pious gesture and especially when it was used for various images of the Mother of God.

Let us look at a few well-known examples of the image of Mary as orant in ancient art and consider the symbolic value that was attributed to them through the medium of a certain theological interpretation of the Annunciation and the Ascension and of the role that the Virgin played in these events. For instance, in a fourth-century fresco in the catacombs of the Cimitero Maggiore in Rome, the mother shown praying with her child in front of her may be the orant Mary with the divine Child placed before her. Two other figures in the same *arcosolium* make the same gesture as the mother. The Virgin's piety is shown by her gesture, that of the ancient *pietas*, which here repeats a sign she had already made at the Annunciation, when she submitted to the will of God and accepted her role as the instrument of the Incarnation.

194 Mary makes the same gesture during the Ascension. Like the angels, who promise the return of Christ to the apostles who are present, Mary testifies to this second advent by making the same gesture that, at the Annunciation, she used to indicate his first coming. However, in scenes of the Ascension, where historically she ought not to appear, the orant Mary is at the same time herself and a symbol of the Church on earth, as she is also in the images, more abstract in meaning and dating from the fifth and sixth centuries, that appear on an ampulla from Jerusalem *195* now at Bobbio and on a carved panel of the door of S. Sabina in Rome. In Ascension scenes Mary's gesture of prayer signifies the Incarnation and the Redemption, of which she is the instrument (and thus recalls her gesture during the Annunciation), while at the same time it symbolizes the function of the Church, which is to assure perpetual prayer to God. A manuscript from Trier, the Egbert Psalter at Cividale del Friuli (Museo Archeologico, no. CXXXVI), presenting a virtual portrait gallery of bishops, shows the subjects in the same posture of the orant and certainly for the same reason—assurance of perpetual prayer to God.

The orant portrait has led us to a consideration of certain images of the Virgin. Let us now look at some other portraits of the Mother of God and some of Christ, which we have not heretofore considered because they did not occupy the central position in the Christian iconography of late antiquity that we might expect them to have held at this period (but that they did effectively hold in the iconography of the Middle Ages). We will see that portraits of Christ and the Virgin, when they are found in early Christian art as representations of individuals, that is, as portraits (not as representations of the protagonists of a historical scene), are always rendered by means of typological formulas in common use at the time, and are not intended to be taken for direct and spontaneous likenesses. We have already seen images of Christ in the apostolic college, patterned after groups of sages or members of a

profession. We will see him again in other Christian adaptations of established iconographic types, and this means that these portraits of Jesus were meant to show him from some particular point of view, that is, they were meant to bring out some aspect of his personality (and not simply his physical appearance, as in an ordinary portrait). When he is seated among the apostles, the image of the sage teaching is presented; in another conception, it is the universal sovereign enthroned in majesty and receiving the homage of his subjects; or else he directs, from his place in heaven, the Christian prince who is his lieutenant on earth and secures the victory to him. In other words, these are all images in which once again the meaning of an action or an activity is concealed. They are functional or dramatic portraits conceived according to established types.

The Virgin Mary herself is the subject of equally functional and typological portraits, with this difference from the typological and functional portraits of Christ: that what serves to define Mary, in her relationship to God and to men, is the exceptional character of the ties that bind her to Christ. The typology of functional portraits of the Virgin derives entirely from this relationship to Christ.

The formulas for typological portraits of Christ and the Virgin do not come from the usual portraits of private persons, whether made during life or after death for funerary use. For Christ and the Virgin, the portrait formulas are derived from the official effigies of the sovereigns (*sacrae imagines*) and occasionally of the consuls. Such borrowings must have been practiced from the time of the triumph of Christianity, in the fourth century, when images of the official art of the Empire probably ceased to offend those who were formerly persecuted by the Roman state. The process may even have begun somewhat earlier than this, not so much as a direct imitation of Imperial Roman art but through the agency of certain iconographic clichés that referred in a general way to the ideas of sovereignty, victory, power, tribunal, or to the relationship between the sovereign and the dignitaries of his court. However, the earliest portraits of Christ and of Mary that one can include within this group do not antedate the fifth century, and I think that it was in fact in the reign of Theodosius II that they originated or, at least, came into wider use.

To explain why Christians used as portrait models the *sacrae imagines* of the Roman monarchy, few of which have survived, we must first of all look at comparable works, the consular diptychs of the early sixth century. The diptychs were made at Rome and at Constantinople by order of the consuls, whose term of office began on the first of January each year and who announced the appointment officially by means of a text held between two plaquettes of bronze or ivory. On these tablets the consul is represented in his official seat in the loggia at the Circus, presiding over the games offered for the occasion. He is seated under a canopy, over which *196* are shown the official portraits of the emperor and empress and another that is

probably his colleague, the second consul of the year. The group of portraits above the consul signifies that he receives his power from the sovereigns and shares it with the second consul.

197 An icon in encaustic, similar in shape to the consular diptychs, was recently discovered at Mt. Sinai. It is perhaps slightly later than the diptychs, but not by more than half a century. It has the same narrow, elongated form, and it retains the same elements grouped in the same manner. It is, however, a Christian icon: St. Peter with a cross-scepter takes the place of the consul, appearing against the architectural background of an exedra. Above him, in the same order as on the consular diptych, we see Christ (in place of the emperor), the Virgin (in place of the empress), and probably a second apostle, perhaps St. John (instead of the second consul). The reason for these small portraits above the large one is the same: St. Peter is an apostle and a saint only through Christ and the Virgin, and he has as a fellow disciple of Jesus this other apostle. The icon at Mt. Sinai is thus an example of an image of an apostle inspired by the iconography of the Roman state. Other very early images of the apostles, like those of Christ, reflect sometimes Imperial imagery and sometimes the iconography of the *magister*.

It is possible to establish by means of extant examples that certain portraits of Christ himself and of Mary similarly depended on official art. Here the models are to be sought among the sacred images of the sovereigns themselves, and on the whole the demonstration can be made in a fairly convincing manner. But it is less easily manageable than with the consular diptychs because the number of official effigies of emperors and empresses that have come down to us is minute, and comparisons can therefore be made only through the use of incomplete scraps of evidence. Here I can give only a few examples, without claiming to prove the correspondences point by point. Everyone accepts the broad fact that those who created images of the majesty of Christ and of the Virgin borrowed from the official imagery of the Empire. We will therefore attempt only to view the question in the light of our present problem, the study of early Christian portraiture.

At the point of departure there is in the Lateran the famous icon of Christ, called the Acheiropoetos, which is a painting on wood with a sliding wooden cover decorated with a cross. The portrait of Christ was protected by this sliding cover just as relics and manuscripts were protected in the early Middle Ages. The painting, which is almost effaced, shows Christ enthroned as sovereign (in majesty). It dates from the sixth century, and it has the same long, narrow shape as the consular diptychs. The similarity can be explained by the fact that the portraits of emperors which must have inspired the maker of this portrait of Christ had the same shape as the diptychs, which in this respect imitated them. This relationship of the consular diptychs to the Imperial portraits can be deduced from the images of the reigning

Roman emperors depicted in the *Notitia dignitatum*, a well-known compilation of the fourth century; for these images have the same shape as the consular diptychs and the icon of the majesty of Christ that has just been mentioned.

As to the Imperial portrait itself, in this book of the *Notitia dignitatum* it adopts *198* not the formula of the sovereign enthroned in majesty but that of the effigy of the prince, cut at the level of the neck or shoulders, as on the coins or that of the consuls, shown at waist length, on numerous ivory diptychs. So far as I know, no portrait *199* of an emperor enthroned accompanied by his dignitaries has been preserved except in Byzantine copies of the Middle Ages. But the formula of Majesty (the sovereign *200* enthroned) must also have existed for official portraits at the same time as the formula for the type depicted in the *Notitia dignitatum*. Two kinds of evidence suggest it. On the one hand, there are ivories of the requisite shape which show the empress standing or enthroned (the latter in the Antiken-Sammlung in Vienna). *201* The portrait is as official as possible, in the costume and the insignia of power, and a symbolic canopy is raised above the princess as it is above the consuls on their diptychs. The other group of monuments shows emperors enthroned in majesty, but they are not, properly speaking, *sacrae imagines* of the sovereign but copies of these images adapted to objects of various kinds. For example, at the top of a fifth-century consular diptych at Halberstadt, there are two coregnant emperors seated *202* on a single throne and, beside them, personifications of the two Romes and members of the emperors' guard. The emperor enthroned in majesty is also found on several gold medallions of the Constantinian epoch in Vienna and in the Cabinet des Médailles in Paris, as well as on a famous silver plate in the Academy of History in Madrid: these works not only show the sovereign enthroned but also include the coregnant emperors (the sovereign's sons) and the members of the guard. Finally, the canopy reappears in all of these works and gradually takes on the semblance of a monumental pediment.

In brief, despite the absence of a single example of an *imago sacra* of the emperor enthroned, it is certain that the portrait of the emperor seated in majesty surrounded by his attendants was among the formulas used for official effigies of the Roman monarch, as well as for the empress, at the time of the Christian Empire. This is confirmed by another genre of consular figurations that reproduce Imperial images—for example, an ivory at Darmstadt: here the magistrate is shown seated between two lictors. *203*

It is from such official portraits that numerous portraits of Christ and the Virgin are surely derived, in particular those that show them solemnly enthroned, facing front, usually with one or more attendants at either side: angels for Mary, two apostles for Christ. These groups, which could be enlarged to include other saints, underlie the "holy conversations" of the Italian painters of the Middle Ages and the Renaissance.

A few examples of portraits of Christ and the Virgin, most of them very well known, can be mentioned:

For Christ enthroned, the mosaic of the triumphal arch of S. Maria Maggiore, where the Child Jesus is receiving the offerings of the Magi; the apsidal mosaic of S. Vitale at Ravenna; two frescoes (fourth to fifth century) in the catacombs of Domitilla and Commodilla, each showing Christ enthroned among the apostles; at Rome, Milan, Ravenna, and elsewhere a number of Paleo-Christian sarcophagi (fourth to fifth century), where Christ is seated among the apostles; the ivory "diptych in five compartments" (sixth century) where, in the center of the left wing, Jesus is enthroned between the two chief apostles.

204

For the Virgin enthroned, there are the mosaic (sixth century) in the church of St. Demetrius at Salonika; the now famous icons on wood (sixth to eighth century), one at Mt. Sinai and the other in S. Maria in Trastevere in Rome; several ampullae from the Holy Land; and once again, in the center of the right wing, the diptych in five compartments mentioned above. The Virgin is consistently shown frontally, generally with two angels for attendants but sometimes with saints.

III

205

The diptychs in five compartments (possibly originally covers for Gospels) show portraits of Christ or the Virgin in majesty, surrounded by small narrative scenes. A triumphal composition, with flying Victories, appears in the upper part of the leaf. There is some reason to suppose that in the official art of the Roman monarchy in Christian times this formula was adapted from a model on similar ivory pieces which perhaps served as bindings for Imperial edicts; the latter show the emperor in the center with his high dignitaries and, around them, in the small compartments of the frame, scenes referring to the important deeds of the prince. It is thus very probable that the portraits of Christ or the Virgin on the covers of Gospels owed not only the central images of majesty to their Imperial models but also the rest, that is, the frame of small narrative scenes which, for Jesus and Mary, are taken from evangelical history, canonical or apocryphal: biographical images for the Virgin and images of miracles—the "great deeds" of Jesus—for Christ.

In other words, it can be established that one of the most common types of images of Christ and Mary which functioned as portraits, that is, the large group that shows them in majesty, was formed in the same manner that was noted for the types of portraits already considered: by adapting common portrait formulas of the period to Christian subjects. In the representations of Christ and the Virgin in majesty—which include several series of images—the formulas were furnished by the official imagery of the Roman state.

For other types of portraits of Christ and the saints, one can equally well find Roman models and recognize analogous processes at work in their assimilation into Christian iconography. Thus, for instance, the Christians adopted the fashion

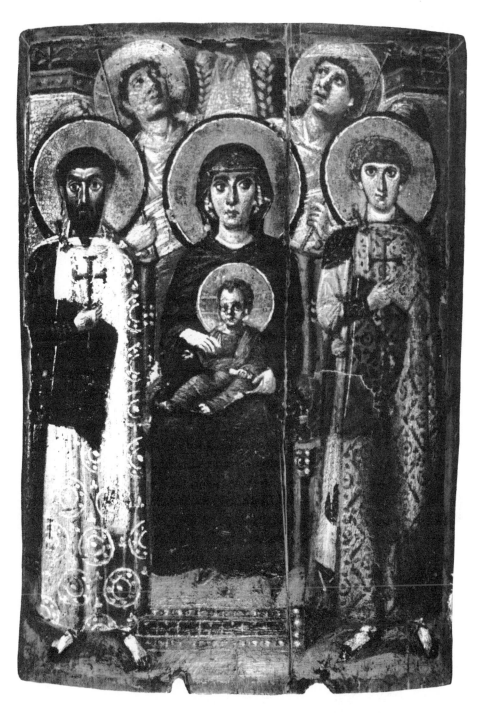

III The Virgin and Child with saints. Icon on wood, Mt. Sinai [80]

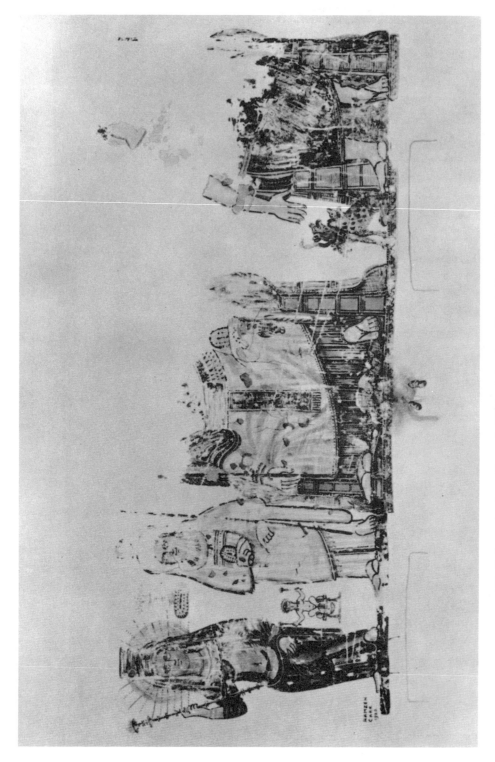

IV Enthroned and standing gods. Wall painting from Karanis, Egypt. Kelsey Museum of Archaeology, University of Michigan (copy) [82]

(which must go back to the time of the first books presented in codex) of using a portrait of the author as the frontispiece for a manuscript. This practice is first known to us in the works of several pagan authors. Then we see it inspiring the editors of Christian books—from the sixth century, at the latest—and the Christians were even familiar with the two versions that we find used for pagan authors: the bust portrait of the author presented as an *imago clipeata* and the portrait of the author seated at his desk, writing or meditating on his work.

206

207, 208

In taking over an established iconographic tradition, the Christians, as has been said, were continuously adapting for their own particular needs the models before them. But they also did exactly the opposite, and adapted their specifically Christian subjects to formulas of representation in current use. Thus the silversmiths who made the ampullae of the Holy Land at the end of the sixth century reworked the descriptive iconographic scheme of the Adoration of the Magi and the Shepherds, to make it into an image of Majesty. It is a Virgin Empress that one finds, surprisingly, seated on an immense throne in the center of the composition, while two symmetrical groups of persons—Magi and shepherds—bow before the princess. This reversal in the adaptation process must have been a common one, favored by the very powerful monarchical influences at work in the Christian Empire. But images of this kind are no longer portraits as such. They demonstrate the integration of the portrait genre into narrative and dramatic scenes. This is another subject.

209

Certain procedures of the Christian image-makers, in particular that of forming Christian portraits or pseudo portraits on the basis of established formulas, have obvious analogies in the iconographic practices of other religious communities of the first centuries of our era. Up to this point, we have considered only Christian portraits derived from profane portraits, among which I have included the official images of the magistrates of the Empire. But the religious iconography of other faiths that flourished in the bosom of the Empire at the time of the beginnings of Christianity, a little before Christian art sprang into being, seems to have followed similar paths of creation. Limiting the subject to portraits, or works which can reasonably be included among them, we may recall first of all the representations of Zeus or Jupiter enthroned, shown frontally, as the sovereign of heaven and earth. This iconographic theme is, of course, much earlier than the art of the Hellenistic and Roman monarchies. But the version of it that was composed at the end of antiquity (for example, in the illustrated Virgil of the sixth century in the Vatican) indicates direct imitation of the majesties of the Roman emperor. And the illustrators of the sixth-century manuscript of the *Iliad* in the Ambrosiana in Milan show a group of gods or military chiefs seated on a curved bench, employing the very same formula mentioned above for Christian collective portraits.

210

211

Figurations of sovereignty multiplied at this period, and we see the formula applied to Dionysus, Isis, Ariadne, or Venus. These deities appear in images that depict them as kings and queens in majesty. Their coronation is represented in the mosaic of Venus-Ariadne from Carthage. And in a mosaic from Antioch (Daphne) Dionysus-Bacchus appears as a victor, surrounded by beasts taken in the chase as if they were vanquished enemies. The popularity of such images is surely related to the growth of monarchy in the Hellenistic kingdoms and then at Rome. It must also have been as a reflection of the iconography of the Hellenistic kings that the image of David in majesty, as the ideal king of Israel, was created, such as appears in a fresco of the synagogue of Dura, where the central panel is reserved for it (among all the symbolical and historical scenes united there). The painter shows frontally the king enthroned, with acolytes on either side and dignitaries flanking him. Here, too, we can surmise the existence of models taken from the art of the Hellenistic courts, perhaps from the neighboring court of the rulers of Osroene, those Abgars who had their capital at Edessa and who were first Jews, then Christians.

In Syria and Egypt, still in Imperial times, those who worshiped local gods made something like icons, painted on the walls of buildings or traced on thin wooden panels in triptych form, which can be compared to the small tabernacles of the *lararia* of Roman houses. On these "icons," the gods appear once more as enthroned princes surrounded by other less important gods who are lined up at the sides or who approach them, exactly as in the Imperial and Christian images of majesty that we have just seen. Two frescoes of the second century, from Karanis, in Egypt, can serve as examples: one shows Harpocrates enthroned, and the other an indistinct divinity between other gods. Copies of these interesting paintings, rarely cited, are at present in the Kelsey Museum of Archaeology at the University of Michigan. They come from excavations undertaken by the University in the twenties of this century. Another example of "icons" of local deities is the central portion and one leaf of a wooden triptych, in the Berlin Museum, with painted images of Palmyrene gods.

Such "icons" are forerunners of medieval Christian triptychs on the order of the tenth-century Byzantine ivory in the Louvre called the Harbaville triptych. At Mt. Sinai, some leaves of similar triptychs have recently been discovered, but they are of wood and date from the seventh or eighth century. They show superposed images of various saints (this use of superposed secondary images had already appeared on the leaves of pagan triptychs in Syria). The Mt. Sinai pieces give us an idea of the intermediaries between the pagan triptychs and those of Christian art in the Middle Ages.

Finally, there are pagan "icons" where the portrait of the divinity occupies the center of the field and episodes of his life or his deeds fill the surrounding frame. They

212
213
214
IV
215
216
217

are often found in ancient Mithraea, either in the form of mural paintings, as in the Mithraeum of Dura or in that of the church of S. Prisca in Rome, or on sculptured slabs where the "portrait" of Mithras is surrounded by scenes from his "life." The most beautiful ancient example of this last type of composition is a relief in the Museo Nazionale, Naples, showing Hercules and Omphale framed by a series of little scenes of the labors of Hercules.

218

 There is no question but that this iconographic formula served as a model for innumerable Greek icons of the Middle Ages (the treasure of the monastery of Vatopedi on Mt. Athos contains one example, among others, showing a Crucifixion framed by evangelical scenes, dating from the twelfth century). Even earlier (in the sixth century) the same arrangement appears on the diptychs in five compartments that I assume to have been used in the binding of Gospels. Here, it will be recalled, it is Christ or the Virgin who occupies the central place, with scenes of their "history" shown on the "frame."

Very little is known about how the Christians of the early period felt about portraits or how they responded to portraits of any kind and, in particular, to those portraits of saints which played such a considerable part in the Christian iconographic repertory. Two or three facts are worthy of mention; although they tell us little of the effective forms of a cult of this kind, they allow us to establish some dates and some chronological zones.

 I think I was the first to point out that evidence as to a cult devoted to Christian images, starting with representations of Christ, begins to multiply from the second half of the sixth century on (*Martyrium*, II, 1946). This is one point that is now settled, especially since the publication of Ernst Kitzinger's collection of a large number of contemporary texts which speak of images of Christ and the saints and of the cult that arose around them. But it would be incorrect to deduce from this that the Cult of the Christian portrait began as late as the second half of the sixth century; this is what I wish to emphasize here.

 The texts that I will cite are not unfamiliar ones. But it is important to remember that most of them are contemporary with each other and that they belong to the end of the fourth and the beginning of the fifth century. Here they are:

 (1) The well-known phrase of St. Augustine affirming that many persons reverence sepulchers and paintings: *novi multos esse sepulcrorum et picturarum adorates* (*De moribus ecclesiae catholicae . . .* I xxxiv 75, in Migne, *PL*, XXXII, 1342). The text does not specify to which paintings he refers, but the juxtaposition of sepulchers and paintings suggests that they may be funerary portraits.

 (2) During this period, at Antioch, St. John Chrysostom mentions the eagerness of his Christian compatriots to produce increasing numbers of portraits of the

bishop St. Meletius: they attached religious significance to these images (*Homilia encomiastica in S. Patrem nostrum Meletium* . . . , in Migne, *PG*, L, 516).

(3) From Antioch, too, comes the custom, repeated at Rome, of placing images of St. Simeon Stylites in shops, for prophylactic reasons (Theodoret, *Religiosa historia* xxvi, in Migne, *PG*, LXXXII, 1463 ff.).

(4) Later, and therefore somewhat less reliable, texts tell us that the famous icon of the Theotokos with the Child, called the Hodegetria, which for centuries was to be almost a palladium of the Eastern Empire, was sent to Constantinople to the sister of Theodosius II (408–50), Pulcheria, by the sovereign's wife, Athenais Eudocia, from the Holy Land, where she discovered it. This painting, which passed for a portrait taken from life by the evangelist St. Luke, was considered by the Byzantines to be an authentic portrait. From the time of its arrival in the capital it was the object of a cult, since Pulcheria placed it in a church (or oratory) that she had built for it. This was in the first half of the fifth century, probably in the years following the Council of Ephesus, which proclaimed Mary the Mother of God, thus favoring all the various cults of the Virgin. The cult of these icon portraits could have been established or could have become widespread at that time, perhaps before the cult of the portrait images of Christ (texts of the second half of the sixth and of the early seventh century, which were mentioned on page 83, deal particularly with portraits of Christ).

Briefly, then, by about the year 400 or in the first decades of the fifth century, to some extent a cult of portraits of the saints, including the Virgin, existed in different cities or sections of the Christian Empire. The evidence, although it is inadequate (as to the form of cult or how widespread it was), takes us back to a period that is a good deal earlier—by two centuries or so—than the second half of the sixth century.

We can go back even farther. Speaking of Christian origins, Eusebius, as we have seen (see above, p. 68), affirmed that portraits of Christ himself and of his apostles had been made during their lifetimes and venerated by their contemporaries. It is, of course, possible to set this evidence aside as being late and to ignore it as an anachronism. But this negative attitude seems to me to be out of place, because, so far as we know, portraits of Christ and the apostles were neither common nor particularly venerated in Eusebius' time. It would therefore be wrong to see in his text a reflection of the state of affairs that he himself knew from what he observed around him and all the more so since he was personally a declared adversary of any use of portraits of Christ and the saints.

We are more likely to interpret correctly the passage of Eusebius cited above if we consider it in connection with the apocryphal Acts of St. John the Evangelist that tell of the making of a portrait of this apostle and the veneration that was ac-

corded it in the house of one of his disciples (see p. 66). But it should be added that
the veneration shown it took the usual forms of the time: the portrait was placed
on a table covered with a cloth, it was crowned with flowers, and two candles and
an altar were placed before it. The apocryphon does not fail to put into St. John's
mouth a discourse in which the apostle disapproves of portraiture and forbids the
veneration of portraits and of a representation of himself. In spite of this, the fact
remains that a disciple of John, who considered himself a Christian, saw nothing
wrong in possessing a portrait of his spiritual father, the apostle, or even in devoting
to it a certain cult of veneration. The text, you will remember, is one that according
to philologists comes from Asia Minor and goes back to the second century. It is
thus acceptable evidence as to the customs of the time of the apostles.

The apocryphon and Eusebius are unanimous in attributing this use of the
portrait and its veneration to the first generation of Christians, who were accus-
tomed to reverence their benefactors by a cult devoted to their portraits. In other
words, it is certain that Christian portraits were venerated well before the end of the
sixth century. However fragmentary our information may be on this subject, it
cannot be ignored, and it suggests that the hypothesis that a Christian cult of por-
traits of Christ and the saints was born at a date as late as the sixth century is less valid
than the hypothesis that it came from an ancient custom of venerating certain
portraits, a usage that was prolonged without any real interruption among the
first Christians, albeit with greater or less reserve or enthusiasm. Our observations
on the existence of different categories of ancient sacred portraits in Paleo-Christian
art tend to confirm such continuity in the practice of the art of portraiture after it
passed into Christian hands.

It is probable that the first generations of Christians, if they possessed portraits
of Christ, the apostles, or martyrs, saw no wrong in surrounding them with
material symbols of respect in memory of the person portrayed. In doing so, they
were conforming to the usages of the social milieu to which they belonged. More
especially, it was customary at the time for the disciples of a great man, the founder
of a religious sect or of a school of philosophy, to possess and also venerate his
portrait. St. Irenaeus (*Adv. haereses* I xxiii 4, in Migne, *PG*, VII, 672 f.) and Eusebius
(Letter to Constantina, in Migne, *PG*, XX, 1545 f.) tell us so for the disciples of Simon
Magus; and we learn it also for Manes (from the same text of Eusebius and from
other testimony). It was probably later that the clergy, fearing a tendency to idol-
atry, opposed the practice and forbade not only the cult of veneration but funerary
portraits themselves. However, about 400, at the time that Christian figurative art
burst into vigorous bloom and borrowed so many of the artistic usages of the past,
this interdiction—if it was ever systematic—was definitely raised. Christian portraits
and miniatures of these portraits became frequent and were tolerated by the Doctors

of the Church. This happened at the very same time that Theodosius II forbade the pagan ancestor cult, in a prohibition which ought to have been fatal to the art of the funerary portrait. But one branch of funerary art was saved by the Church, that of portraits of the dead who were recognized saints of the Church and, by virtue of this, the legitimate objects of an authorized cult.

We have noted above that the funerary portrait of the simple mortal disappears at the end of the fourth century, while the iconographic formulas of funerary portraiture are retained exclusively for images of Christian saints. Something similar must have occurred with respect to the veneration which originally was devoted to any portrait of the deceased and which after about 400 was reserved for portraits of saints. It goes without saying that at this period the veneration of saints had a commemorative character and involved only the forms—crowns, *lumina*—that the early Christians reserved for the cult of commemorative portraits of every kind. The progress of this cult in Constantinople in the following centuries should perhaps be connected with the fact that, in the second half of the sixth century and at the beginning of the seventh, a closer relationship had been established there between the sacred images of the emperors and the images of Christ. It is then, I think, that the more exacting and religious cult, traditionally enjoyed by official portraits of the monarch, was transferred to images of Christ as sovereign and, by way of these images, to all portraits of saints. What is new at this period is not the appearance or the increase of Christian portraits, but the development of a religious, rather than purely commemorative, veneration of Christian portraits and perhaps especially of the portrait of Christ.

IV. The Historical Scene

It is sometimes said that Christianity gave a historical turn to the religious art practiced in the Roman Empire: instead of representing imaginary beings and imagined events, both inspired by mythology, the Christians represented scenes and persons recorded in their Scriptures. This statement is, of course, only half true, like all large generalizations. Early Christian iconography often limited itself to highly schematic figurations, which evoked events and persons described in the Bible but did not represent them. As we have shown, it more often produced image-signs than narrative scenes and portraits of the protagonists of religious history. But it is still true that the aim of Christian imagery from the beginning was to refer to the events of a historical past. The rest is a question of forms and processes.

These forms and processes are, however, of great importance to the historian. It is by studying them that we can arrive at a better understanding of how these Christian historical images were created, what part of them goes back to earlier models, and what part is original and properly Christian. We observed in Chapter III that Christian portraits owe a great deal to the types of portraits that were common at the time. The following pages will show that historical images also bear the imprint of traditions proper to this genre in contemporary art.

In speaking of Christian historical images, I refer to images of events drawn from the earthly life of Jesus and the biographies of the saints, as well as from the books of the Old Testament. We all know hundreds of paintings and reliefs of the Annunciation to the Virgin, or the Holy Women at the Empty Tomb, or the Pentecost, or Moses on Mt. Horeb; but we do not know how these images were created. To increase our chances of discovering how, let us take separately images appearing on objects of the same kinds; for very often an iconographic tradition attaches itself to images having the same religious function. We will begin the experiment with images that were used to illustrate manuscripts of the Scriptures, for the reason mentioned in the Preface to this part of the work: the art with which we are concerned is, after all, the art of a religion revealed in these Scriptures. Is it

not therefore likely that we should find in the manuscripts the first flowering of Christian iconography?

For late antiquity and until the ninth century, we have at our disposal only a very small number of manuscripts useful for this experiment: in particular, two manuscripts of books of the Old Testament and four of the New. In both groups, the manuscripts sometimes comprise only a part of the Old Testament or of the Gospels. The experiment must therefore proceed under scientifically inadequate conditions; but let us pursue it just the same, since we cannot do better.

For the Old Testament, there is in Vienna a sixth-century manuscript in Greek of the first Mosaic book, Genesis, and in Paris the Latin Pentateuch from Tours, once in the collection of the Earl of Ashburnham, a manuscript attributed to the eighth century, with illustrations inspired by an earlier model, probably of the sixth century. Where these manuscripts or their illustrations originated is unknown; and because of the isolation of these works, our ignorance is likely to remain. The fact that the illustrations are differently conceived in the two manuscripts emphasizes their isolation. The variance is all the more apparent if one also keeps in mind the evidence of several other manuscripts. Of these, one is today little more than a ruin: a sixth-century Bible in Greek in the British Museum, a work once in the collection of Sir Robert Cotton and so called the Cotton Bible, of which only a few more or less badly scorched images remain owing to damage by fire in the eighteenth century; another is the Syriac Old Testament (syr. 341) in the Bibliothèque Nationale in Paris. Each of these manuscripts presents not only a different series of images but even a different understanding of the role of the illustrator of the divine text.

I have no intention of describing each of these illustrations here. But it is important to observe that of three of the surviving examples of illustrated Bible manuscripts, there are two, the most important ones, which are decorated with paintings that can be called illustrations in the strictest sense of the word. These are images which attempt to give a more or less complete pictorial version of the *219–221* Biblical story and do not try to interpret it. In the Genesis in the National Library in Vienna, the placement of the images at the foot of the page permits them to *222, 223* accompany the text to which they refer. In the Ashburnham Pentateuch in Paris, the illustrations comprise several scenes, based on successive paragraphs, brought together in single compositions to which entire pages of the manuscript are devoted. *224* And to judge from the remaining fragments, the paintings of the Cotton Bible were little rectangular inserts set into the text next to the passages they illustrate. Despite the very different forms of their respective images both the Vienna Genesis and the Ashburnham Pentateuch attempt to create visual equivalents of the text and do not try to make the images a commentary on it.

One might think that this is the usual and banal thing. But this is not so. The

Cotton Bible already offers painted commentaries, such as the images of creation, where the illustrators, inspired by the exegesis of the Alexandrian theologians, show not only what was created on each day but also the personified idea of the work accomplished on each day. A personification of this kind corresponded to each day of the Creation, the image of the third day showing three of them and that of the sixth day, six. These personifications, which are not in the Biblical text, in no way modify the Biblical story itself. But through them the illustrator adds to the story an element of interpretation which corresponds to the particular commentaries of Christian theologians. It should be kept in mind that here, for the first time, we see Biblical illustrations where a factor foreign to the sacred text is interpolated by the illustrator. In the Cotton Bible, the painter did not limit himself to the inspiration of the text itself in creating his historical scenes. But I do not know whether he himself composed the images of winged personifications of the days of creation that he used or whether he borrowed them from an earlier "Platonizing" image-maker. The motif is in the tradition of Alexandrian painting of Imperial times (cf. the frescoes from Hermopolis West [Tuneh el Gebel], in Egypt). *225*

The illustrations of the two other oldest Biblical manuscripts (the Vienna Genesis, the Ashburnham Pentateuch) are entirely faithful to the text. Nothing indicates who their makers were. One can wonder whether there were not Jewish models behind the illustrations of these two Christian manuscripts. It is impossible to go further, but the following hypothesis can be suggested: there may have been several illustrated Hebrew manuscripts of the Mosaic Pentateuch and perhaps even more than one version of the illustrations. This hypothesis gets a certain support from the fact that, in contrast to the illustrations of the Old Testament manuscripts we have mentioned, the illustrations of all early gospel manuscripts decorated with miniatures are more than simply a visual, or pictorial, equivalent of the text.

Let us examine the Gospels in Greek in the Cathedral Treasury at Rossano in *226, 227* Italy. Through the initiative of the artist the paintings depart to a considerable degree from the gospel text. Except for the portraits of the Evangelists, which precede their Gospels, all the paintings are gathered at the front of the volume, separated from the text which they are supposed to illustrate. In fact, what one finds is that the illustrations are not so much images following a specific passage of Scripture as paintings that evoke the events described in the Gospels. In more than one instance traces of an iconographic intent bring an additional element to the related text. In the story of the Last Supper, for example, the scene of Christ seated *226* at the table with the apostles is followed by dual processions of the apostles to receive the bread and the wine from the hands of Christ. This composition surely comes from monumental painting and, as in wall paintings, implies a desire to recall to the spectator that this Supper of Christ and the apostles was regarded as

the foundation of the Eucharist. On another page, the exceptional emphasis on the illustration of the parable of the wise and the foolish virgins, which depicts the wise virgins in a garden of paradise, is equally removed from the simple translation of the sacred account into iconographic language: here again liturgy intrudes between the gospel text and the miniature.

227

The extant leaves of the sixth-century Gospel according to St. Matthew in the Bibliothèque Nationale in Paris, which are known as the Sinope Gospel, have this same feature in common with the Rossano Gospel—interpolations inspired by liturgy. Here, the foundation of the communion is shown as going back to the event of the multiplication of the loaves and fishes. In a group of three figures separated from the crowds camping in the grass, Christ blesses the loaves and fishes brought by Peter and Andrew, an act that is a symbol of the Eucharist.

228, 229

228

The Sinope and Rossano manuscripts both resort to the same device in order to invite the spectator to interpret the gospel scenes in the desired way. In both manuscripts, each descriptive scene is accompanied—on both sides or below—by two or four images of Old Testament prophets who point to the scene and hold out toward the spectator very large open rolls. Each prophet's prediction concerning the gospel event that is represented in the main scene is written on the roll he holds. These are early appearances of a convention that was to have long and frequent use until well into the Middle Ages. This is, in fact, the first known appearance of an iconographic device that Christian artists were commonly to employ. It is the specifically Christian variant of a typical procedure of every iconographic language, that of comparison, or the juxtaposition of likes or of opposites. (Here it is the events of the two Testaments that are brought together, but in a particular way, the Old Testament being represented only by its prophecies announcing the New.) We will come back to this procedure in connection with methods of creation in theological iconography. It appears, then, from examination of these two sixth-century Gospels that the illustrations show evidence of deliberate interpretation of the text.

229

An analogous attempt at interpretation, in another form, appears when we analyze the paintings of the Syriac Gospels of 586 (the Rabbula Gospels) in the Medicean-Laurentian Library in Florence. Here all the paintings are placed at the beginning of the volume, somewhat as in the Rossano Gospel, but with one difference: this time, the paintings are of two kinds, full-page miniatures and marginal decorations. Of the few paintings to which a full page is assigned, two are devoted to gospel scenes (the Crucifixion with the Holy Women at the Tomb of Christ, and the Ascension) and two to the Acts of the Apostles (the Pentecost and the Election of Matthias), while all the other miniatures, of which there are many, instead of filling entire pages, are painted on the margins of the canon tables. This means that the great majority of the scenes represented occur not with the corresponding

230, 231

230

231

passages of the gospel text but beside a kind of index or concordance. The system of arrangement is closely akin to that of the Rossano Gospel, where the images are separated from the text and grouped at the beginning of the book; and the resemblance extends further to the figurations of the prophets who, there too, accompany the evangelical scenes. But in the Rabbula Gospels these prophets are placed above the scenes of New Testament events, and instead of appearing with the individual scenes, they appear in a row which continues across the top of twelve pages as a "gallery" of portraits. Their presence suffices to call to mind their Messianic prophecies. The representation of the prophets with the evangelical scenes formed a commentary on the gospel text by showing that Jesus was the Messiah awaited by the prophets and that the New Testament was the fulfillment of the Old.

Another Syriac Gospel (syr. 33) in the Bibliothèque Nationale in Paris also places all the images on the margins of the canon tables, but it omits the prophets. *232* (The illustrations for a Syriac Old Testament, syr. 341, in the Bibliothèque Nationale hardly go beyond the portraits of the authors of the different books.) Four miniatures from an illustrated Armenian Gospel of the sixth or seventh century are found at the end of the Echmiadzin Gospel (Yerevan, no. 2374, formerly no. 229). *233*

There remains to be mentioned one more illustrated manuscript of the Gospels: the Gospels of St. Augustine in Corpus Christi College, Cambridge, a Latin manu- *V, 234* script going back to the sixth century. It must have been painted in Italy. Once again there is a change in the system of presenting the images, and the scheme used here occurs nowhere else. The illustrations of the Gospels correspond to specific passages, but, perhaps because of their small size, they are as laconic as the scenes depicted in the frescoes in the catacombs or the reliefs on the sarcophagi. To represent a scene, there are only one or two personages, together with a strict minimum of accessories. Once again the images are separated from the passages to which they refer, but this time they are assembled between the end of the text of one Gospel and the beginning of the next. Thus the system, in its separation of image from text, is like that of grouping the illustrations next to the canon tables, but the presentation is materially different and particularly original; for certain small scenes are superposed on either side of the portraits of the Evangelists which precede their texts, and other scenes, almost as small, are again grouped next to the end of a Gospel. These two kinds of paintings imitate two different kinds of pagan cult reliefs of Roman times, as we will see later. The Christian painter who illustrated the Gospels of Corpus Christi College did not take his reading of the sacred text for his inspiration. He knew, and imitated, a kind of image-sign commonly employed in the art of the time.

To go back to our observations on the earliest illustrated Gospels: None of them has images that are direct illustrations, such as the miniatures of the Vienna Genesis,

which occur with the text they illustrate, or such as the miniatures of the Ashburn-ham Pentateuch, which attempt to group several scenes on a page placed as close as possible to the passages of related text. In the Gospels, with only one exception (the Sinope Gospel), the images are always completely separated from the text, generally being grouped at the beginning of the work. In the Cambridge Gospels, a miniature serving as a frontispiece follows the index of chapter headings and precedes the text of a Gospel, but another miniature follows the end of the gospel text. In the Rabbula Gospels, written in Syriac, and the Syriac Gospel in Paris (syr. 33), many of the illustrations occur beside the canon tables. In the Rossano Gospel, the images are independent of the canon tables, but they also are gathered on the first pages of the manuscript and are thus comparable to an iconographic table of contents. This typical arrangement in the Gospels of the sixth century must be brought out, because it can help us to understand the function of these paintings. In the two Syriac Gospels and the Cambridge Gospels, even the appearance of the images seems to confirm likeness to a table of contents; for the images are small and abbreviated in the extreme. In somewhat the same way as the little pictures in the catacombs and the reliefs on the sarcophagi, these are signs meant to recall a certain evangelical event rather than paintings which attempt to describe it. One can imagine the reader of these manuscripts looking for a desired passage by running through the series of little marginal images on the leaves (or those grouped as on an icon at the end of each book, as in the Cambridge Gospels). It is in the similar form of very brief iconographic signs that there appear on the margins of the papyrus

235 manuscript known as the Alexandrian Chronicle (in the Pushkin Museum of Fine Arts, in Moscow), portraits and abbreviated scenes evoking events of Christian history. We are still within the category of image-signs.

The question naturally arises whether, in early manuscripts of the Gospels, we have to do with the abbreviation of more complete figurations or descriptions originally created for direct illustration of the text and then schematized and simplified for the canon tables and indexes of chapter headings, or whether it is rather a matter of figurations specially composed for this function that the surviving examples allow us to observe. In favor of the second alternative, we have, in addition to the direct evidence of the majority of early illustrated Gospels, the analogy of the images of the Roman catacombs and sarcophagi and those high on the walls of the baptistery of Dura-Europos (see above, p. 21). In other words, the evidence of all the earliest Christian images points in the same direction: the image-sign comes first. It is not until the end of the fourth century that certain very instructive cases come up, testifying to an evolution of taste that led to the substitution of descriptive paintings for the schematic images. We will return later to this evolution, in con-firmation of the suggestion that the Christian image-signs are earlier than the

V The evangelist Luke and evangelical scenes. Miniature, Gospels of St. Augustine, Corpus Christi College, Cambridge [91]

descriptive images. At least this appears to have been the rule. This means that the little image-signs that we see in the Gospels of the sixth century do not necessarily have to derive from more descriptive and complete paintings. Their function in these books, to serve as a "table of contents," is of a piece with the very general and schematic iconographic programs which were more or less the same for these manuscript illustrations, for funerary paintings, or for the adornment of a small baptistery or various small objects designed for ecclesiastical or domestic use on which religious subjects were wont to be represented. There is no reason to assume that illustrations of the books of Scripture influenced these often rapidly executed images. No image-maker needed to consult the text of the Gospels in order to make a rapid sketch of a Baptism of Christ or an Entry into Jerusalem. He composed the scenes from memory, especially when they were addressed to everyone, including the illiterate, as was the case with paintings in places of worship or on objects in everyday use. It is imagery of this kind, the most widespread sort, that, according to the celebrated statement of Pope Gregory the Great (in a private letter, about the year 600), took the place of the book for those who could not read. The pope does not say that the images to which he thus attributes an educative role were on the walls of basilicas and on objects in common use; but it goes without saying that it was not book illustrations that served for the religious instruction of the illiterate, who seldom had reason to have books in their hands.

Meanwhile, let us remember that at first glance one of the sixth-century Gospels seems to be the exception to the general rule, showing paintings that could pass for direct illustrations of the text. This single example comprises the leaves of the Sinope Gospel. At first glance, at least, these paintings are distinguished from the others in sixth-century Gospels by the fact that they are distributed on the pages of the text (instead of being grouped on leaves preceding the text) and are placed next to the passages which they evoke. But, as we have said (p. 90), several of the paintings of the *Sinopensis* are certainly not immediate translations into iconographic language of the phrases of the text. Between the text and the images, other images intervene, which take their inspiration elsewhere; and it is also because of this that we have figures of the prophets with their phylacteries at either side of the evangelical scenes.

All the characteristics of the presentation of the paintings of the *Sinopensis*— the purple parchment, paintings on the horizontal margins, prophets beside the gospel scenes—are found again in the *Rossanensis*, where, however, the images are better arranged and the prophets more happily placed, under the evangelical passages to which they refer, without going over into the side margins. In the *Sinopensis*, for lack of space, the prophets are placed in the margins, and they are disproportionately large in comparison with the personages of the gospel scenes. In the

236

Rossanensis, the prophets are placed on different registers from the gospel scenes, as, for example, at S. Apollinare Nuovo in Ravenna and in the great Roman basilicas; and this similarity to monumental art probably indicates the path to follow in order to explain the paintings in these two manuscripts. The paintings grouped at the beginning of the *Rossanensis* seem to me to reflect works created for monumental decoration and subsequently adapted to the pages of the manuscripts (cf. also p. 89). In my opinion, neither the paintings of the *Rossanensis* nor even those of the *Sinopensis* were originally created for a manuscript. It is later, and as it were *ad hoc*, that they seem to have been adapted for books and to the role of actual illustrations which they are made to play in the *Sinopensis* by being placed next to the passages of the text to which they relate.

I have said above that the evolution of Paleo-Christian painting indicates that image-signs are earlier than descriptive painting. Comparison of Roman funerary paintings of different dates in fact proves it: we begin with schematic images that are as concise as possible; the tendency then is to complete them, to render them more exact, so that toward the end of the fourth century, we arrive at figurations of persons and scenes of a descriptive or individualized character. This evolution is irreversible.

Numerous Paleo-Christian images of the orant demonstrate this evolution. The series begins with the very earliest paintings in the catacombs, at the beginning of the third century, where the orant is a semiabstract sign. It is a schema of a frontal figure, ageless and sexless, about which we know only one thing: it raises both arms symmetrically in prayer. Then, not very systematically, but progressively (if we consider a greater number of monuments, including the painted and sculptured orants on sarcophagi), the person in prayer becomes more solid, and the representation ends by becoming the funerary portrait of an individual. The traits of his face, the details of his costume, are reproduced. Somewhere about 400 perhaps, the Church takes over the formula for portraits of martyrs, probably because the gesture of the orant is appropriate to express the idea of the intercession of the saints. But in any case, the evolution of the image of the orant follows the curve that we have drawn: from sign to descriptive image.

Similar evolutionary curves are followed by certain other categories of typical images of Paleo-Christian art, for example, scenes of repast. In the beginning (third century), the scenes comprise groups of a variable number of diners without age, sex, or name, which leave us to wonder whether the scene represents a ritual repast of the Christians or whether it evokes one of those described in the Gospels. Both interpretations, significantly, may be valid; for these allusive images could signify at the same time a specific gospel event and the ritual repast which renews it litur-

gically. The figurations tend to become more concrete later, the persons and acces-
sories taking on sufficient detail to eliminate ambiguities, but after the fifth century
the images of ritual agapae disappear while the iconographic scheme of the repast
is definitely and exclusively devoted to gospel subjects such as the Last Supper or *237*
the Multiplication of the Loaves and Fishes.

Other series of Paleo-Christian images allow similar observations, confirming
that the normal evolution of Christian images followed a course from the sign-
reminder, or image-sign, to descriptive representation. We will mention only a
small number of examples selected from the historical subjects to which the present
chapter is devoted. The discovery in 1955 of frescoes in a private hypogeum of the
end of the fourth century under the Via Latina affords us a series of remarkable
paintings corresponding to the last phase of the development of the Christian
historical scene in Paleo-Christian art. It is from among these that we will take our
examples of the final stage, to compare with other images of the same subjects and
with other historical scenes in their earliest versions.

The Sacrifice of Abraham is the subject of an image-sign in a fresco of a third- *238*
century catacomb and offers a comparison with the same sacrifice as it is interpreted
in the hypogeum of the Via Latina, where it is presented in a much more descriptive *239*
manner. The scene of the Samaritan woman at the well in the very early catacombs *240*
of Calixtus (crypt of Lucina) is as schematic as possible but has become a genre
scene in the painting under the Via Latina. The Crossing of the Red Sea, and Moses *241, 242*
Receiving the Law on Mt. Sinai and inaugurating the first sanctuary, give occasion
to the artist of the Via Latina to paint large crowds of people, space, and landscapes.
This narrative style, which stresses action and the picturesque, and aims at creating
iconographic counterparts to the textual descriptions, is manifest everywhere in
this catacomb. The repertory of historical subjects also has expanded remarkably,
especially for subjects from the Old Testament, among which are included Jacob's *243*
Ladder, the Benediction of Jacob, the dreams of Joseph, the infant Moses saved by *244*
the pharaoh's daughter, the exploits of Samson, and the preservation of Lot and his
daughters, as well as many other historical episodes drawn from the Old Testament
that are not represented in any earlier monument.

This expansion of the repertory of images is not only a sign of the development
of Christian iconography but also an indication of the changing meanings of these
images of historical subjects. For these extensive arrangements of Biblical images
(in certain places there are nearly twenty of them) are no longer collections of
paradigms of the salvation or deliverance of individual believers. The historical
cycles of the hypogeum under the Via Latina prefigure those of the surface basilicas
built from the early fourth century on (or possibly the underground frescoes are
echoes of the paintings in the basilicas). Furthermore, certain specific iconographic

types (for example, Jacob's Ladder, the Benediction of Jacob, etc.) have precedents in the mural paintings of the synagogue of Dura, as does, also, the very idea of a historical cycle evoking the providential history of the chosen people whose salvation is promised (as distinguished from the cycle of individual deliverances, which have to do with the destiny of an individual). This relationship between the frescoes of the hypogeum of the Via Latina and those of the Dura synagogue calls attention to the priority of the monumental iconography of the synagogues, where, from the beginning of the third century, a kind of narrative, historical image was adopted which the Christians seem not to have accepted until over a century after the Jews. And the same relationship suggests also some direct contact between Jewish and Christian works, not only at the beginning of the Christian experiment, as has often been thought, but during the whole of late antiquity, and perhaps especially at the period of the hypogeum of the Via Latina, that is, in Theodosian times. This is only a hypothesis, but certain iconographic similarities between Jewish and Christian works make it almost inevitable. For, if it is true, one could also postulate some link between the presumed Jewish influence and the appearance of the narrative style in the imagery of the Roman catacombs, particularly since the frescoes of the Dura synagogue already show the same stylistic tendency at the beginning of the third century.

However, it would certainly be wrong to insist too much on this last idea, since certain painters in Rome were also cultivating a descriptive style during the first third of the third century (at the time when the Dura frescoes were painted). For instance, in the syncretist hypogeum of the Aurelii on the Viale Manzoni, under the barrel vaults, are painted scenes filled with crowds of people and with architecture and hills that attempt to represent space. At the same period, the Capella Greca of the catacomb of Priscilla is decorated with Christian paintings in the same style (especially the paintings at the bottom of the vaults and on the tympana: the big Resurrection of Lazarus, a Sacrifice of Abraham, etc.). Other examples of the same kind could be cited from among earlier Roman paintings. In other words, the evolution from schematic to descriptive style that is evident in Roman Christian painting between the beginning of the third century and the end of the fourth is not a Christian reflection of the general evolution of Roman painting of this period. Roman painting knew and practiced all genres simultaneously or alternately. But this observation, limited to Christian painting, is not the less important for that. It leads to the assumption that the Christians—or at least the Christians at Rome—made a deliberate choice for their historical images: at the beginning, the choice of the image-sign; in the late fourth century, the choice of the descriptive image.

Taken together, all the evidence as to the evolution of the Christian images of Rome is in complete agreement and tends to confirm the conclusions we have

drawn from other series of historical images: that image-signs have chronological priority over narrative images.

If one adheres strictly to the lesson that emerges from the study of extant monuments (without making the usual hypothesis of lost prototypes, which one infers a priori to have been more complete and more intelligently composed than the extant works, the only ones that can be examined), the sixth-century illustrated manuscripts of the Gospels give us no example of illustrations of a direct kind, that is, narrative illustrations innocent of interventions from other sources of inspiration than the texts of the Evangelists. One cannot, of course, affirm that direct illustration of Gospels did not exist in the period of Justinian (reigned 527–65). While there is evidence that such illustration existed at this date for one book of the Bible, Genesis, there is no evidence for the New Testament. The conclusion should be emphasized: it means that we should no longer hope to find early historical Christian images of detailed descriptive character there where it seemed most likely, directly reflecting the text of the Scriptures.

But if they did not exist in the manuscripts, did such images perhaps exist elsewhere? In fact, subjects drawn from the Gospels were frequently represented on mosaics, ivories, textiles, goldwork, icons on wood, and other kinds of objects in the fifth and particularly in the sixth century. Either alone or grouped in cycles, gospel images were then increasingly common. But there is nothing to make us believe that such figurations were first created to illustrate manuscripts of the Gospels.

Let us consider some characteristic examples of historical scenes taken from various objects and monuments. There is, for example, a miraculous healing by Christ on an ivory medicine box. The scene is patently inspired by a passage of the Gospels. But there is no indication that the sculptor borrowed it from a miniature, and still less that the hypothetical miniature was part of a systematized illustration of the gospel text. The scene of healing is on the medicine box for a very obvious reason, which has nothing to do with images for illustration: in referring to one case of a cure, the maker of the box expressed his hope, or his conviction, that similar cures would attend those treated with the medicines in this medicine box.

On a medallion made to be worn around the neck, we have the Annunciation to the Virgin on one side and the Miracle of Cana on the other. The two scenes have a much more specific function than to illustrate the appropriate passages of the Gospels: the Miracle of Cana is accompanied by a Greek inscription meaning "the first," recalling the words of the Evangelist that in the miracle of Cana Christ for the first time manifested his power, the sign of his divinity. On the other side is the Annunciation. It is the first word of the archangel's speech to Mary—χαῖρε, or "hail,"

246

247

a salutation invoking wholeness and good health—which assured the efficacy of this scene on amulets. Used by God's messenger to Mary, the salutation could be easily transferred to the medallion's wearer. In other words, of the two images on the medallion, one referred to the power of God through Christ, the other to the greeting and the promise contained in the word "hail." One can infer from this that these images were placed together on a necklace for reasons which were prophylactic and which, if one could pin them down, would assume different aspects, ranging from the blessing of the Church to belief in magic. In any case, this collocation of scenes is far from a simple reference to the two evangelical episodes, and for this reason: the fact of their being used together—which would be inexplicable otherwise than by their prophylactic intent—makes us certain of their function.

248 There is a pair of medallions, in thin gold leaf, which extend this prophylactic use of evangelical imagery to whole cycles of juxtaposed and superposed scenes on several horizontal bands. The two objects were found at Adana, in eastern Asia Minor, and are attributed, probably correctly, to the sixth century. The two medallions are identical and come from the same mold, a fact which implies a workshop producing quantities of medallions that must have been worn as pendants on necklaces. Within a frame composed of schematic portraits of Christ and the apostles, there is a whole cycle of scenes of the childhood of Christ on one side and on the other, a cycle of his miracles. The first of these cycles might possibly pass for an illustration of the first chapters of the Gospels of Matthew and Luke, but the second immediately excludes any such hypothesis that the images tell a story of events in chronological order. For the miracles of Christ here shown are arbitrarily brought together, and we can reasonably suppose that this was done because they are cures. They are subjects which, just like those of the medicine box, recall events that testify to the saving power of Christ in order to appeal for the same preservation for the wearer of the medallion. The apotropaic value of the cycle of the childhood of Christ is less immediately evident. But this cycle furnished images for several objects of the same kind (for example, above, the medallion with the Annunciation); and on the medallions from Adana, close to the anonymous owner (that is, the person who wore the medallion) represented at the beginning of the cycle, we read the word "hail," the initial word spoken by the archangel of the Annunciation, which we have already seen on another sixth-century prophylactic medallion. This time the passage is reproduced as far as the words that mean "the Lord is with thee." Nothing could answer better to the desires of the amulet's owner. The cycle ends with an Adoration of the Magi accompanied by the legend, not at all commonplace: "Here is the basileus." These words, which are put in the mouths of the Magi, do not come from the Gospels; but they express an idea ever present to users of amulets in reiterating the power of those by whose aid their appeal is made. The acclamation

of the Magi signifies recognition of the supreme power of Christ (designated by the word basileus). In other words, the cycle, beginning with the "hail" and the affirmation that the Lord is with the medallion's owner, ends with the reminder of the all-powerfulness of this Lord. The wearers of these medallions could have confidence in their efficacy.

In another branch of the applied arts, namely, textiles, numerous other *249* examples of Christian historical images are seen. In Paleo-Christian churches such fabrics were used to cover altar tables and for curtains that stretched between columns in the chancels and in the naves. Representations of such textiles occur in *250, 251* paintings at S. Maria Antiqua in Rome. The historical scenes on these fabrics are very close to the images that adorned liturgical furnishings and the walls of the churches (we have looked at examples of both). Other textiles with the same kinds of images were used for ceremonial robes. Theodora, in a mosaic at S. Vitale in Ravenna, is wearing one decorated with the Adoration of the Magi; and the choice *252* of this subject, for a scene which shows the Empress making an offering, indicates a symbolic intent. A well-known text of Asterius of Amasia mentions that the Christians of Asia Minor frequently used evangelical scenes on their clothing (*Homilia in locum Evangelii secundum Lucam . . .* , in Migne, *PG*, XL, 164 ff.). The fact that the subjects which he mentions are miracles again suggests their intent, this time prophylactic. Costumes ornamented with images of the miracles of Jesus were like the prophylactic necklaces and bracelets bearing images of the same miracles: both had the virtue of protecting the wearer from sickness or evil. Asterius of Amasia found this usage unworthy of Christians; and the Church must have fought it effectively, for it seems to have disappeared before the sixth century. The usage was in fact pagan: one need think only of the innumerable Coptic tunics decorated with motifs of Bacchic imagery, or the robe ornamented with divine and *253* astral symbols worn by a fourth-century emperor in a miniature of the Roman Calendar of 354. The use of these images in textiles certainly had a religious basis and probably a prophylactic function as well. Whether pagan or Christian, the narrative scenes in textiles are necessarily schematic and concise; they are image-signs.

Let us now turn to monumental works and consider first the celebrated series of mosaic panels on the lateral walls of the basilica of S. Apollinare Nuovo in *254-256* Ravenna. These well-known mosaics show a number of scenes from the Gospels, arranged in chronological order. But many important episodes (the Annunciation, the Nativity, the Baptism, and others) are not there at all, while other secondary ones take up entire panels, and a full half of the mosaics are devoted to scenes of the Passion of Christ (where, however, the Crucifixion is omitted). It was long ago remarked that there are anomalies here if one subscribes to the idea that every

evangelical cycle was an illustration of the scriptural story; for no representation of this story could possibly neglect so many essential events of the earthly life of Christ. It was then thought that the influence of the liturgy, particularly the choice of gospel passages read during the Mass at a certain period of the year, dictated the choice of images. This hypothesis is still accepted, although one no longer refers to the Syrian Jacobite, or Monophysite, Calendar but to that of Rome or Milan. It should, however, be noted that the list of subjects in the mosaics coincides only approximately with the list of passages appointed to be read at services, and other solutions ought therefore to be sought. In any case, one can observe the appearance, here on the walls of a sixth-century church, of cycles of evangelical scenes such as we have seen on the Adana medallions; but, while on the medallions the cycles were those of the childhood and the miracles of Jesus, here again the miracles (completed by some parables) constitute one cycle and the Passion, the other. The method of composing cycles is observably the same on amuletic medallions and on basilica walls, although the iconographic program of the medallions was inspired by prophylactic considerations and that of the mosaics by liturgical sources (these last, however, still not absolutely certain). Nothing seems to suggest, at any rate, that the intention at S. Apollinare Nuovo was simply to put before the eyes of the faithful a choice of evangelical scenes having no other end than to recall certain episodes of the gospel story. And, if one considers them carefully, these mosaic scenes do not correspond at all to one's ideas of narrative imagery, because instead of being precise and detailed they show only a minimum of detail—only what is strictly necessary to make the subject recognizable. One can, of course, admire this discreet reserve and the extreme simplicity of the forms; but, aside from several expressive heads, this art is still on the level of the cliché; and the images, in the last analysis, are not very different from the image-signs of the catacombs or the miniatures beside the canon tables that we saw earlier. No wonder that these panels of scenes were relegated to the top of the walls, since nothing would have been added by having them closer to the spectator.

All these gospel cycles, from the most abbreviated to the most extensive (S. Apollinare Nuovo), belong to the same category of multiple-image figurations which must have been created independently from manuscript illustrations and for other ends than the paintings that appear beside the corresponding texts in manuscripts of the Gospels. Designed for a very great and largely illiterate public, these images, when they were on church walls or on liturgical furniture, could evoke the gospel passages read during the offices; and when they were represented on various small objects, they served prophylactic ends.

Of course, some of the narrative and detailed cycles in the churches of this period may be connected with particular manuscript illustrations; but we know no

surviving example capable of proving this connection. A rhetorician of the sixth century, Choricius of Gaza, has left us a description of mosaics in a church of that Palestinian city, the church of St. Sergius. He speaks at length of the mosaics (which no longer exist), and the numerous details that he cites in describing the scenes of the childhood of Christ almost make one believe that these were descriptive paintings, like manuscript illustrations. But the Ekphrasis of Choricius is a piece of rhetoric; and we cannot eliminate the possibility that the text, while not necessarily contradicting the images of Gaza, interpreted and enriched their iconography in the direction of drama and narrative. In any event, in the absence of these mosaics, we can hardly oppose the evidence of this text to that of the preserved monuments, which show us no images of a kind that would correspond to the descriptions of the rhetorician Choricius.

Finally, let us turn to some Christian ivories of the sixth century which belong in part to the decoration of churches and from this point of view can be considered in relation to monumental art. This is the case for the most remarkable of Christian ivories, those of the throne of the Archbishop Maximian of Ravenna. But before turning to these, let us recall the diptychs with five compartments, already mentioned in connection with portraiture because they show an image of Christ or the Virgin with a frame of little scenes taken from their lives. When we looked at these before, we were concentrating on the portraits themselves. Now let us turn to the images in the frames. They are generally five in number (two on each side of the portrait and one underneath it), and once again the rendering of the scenes is extremely abbreviated. In accordance with the official prototypes for these portraits (see above, pp. 79 ff.), the biographical episodes in the frame are chosen with the intention of augmenting the glory of Christ or the Virgin. For the Virgin, the cycle has a biographical character; for Christ, it is a choice of his miracles. In any case, the cycles consist of only a few episodes, and the small scale of the images excludes any narrative development (although occasionally a realistic detail intrudes by accident). They are "résumés" in five scenes of a life or of an activity, a selection of typical episodes of a much longer history. But, as in the cases we saw before, these selections do not in any way suggest the chronological priority of more complete cycles drawn from the same panegyrics or biographies.

The most beautiful and the only monumental example of this kind of iconographic résumé is the sculptured decoration of the famous throne of Maximian, *257–259* Archbishop of Ravenna, a contemporary of Justinian. Here the historical cycle is more highly developed, both in the number of evangelical scenes and in the way they are interpreted. Usually each ivory tablet treats a different subject (but sometimes two tablets are devoted to the same scene). The scenes are numerous, and each of them, in this carefully executed work, is presented with naturalistic detail

259
(as in the representation of the pregnant Mary in the Journey to Bethlehem). It is the same iconographic art as in the frames of the ivory diptychs with portraits of Christ and of the Virgin. But the greater technical prowess of the sculptor of the throne, and his desire to give more life and realism to the evangelical scenes, made him transform the usual image-signs, bringing them closer to descriptive images. That we owe these transformations to the individual who made the ivories of the throne of Maximian would seem to be indicated by the presence of other innova-
257, 258
tions equally his own—for example, the division of certain scenes into two parts, each of them expanded to the dimensions of one of the rectangular tablets which cover the chair. The historical scenes of the throne of Maximian certainly do not take their inspiration from manuscript illustrations. They are amplifications of the usual subjects seen on the ivory diptychs, where the images are always on a much smaller scale than those on the chair.

All the examples that we have cited were selected because they show us historical images, whether isolated or in more or less extensive cycles, which have no connection with illustrations of the books of the Scriptures. We have seen that these Christian historical images are generally very concise and, by virtue of this, more closely allied to the image-signs of the catacombs and the Roman sarcophagi than to descriptive illustrations of a text. Furthermore, we can usually, if not always, define the religious or superstitious function of the objects that were decorated with historical images, and this function suggests the reasons why these images were created. The choice of subject and the place where it is used, whether in a building or on a certain object, is valid testimony as to the intent that lies behind the use of an image.

We can increase the force of our argument by remembering certain analogies from among contemporary non-Christian monuments. We know already the frames of the portraits of Christ and the Virgin, with their little historical scenes. As we have seen (pp. 80–82), they have counterparts in the pagan art of the period. In fact, pagan art supplies counterparts for the Christian cycles with which we have been concerned. The biographical episodes, corresponding to the childhood of Jesus, that fill the frames around the portraits of the Virgin have a counterpart in the "biographical" cycles of Mithras or Hercules, scenes which were sculptured or painted as frames for the image of the god or hero. Several characteristic examples are known; in each, very simple features suffice to distinguish one event from another, a rapid sketch of one or two persons, a tree, a mountain, summarizing the
260, 261
episodes of the legend. The figurations are very similar to those of several little Christian icons or the miniatures of the sixth-century Cambridge Gospels. Both the pagan and the Christian types show a series of sketches presented as though they form a continuous succession of historical episodes; and, in both, the sketches are so

abbreviated that only the spectator familiar with the history thus schematically translated could recognize the subjects. Among both pagans and Christians, the iconography of image-signs reigns.

The cycles of image-signs drawn from the stories of Mithras and of Hercules catered to folk piety. Innumerable little pagan icons in low relief, in stone, wood, or metal, were created for the same public, in response to similar forms of devotion. The same thing should be said of the image-signs, always concise, which had a prophylactic or apotropaic function: in these the Christians prolonged practices of popular imagery which were used neither in luxurious illustrated manuscripts nor in artistic masterpieces.

The biographical cycles of the Imperial era were firmly established and in common use, and they certainly served as models for various Christian biographical cycles, particularly for episodes that were established by tradition for the representation of childhood.

A few examples of Roman biographical imagery should be considered. We find them mostly on sarcophagus reliefs from Imperial times. There are, first, the sarcophagi with Dionysiac subjects where we see the various steps in the career of Dionysus, exactly as we see the heroic history of Mithras at Dura. The same "biography" of Dionysus appears again on the "veil of Antinoë" in the Louvre, a printed *262* silk of the fourth century, where, above a great procession of the thiasos of Dionysus, several episodes of his life are presented, beginning with his miraculous birth and the newborn's bath. Pavement mosaics, for example, at Djemila, also retain a certain number of subjects of the same "biographical" cycle.

Some of the subjects of this cycle belong particularly to the story of Dionysus. But others are typological in nature, especially those which represent his childhood. The proof is to be seen in Roman sarcophagus reliefs showing the life of the de- *263* ceased. These biographical reliefs, which summarize the life of a simple mortal, generally are found on the façade of the sarcophagus. They begin with the scene of his birth (a seated woman, supported by another woman), followed by the bath of *264* the newborn child. These first episodes are related to those of the "biographical" cycle of Dionysus or, rather, both of them follow the same typology. Then there follow various episodes showing the subject at a later age. One Roman sarcophagus in the Museo Nazionale Romano in Rome, which dates from the second or third century, has a particularly interesting development in this part of the typological *265–267* cycle of childhood. The biographical cycle is more developed here than elsewhere, going all around the sarcophagus on a narrow band on its upper edge. After the bath of the newborn, it shows the child taking his first steps, supporting himself on a contrivance that looks very much like a modern scooter. The history of the child

continues with a school scene and various scenes of play. Several of the reliefs are effaced, so that we cannot identify all the images that follow these on the frieze around the top of the sarcophagus.

The study of pagan cycles of this kind is of especial interest for our examination of Christian historical iconography, since they prove the existence of established biographical cycles and even of typological scenes in such cycles. Many elements borrowed from these models went into the composition of the Christian biographical cycles; and this is especially true of the cycles of the childhood of the Virgin and of St. John, as well as other similar biographical cycles that pertain to David or to the saints of the Church (see above, p. 80). This means that the Christians did not have to create their cycles outright, beginning with a reading of the Gospels and the lives of the saints; they had only to adapt the typological cycles in constant use around them to the Christian stories.

Let me repeat once again that these conclusions are based on direct examination of the extant monuments. There may also have been other iconographic cycles which were the result of direct and spontaneous transposition of the Gospels and other texts into original images offering a complete and detailed illustration of the evangelical story. But these other images and cycles, if they ever existed, have left no trace in the Christian monuments that have remained from late antiquity. The only way in which we can obtain an idea of their spirit and their forms is by examining certain series of paintings in the manuscripts of the early Middle Ages (ninth to tenth century) which are assumed, with much justice, to be copies of Paleo-Christian originals.

Of Greek manuscripts of the Gospels, I will cite only the little paintings, of surprisingly classic style, which occur on the margins of a Gospel (gr. 115) in the Bibliothèque Nationale (Paris). This tenth-century work, though badly damaged, preserves the elements of a detailed and direct illustration of the Evangelists; and the style, colors, and various concrete details of these miniatures (the curtain behind the scene, the landscape heightened in part by trees, buildings, etc.) presuppose a model from the end of antiquity.

The Greek Psalters with marginal illustrations (Pantocrator 61, Athos; "Chludov" Psalter, State Historical Museum, Moscow; gr. 20, Bibliothèque Nationale, Paris), which are slightly older (late ninth and early tenth century), also contain many narrative scenes, strikingly realistic, which represent the events of the New Testament (such as Christ in the Garden of Gethsemane and many other scenes of the Passion) in a style of the end of antiquity. Their probable models are gospel illustrations of the sixth century, created either for the books of the Gospels themselves or for illustrations of the Psalms, where evangelical subjects were frequently inserted to illustrate the exegesis of the Psalms that the Christians had practiced from an early date.

Another ninth-century manuscript, the Latin Utrecht Psalter, that extraordinary Carolingian work, preserves other copies of illustrations of Biblical books from the end of antiquity. The Psalter is, of course, a book of the Old Testament, and the first illustration of the text, like that of the Vienna Genesis (above), could have been undertaken by the Jews. But in almost all the images of the Utrecht Psalter which depend on models of late antiquity, a Christian intervention is evident. The whole cycle must have been created in the fifth century, probably in Rome, and this model—among those which can safely be reconstructed on the basis of the copy —would be the best proof of continuous Christian illustration of at least one book of the Bible, an illustration which chronologically must be placed in late antiquity.

Other evidence of the same kind comes to us from Ottonian works, such as the Egbert Codex and the Aix-la-Chapelle Gospels, and others. They are less striking as evidence because the images have undergone additional stylistic transformation in the Middle Ages. Though time permits me only to mention them, a further study of these manuscripts would probably invite us to see in them an echo, as it were, of a direct and ample illustration of the Gospels, realized before the end of antiquity in a Latin country, probably Italy.

Traces of another early iconography, perhaps as highly developed as the Ottonian and extending to the two Testaments, can be recognized behind the illustrations of Spanish Mozarabic Bibles. But the iconography one glimpses here seems to belong to an Oriental tradition, perhaps equally as old as the prototypes for the Ottonian works. New studies in this area will perhaps permit us to know more some day.

In the absence of early examples, it is naturally extremely difficult to get a better idea of what this direct and narrative illustration of the Gospels—and again, its very existence is no more than a probability—could have been. And yet, formerly, by a series of different inductions and suppositions by analogy, this was placed at the origin of all Christian iconography, and it was even thought possible to distinguish an Alexandrian and an Antiochan version of this iconography (the two cities being fixed upon because they were the seats of important schools of theology). None of this appears to me to be any longer possible. Alexandria and Antioch in iconography remain almost entirely terrae incognitae; and of the other cities of the Empire, it is rather Rome, Ravenna, Salonika, and Milan, and Naples as well, that is, the cities of the West, which furnish our early iconographic documents. But what has been preserved, in the way of vestiges of early Christian iconography, is insufficient to allow any decision concerning the date or the place of origin of Christian images that could have been derived from integral illustrations of the books of the Bible; and we would do better to recognize this than to insist on demanding of the documentation, poor as it is, answers that it cannot give.

We are much better informed, as we have seen, about the cycles of more or

less abbreviated evangelical images composed to serve as résumés or as sketches of a given subject. Here at least, where we have the advantage of being able to examine the monuments directly, we find cycles of images which have a particular religious function and which depend on many pre-Christian traditions, continuing them and adapting them to specifically Christian subjects.

PART THREE

Preface

Our last two chapters will be devoted to images representing theological ideas. It is, of course, true that any image that shows a person or an event of the Gospels is, in a sense, charged with theological content in so far as such a figuration shows what is contained within the revelation. Considered from this point of view, any image of the Nativity of Christ, or of the Entry into Jerusalem, is an affirmation of Christian doctrine.

We have already discussed such historical subjects, and we have seen that images of this kind—like the quotations of Scripture by authors of homilies or by theologians—were constantly referred to but in contexts that cannot be compared to theological demonstrations. Sometimes they are used in connection with the prayers for the dead which express the hope of resurrection for the followers of Christ; elsewhere they glorify the power of the God of the Christians, the victor over paganism and the patron of a regenerated Christian Roman Empire; or, finally, in many cases, these images are simply references to the author of this evangelical revelation, Jesus Christ, or his disciples, and to the events in which they figured; these last images can be compared with "biographies" recorded in pictures. Of course, as we have said, the Christian artists found it difficult to limit themselves to the role of disinterested illustrators of the life of Christ; and their frequent interventions, directed toward the religious meanings of the events they represented, have been noted. Theology thus came in, retouching, as it were, biography. But it remains true, none the less, that the evangelical cycles—especially in manuscripts of the Gospels, but also elsewhere—arrived at these theological themes only indirectly. They took the form of commentaries on texts that described the life of Christ and his disciples, and usually kept within a framework imposed on them by the formulas of biographical figurations common in the early Christian period.

It is within this framework that the Christian image-makers of the end of antiquity generally worked. But sometimes they took upon themselves more ambitious tasks, attempting to create images that had as their direct and primary

purpose the explanation of theological ideas which it was difficult to adapt to the existing iconographic language.

How was one to proceed in such a case? It is to iconographic creations of this kind that we will turn our attention now, limiting the subject to a small group of the greatest theological themes: the Trinity, the Incarnation, the Resurrection, and the sacraments of baptism and communion.

Let us try to envisage the first Christian image-makers with these themes before them. Remember that, at the time of these iconographic creations in the Mediterranean area, more than a thousand years had passed since writing had replaced pictures as the principal means of communicating man's thoughts. It was not to iconography that the Fathers of the Church thought of turning to establish the truth of Christian theology. They, like everyone around them, wrote much; and, of course, in writing on everything including dogmas, they sometimes made use of poetic comparisons; for example, they would recognize the Cross in the outlines of a plow, or a sailboat, or an anchor. The Gospels and the Epistles had opened the way for them by making the Lamb or the Good Shepherd a symbol of Christ, or by speaking of the apostles and their mission as the "fishers of men" and of the kingdom of heaven as a "net." But all these allegories could not have sufficed to establish a comprehensible and adequate theological iconography. Under the Empire, in the Mediterranean area, the use of iconography to explain high levels of religious thought would have appeared to many intellectuals as a most singular enterprise. For them, it would have seemed quite antiquated; and it was, as a matter of fact, a kind of fossil. For at the beginning of our era, in the territory of the Empire, iconography was a little-used and manifestly imperfect means of expressing contemporary philosophical and religious doctrines. Even though the people of that time must also have known, as we do, how long it takes for an obsolete custom to disappear, all the religions among which Christian iconography originated were in fact continuing the practice of using symbolic figurations.

The Christians did as the others did. But the creative effort demanded of them was far greater than what other religions asked of their image-makers since, instead of simply using the image to recall historical persons and events or to present summary allegories, they had to find iconographic expressions for the abstract ideas of Christian dogma. In this instance no pagan iconographic repertory that the Christian image-makers might have known could furnish any model for them, because the pagan religions had no iconography of their dogmas, lacking, as they did, any dogmas to express. Sometime in the future we may perhaps learn that Jewish Messianism had given rise to some antecedents for Christian dogmatic imagery; but for the time being, nothing positive can be said on this subject, and we ought, instead, to emphasize the originality and the novelty of Christian experiments in

this area. The Christian image-makers did not, of course, start from zero so far as the kinds of motifs they employed for their dogmatic figurations were concerned or the processes by which they constructed them and gave them the meaning they wished them to convey. Nevertheless, the novelty of this branch of iconography is not the less for that.

I have chosen a few examples—and there are others—to show what these earliest dogmatic images were. Before examining them, I would like to point out one thing more: that from the beginning, the attempt at iconographic expression of these ideas, so poorly adaptable to pictorial interpretation, took two different forms. On the one hand, there were images that we can call direct and simple: with these, one single image defines the dogma, the image thus being comparable to a verbal term made up of only one word. The other manner of expressing these ideas is apparently as ancient as the first, and translates a theological idea not by a single image but by the juxtaposition of two or more images. It is the ensemble that defines the dogma, like a verbal definition that is composed of more than one word; for it is the nature of the plastic arts that they must juxtapose the terms that, in written or spoken language, follow one after another.

There is one area of Christian thought that in its interpretation into images invariably produces topographical juxtaposition of figurations which complement each other. This is the area of typology, in the special sense that the term has for theologians and image-makers: that is, the establishment of relationships between persons and events of the Old and the New Testaments. The richest results of juxtapositions of this kind come only in the Middle Ages, in western Europe. But the beginnings of the method appear in Paleo-Christian art, and we will see some ancient examples of such iconography in a very complex form, observing at the same time, not without surprise, that the Christian image-makers of late antiquity lagged several centuries behind the theologians. Christ himself, St. Paul in the Epistles, and all the Fathers of the Church had already cited the events of the Old Testament as prefigurations of future evangelical events.

With some examples of this typology in Christian iconography we will end the third part of our study and complete our examination of the form and content of early Christian iconography.

V. Dogmas Expressed in a Single Image

Christian theological iconography in late antiquity was incomplete and accidental, taking initial steps in various directions, retaining a few of the results, and quickly abandoning others. Nevertheless, it did exist.

The difficulty of transposing the ideas of Christian doctrine into images did not prevent artists from attempting certain essential themes. Their achievements are very unequal, and they include a number of failures. One of these is the image of the Trinity. The image-makers of late antiquity failed here, not surprisingly, because the subject is a most difficult one, and has been so always and everywhere. No satisfactory iconography of the dogmas of the Trinity has ever been achieved, and the best proof of this is that all the iconographies that have ever been proposed have been rapidly abandoned, to be followed by new attempts just as debatable and equally ephemeral.

Three attempts to represent the Trinity in early Christian times merit attention. First, a particularly unhappy effort, repeated in the Middle Ages with as little success, was that of the sculptors of sarcophagi. We should say, rather, of one sculptor, for we know only one example. The fact that this sarcophagus in the Lateran Museums is unique plainly indicates its lack of success, since the workshops that produced sarcophagi tended to repeat everything they had learned to represent. But here, by exception, we find only once the attempt to represent the Trinity by showing three identical Persons side by side (at the extreme left of the upper row of reliefs), one seated, the others standing. The failure of such a figuration is understandable, since it retains only the idea of the identity of the three divine Persons, entirely neglecting their unity.

Another formula, again illustrated by a single monument, might have been more appealing. It occurs in a fresco at Bawit, in Egypt, which may date from about the sixth century. It shows an eagle, like the Roman Imperial eagle, above whose head and raised wings are three identical wreaths, each one enclosing the two letters α and ω, which are usually placed beside Christ (who said of himself, "I am Alpha

and Omega," the beginning and the end) or next to the Cross which replaces the image of Christ. In the Coptic fresco, the three divine Persons are thus represented by a formula, abstract in meaning, that repeats three times a symbol of Christ and unites these three distinct signs upon the single support provided by the eagle with its two raised wings. The unity that this image expresses is evident, for in Imperial Roman iconography the raised wings of the eagle as a rule support the bust or the monogram of a single sovereign. When two or three symbols are used, they designate two or three coregnant emperors who assumed jointly the supreme power of the Empire (cf. on consular scepters one, two, or three busts of the coregnant emperors). Nevertheless, the formula employed at Bawit also is represented by only a single example—an indication that it was as unsuccessful as the formula for the Trinity on the sarcophagus mentioned above. I do not know why the Bawit formula was unsuccessful. It may have been because the iconographic elements were too abstract in character and perhaps because a symbol generally reserved for Christ was chosen for all three Persons of the Trinity. Since the figure of the eagle also symbolized Christ, the whole group presents a figure of the Trinity conceived through the second Person. In other words, if the first formula, that of the sarcophagus, accentuated the separation or antinomy of the three Persons, the second leaned toward expressing only their unity and unduly emphasized the characteristics of God the Son.

270, 271

Other figurations of the Trinity in late antiquity are based on events described in the New Testament or on their Old Testament counterparts. Sometimes they combine conceptions that are rather abstract with elements borrowed from historical scenes; at other times they show the historical scene as a whole but with particular attention to the Trinitarian motifs. Toward the end of antiquity the Adoration of the Magi, for example, was used to represent the Trinity because some very early Semitic legends related that each of the three Magi had had a different vision of the theophany. According to the legends, each of them saw a different person of the Trinity; and Byzantine images of the early Middle Ages demonstrate that the image-makers were not unaware of these stories. A miniaturist of the eleventh century in Constantinople (Taphon, Codex 14, Greek Patriarchal Library, Jerusalem) went so far as to show one of the Magi carrying the Ancient of Days, an old man, in his arms, as God the Father; the second carrying Christ, with the small beard he was usually shown with; and the third bearing an infant, Emmanuel, who in this case stands for the Holy Ghost. A recently discovered mural painting in central Asia Minor, a provincial medieval work, puts each of the Magi in a separate frame and places before each a separate image of God—a less daring interpretation of the same theme. These iconographic variants may go back to the end of antiquity, although this cannot be proved.

Other attempts at representing the Trinity certainly do go back to this early date. The best-known ones—best known because of the quality of these works— show the Trinity in the guise of the three mysterious visitors who came to Abraham under the oak of Mamre. An allusion to the Trinity is probably present even in the earliest version of this subject, a painting in the recently discovered hypogeum of the late fourth century under the Via Latina in Rome. The emphasis on the identity of the three celestial visitors would lead us to think so. In a mosaic of the same subject at S. Maria Maggiore in Rome (about 430), the Trinitarian intent of the image-maker is certain, for the central figure among Abraham's three guests is surrounded by a circle (or, rather, oval) of light; and this is an iconographic distinc- tion which can designate only Christ (as in the Transfiguration). The two other figures can thus be only God the Father and God the Holy Spirit, since, except for the aureole, there is no distinction between them and the figure of Christ. At S. Vitale, in Ravenna, the same visitors are shown simply at table, served by the patriarch. But even there, although there is no aureole, the central Person is distin- guished from the others. This time it is the position of the two arms and the gesture which distinguish him, being exactly what we usually find in bust portraits of Jesus. One of his neighbors makes the sign of benediction, as he does, but in all other respects the three figures are identical. In the Middle Ages, especially in the Byzan- tine Empire, Abraham's three visitors, grouped around the table, regularly served to represent the Trinity, evidently because the text of Genesis affirms the theophanic character of Abraham's vision, and the presence of three figures in this theophany led to its acceptance by Christian theologians as a manifestation of the Trinity. The image-makers, as we have just seen, echoed the established interpretation, beginning in the late fourth or at least in the early fifth century, making it into a representation of the Trinity that never went out of use.

Two other attempts at representing the Trinity are more abstract in character, although the elements of these compositions are borrowed from evangelical scenes. Both figurations are isolated instances, which generally means that they met with little success, perhaps through lack of clarity. The first is a *repoussé* relief on ampulla no. 10 at Monza. It shows the Ascension, combined, it would seem, with the Pente- cost. In most of its details the image is the usual one of the Ascension, but beneath the feet of the enthroned Christ who mounts into the heavens there are a Hand of God (the Father) and the dove of the Holy Spirit. These symbols should probably be interpreted as meaning that the Grace which descends on the apostles and Mary has its origin in the Trinity. The second example is recorded in a text of St. Paulinus of Nola (Epistula XXXII, to Severus, reproducing an inscription in verse on the apse mosaic at Nola) which says in so many words that in the apse of a church of his time there were images that, used together (undoubtedly one above the other),

272–274

272

274

273

275

represented the Trinity: the Hand of God (the Father), the dove (the Holy Spirit), the Cross and Lamb (the Son). This figuration had no more success than the preceding one. It is plain that the order of the three elements of this composition is more normal than that of the three motifs used together on the ampulla. But both figurations surely borrowed the theme of the dove descending from heaven and probably the Hand of God which looses it (on the ampulla) from the iconography of the baptism of Christ, where the presence of these two motifs depends directly on the Gospels.

Apart from Abraham's vision, the scene of the baptism of Christ is the only iconographical interpretation of the Trinity that survived the Paleo-Christian period and that remained valid throughout the Middle Ages and into modern times. It had the advantage of being supported by a phrase of the Gospels which affirms that at the moment of the baptism of Jesus there was a simultaneous theophany of the three Persons: the voice of God the Father was heard descending from heaven; God the Son stood in the waters of the Jordan; and God the Holy Ghost appeared as a dove hovering above the Son. From the sixth century on, the image-makers followed the revealed text, bringing to it only one "technical" elaboration not furnished by the Evangelists. To evoke God the Father, who manifested himself only by his voice, they turned to the motif of the Hand descending from heaven— *276* a motif which the Christians surely borrowed from contemporary Jewish art, not only here but elsewhere (as on the medals of the Emperor Constantine). The Hand *100* signified the presence of God. The fingers pointing to Christ, or the crown about to be put on Christ's head, express the gospel words: "This is my beloved Son, in whom I am well pleased." Of course, this representation of the Trinity, like the images of Abraham's vision, evoked, in fact, only a particular manifestation of the Trinity, instead of evoking specifically its immutable character. But this, probably, explains the success of this kind of image: one can suspect that the Trinity cannot be grasped pictorially in its essence, but only represented in its manifestations and precisely in the same manner that it manifested itself to the witnesses of Abraham's theophany or the baptism of Jesus.

We should perhaps cite one more early Christian figuration of the Trinity, the one on the triumphal arch of S. Maria Maggiore which shows the empty Throne *277* (standing for God the Father) and the book of the Gospels on the Throne (standing for God the Son). The same image at Capua Vetere also has the dove on the book *278* (standing for the Holy Ghost). The Byzantines, in the Middle Ages, occasionally went back to this image, which has, however, the defect of appealing very little to the imagination of the spectator and of using symbols that do not take into account the idea of the identity of the three Persons. The same thing is true of several images we have discussed; however, those did not generally claim to represent the essence

of the Trinity but only one of its momentary theophanies (and for Abraham's vision and the baptism of Christ the artists relied on the revealed text, except for one conventional detail).

The most ancient images of the Trinity can, then, be summed up in this way: they are rare and imperfect, especially in view of the great importance of discussions of Trinitarian problems during all the centuries of late antiquity. One sees clearly the predicament of the image-makers, since the Trinitarian doctrine could probably not be represented by means of the terms at their disposal. Some terms of their repertory, like the Roman eagle supporting the Imperial monogram or the throne borrowed from the same official repertory, were tried out, retouched, and adapted to the subject; the dove on the throne could also have been drawn from the symbolic iconography of the period, as well as the closed book that was used to mean the Holy Book.

Since the Gospels taught that God in heaven, God the Father, is invisible, he has never been represented as he is, that is, in his essence. But there are several well-known exceptions to the general rule of the invisibility of God. The prophets, notably Isaiah and Ezekiel, were able to contemplate God with their own eyes. The conclusion therefore follows that, since the theophany was accorded to these prophetic visionaries, their description of it authorizes its pictorial representation. It is thus that the images of visions of God by the prophets—and then by the author of the Apocalypse—were introduced into the repertory of Christian iconography. In contradiction also to the numerous affirmations of the theologians, who continued to deny the possibility of representing God in heaven pictorially, these images made their appearance soon after the year 400, and were never abandoned afterward. However, in order not to conflict with the principle that God the Father cannot be represented, they had to take the precaution of explaining unequivocally, through the iconography, that this was an exceptional vision (accorded to exceptional witnesses) and a momentary one. The image-makers express this idea in two ways: they show the visionary with the vision of God; and they isolate the vision of God, the supernatural, from the rest of the image, confining it within an aureole of light or within a disk. In the language of the period, this was equivalent to saying that the apparition was foreign to the perceptible world about us and seen only by the visionary (or visionaries).

We have several early Christian examples of such images, all of them constructed in the same manner: the vision appears frontally in a "cloud" of light; the visionary contemplates it, showing it to an acolyte, or he is struck down by the fearfulness of the divine light. The frescoes of Bawit give us a beautiful example of the Vision of Ezekiel, with the prophet struck to earth and—by iconographic license—the disciples of Christ represented simultaneously as other visionaries ex-

cited by the miraculous sight which they are witnessing. The same elements are combined in the image of the Transfiguration when it appears in the sixth century: *279* the aureole of light surrounds Christ, who is transfigured and thus manifests his divinity, while the three apostles who are present at this theophany are represented as visionaries, falling to their knees or thrown back by the mysterious light. A beautiful mosaic of the fifth century, in the chapel of Hosios David (or Christ Latomus) *280* at Salonika, represents a vision of Christ in a cloud of light and two witnesses of the theophany, one of whom watches in terror while the other displays a codex. In all these cases, the image, for which no inspiration could be found in the everyday world, is based on a Roman iconographic formula that goes back to a time before the flowering of Christian art. It is the formula used to represent the Sun rising in the sky; by derivation from this one, another figuration came into use, to show the ascension of the soul of the deceased emperor. In the first version, a bird is ascending *283* into heaven, ridden by the personification of the sun, and in the second, a quadriga *284* ascends, driven by the now divine emperor, while in both versions a figure seated on earth raises his arm toward the new god. For the sun, this figure is Tellus, a personification of the earth; for the apotheoses of the emperors, this figure is the eyewitness to the ascension of the divus, whose testimony was required by law. The earliest iconographic formula of apotheosis, certainly Roman, showed the celestial quadriga moving upward obliquely (and not enveloped in an aureole of light). Christian iconography inherited it in the fourth century, but without making very frequent use of it.

A curious fresco in the hypogeum under the Via Latina, as well as a few sarcophagus reliefs, ought to be mentioned among the early Christian representations of theophanies, for they show the Ascension of Elijah. One sarcophagus relief is par- *281* ticularly remarkable for the large semisupine figure of a shepherd. He takes the *282* place of the Tellus in the ascensions of the *Sol Invictus* on Roman coins, and is shown in the same posture. The later, and more heraldic, variation of the theme of Ascension shows the chariot frontally, and this was the version that was adopted for the theophanies where God appeared in the visions of the prophets. This formula was easily adaptable to the vaults of apses, when theophanies were represented there. In these, as in the Transfiguration scenes (see above), the aureole of light appears around God, and the prophets are often shown as witnesses of the miraculous apparition at his feet and to the side. It was the Christians who added the aureole or oval disk of light. The aureole, which shows the illuminated air around the entire person, is of the same origin as the luminous frame around the head of a figure, for example, the personified Sun. This nimbus probably comes originally from Mazdean Persia. *285* The first Western example of it appears in a mosaic in the nave of S. Maria Maggiore in Rome. As I mentioned earlier, it serves to show that the three mysterious visitors *274*

whom Abraham received under the oak of Mamre are theophanic figures, although it surrounds only the central figure of the group (cf. also in S. Maria Maggiore in Rome a cloud of dust surrounding three figures). It was a new pictorial motif for theophany, independent of the text of the Bible, which makes no allusion to such an aureole.

Briefly, then, the earliest images of God in heaven, or God the Father (independently of figurations of the Logos), are compositions inspired in their essential form by the symbolic figurations of the apotheoses of the divi and completed by the new motif of the luminous aureole. By analogy (although a very incomplete one) this new device was extended to the scene of the Transfiguration—another example (in addition to that of the Trinity) of an iconographic creation limited to a very approximative adaptation of a more or less adequate formula.

It is difficult to distinguish in some of these divine visions what properly represents God the Father, the God of the Old Testament, and what represents God the Son as Logos, who, like the Father, is eternal and uncreated, except when represented as Jesus Christ during the period of the Incarnation. This uncertainty may be intentional, referring to the passages of John where Christ declares, "He that seeth me seeth him that sent me," or, "He that hath seen me hath seen the Father." The respective essence of the two Persons is always distinct, but the aspect that they offer to the sight of men—what one sees and what the image-maker is able to represent —is what is identical in the Father and the Son.

It is from this that the early Christian image-makers, for example, at Salonika, took their authority when they amalgamated theophanies of the prophets and apocalyptic theophanies, blending the vision of God from the Old Testament and the vision of Christ at the end of time. The influence of the Apocalypse in such images, and thus the presence of the second Person, is indicated by the books held by the symbolic beasts. The theophanies represented in mosaics and frescoes are thus at the same time visions of God in heaven in his first Person, or God the Father, and visions of the Logos after, and apart from, the Incarnation. The Second Coming, also, is evoked by the witnesses who behold the vision, that is, the apostles: we are told in the Acts of the Apostles that at the time of the Ascension "two men . . . in white apparel" appeared to the apostles and said: "This same Jesus, which is taken up from you into heaven, shall so come in like manner as ye have seen him go into heaven." In short, the second Person of the Trinity could be designated iconographically without recourse to any other formulas than the formula of the theophanic visions with their witnesses; and it was through the details, not always sufficiently explicit, that the presence of the Logos was indicated. But the Logos— apart from the Incarnation—could also be represented in several different ways.

In contrast to the images considered above, the images of the Logos place the

scene outside the material world where, except during the Incarnation, God was visible only to a few exceptional men and only during a few moments. We are transported in imagination to the celestial abode of God, where we find him surrounded by the other inhabitants of paradise, angels and saints. No text of the revealed writings describes this abode, but several passages here and there in the Gospels and the Apocalypse permit us to people this rather vague paradise: it is a garden with four rivers, but also a walled city, and Christ sits there on a throne surrounded by saints and angels. Many sarcophagi and several apsidal mosaics between the fourth and the seventh century show God the Son in the splendor of this abode in paradise. It was formerly thought that in showing him as a young man, a beardless youth, or on the contrary as adult, even old, but virile, with a beautiful beard and majestic stature, the image-makers suggested subtle differences in their image of a resplendent Christ. But this does not seem to be true. Beardless or bearded, with flowing locks or short hair, a sweet or a severe expression—all these traits, although they *could* have served for a more precise theological iconography of Christ, do not seem to have been used in this way, at least not in any regular fashion. By this I mean that, if in representing the seated Christ sometimes as a very young man, a gracious dreamer, or as a bearded and energetic older man, the Christian sculptors followed some religious idea, expressing some feature of the definition of the second Person of the Trinity or a certain aspect of his work, their intention, if there was one, cannot be described or explained with any certitude. The question always remains: What is symbol in these images made by sculptors accustomed to realistic imagery, and what is simply imitation of a gracious or expressive head, reflecting the taste and talent of the artist?

The impossibility of separating as to their significance the representations of Christ made man (or the Word Incarnate) from those which mean to represent him apart from the Incarnation as God the Word, born before time and eternal, makes for skepticism concerning the existence of a theological iconography of Christ in early Christian art. Take, for example, the youthful Christ. He can be shown either in an evangelical scene, for example, the Entry into Jerusalem on the sarcophagus of Junius Bassus, or as a triumphant king for eternity, enthroned in paradise, as in the apse of S. Vitale in Ravenna or in certain chapels at Bawit in Egypt, and thus, in the latter form, not as the Incarnate Christ. But in just such a scene of Majesty we can have a different Christ, bearded, severe, authoritarian. Only one conclusion is possible: For the image-makers, the traits of Christ, the hair, or the expression of the face do not distinguish the Incarnate Word from the Logos unincarnate. Does this imply that the image-makers declined to give precise meaning to these particular terms of the iconographic language they used?

Let us try another test. Let us admit that the youthfulness of the Christ-Logos

<div style="text-align: right">*290*</div>

represented in eternity, for example, in the apse of the chapel of Hosios David (or Christ Latomus) in Salonika, has not the same meaning as that of the Christ in the sculptures on the sarcophagus of Junius Bassus (an annoying coincidence in any case, which would illustrate from another side the poverty of iconographic language). And let us assume that at S. Vitale the youthfulness of the Christ in paradise is a symbol of the powerlessness of time over the Logos. Time does not act on him: he remains eternally young. Thus eternity is equated with immutable youth. We have elsewhere, however, the same Christ as Uncreated Word, thus eternal, and he is old. He has the white hair and beard of an old man; and we are certainly not talking about an old man. Here the traits of age are a symbol, but an inverse one, of eternity: eternity implies a very long period of time, as does the head of an old man. In short, the same conception of eternity can be explained iconographically by a young face or an old one.

287

The uncertainty goes farther. It has been said that the beardless Christ is in accordance with the gracious and superficial art of Imperial times which, for example, substituted *putti* or children for the real, mature participants in an activity. In pagan and profane images, these children replace adults in scenes of agricultural work, gardening, the harvesting of grapes or wheat, horse racing, hunting, and so on. It is within the context of a prolongation of this art that we must place the images of Christ as a very young man, amiable and insignificant, whereas the images of the bearded Christ, when they occur in mosaics, appear to signify realistic preoccupations that would substitute seriousness for playfulness, the historical truth (Christ as a Semite) for the light idealism of the Romans. But call to mind two or three examples of these bearded Christs of Oriental aspect. One is in a fresco in the catacombs of SS. Peter and Marcellinus, where the subject is a scene of Majesty, as in the apses of basilicas. The ceiling decoration of the catacomb of Commodilla and the recently discovered marquetry work at Ostia, however, each show a beautiful and very noble head with long hair and an abundant beard but with no Oriental traits. It is therefore time to denounce the error of those who associate an Oriental influence, Syrian or Aramaean, with the images of the bearded, long-haired Christ. Were not all the bearded, long-haired Zeuses and Jupiters the epitome of all that was Greek, all that was Roman? Let us then discard the Oriental hypothesis and point out instead that the images of the long-haired, bearded Christ can belong to two quite distinct categories. One of these reminds us of a portrait such as the head of Christ in a clipeus in a mosaic at S. Apollinare in Classe, in Ravenna, while the other represents simply the head of a man of ripe age who has let his beard and hair grow, as in an apsidal mosaic at SS. Cosma e Damiano in Rome.

289

288

The same difficulties in determining the image-makers' intentions (supposed, but not proved) can appear under very different aspects. A final example is presented

in the Syriac Gospels of Rabbula (of 586) in Florence. This instance is somewhat different from the others because it shows in the same manuscript and in miniatures by the same painter images of Christ of different physical types. Throughout the manuscript, Christ is conceived as rather young, with a small beard. But sometimes his face has a triangular shape, with a low forehead, a small beard following the out-line of the jaws and chin, and short, frizzled hair. Or he has, in the same Rabbula Gospels, a rounded face, a longer and more abundant beard, and very long hair falling on his shoulders. This last formula occurs only once, in the Ascension, where Christ is represented as a theophanic apparition, while the other formula serves for the Christ of the gospel scenes. Should we conclude that the Syrian miniaturist wished to distinguish the Logos made man from the unincarnate Logos? It is a tempting hypothesis, but it is difficult to support it without comparisons. We cannot say surely whether or not a painter or a sculptor had (or did not have) the idea of putting to such use the expressive elements that the beard and hair furnish for the masculine image. The two alternatives are equally possible, but neither is ever certain, at least in the early Christian period.

292

Comparative studies of Paleo-Christian images of Christ indicate that there was a good deal of variety in the use of all the traits that sometimes served to charac-terize the figure and especially the head of Christ in order to create counterparts to the theological definitions of the second Person of the Trinity, either during or apart from the Incarnation. One could equally well acknowledge that the image-makers were preoccupied with this problem (the great problem of the theologians at the period of the ecumenical councils) or that they were not. Now if in the work of the image-makers such uncertainty exists as to the central theme of Christology from the fourth to the seventh century, there is all the more reason to doubt the existence at that time of iconographical terms sufficiently precise to express theological notions that were difficult to translate into imagery. This conclusion may be surprising, particularly to those familiar with the writings of many archaeologists of the past hundred years, who labored in the tradition of Joseph Wilpert, Oskar Wulff, and Ludwig von Sybel, to cite only the dead. But I think that these excellent works, the majority of them by men trained as theologians, inverted the problem. They were not so much attempts to discover the religious background of the extant monu-ments—as we are trying to do—as attempts to see in the monuments illustrations of theological systems. This method should be discarded, because it tends to make the monuments say what we want them to say.

It is possible that already in late antiquity some spectators may have read into the images that they saw the expression of a certain Trinitarian or Christological doctrine. But unless a contemporary text reveals to us a particular learned interpreta-tion—which, true or false, is naturally of interest to the historian—it is the evidence

of the monument itself which should guide us, and we must stop where the evidence stops, our whole study being based on deciphering it. Thus we would say that the monuments which we know tend to show that the major theological ideas, that of the Trinity and those which characterize the second Person of the Trinity, did not receive satisfactory iconographic expression in Paleo-Christian times.

At the moment we are speaking of a kind of iconography that I have called "direct," which expresses a thought by the characteristics it gives to a human figure, to any other living being, or to their accessories. It is the method of figuration which has its linguistic counterpart in the use one makes of a common word to express a new idea through the qualifications one adds and through the intonation of the voice. The following chapter will show that other methods sometimes allowed the image-makers to improve upon these modest achievements, just as spoken and written language permits the expression of thought by groups of words and by syntax. But before coming to these other methods of the image-makers, a few more examples of creations by the direct method, that is, autonomous images, demand attention.

The case of the third Person of the Trinity is an interesting one. At the period with which we are concerned, there was, I think, only one symbol of the Holy
291 Ghost: the dove. It appeared, as we remarked earlier, in a scene of the baptism of Christ from at least the fifth century (in a mosaic in the baptistery of the Orthodox Cathedral in Ravenna) and, again from the beginning of the fifth century, on the
278 Throne of God (in a mosaic in S. Prisca, at Capua Vetere). Aside from rare representations of the Trinity, the image-makers of late antiquity do not seem to have touched the problem of an image of the Holy Ghost that would take into account all that, according to the theologians, defines its nature, and particularly its relationship to God the Father and God the Son. This part of the Credo of the first ecumenical councils finds no echo in the art of that time, and this is to be emphasized, as significant of the distance that then separated higher theology and iconography. But what happened to the one iconographic formula that was used, that is, the dove, is equally curious. This allegory, of course, goes back to the words of the Gospels describing the baptism of Christ, but we must recognize that it is archaic by comparison with other Christian theological figurations and is comparable to the initial Christian symbols, like the anchor and the lamb. These early allegories were generally replaced by representations of human figures in the fourth century; but the dove of the Holy Ghost remained, and still serves today to designate the third Person of the Trinity. Image-makers must have tacitly recognized that the subject was beyond the means at their disposal.

Nevertheless, even keeping the symbolic dove, artists could have shown the procession of the Holy Ghost in order to express the Credo. This was done in-

numerable times in the Middle Ages. How often then do we see the dove leaving the Hand of God the Father, or placed so as to express the filioque, that is, the conception that the Holy Ghost proceeded from the Father and Son together! Antiquity seems not even to have touched on this subject.

Let us turn now to the two moments in the history of God the Son which are dogmatically among the most essential: the moment of the Incarnation of the Word and, after the death of Jesus, the Resurrection. Of course, we have to recognize that in iconography images of the earthly life of Jesus are overwhelmingly predominant. And certainly this predilection needs little explanation, given the role of the Incarnate Word as the salvation of man. Already in the Credo, the passages devoted to the Father and to the Holy Ghost are very brief in comparison with the space devoted to the Son, for it was Christological problems which principally occupied the theologians in the ecumenical councils of the fourth, fifth, and sixth centuries. Iconography reflects this same interest, reinforcing once again the predominance of Christological themes.

These themes are of two kinds: first, the evocation of gospel events which have no special relation to dogma—the subjects which we discussed in Chapter IV, but with which we are not concerned here—and, second, representations which in various ways try to translate iconographically the essential dogmas of the Incarnation and the Resurrection of Christ. This was done in several ways; and while we cannot consider them all, there are several examples which I find suggestive.

For a reason which can, I think, be easily understood, the dogmas of the Incarnation and the Resurrection were not treated iconographically in the same manner. While the dogma of the Incarnation was interpreted by the juxtaposition of several images (that is why we will discuss the Incarnation images in the next chapter), the Resurrection gave rise to several series of direct figurations, complete and autonomous. An early series of Resurrection images (not, however, the first) accords with the Gospels, which, as we know, do not describe the Resurrection of Christ, with his awaking to life and leaving the tomb after forcing the stone that closed the exit from the sepulchral vault. It was in the West, probably in Ottonian Germany, in the tenth century, that for the first time one dared to imagine pictorially these first movements of the resuscitated Christ. Late antiquity, more intent not to exceed the testimony of the Evangelists, did not show the Resurrection but, like the Gospels, noted the testimony of the two or three Marys (the number of witnesses required by Jewish law) who came to the tomb and found it empty. Instead of Christ, whose body has disappeared, they see and hear an angel who announces the Resurrection. A very early version of this image must have been created in Palestine or in Syria between about 200 and 230, that is, at the very beginning of Christian iconography. We find it at this date among the frescoes of

293

the baptistery of Dura in northern Mesopotamia. Some of the iconographic details are singular (the sarcophagus of Christ is closed, and the angel is absent). It seems that the painter represents the moment before the Resurrection, perhaps inspired by images of the *paternalia* (visits of relatives to tombs), and also compares the Marys with their lamps to the neophytes who advance in procession toward the baptismal font.

A second version of this image existed from about 400 on and has never left the Christian repertory. This version puts the emphasis on the conversation between Mary and the angel, the subject of which is the resurrection of Christ. One of the *294* best-known examples is a mosaic in S. Apollinare Nuovo in Ravenna, dominated by the rotunda of the Holy Sepulcher, which is entirely classical in appearance. Another variation of the same image, half a century later, appears in a Syrian miniature in the Rabbula Gospels in Florence and in several small reliefs which *295* decorate the silver phials made in Jerusalem at the end of the sixth century to hold sacred oil.

Like the Gospels, early Christian iconography was not content with the testimony of the three Marys but followed it by the accounts of other eyewitnesses, especially the apostles. On different occasions, some of them saw the resurrected Christ and touched his body. They spoke to him and heard him. The images show all these scenes of the appearances of Christ and especially the scene with St. Thomas (when he could not resist the truth of the resurrected Christ), because, one could suppose, his reputation for incredulity was of a nature to persuade the most skeptical.

All these images—comparable to the *procès-verbal* before a public authority—are, in fact, representations of the Resurrection of Christ. It would be hard to find better examples than the small reliefs of the ampullae from Jerusalem preserved at *296* Monza and Bobbio. The image which shows St. Thomas touching the wound of Christ with his finger is particularly interesting from this point of view because an inscription above the figures recalls the words of the apostle convinced by his touch: "My Lord and my God."

This first type of image of the Resurrection, which I call juridical and evangelical (because, like the Gospels, it evoked the dogma by showing the story of the eyewitnesses to the Resurrection), was not the only one that the image-makers invented. It outweighed all the others, however, from about 400 until the eleventh century in the West and until modern times in the Byzantine world. But in the fourth century, probably in Rome, another image was invented, symbolic in its iconography, that had great success but was abandoned a hundred or a hundred and twenty years later, perhaps because its meaning had become obscure. It was a figuration inspired by the art of military triumphs of pagan Roman tradition, and as it became further removed from pagan times, it must have appeared less explicit. It

is on Roman sarcophagi of the fourth century that we find almost all the examples. *297, 298*
Here we see the military trophy, and in it the phoenix—symbol of the Resurrection
—with seated or standing figures on either side. The origins of this iconography are
recognizable in the reliefs of a pagan sarcophagus where the usual military trophy,
displaying the arms of the vanquished, is represented, along with the barbarians *299*
beneath it who were conquered by the Romans. The Christian formula replaces
the trophy by the Cross, on which is suspended a triumphal crown, and substitutes *300*
for the captured barbarians two armed but sleeping soldiers—in an allusion to the
guardians of the tomb of Christ: their arms are as powerless to prevent the victorious
Resurrection of Christ as the arms of the barbarians were powerless before those of
the Imperial armies.

The origin of this singular iconography must have had some relation to the
creation of that Christian symbol of military character, the monogram of Christ
on the labarum, which is certainly to be traced to Constantine. Like the Constan-
tinian Christian symbol, the Resurrection image which we are discussing now must
not long have survived the reigns of the two Theodosiuses (Theodosius II died in
450) and the brief but impressive return to triumphal images which they sponsored.
On the base of the column of Arcadius we find, simultaneously, the trophy of
Roman victory with barbarians cowering beneath it and also two soldiers on either
side of the Cross. But here, on this iconographical homonym of the Resurrection
image, the soldiers are not pagan guards vanquished by the triumphal Cross but
soldiers of the Christian Roman Empire who, as in the time of Constantine, form
a guard of honor for the Christian trophy. In reality, the iconographic theme is no
longer the same: instead of representing the Resurrection of Christ, that is, a
Christian dogma, this composition shows a consequence of that resurrection. As a
matter of fact, on the political level—which is evoked by the reliefs on the base of
the column of Arcadius—the consequence of the Resurrection of Christ is the
victory that the Cross, the instrument of Jesus' triumph, procures for the armies of
the Christian emperors.

Still another iconographical interpretation of the Resurrection was inspired by
Roman images of victory. It was probably in very late antiquity that this new
iconographic formula was created, later than the images of the Constantinian cycle
but at a time when allegorical images dealing with the triumph of the emperors
were still in use. The Christian subject matter is the immediate consequence of the
Resurrection, more specifically, the Harrowing of Hell. This event is interpreted *302*
as the triumph of Christ over Hades, the prince of the kingdom of the dead, who
compelled the deceased to stay eternally in his underground world. This manner of
conceptualizing the Descent into Hell defined for later times a subject which re-
mained particularly popular in medieval Byzantium. Under the name Anastasis

Resurrection, this scene often replaced all other representations of the Resurrection of Christ.

Iconographically, the Descent into Hell, as it was created in late antiquity, is a replica of allegorical representations of the victorious Roman emperor, shown pulling toward himself the kneeling or prostrate personifications of the conquered city or province or representatives from among its inhabitants. The official language of the Empire saw these representations of victory as images of the "liberation" of the vanquished, who were thought to have been torn from the "tyranny" of their leaders by the Roman emperor. This interpretation allowed the Christians to use the same iconographic formula for images of Christ descending into hell: victor over the tyrannical prince of death, he liberated and took to himself all the unwilling inhabitants of the kingdom, starting with Adam and Eve. The oldest extant instance of this image occurs in a fresco of the seventh or eighth century, in S. Maria Antiqua in the Roman Forum.

Sometimes all the images of Christ in Majesty, Christ Triumphant, and Christ as Lawgiver and Founder of the Church are considered together with the figurations of his Resurrection that we have seen. But these figurations, which are evocations of the eschatological future, or which confront us with celestial visions, do not represent the dogma of the Resurrection. Of course, the final salvation of men, the eternal reign of God, and the founding of the Church by Christ are all consequences of the Resurrection. But it is obviously a group of subjects of which none is confused with the Resurrection itself. When we turn to the iconography of the Incarnation in the next chapter we will come back to some of these images.

As we have seen, early Christian art did not make the Resurrection of Christ one of its central subjects as a priori one might have expected. But it did treat it, and even in different ways. The linguists would say: We have here an iconographical field, with the central theme of Resurrection and a choice of synonyms by which to refer to it. For a certain time, Christian iconography was content with allegorical symbols, the oldest of them borrowed from the repertory of current symbols of periodic resurrection, like the phoenix. Under Constantine, or later, these symbols were replaced by triumphal symbols corresponding to the military character that the emperors, turned Christian, imposed on Christian iconography. Independent of the formulas, there was a third representation of the Resurrection, also allusive, but inspired by the evangelical texts and Jewish juridical usage. This iconography evoked the Resurrection by showing the eyewitnesses of the event, whose testimony made the Resurrection of Christ a known fact.

These observations on the oldest images of the Resurrection have to be added to the conclusions concerning the iconographic expression of the dogmas of the Trinity and each of the Persons of God that we examined above. We have seen that,

while such representations as these were sometimes attempted, themes corresponding to dogmas seem nevertheless not to have held a central place in early Christian works; and we have observed also that Christian creations in this domain depended upon extra-Christian antecedents. By adapting the iconographic formulas which they found around them, or by composing new ones by analogy or by minor changes, the early Christian image-makers managed to endow their successors with a limited number of figurations corresponding to the fundamental conceptions of their religion. But this method of iconographic creation was inadequate to express all these ideas in a satisfactory fashion, and it had to be complemented by other methods.

VI. Dogmas Represented by Juxtaposed Images

Continuing our examination of early Christian images that attempt an interpretation of theological subjects, we will now leave the direct images which were self-sufficient and turn to a consideration of themes whose translation into iconographic language necessitated the juxtaposition of two or more figures or scenes. According to our classification, this is the second category of theological images.

Let us begin by considering images of the Incarnation.

The first group I will discuss has as its common denominator the theme of conception. To show the reality of the incarnation of the Word in the person of Jesus Christ, the image-makers undertook to represent the moment when the pre-natal life of Jesus began in the womb of his mother Mary. This iconographic theme had its source in the gospel text that revealed, in the words of the archangel of the Annunciation, the imminence of the conception by the Holy Ghost; and images of the Annunciation in every period have interpreted this idea. From at least the sixth century on, a ray of light is seen to descend on Mary from above, and the dove of the Holy Ghost hovers above or descends toward the ear of the future Mother of God. From this customary iconography of the Annunciation another developed, about the ninth century in the Byzantine Empire, showing Mary in prayer, with both arms raised, and on her breast the Child enclosed in a circle. This surprising motif was a convention to represent—by transparency, as it were—the future Child. The connection of this image with the Annunciation is illustrated by an icon of the late twelfth or early thirteenth century. It is in fact an icon of the Annunciation, but Jesus appears in anticipation in Mary's womb, so as to show quite plainly the beginning of the Incarnation at the moment of the Annunciation.

A variant from the conventional scene of the Annunciation is especially interesting for our study of methods of creation in Christian iconography. The preserved examples are mostly of late date, but they should be mentioned here because they help us to understand the meaning of the representation. In some rare versions

303

304

305

of this scene, Mary, at the moment of receiving Grace, is supported symmetrically *306*
by two young girls who hold her elbows. The best example is in a fresco at Ohrid,
in Yugoslavia, about 1300. The posture of the two attendants shows that, at the
moment that the Grace announced by the archangel descends on Mary, she feels
faint and needs support.

This interpretation is confirmed by the existence of a more hieratic version of
the same image of conception by divine intervention, this time with reference to *307*
St. Anne, Mary's mother. This image of Immaculate Conception is on the wall of
a rock-cut chapel of Cappadocia called Kizilçukur. The painting was attributed to
the ninth century by its discoverers. I think that it is slightly later, probably of the
tenth or eleventh century. In any case, it shows a second stage in the evolution of
the type, the first—a more realistic one—being represented by the Ohrid fresco
where Mary is supported by two young girls.

I have said "first stage," and this is correct so far as the adaptation of this icono-
graphic type to a Christian theme is concerned. But Christian iconography took
it, certainly, from the realistic images of childbirth that occurred in ancient art at
the beginning of the biographical cycles of gods and heroes, like Dionysus or
Alexander (see above, pp. 103 f.), or on the funerary monuments of simple mortals.
Sometimes—for example, in a miniature in the Ashburnham Pentateuch from *308*
Tours and in another in a manuscript of the Book of Kings in Greek in the Vatican *309*
—these scenes are rather crude depictions of childbirth, with the mother seated and
one or two other women supporting her, much as in the conventional images of
the conception of Mary or Anne. There is an early example of such a scene in a
Roman relief of the second or third century in the Museo Nazionale Romano in
Rome, and we have a counterpart of it, from the beginning of our era, in Indian
art: the mother of the Buddha is standing, a woman supporting her under the arm- *311*
pit. The child appears miraculously outside one of her hips (in conformity with the
Buddha's legendary life). An illustrator of the Life of Alexander the Great, in a
Latin version which goes back to a very early prototype, shows us once more the
group of three women, as in the images of the Immaculate Conception. Here the
image represents Alexander's mother, Olympias, feeling the first pains of child- *310*
birth. The miraculous origin of this event is pointed out by the presence, and the
words, of the magician Nectanebo. When the birth approaches, Olympias, still
standing, is grasped by her two companions, who hold her arms and support her,
in accordance with the custom that this whole group of images reflects.

For lack of a sufficient number of early examples I have had to turn to paintings
and sculptures of different periods to show the various steps in the history of the
iconographic motif—or, rather, the history of the formation of the iconographic
motif—of miraculous conception. At the basis of it was the realistic image of two

women supporting a third before or during childbirth: later, schematized and ennobled, this was used to represent a dogma.

A special feature of the dogma of the Incarnation gave rise to the creation of another motif springing from a genre scene. In scenes of the Nativity of Christ, *312* Joseph is sometimes represented as turned toward Mary and the Child and some- *313* times ostensibly turning away from them. The first type needs no special explanation: as the husband of Mary and protector of the Child, he normally turns toward them. But when he does the opposite—which is sometimes very clearly shown— one can legitimately ask whether Joseph's attitude is not a symbol, whether iconography did not thus find a way of showing that it was not Joseph who was the father of the Child.

314 A pavement mosaic recently found in Lebanon makes this supposition very plausible. It represents the scene of the birth of Alexander, that is, another scene of birth through divine intervention, where Philip, Olympias' earthly spouse, was a stranger to the birth of Alexander. What this mosaic shows is significant: Philip is seated in the left foreground, and he turns his back to Olympias and the newborn child. In other words, it is the same motif of turning away as in the Nativities of Christ. Moreover, while the Nativities of Christ show a heavenly ray falling on the infant Jesus, here a serpent (scarcely visible in photographs) slides along Olympias' body and, as an image of Zeus, designates the real father of Alexander.

In short, then, the pose of Joseph, when he turns away in scenes of the Nativity, is probably another motif—a discreet one—which the Paleo-Christian image-makers introduced to represent the virgin birth of Jesus and, indirectly, the fatherhood of the Holy Ghost.

Finally, still with respect to the Incarnation and the images of a historical kind which served to interpret it iconographically, I would like to propose a hypothesis, which, however, requires some additional information.

In illustrations of the Book of Kings, we find images that summarize schematically the career of a prince. The first scene shows his father and mother approaching each other and embracing; the second shows a scene of childbirth, the birth of the prince. The same sequence occurs in the cycles of the childhood of Mary; Mary's birth is preceded by the famous meeting at the Golden Gate of Jerusalem, where *315* Joachim and Anna embrace, as in Giotto's famous fresco at Padua. In both profane and Mariological cycles, the first scene is called the Embrace; and, in the story of the parents of the Virgin, it passes for the moment of the Immaculate Conception. From this the conclusion naturally arises that in the illustrated biographies of the Judaic kings also the Embrace is a symbol of conception. For a king, the illustrator considered it important to evoke not only the moment of birth but, first, the moment of conception.

Now if such was the importance and the meaning of the scene of the Embrace preceding that of the birth, should one not include among the symbolic images of Mary's conception the scene of the Embrace which, from the earliest evangelical cycles on, was shown before the Nativity and which in Greek was called by the same name, the Embrace (ἀσπασμος)? The Palestinian ampullae show typical examples of this sequence. In English and in French the scene is called the Visitation, and it shows the meeting of Mary and Elizabeth. Both women are pregnant, and Elizabeth, the first on earth to do so, proclaims the divinity of the Child that Mary will bear. A sixth-century mosaic at Parenzo, Istria (now Poreč, in Yugoslavia), provides an *316* excellent example of this event. The gospel episode was not the object of any special liturgical cult; there was no feast of the Visitation. This incident, however, figures in all early evangelical cycles, even where they are limited to a minimum of scenes. At Parenzo, in the apse, only two scenes are shown: the Annunciation and the Visitation.

The early Christians gave great attention to images of the Visitation. There must have been an important reason for this. It can perhaps be accounted for by the following hypothesis: The Christian image-makers of late antiquity were accustomed to biographical cycles where, before the birth scene, the Embrace of the parents was presented in symbolic reference to the conception. It seems to me that the familiarity of the artists with this usage disposed them to represent an Embrace before the Nativity of Christ. The meeting of Elizabeth and Mary furnished the possibility of reproducing the theme, since Elizabeth's words about Mary's unborn child permitted them to consider this episode as a testimony to Mary's conception. But since it was the Annunciation that, according to the words of the Gospels, corresponded to the moment of conception, the Christian image-makers placed the Annunciation and the Visitation side by side as two parallel images of the same theme of conception, the second being added—in conformity with common iconographic tradition—to show the first witness to Christ's conception. This interpretation of the relationship of the two scenes, if accepted, would furnish another interesting example of a Christian adaptation of an older motif. In the hands of Christian image-makers, this motif acquired the meaning of a Christian dogma.

The images of the Incarnation which we have considered so far represent this dogma by means of historical scenes evoking—or at least making allusion to—the beginnings of Christ's earthly life, either through the conception or through the birth of God made man. It goes without saying that, indirectly, any scene that shows Christ in the course of his earthly career is a reference to the Incarnation. This is especially true of images of his death on the Cross, since this death always figured among the major proofs of a complete incarnation. It was not in late antiquity, however, but only at the beginning of the Middle Ages that image-makers began

to use the subject of the Crucifixion as a representation of the death of Jesus. In late antiquity, the scene of Golgotha, sometimes realistic in detail, did not extend its

317, 318

realism to the figure of the Crucified, and especially not in order to represent him after his death; for here, as elsewhere, the evangelical scene serves to proclaim a truth. It is often said that the image-makers did not dare to approach the subject of the Crucifixion, but this is a gratuitous affirmation, particularly in view of the fact that the theologians of the same period treated it constantly. It would be more judicious to maintain here our usual point of view and to state that during this period images of the Crucifixion were used not to designate the reality of Jesus' death but to demonstrate the glory of Christ, his victory over death (that is, as a symbol of the Resurrection), the universality of salvation through the Cross, and so on.

To return to the Incarnation: It is important to point out the existence of a second method of representing this dogma. In this treatment the Incarnation is no longer expressed through historical scenes but by means of two or more images which are juxtaposed and grouped in a certain way and must be understood in that relationship. Let us examine some examples before we consider more generally this iconographic procedure.

319

A beautiful example, despite its small size, occurs in a relief that decorates an ampulla of the sixth century, made in Jerusalem. It shows an orant Mary with a brilliant star above her between the torches held by personifications of the sun and moon, who turn aside, dazzled, protecting their eyes with their hands. The star descends toward the Virgin, framed by rays of light that seem to emanate from the starry aureole of Christ. The aureole enclosing Christ is suspended in the heavens, supported by four angels.

The entire composition is a transposition into more abstract, and at the same time more explicit, language of the ideas represented in the preceding images. The orant Virgin is borrowed from the Annunciation. The ray of light and the Hand of God that gives God's blessing from above, or the dove that descends in the ray of light, are replaced by the great star that is usually found above a delineation of the manger of the Nativity or above an image of Mary with the Child when these motifs represent the future Incarnation announced by a prophet, as in the catacomb

320

of Priscilla and elsewhere, or the recognition of the Incarnation by the Magi and the shepherds, as in catacomb paintings, Palestinian ampullae, etc. The star is a

321

symbol that Grace has descended on Mary, as in pagan and Imperial iconography it symbolized the astral existence of the persons above whom it was placed: the Dioscuri or certain men after their death such as Roman emperors or heroes. The Christian image-makers naturally derived their star from the evangelical text that mentions the star of Bethlehem, but the use of the star above the figure of Mary

when she was represented in scenes other than the Nativity and the Adoration of the Magi was suggested by pagan iconography, where the star was a symbol understood by all to mark the divine presence. On the ampulla, the great star clearly indicates that the same God who is simultaneously represented above it, and from whose feet emanate the rays of light that frame it, is present within Mary.

The image-maker must, however, have considered the central part of his composition insufficiently clear, and he completed it in such a way as to exclude any ambiguity. For, besides the two angels who worship Mary as the Mother of God, he included, on either side of the Virgin, John the Baptist and the prophet Zacharias. John holds a sign on which are written the words that he addresses, in anticipation, to the Child to be born of Mary: "Behold the Lamb of God, which taketh away the sin of the world" (John 1:29). Zacharias, father of John the Baptist and priest of the Temple of Jerusalem, swings his priestly censer, but it is surely because of his words of prophecy that he is here: "The dayspring from on high hath visited us, To give light to them that sit in darkness and in the shadow of death" (Luke 1:78–79).

The presence of these two prophets and the words of John the Baptist that are reproduced on his scroll indicate quite precisely the image-maker's intentions. This is a scholarly figuration of the Incarnation-Redemption, and it gives us a new opportunity of seeing how a Christian image-maker proceeded when confronted with an abstract theme. All the elements that he puts to work are borrowed from evangelical history. Their arrangement is inspired by prophetic visions of God. And, finally, he uses the method of juxtaposing images that are independent of each other, such as the prophets and the events which, although announced by the prophets, occurred at other times and other places. By juxtaposing them, he evokes both the prophecy and the profound significance of the historical event. Through the words of John and the censer of Zacharias, the composition on the ampulla emphasizes the connection of the Incarnation with the redemption from sin and the sacrament of the Eucharist, which renews the sacrifice of the Lamb at each Mass.

It is natural, given these meanings, that compositions of this kind are usually to be found in the choirs of churches. It is even probable that they were created as apsidal images. A familiar example is a seventh-century mosaic in S. Venanzio, a chapel adjacent to the Baptistery of St. John at the Lateran. Like the ampulla, this mosaic shows Christ in heaven and, on earth, the orant Mary surrounded by saints. The similarity to the more specific image of the ampulla makes it certain that the meaning of the mosaic is identical. It is a bold schematic figuration of the work of God *sub specie aeternitatis et universi*, for it invites us to contemplate simultaneously, and in an order corresponding to the structure of the cosmos, God apart from the Incarnation (above) and, by allusion, God made man for universal salvation (below).

322

Several apsidal paintings at Bawit treat the same general theme that we have observed on the ampulla and in the chapel of S. Venanzio. They demonstrate that this unchanging theme could be interpreted through similar but not identical motifs, which, despite their different origins, were employed to represent the same thing. This means that when these motifs formed part of complex compositions like those at Bawit they were considered to be equivalent signs.

323 Several frescoes at Bawit show Christ in an aureole and a number of apostles below. These two elements of the composition are plainly borrowed from the iconography of the Ascension, while other motifs are foreign to that scene. The painters of Bawit were not deterred by rather curious mixtures. For instance, in one of the chapels, Ezekiel appears among the apostles of the Ascension as a visionary, an indication that this theophany of Christ was beheld by the prophet. Nevertheless, the apostles also are there, and we can see why: If the vision of God in heaven corresponds to the theme of God apart from the Incarnation, the lower part of the image must necessarily evoke the Incarnation. Now this is tenable for an image of the Ascension, even a partial one, but not for a figure of a prophet, who belongs to the world before the age of Grace.

325 With only one exception, Chapel 45 (perhaps due to lack of space?), it is the Virgin who is represented at Bawit, alone or with the Child, on the axes of the apses under the vision of God, as the iconographic sign of the Incarnation. It is she who, placed under the image of God in eternity, is charged with the representation of the mystery of the Incarnate Word. It is precisely through this grouping by opposition (God in eternity—God incarnate) that the image-maker tried to express the dogma of the Incarnation. The idea, manifestly, was to translate the dogma by means of the image of the maternity of Mary. It is especially obvious in those apse paintings

324 where Mary holds the Child in her arms or, better still, nurses him. Even where

326 Mary is alone, her arms raised toward heaven, she represents the Mother of God, because this gesture—as we have seen on the ampulla from the Holy Land now at Bobbio and in the mosaic of S. Venanzio—corresponds to the idea of Grace descending on her, that is, the idea of the conception and the beginning of the Incarnation. It is because the image of Mary as orant meant this that the iconography of the Ascension, with its orant Virgin, enjoyed great popularity at Bawit, although apparently in the eyes of the artists there it was not the Ascension that was the theme of the apsidal compositions but, quite evidently, the image of the Mother of God placed under the celestial vision of God. That this is the theme is brought out by the variety of the iconographic types of the Virgin shown in the paintings, while the vision above and the surrounding apostles remain the same.

It is understandable, too, why this kind of composition was usually placed in the apse of a church or chapel: it is because the idea of the Incarnation was closely

tied to the sacrament of communion, celebrated before the apse. The communion presupposes Incarnation and explains the frequency of the images of Mary in the apse. In some of the apsidal paintings at Bawit, the idea of communion is rendered especially emphatic, as, for example, in Chapel 51, where the chief apostles, placed above the others, are shown holding the chalice and Eucharistic bread: here the allusion to the communion is direct and evident. But, in fact, the presence of the Mother of God with the Child (or as orant) said the same thing: Incarnation and communion, the second being a function of the first.

The frescoes at Bawit illustrate the dogma of the Incarnation in another way than through scenes of the coming of the Logos on earth. This method of representation utilized more abstract formulas than we have seen previously. Moreover, it had two particular features that the historian of iconography should not fail to notice.

(1) It took into account the liturgy, its special themes and its material tie with the places of worship. In this connection, we will find other realizations of the same kind, which, though rather complex, are still clear.

(2) It achieved new figurations by grouping several motifs and different scenes in a single demonstration. As we mentioned before, this method produced some of the most interesting and most explicit creations in the field of dogmatic iconography.

The first method of representation that we observed, before considering the ampulla and the apsidal compositions showing the Incarnation, used direct iconographic terms, terms which individually define a theological idea (exactly like a term of written or spoken language that consists of a single word or a brief and simple phrase). But on the ampulla and at Bawit and in other examples which will follow, the iconographic definitions are arrived at by juxtaposition of two or more iconographic locutions. Each term has its value only as a function of the others which are brought together with it, and only in the precise combination thus made. In language, the counterpart would be a definition demanding the concurrence of several and even many words or phrases, where the context—vocabulary and syntax—gives meaning to each term employed. At the period which interests us, this second method of procedure in iconography was very fruitful; and we know many different applications of it, which include the most significant of the creations that translate happily a profound religious thought.

Beginning with the simplest series of examples, let us turn first to the Paleo-Christian works where, as on Italic sarcophagi of the fourth century, there are two registers of reliefs. On the principal register of such a sarcophagus at S. Ambrogio in Milan, Christ is represented with the assembly of apostles; and on the narrow register below, a row of sheep flank the Lamb. The Lamb, of course, is Christ, the

327

328

sheep are the apostles, and the choice of these animal symbols, rather than any other, is explained by the Gospels, where the Lamb and sheep are specifically mentioned. But why are two images, different in form but identical in subject—synonyms, so to speak—brought together on the same sarcophagus façade?

This is a procedure to which early Christian image-makers were very partial. The apostles and Christ, coupled with the sheep and the Lamb, occur on apsidal mosaics in early Christian basilicas and for a long time afterward (in Rome, there are examples of the twelfth century). The same method is used on small objects, such as the Pola casket; and all the examples raise the same question: Why repeat a thing, changing the manner or the mode? It is as though one said the same thing twice, once in words and once in code, or, better, once in plain terms and again in metaphors.

So far as I know, no one has considered this small problem. It can, however, tell us much about the psychology of early Christian art. The Gospels, as we have just mentioned, speak of the Lamb and the sheep, and also of the dove of the Holy Ghost and of several other allegorical animals. On the other hand, Roman art of the period favored allegorical images and gave an important place in its iconography to animals and birds symbolizing the gods, the Empire, and the legions: the eagle of Jupiter and of the Empire, the peacock of Juno; lions, bulls, falcons, and so on, which represent particular units of the Roman army. Usually pagan monuments show either the effigy of the god or his symbolic animal. If, exceptionally, we find Jupiter with his eagle beside him, or Juno with her peacock, or the personification of a province with the totem animals of the legions, these animals were the accessories of the gods and goddesses rather than their doubles; and, of course, in the case of the totems of the legions, they complemented, but never replaced, a personification of a province.

It seems to me, therefore, that this method of duplicating images—the realistic and the allegorical—is specifically Christian and has its sources in the gospel language and in Roman iconography. The duplication is only partial: the Lamb, represented in addition to Christ, does not signify simply the same Christ, but is a symbol of Christ as victim, sacrificed for the salvation of men; the sheep are the apostles, and they also represent the martyrs and all the faithful, not everywhere and in everything but the disciples and other Christians as the flock of the Good Shepherd, that is, those who obey him and will be recompensed by him. This juxtaposition of two different modes of expression, apparently superfluous and thus inexplicable, is in fact a means of bringing out a particular nuance not apparent in the basic image. On the sarcophagus mentioned above, the central image shows a beautiful figure in whom Christ is easily recognized; but the Lamb, shown at the same time, reminds us that Christ is the Saviour who sacrificed himself as one sacrifices a lamb

on the altar of a temple. The metaphor serves, as it does in language, to give more precise significance to a story.

This first type of iconographic creation by juxtaposition is original, but it is also inflexible and offers little opportunity of expressing finer and more complex religious ideas. It was thus quickly, and completely, abandoned. Very little remains of it after the sixth century either in Byzantium or in Italy or Gaul.

But, in contrast, another whole realm of comparison opened wide for the Christian image-makers when they realized that iconography could well follow the lead of the theologians and of liturgical usage and profitably bring together subjects from the Old and the New Testaments. This is not a matter simply of material proximity (as on the walls of the catacombs and sarcophagi) but of deliberate juxtaposition to which a meaning was attributed. Of course, the same images were juxtaposed in different ways, and then the intended meaning also varied.

In certain cases, subjects drawn from each of the Testaments are shown together without any idea of establishing a direct correspondence between the persons or events that are depicted. The meaning here is: beginning in Old Testament times, history continues under the new covenant, and the images reflect the unfolding of events in two successive stages. This formula may represent the earliest type of juxtaposition. In fact, we have an archaic example in S. Costanza in Rome. The mosaics of the cupola, of which only old drawings are preserved, showed two rows *331* of little scenes: those below devoted to the Old Testament and those above to the Gospels. In the present state of our knowledge, the cycle cannot be reconstructed, and in the register of the New Testament only one scene can be identified: the cure *332* of the centurion's servant. Despite this, the absence of correspondence scene by scene seems to be established. In the sixteenth-century drawings which show the superposed scenes, the healing of the centurion's servant is placed above a scene of the sacrifice of Elijah in one instance and, in another, above a scene with Susanna; moreover, the Old Testament subjects that are represented (Adam and Eve in paradise, the sacrifice of Cain and Abel, Moses striking water from the rock, Susanna and the elders, Tobias and the fish, the sacrifice of Elijah) all belong to the large category of paradigms of deliverance accorded to various Biblical personages through prayer. In other words, it is another version of the earliest cycle of Paleo-Christian art, the cycle of salvation or deliverance, which was especially frequent in funerary art but which was also found elsewhere than in sepulchral use (for example, on gilded or engraved vases).

Another example of juxtaposed, but not corresponding, scenes from the two Testaments belongs to the seventh decade of the fourth century: I am thinking of the Brescia lipsanotheca. The Old Testament subjects here are more numerous, *333–337* while the Gospels retain only moral predominance by the central placement of

the panels devoted to them and their larger scale. The arrangement is this: On the four sides of the casket there are three superposed registers (above them, in addition, there is a row of heads in clipei). The central register is wide and shows figurations that are properly Christian, while the numerous Old Testament images are crowded together on the narrow bands that border it above and below. It is easy to establish the absence of any link (by likes or opposites) between the scenes of the two borders and those of the central panel. To take only the principal face of the casket: the borders show the stories of Jonah, Susanna, and Daniel, while in the central panel there are the *Noli me tangere*, Christ teaching, and Christ at the entrance of the sheepfold. Examination of the other sides of the casket (and its cover, which has only gospel scenes) leads to the same conclusion. The ensemble of subjects from the Old Testament and the ensemble of subjects from the New Testament on the Brescia casket cannot be compared with each other; there are no appropriate terms of comparison.

335

Here again we find, as at S. Costanza, the initial Biblical cycle, the paradigms of deliverance. It is, in principle, the same cycle that had such popularity in the catacombs and on sarcophagi. Here it is enriched by episodes that funerary art never, or almost never, used. Thus in the sixties of the fourth century, the Biblical cycle of paradigms of deliverance was still flourishing and growing.

This growth is revealed with particular force in the frescoes of the newly discovered hypogeum of the late fourth century under the Via Latina in Rome. Biblical subjects, and especially scenes drawn from the Old Testament, are more numerous there than elsewhere; the paintings include several subjects that had not been found before in Roman funerary art. The discovery is of lively interest to the historian of the iconography of late antiquity, but it is not necessary to pause longer over it here because the Biblical paintings of this hypogeum, which are dispersed in different cubicula, do not present iconographic ensembles of subjects chosen and grouped together in order to demonstrate some theological idea. The paintings are simply an extension of the usual Paleo-Christian funerary cycle where, in principle, each subject stands alone. This is true despite the painters' tendency in these works to transform image-signs into narrative images and despite the appearance of several scenes that do not fit into the category of deliverances but simply make some reference to sacred history (the story of Isaac and Jacob, etc.). The paintings of the hypogeum probably reflect monumental wall paintings in churches.

242–244

By contrast, on certain monuments of the fifth and sixth centuries, there are systematic cycles based on the books of the two Testaments where, however, the method is still the same as that outlined above: that is, the Old Testament and gospel subjects that are brought together do not form direct counterparts, either in the ensemble or subject by subject within each series. In other words, the subjects from

the Old Testament and the subjects of the New form separate wholes, which are carefully distinguished topographically. But binomial composition is not pursued farther, and each cycle keeps to the narrative text of the Scriptures, without attempting to raise echoes in the neighboring cycle.

Such, for instance, are the mosaics of S. Maria Maggiore in Rome and the ivories of the throne of Maximian in Ravenna. In these two well-known works, the iconographic ensemble includes a cycle of the New Testament and a cycle of the Old. At S. Maria Maggiore the two cycles are separated by their different locations, the gospel scenes being on the triumphal arch and the Old Testament scenes in the nave. On the throne of Maximian a similar separation appears, first of all, in the use of each of the cycles on a different part of the chair: the back (both sides of it) has gospel scenes; the arms, Old Testament ones. Is it simply chance that there are such similarities in the procedures of the designers of these very different works? The similarities go further. In both cases, the group of evangelical images beside which the Old Testament cycle is placed evokes the beginnings of the age of Grace and the Incarnation; and in both works each of the two cycles is characterized by similar treatment: the Old Testament episodes are presented as descriptive genre scenes recalling the successive stages of a story, while episodes of the childhood and youth of Christ are presented in a more solemn and deliberate fashion, like parts of a demonstration. At S. Maria Maggiore the scenes of the childhood of Jesus on the triumphal arch acquire their solemnity by being adapted to the formulas of Imperial iconography; on the throne of Maximian, each episode (or sometimes the two separate halves of a scene that is artificially cut into two images) is transformed into an autonomous picture in its frame, and each subject, even the homeliest, becomes a solemn event.

Both monuments are excellent examples of the procedure under consideration. Its significance lies in the use of Old Testament themes in support of a cycle of images drawn from the New. That the latter are the more important is clearly shown, and there are several ways of stating their pre-eminence. The most unexpected of these is the phenomenon that we referred to before, in Chapter IV, that the images from the New Testament become objects of more or less deliberate interpretation (serving as a demonstration), while in most cases the Old Testament images remain simply narratives. Hence the observation, directly pertinent to the present study, that Old Testament subjects, when they are used in iconographic ensembles that bring the two Testaments together, are descriptive in appearance. The images seem to have been taken as such from other monuments for which they were originally composed, whereas their neighbors, the evangelical images, are made to order. The hypothesis that seems to me most plausible is that the Old Testament scenes which were adopted for these complex iconographic ensembles

come from illustrations of manuscripts of the Old Testament of the type represented by the Vienna Genesis or the Ashburnham Pentateuch. These perhaps afforded the stock of Old Testament images that were called upon as the need arose. There was, after all, much less occasion for their use—except in the funerary cycles of the third and fourth centuries—than for images drawn from the New Testament.

Another iconographic problem is posed by such works as the mosaic decoration of S. Maria Maggiore and the ivory decoration of the throne of Maximian. If one plans to use an Old Testament cycle near a New Testament cycle, why choose a story from the Old Testament (as on the throne) or several such stories (as at S. Maria Maggiore) which in no way correspond to the basic evangelical cycle? Let us look at the facts.

At S. Maria Maggiore, the cycles that are lined up one after another and facing each other represent the great deeds of Abraham, Moses, and Joshua. These are certainly important chapters in the history of the chosen people before and after the giving of the Law, and they contain an abundance of significant and celebrated episodes that Christian theologians had compared with various events of the gospel story or with certain ideas held by the Christian faith. Their evangelical counterparts, however, are not found among the few subjects of the childhood of Jesus that are assembled on the triumphal arch of the same church. It would not be wrong to put the matter this way: At S. Maria Maggiore, the Old Testament subjects represent some of the earliest chapters in the history of salvation; some chapters of this history, which go back to the time of the great leaders of Israel, are evoked first, and then the same story is continued beyond the beginning of the age of Grace in the scenes of Jesus' childhood. I think there is no reason to look for any other link between the mosaics of the nave and those of the arch.

The case of the throne of Maximian is analogous in that the story of Joseph does not counterbalance the story of the childhood of Jesus and his miracles. Parallelism is, of course, possible here, since Joseph had always been considered an antetype of Christ. But the artist did not take advantage of this relationship, and the two cycles show no parallels unless it be in allusions to the theme of the repast and thus perhaps to communion. In the choice of gospel scenes, the absence of the Passion and the Resurrection seems to indicate that the person who was responsible for this iconographic arrangement had little interest in establishing any connections between the life of Joseph and the life of Jesus. So here again the most plausible explanation is the same: the arrangement is not a matter of cycles from the two Testaments shown as parallels but an evocation of two important chapters of the same sacred history that began at the Creation and continues beyond the Incarnation.

In respect to the Old Testament subjects introduced into the two Christian works just discussed, two things must be emphasized: the attempt to demonstrate

the unity of sacred history since the beginning of the world, and the presentation of this history in two successive periods corresponding to the Old and the New Testaments.

There are, however, a number of Paleo-Christian monuments where Old Testament subjects are not simply references to persons or events having their place in this continuously unfolding sacred history, with its two successive periods, but are, instead, references to some mysterious but all-important link established by Providence between the events of the two Testaments. This link, which we have mentioned before, is affirmed by the Gospels and in the Epistles of St. Paul, and under exactly the same form that appears in certain works of Paleo-Christian art. I am thinking of the following theme: a prophecy made in the course of the Old Testament is realized in gospel times. In iconographic terms, this theme becomes the image of an event of the age of Grace accompanied by the figure of the prophet who, *sub lege*, announced the event. In the catacomb of Priscilla, there is perhaps a prophet Isaiah next to a Virgin and Child to say that the birth of the divine Child was prophesied by Isaiah. In the Sinope Gospel fragments in Paris and in the Rossano Gospel the same method is used with all possible clarity. The gospel event which is represented is regularly accompanied by two or four prophets who point to the scene and who hold enormous open phylacteries. On the parchments are written the words of the prophets predicting the event which is shown near by: above the prophets in the Rossano Gospel, between them in the Sinope Gospel. The Rabbula Gospels have a simplified variant of this scheme, with the prophets of the Old Testament lined up above the canon tables, which form a concordance for the story of evangelical events. The content of the individual prophecy is not revealed, nor is the exact event of the age of Grace to which it refers. The prophets that are shown on the side walls of S. Apollinare Nuovo beneath the topmost register of gospel scenes were perhaps placed there with the same idea: the prophets, in a body, are placed before the group of events that they predicted.

Although the iconographic means available to the authors of these images were very limited, they are of great interest to us in this study. For, in fact, what we see here is the simplest way of expressing in iconographic language the idea that the Old Testament not only preceded the New but foreshadowed or prefigured it; and this is exactly what these iconographic images were meant to convey.

It is more difficult to give iconographic expression to links of another kind between the two Testaments, where the activity of a certain person or a specific event is involved. It has been said that if Jesus himself compared his destiny to the experience of Jonah, and the Cross to the brazen serpent, his followers went a great deal farther. They sought and found innumerable significant resemblances between the persons and events of the two Testaments. In doing so, they were adapting a

very common procedure to Christian thought. It was the old method of Stoic origin that established mysterious correspondences between events widely separated in time and space, and that frequently appealed to symbolic interpretations of mythological and historical stories to facilitate such correspondences. Philo was the first to apply this method to the Bible, proposing symbolic interpretations of events and objects mentioned in the Mosaic books; and he opened the way to a typological exegesis of the Old Testament by comparison with the New.

I do not know whether the rather early texts (St. Nilus, Prudentius, etc.) that mention the simultaneous presence of cycles drawn from the Old and New Testaments on the nave walls of basilicas in the fifth century refer to antithetical cycles or not. St. Nilus speaks of an ideal church (*Epistula* LXI: *Ad Olympidoro Eparcho*, in Migne, *PG*, LXXIX, 577 f.), and the other texts refer to the great basilicas of the West. We do not know the monuments to which these texts refer; neither have we lists of the subjects represented. We cannot, therefore, know whether the images that they showed were counterparts taken from the two Testaments, such as we see in the Middle Ages, or whether they were intended to do no more than demonstrate the continuity of a single iconographic story across the two Testaments in a formula comparable to that of S. Maria Maggiore.

Something new appears only when we come to the reliefs of the famous sculptured wooden door of S. Sabina in Rome. The basilica, if not the door itself, can be dated in the pontificates of Celestine I (422–32) and Sixtus III (432–40). The work is thus contemporary with the mosaics of S. Maria Maggiore which we have been considering. But the manner in which the Old Testament images are used is different and more knowledgeable. This can be affirmed in spite of the fact that some of the sculptured panels have disappeared and that there is some doubt as to the original placement of the panels.

Whatever the original number of the sculptured panels was, or whatever their arrangement on the door of S. Sabina may have been, there are obviously pairs of panels that without any question go together. Their form and content make them like the two leaves of a diptych. These panels were surely placed originally as they are now, beside each other. The first of these symmetrical panels was dedicated to Old Testament subjects and the other to gospel subjects. Let us look at one example. On the first panel there are the miracles of Moses in the desert: the sweetening of the bitter waters of Marah, the provision of quails and of manna for the children of Israel (in two scenes), and the striking of water from the desert rock. On the panel beside it (now at its left) some of the miracles of Christ are represented: the cure of the blind man, the multiplication of the loaves and fishes, and the wine-making for the marriage feast at Cana.

The image-maker's method was direct comparison of the miracles of Moses

338

339

and those of Jesus. He arrived at this iconographically by putting the two reliefs to be compared beside each other and then giving them the same dimensions, presenting the miracles of each series in small superposed scenes separated from each other by a horizontal motif designating the ground. The intended parallelism is certain, even though the symmetry is not absolute, since only three miracles of Jesus stand beside the four miracles of Moses.

This juxtaposition of two series of events apparently having little to do with one another becomes legitimate and takes on significance in the light of contemporary works of verbal exegesis. The authors constantly refer to stories chosen from the Old Testament and then proceed to reveal their hidden meaning, which is typological: the tree which sweetened the bitter waters is a figure of Christ himself or of the Cross of Golgotha; the wood that makes Marah's waters drinkable is the first version of the wood of the Cross of Golgotha, and the spring itself anticipates the spring of living waters with which Jesus waters his faithful flock. As for the desert rock, it is the antetype of the crucified Christ, from whose side water and blood will run. The quails and the manna are antetypes of the food that will be served at Cana and at the Last Supper. The Last Supper (symbolized by the multiplication of the loaves and fishes) and the marriage feast at Cana figure on the second panel; the Cross is shown in the image of the Crucifixion, placed just above the panel here described in the present arrangement of the subjects in the door.

Origen, Tertullian, Gregory of Nyssa, Ambrose, and Augustine all made comparisons of this kind. They involuntarily invited the image-makers to do the same thing. We also owe to these fathers of the Church another kind of juxtaposition. It is equally frequent in their writings and consists of recognizing allusions to the sacraments of the Church in the events of the Old Testament. Thus any event of the Scriptures that mentions water is classed among the antetypes of the sacrament of baptism, and especially those miracles of Moses where water is involved. And all references to a meal, including a fortiori miraculous ones like those of Israel in the desert, are welcomed as allusions to the sacrament of communion. This may explain, among other things, the solemn and hieratic representation of the people who eat the manna and quails in the middle of the desert: in a noteworthy anachronism, they are already communicants.

Other correspondences of the same kind between Old Testament and gospel subjects were worked out on the door of S. Sabina, but not always with equal success. Some of the correspondences, and even some of the scenes, are obscure. Nevertheless, the method is the same, and it is used for the reasons we have mentioned. These reasons can be summarized briefly. Iconography was intended to reveal the secret but essential meaning within sacred history of certain events related in the Old Testament, to make that meaning specific by showing that the given events of

the Old Testament were direct and individual antetypes of events of the New Testament, and to show that the correspondences existing between such symmetrical facts extended also to the history of the Church, whose sacraments have their prefigurations in the Old Testament.

Iconography rises here to the level of theological commentary. For this task, intellectually more demanding, new material procedures were evolved: physical juxtaposition of the images which were to be compared; repetition of the same dimensions, proportions, and arrangement for these juxtaposed images; and use of meaningful details to augment the resemblance. A tree is shown in the scene of the bitter waters of Marah not so much because Moses' miracle there required it as because the symbolism of wood (the wood of the Cross) came to be the essential reason for its presence. The rock from which Moses strikes water is shown very prominently because this rock represents Christ. In the scene of the miracle of Cana, only Christ and the amphorae are retained, so that this image makes a counterpart to the miracles of Moses. Clearly, the methods that image-makers of the age of scholasticism were to use constantly already have their beginnings here.

The image-makers here transcended a simple demonstration of Old Testament antecedents or Biblical promises of events of the age of Grace. Having discovered the possibility of evoking Old Testament antetypes, the exegetes—writers and image-makers—were able to enrich their commentary on gospel events with new and suggestive details. Each of its antetypes amplified the event or showed it in a new light; and, conversely, the custom of citing Old Testament antetypes in reference to their gospel counterparts enriched the Old Testament story at the same time. We have just seen how this is translated into iconography: the scenes that represent the children of Israel eating in the desert are shown in a new way because the meals were recognized as future sacraments.

340, 341 One of the most remarkable results of the same method of using Old Testament subjects is seen in the choir mosaics of S. Vitale at Ravenna. Though the elements are similar to those described above, the effect is different in that the ensemble of mosaics in the choir is used to demonstrate, in remarkably harmonious fashion, a single general theme, with the Old Testament subjects appearing not in a series of more or less equivalent diptychs (as at S. Sabina) but comprehended within the ensemble, blended into this one single composition. The theme of the ensemble, however it be worded, is the work of salvation that God has pursued from the time of Moses, who was given the Law, through the prophets, to its decisive moment in the Redemption (the Lamb and the Evangelists in the crown of the vault); the answering piety of man, with his offerings to God in the Old Testament (Abel, Melchizedek, Abraham) and the New Testament (the Magi and the Imperial couple); and finally, in the apse, Christ in majesty reigning in paradise at the end of time.

The Old Testament is represented by Moses on Mt. Sinai, the prophets, and the offering scenes of Abel, Melchizedek, and Abraham. No New Testament scene is introduced into the cycle (except for the Adoration of the Magi embroidered on Theodora's robe) as a counterpart to any of these, but the Old Testament subjects are at the very center of the general demonstration. They are as indispensable to the equilibrium of the iconographic ensemble as the events that they recall are to the total work of divine salvation, in which each of them has its own place. This manner of using Old Testament subjects marks the beginning of a procedure that became common in the Middle Ages, just as did the method used at S. Sabina. But S. Vitale, I think, is a forerunner primarily of the variant method principally seen in Byzantium in medieval times, especially for mural decorations of churches with cupolas. These retained, like S. Vitale, only a limited number of Old Testament subjects, carefully integrated into a strict system of figurations where, together, they represent sacred history from the time of the first covenant (excluding any reference to the original sin).

Here again—at S. Vitale and in the Byzantine monuments which follow its lead—the exposition of events of the age of Grace is enriched and amplified by reference to their antetypes in the Old Testament. In the iconography of S. Vitale (where the iconographic decoration is limited to the choir) representations of the age of Grace are put in the most prominent positions and a gold background is reserved for them, but most of the wall space is devoted to Old Testament subjects. This seems to have been done for purposes of demonstration, and it is true that Old Testament subjects lent themselves easily to iconographic exposition because they were dramatic and picturesque. But the Old Testament scenes, particularly those of offerings, as at S. Vitale and at S. Sabina, showed in addition the influence of the liturgy; for these images translated the thought of the exegetes, who, when they evoked Old Testament offerings, did so in order to make them into antetypes of the Eucharistic offering.

Considered from the point of view of Christian iconographic language, the use of Old Testament subjects is extremely important. Even taking only the Mosaic books and the other historical books of the Bible, including the Psalms and the prophetic books, the mass of subjects that they offer is enormous, including people, situations, and events from the simplest kind of scene to theophanic visions. Beside these, the Christian subjects are insignificant in number, more monotonous, less dramatic, and often (in all that concerns the teaching of Jesus) less adaptable to iconographic interpretation.

For the Christian image-maker of late antiquity, and for his successors in the Middle Ages, the use of Old Testament subjects opened the door to a prodigious enrichment of his vocabulary of iconographic terms. It gave him new opportunities

of demonstrating the Christian truth in iconographic language. It made more innovations possible, allowing him to shift the meaning of a common image in the direction he chose. The image-maker drew from this expansion of his field of vision all the advantages that the author of a literary work would draw in a similar situation if the means of expression available to him were suddenly increased by more terms and more ways of using them, in order to make his meaning more exact or more imaginative or both of these at once.

Like theology, Christian iconography profited greatly when it turned to Old Testament subjects, not only because they increased the number of images an artist could use but because, in furnishing him with a more varied and far fuller iconographic vocabulary, they increased his potentiality for expression and rendered him more capable of accomplishing the tasks that the Christian religion set for him.

SELECTIVE BIBLIOGRAPHY

Selective Bibliography

Instead of notes, a selective bibliography has been compiled. In addition to a general reading list, each chapter is provided with a list of books and, more rarely, articles dealing with subjects mentioned in the text. The works cited are principally well-known ones containing reproductions of the monuments referred to and other monuments of the same kind. Only a few monographs or other studies of these monuments are cited: specifically, only those which in their treatment of allied subjects complement or justify the observations made here.

General

PUBLICATIONS PERTINENT TO ALL THE CHAPTERS OF THIS STUDY:

BAUR, P. V. C. "The Paintings in the Christian Chapel." *The Excavations at Dura-Europos Conducted by Yale University and the French Academy of Inscriptions and Letters: Preliminary Report of the Fifth Season of Work, October 1931–March 1932.* Edited by M. I. Rostovtzeff. New Haven, 1934.

BENOIT, F. *Sarcophages paléochrétiens d'Arles et de Marseille.* (Gallia, suppl., 5.) Paris, 1954.

BERCHEM, MARGUERITE VAN, and E. CLOUZOT. *Mosaïques chrétiennes du IV^e au X^e siècle.* Geneva, 1924.

CABROL, F. *Dictionnaire d'archéologie chrétienne et de liturgie.* 15 vols. Paris, 1913–53.

DELBRÜCK, R. *Die Consulardiptychen und verwandte Denkmäler.* (Studien zur spätantiken Kunstgeschichte, II.) Text and atlas. Berlin, 1926–29.

FERRUA, A. *Le Pitture della nuova catacomba di Via Latina.* (Pontificio istituto di archeologia cristiana. Monumenti di antichità cristiana, series 2, 8.) Vatican City, 1960.

GERKE, F. *Die christlichen Sarkophage der vorkonstantinischen Zeit.* (Studien zur spätantiken Kunstgeschichte, XI.) Berlin, 1940.

GRABAR, A. *Ampoules de Terre Sainte (Monza-Bobbio).* Paris, 1958.

KRAELING, C. H. *The Excavations at Dura-Europos . . ., Final Report, VIII, pt. 1: The Synagogue.* Edited by A. R. Bellinger and others. New Haven, 1956.

LAWRENCE, M. *The Sarcophagi of Ravenna.* [New York] 1945.

PEIRCE, H., and R. TYLER. *L'Art byzantin.* 2 vols. Paris, 1932, 1934.

TALBOT RICE, D. *Kunst aus Byzanz.* Photographs by M. Hirmer. Munich, 1959. (*The Art of Byzantium.* London [1959].)

———. *Art of the Byzantine Era.* New York [1963].

VOLBACH, W. F. *Elfenbeinarbeiten der Spätantike und des frühen Mittelalters.* (Römisch-germanisches Zentralmuseum zu Mainz. Katalog 7.) 2nd edn. Mainz, 1952.

———. *Frühchristliche Kunst.* Photographs by M. Hirmer. Munich, 1958. (*Early Christian Art.* [Translated by Christopher Ligota.] New York [1962].)

WILPERT, J. *Die Malereien der Katakomben Roms.* Freiburg im Breisgau, 1903.

———. *Die römischen Mosaiken und Malereien der kirchlichen Bauten vom IV. bis XIII. Jahrhundert.* 4 vols. Freiburg im Breisgau, 1916.

———. *I Sarcofagi cristiani antichi.* 3 vols. Rome, 1929–36.

I. The First Steps

CATACOMB PAINTINGS AND OTHER CHRISTIAN WORKS:

ACHELIS, HANS. *Die Katakomben von Neapel.* Leipzig, 1936. (Texts of the *commendatio animae* and other Paleo-Christian prayers.)

BRUYNE, L. DE. "Arcosolio con pittura recentemente ritrovato nel cimitero dei SS. Marco e Marcellino a Roma." *Rivista di archeologia cristiana* (Rome), XXVI (1950), 195–216.

ELLIGER, W. *Die Stellung der alten Christen zu den Bildern in den ersten vier Jahrhunderten.* (Studien über christliche Denkmäler: Neue Folge der archäologischen Studien zum christlichen Altertum und Mittelalter, 20, 23.) 2 vols. Leipzig, 1930, 1934.

FERRUA, A. "Scoperta di una nuova regione della catacomba di Commodilla." *Rivista di archeologia cristiana,* XXXIII (1957), 7–43.

JOSI, E. "Le Pitture rinvenute nel cimitero dei Giordani." *Rivista di archeologia cristiana,* V (1928), 167–227.

KLAUSER, THEODOR. "Studien zur Entstehungsgeschichte der christlichen Kunst I," *Jahrbuch für Antike und Christentum,* I (1958), 20–51. Publ.: Münster, Westfalen.

KOCH, HUGO. *Die altchristliche Bilderfrage nach den literarischen Quellen.* (Forschungen zur Religion und Literatur des Alten und Neuen Testaments, n.s., 10.) Göttingen, 1917.

LE BLANT, E. *Étude sur les sarcophages chrétiens antiques de la ville d'Arles.* (Collection de documents inédits sur l'histoire de France, series 3; Archéologie.) Paris, 1878.

MICHEL, K. *Gebet und Bild in frühchristlicher Zeit.* (Studien über christliche Denkmäler, I.) Leipzig, 1902.

ROSSI, G. B. DE. *La Roma soterranea cristiana descritta ed illustrata,* I–III. Rome, 1864–77.

STYGER, P. *Die römischen Katakomben: Archäologische Forschungen über den Ursprung und die Bedeutung der altchristlichen Grabstätten.* Berlin, 1933.

WIRTH, F. *Römische Wandmalerei vom Untergang Pompejis bis ans Ende des dritten Jahrhunderts.* Berlin, 1934.

JEWISH MONUMENTS:

GOODENOUGH, E. R. *Jewish Symbols in the Greco-Roman Period.* (Bollingen Series XXXVII.) 12 vols. New York, 1953–65. (Especially III.)

KOHL, H., and C. WATZINGER. *Antike Synagogen in Galilaea* (Deutsche Orient-Gesellschaft. Wissenschaftliche Veröffentlichungen, XXIX.) Leipzig, 1916.

MANICHEAN MINIATURES:

KOEHLER, WILHELM. *Die Karolingischen Miniaturen*, I. (Denkmäler deutscher Kunst.) 2 vols. Berlin, 1933.

LE COQ, A. VON. *Die manichäischen Miniaturen*, II, in: *Die buddhistische Spätantike in Mittelasien.* 7 vols. Berlin, 1922–33.

NYBERG, H. S. *Die Religion des alten Iran.* (Mitteilungen der Vorderasiatisch-Aegyptischen Gesellschaft, 43.) Leipzig, 1938.

PUECH, HENRI CHARLES. *Le Manichéisme: son fondateur—sa doctrine.* (Musée Guimet. Bibliothèque de diffusion, 56.) Paris, 1949.

WIKANDER, OSCAR STIG. *Feuerpriester in Kleinasien und Iran.* (Skrifter utgivna av Kungl. Humanistiska Vetenskapssamfundet i Lund, 40.) Lund, 1948.

GRECO-ROMAN PAGANISM:

Antioch-on-the-Orontes. Edited by George W. Elderkin.... (Publications of the Committee for the Excavation of Antioch and Its Vicinity, 4.) 3 vols. Princeton, 1934–41.

CARCOPINO, J. *La Basilique pythagoricienne de la Porte Majeure à Rome.* I, in: *Études romaines.* Paris, 1943.

DEONNA, WALDEMAR. "L'Ornementation des lampes romaines." *Revue archéologique* (Paris), ser. 5, XXVI (1927), 233–63.

Great Palace of the Byzantine Emperors, The. (The Walker Trust, The University of St. Andrews.) 2 vols. I: London, 1947; II: Edinburgh, 1958.

LEVI, D. *Antioch Mosaic Pavements.* 2 vols. Princeton, 1947.

REINACH, S. *Répertoire de peintures grecques et romaines.* Paris, 1922.

———. *Répertoire de reliefs grecs et romains.* 3 vols. Paris, 1909–12.

ROBERT, C. *Die antiken Sarkophag-Reliefs im Auftrage des ... Deutschen Archaeologischen Instituts.* 7 vols. Berlin, 1890–1952. (Especially II, III.)

SALOMONSON, J. W. "The 'Fancydress' Banquet." *Bulletin van de Vereeniging tot Bevordering der Kennis van de Antieke Beschaving te 's-Gravenhage* (The Hague?), XXXV (1960), 25–55.

WADSWORTH, EMILY L. "Stucco Reliefs of the First and Second Centuries Still Extant in Rome." *Memoirs of the American Academy in Rome* (Bergamo and New York), IV (1924), 2–102, pls. 1–49.

II. The Assimilation of Contemporary Imagery

MOSAICS, COINS, AND SCULPTURE:

BECATTI, G. *La Colonna coclide istoriata: Problemi storici iconografici stilistici.* (Studi e materiali del Museo dell'Impero romano [ora Museo della civiltà romana], 6.) Rome, 1960.

CAPRINO, C., A. M. COLINI, G. GATTI, M. PALLOTTINO, P. ROMANELLI. *La Colonna di Marco-Aurelio.* Rome, 1955.

GAUCKLER, P. *Inventaire des mosaïques de la Gaule et de l'Afrique, II: Afrique proconsulaire (Tunisie).* (Académie des inscriptions et belles-lettres.) 2 vols. Paris, 1910, 1914. (*Supplément*, by A. Merlin. Paris, 1915.)

———— and others. *Catalogue du Musée Alaoui.* (Musées et collections archéologiques de l'Algérie et de la Tunisie, VII.) Paris, 1910. (*2ᵉ Supplément*, by A. Merlin and R. Lantier. Paris, 1922.)

GENTILI, G. V. *La Villa Erculia di Piazza Armerina: I Mosaici figurati.* (Collana d'arte Sidera, 8.) Rome, 1959.

KINCH, K. F. *L'Arc de triomphe de Salonique.* (Publié sous les auspices de la Fondation Carlsberg.) Paris, 1890.

KOLLWITZ, J. *Die oströmische Plastik der theodosianischen Zeit.* (Studien zur spätantiken Kunstgeschichte, 12.) Berlin, 1941.

LEHMANN-HARTLEBEN, K. *Die Trajanssäule: Ein römisches Kunstwerk zu Beginn der Spätantike.* Berlin and Leipzig, 1926.

L'ORANGE, H., and A. VON GERKAN. *Der spätantike Bildschmuck des Konstantinbogens.* (Studien zur spätantiken Kunstgeschichte, 10.) Berlin, 1939.

MATTINGLY, H., and E. A. SYDENHAM. *The Roman Imperial Coinage.* 5 vols. in 8. London, 1923–49. (Especially IV, V.)

MAURICE, J. *Numismatique constantinienne.* 3 vols. Paris, 1908–12.

MERLIN, A., and L. POINSSOT. *Guide de Musée du Bardo (Musée Alaoui).* Tunis, 1950. (Revised by P. Quoniam, 1957.)

MUSIL, A. *Kusejr-'Amra.* (Akademie der Wissenschaften, Wien.) 2 vols. Vienna, 1907.

SCHLUMBERGER, D. "Deux Fresques Omeyyades." *Syria* (Paris), XXV (1946–48), 86–102.

STRACK, P. L. *Untersuchungen zur römischen Reichsprägung des zweiten Jahrhunderts.* 3 vols. Stuttgart, 1931–37. (Especially II, III.)

CHRISTIAN MONUMENTS:

BRUSIN, G., and P. L. ZOVATTO. *Monumenti paleocristiani di Aquileia e di Grado.* Udine, 1957.

CECCHELLI, C. *I Mosaici della basilica di S. Maria Maggiore.* Torino [1956].

CLÉDAT, J. *Le Monastère et la nécropole de Baouit.* (Mémoires de l'Institut français d'archéologie orientale, XII, XXXIX.) 2 vols. Cairo, 1904–16.

SOTÉRIOU, G. A. and M. *Icones du Mont-Sinaï.* 2 vols. Athens, 1956.

III. The Portrait

ANTIQUE PORTRAITS OF THE LATE EMPIRE; BYZANTINE PORTRAITS:

DELBRÜCK, RICHARD. *Antike Porphyrwerke.* (Studien zur spätantiken Kunstgeschichte, 6.) Berlin, 1932.

———. *Spätantike Kaiserporträts von Constantinus Magnus bis zum Ende des Westreichs.* (Ibid., 8.) Berlin, Leipzig, 1933.

EBERS, GEORG MORITZ. *Antike Porträts: Die hellenistischen Bildnisse aus dem Fajjum untersucht und gewürdigt.* Leipzig, 1893.

GRAINDOR, P. *Bustes et statues-portraits de l'Égypte romaine.* (Université égyptienne. Recueil de travaux publiés par la faculté des lettres [fasc. 16].) Cairo [1939?].

GRÜNEISEN, W. DE. *Études comparatives: Le Portrait. Traditions hellénistiques et influences orientales.* Rome, 1911.

L'ORANGE, H. *Studien zur Geschichte des spätantiken Porträts.* (Instituttet for sammenlignende Kulturforskning, Oslo. Skrifter, ser. B, [no.] 22.) Oslo, 1933.

WROTH, W. *Catalogue of the Imperial Byzantine Coins in the British Museum.* 2 vols. London, 1908. (Especially I.)

THE EARLIEST CHRISTIAN PORTRAITS (CHRIST, THE VIRGIN, SAINTS); SOME PAGAN ANALOGIES:

A. *Christian:*

BESSON, MARIUS. *Saint Pierre et les origines de la primauté romaine.* Geneva, 1929.

BRUYNE, L. DE. "L'Antica Serie di ritratti dei papi in S. Paolo fuori le Mura." *Rivista di archeologia cristiana,* VII (1930), 107–37.

EBERSOLT, J. *Sanctuaires de Byzance: Recherches sur les anciens trésors des églises de Constantinople.* Paris, 1921. (Pp. 69 ff.)

GRABAR, A. *Martyrium: Recherches sur le culte des reliques et l'art chrétien antique.* 2 vols. and atlas. [Paris] 1943–46.

KONDAKOV, N. P. *The Iconography of the Mother of God* (in Russian). (Imperial Academy of Science.) 2 vols. Petrograd, 1914–15.

LADNER, G. B. *I Ritratti dei papi nell'antichità e nel medioevo.* Vatican City, 1941.

VENTURI, ADOLFO. *Storia dell'arte italiana.* 11 vols. Milan, 1901–7. (Door at S. Sabina, Rome: I, figs. 308–25.)

B. *Pagan:*

BIANCHI BANDINELLI, R. *Hellenistic-Byzantine Miniatures of the Iliad (Ilias Ambrosiana).* Olten, 1955. (A complete facsimile in color of the Ambrosiana Iliad was published in 1953.)

BOAK, A. E. R., and E. E. PETERSON. *Karanis, 1924–1928.* (University of Michigan Studies, Humanistic Series, XXV.) Ann Arbor, 1931.

————. *Karanis: The Temple, Coin Hoards, Botanical and Zoological Reports, Seasons 1924–1931.* (Ibid., XXX.) Ann Arbor, 1933.

LAUER, J.-P., and C. PICARD. *Les Statues ptolémaïques du Serapéion de Memphis.* (Paris, Université. Institut d'art et d'archéologie. Publications, III.) Paris, 1955.

Notitia dignitatum imperii Romani. Reproduction réduite des 105 miniatures du manuscrit latin 9661 de la Bibliothèque Nationale [Paris]. Paris [1911].

Roman Virgil, The: *Picturae ornamenta complura scripturae specimina codicis Vaticani 3867.* . . . Introduction by F. Ehrle. (Codices e Vaticanis selecti quam simillime espressi, ser. maior II, no. 173.) Rome, 1902.

Vatican Virgil, The: *Fragmenta et picturae Vergiliana codicis Vaticani Latini 3225.* . . . Edited by F. Ehrle, revised by G. Mercati. (Ibid., ser. maior I, no. 172.) 3rd edn. Vatican City, 1945.

c. *Texts:*

Apocryphal Acts of John. In: LIPSIUS, R. A., and MAXIMILIAN BONNET (eds.). *Acta apostolorum apocrypha post Constantium Tischendorf.* 2 vols., each in 2 parts. Leipzig, 1891–1903. (Especially I: 1.)

————. In: *The Apocryphal New Testament.* . . . Translated by Montague Rhodes James. Oxford [1960, as corrected in 1953]. (Especially pp. 232–34.)

AUGUSTINE, ST. *De moribus ecclesiae catholicae et de moribus Manichaeorum libri duo.* In: MIGNE, *PL*, XXXII, 1342, q.v.

CHRYSOSTOM, JOHN, ST. *Homilia encomiastica in S. Patrem nostrum Meletium.* . . . In: MIGNE, *PG*, L, 516, q.v.

EUSEBIUS. *Ad Constantiam augustam* (51). In: MIGNE, *PG*, XX, 1545 f., q.v.

————. *Historiae ecclesiasticae* VII xviii. In: MIGNE, *PG*, XX, 680, q.v.

————. *The Ecclesiastical History.* In: *A Select Library of the Nicene and Post-Nicene Fathers of the Christian Church,* ser. 2, I. Translated into English under the editorial supervision of Philip Schaff and Henry Wace. New York, 1890. (Also: With an English translation by Kirsopp Lake. Loeb Classical Library. 2 vols. Cambridge, Mass., and London, 1949 and 1947, respectively. [Especially II.])

HENNECKE, E. *Neutestamentliche Apokryphen.* 2nd edn. Tübingen, 1924. (Pp. 174–77.)

IRENAEUS, ST. *Adversus haereses* I xxiii 4. In: MIGNE, *PG*, VII, 672 f., q.v.

JOHN, ST. Apocryphon. *See* Apocryphal Acts of John.

KITZINGER, ERNST. "The Cult of Images in the Age before Iconoclasm." *Dumbarton Oaks Papers,* VIII (1954), 83–150.

MICHAELIS, M. *Die apokryphen Schriften zum Neuen Testament.* Bremen, 1956. (Pp. 228–29, 236–39.)

MIGNE, J. P. (ed.). *Patrologiae cursus completus.*
PG = Greek series. 166 vols. Paris, 1857–66.
PL = Latin series. 221 vols. Paris, 1844–64.
References are to columns.

THEODORET. *Religiosa historia* xxvi. In: MIGNE, *PG*, LXXXII, 1463 ff., q.v.

IV. The Historical Scene

PROFANE ILLUSTRATED MANUSCRIPT:

BAUER, ADOLPH, and JOSEPH STRZYGOWSKI. *Eine alexandrinische Weltchronik: Text und Miniaturen eines griechischen Papyrus der Sammlung W. Goleniščev.* (Denkschriften der K. Akademie der Wissenschaften in Wien, Philosophisch-historische Klasse, LI: II.) Vienna, 1905.

SOME ILLUSTRATED MANUSCRIPTS OF BOOKS OF THE BIBLE BEFORE THE MIDDLE AGES (IN GREEK, UNLESS OTHERWISE MENTIONED):

Ashburnham Pentateuch from Tours in Latin: GEBHARDT, G. VON. *The Miniatures of the Ashburnham Pentateuch.* London, 1883.

Cambridge, Corpus Christi College, Gospels in Latin: WORMALD, F. *The Miniatures in the Gospels of St. Augustine: Corpus Christi College MS. 286.* [The Sandars Lectures in Bibliography 1948.] Cambridge, 1954.

Cotton Bible: DALTON, O. M. *Byzantine Art and Archaeology.* Oxford, 1911. (Figs. 263, 264.)

Echmiadzin Gospel in Armenian: DOURNOVO, LYDIA A. (ed.). *Miniatures arméniennes.* Preface by S. Der Nersessian. Paris [1960].

Rabbula Gospels in Syriac: CECCHELLI, C., G. FURLANI, M. SALMI (eds.). *The Rabbula Gospels.* Facsimile edition of the miniatures of the Syriac manuscript Plut. I, 56, in the Medicean-Laurentian Library. Olten and Lausanne, 1959. (In the same work, reproductions of the miniatures of the Paris Bible syr. 341 and of the Paris Gospel syr. 33.)

Rossano Gospel: MUÑOZ, A. *Il Codice purpureo di Rossano e il frammento sinopense.* Rome, 1907.

Sinope Fragments: GRABAR, A. *Les Peintures de l'Évangilaire de Sinope.* [Paris] 1948.

Utrecht Psalter in Latin: DE WALD, E. T. *The Illustrations of the Utrecht Psalter.* Princeton, London, Leipzig [1932].

Vienna Genesis: GERSTINGER, H. (ed.). *Die Wiener Genesis.* Farbenlichtdruckfaksimile der griechischen Bilderbibel aus dem 6. Jahrhundert n. Chr., Cod. Vindob. theol. graec. 31. 2 vols. Vienna [1931].

Important studies by K. Weitzmann, in whose opinion all images inspired by the Old Testament and the Gospels derive from manuscript illustrations:

WEITZMANN, K. *Illustration in Roll and Codex: A Study of the Origin and Method of Text Illustration.* (Studies in Manuscript Illumination, no. 2.) Princeton, 1947.

———. "Die Illustration der Septuaginta." *Münchner Jahrbuch der bildenden Kunst* (Munich), III/IV (1952/53), 96–120.

ANOTHER MONUMENT:

Maximian's throne: CECCHELLI, C. *La Cattedra di Massimiano ed altri avorii romano-orientali.* (R. Istituto di archeologia e storia dell'arte.) Rome [1936–38?].

TEXTS:

ASTERIUS of Amasia. *Homilia in locum Evangelii secundum Lucam, de divite et Lazaro.* In: MIGNE, *PG*, XL, 164 ff., q.v.

CHORICIUS of Gaza. Ἐγκώμιον εἰς Μαρκιάνου ἐπίσκοπιν Γάζης ἐν Ἰγ καὶ ἔκφρασις ναοῦ τοῦ ἁγίον μάρτυρος Σεργίον. *Orationes, declamationes, fragmenta.* ... Edited by J. F. Boissonade. Paris, 1846. (Pp. 79 ff.) (Also: *Choricii Gazaei Opera.* Recension of Richard Foerster; edited by Eberhard Richtsfeig. [Bibliotheca scriptorum graecorum et romanorum Teubneriana.] Leipzig, 1929. [Pp. 2 ff.])

Part Three: Preface

CUMONT, F. *Lux Perpetua.* Paris, 1949.

――――. *Les Religions orientales dans le paganisme romain.* 4th edn. Paris, 1929.

――――. *Recherches sur le symbolisme funéraire des Romains.* (Bibliothèque archéologique et historique, XXXV.) Paris, 1942.

――――. *Textes et monuments figurés relatifs aux mystères de Mithra.* 2 vols. Brussels, 1894–99.

DANIÉLOU, J. *Sacramentum Futuri: Études sur les origines de la typologie biblique.* (Études de théologie historique.) Paris, 1950.

WILL, E. *Le Relief cultuel gréco-romain: Contribution à l'histoire de l'art de l'empire romain.* (Bibliothèque des écoles des études françaises d'Athènes et de Rome, [ser. 1] fasc. 183.) Paris, 1955.

V. Dogmas Expressed in a Single Image

THEOLOGY AND ART, GENERAL:

KAUFMANN, C. M. *Handbuch der christlichen Archaeologie.* (Wissenschaftliche Handbibliothek, 3 Reihe; Lehrbücher verschiedener Wissenschaften, V.) Paderborn, 1905.

SYBEL, L. VON. *Christliche Antike: Einführung in die altchristliche Kunst.* 2 vols. Marburg, 1906–9.

WULFF, O. *Altchristliche und byzantinische Kunst.* (Handbuch der Kunstwissenschaft.) 2 vols. Berlin, 1914–24.

THE TRINITY AND LEGENDS OF THE MAGI:

MONNERET DE VILLARD, UGO. *Le Leggende orientali sui Magi evangelici.* (Biblioteca Apostolica Vaticana. Studi e testi, CLXIII.) Vatican City, 1952.

THE PROPHETS' VISIONS OF GOD AND ST. JOHN'S (THE APOCALYPSE):

MEER, F. VAN DER. *Majestas Domini— Théophanies de l'Apocalypse dans l'art chrétien: Étude sur les origines d'une iconographie spéciale du Christ.* Vatican City, 1938.

NEUSS, W. *Das Buch Ezechiel in Theologie und Kunst bis zum Ende des XII. Jahrhunderts . . . : Eine Entwicklungsgeschichte der Typologie der christlichen Kunst, vornehmlich in den Benediktinerklöstern.* (Beiträge zur Geschichte des alten Mönchtums und des Benediktinerordens, 1, 2.) Münster in Westfalen, 1912.

THE RESURRECTED CHRIST IN OTTONIAN ART:

MESSERER, W. *Der Bamberger Domschatz in seinem Bestande bis zum Ende der Hohenstaufen-Zeit.* Munich [1952]. (Evangelière, Reichenau: fig. 34.)

TEXTS:

PAULINUS, ST., of Nola. *Sancti Pontii Meropii Paulini Nolani Epistulae.* With recension and commentary by Guilelmus de Hartel. (Vienna, Kaiserliche Akademie der Wissenschaften. Corpus scriptorum ecclesiasticorum, 29.) Vienna, Prague, and Leipzig, 1894. (Epistula XXXII.)

VI. Dogmas Represented by Juxtaposed Images

THE ICONOGRAPHY OF THE INCARNATION, GENERAL STUDIES:

GRABAR, A. *Martyrium: Recherches sur le culte des reliques et l'art chrétien antique.* 2 vols. and atlas. Paris, 1943, 1946. (Especially II.)

JERPHANION, G. DE. *Une Nouvelle Province de l'art byzantin: Les Églises rupestres de Cappadoce.* (Bibliothèque archéologique et historique, V, VI.) 2 vols. in 4, and 3 atlas. Paris, 1925–1942.

LASSUS, J. "Les Miniatures byzantines du Livre des Rois d'après un manuscrit de la Bibliothèque Vaticane." *Mélanges d'archéologie et d'histoire* (École Française de Rome) (Paris; Rome), XLV (1928), 38–74.

———. *Sanctuaires chrétiens de Syrie: Essai sur la genèse, la forme, et l'usage liturgique des édifices du culte chrétien, en Syrie, du IIIe siècle à la conquête musulmane.* (Bibliothèque archéologique et historique, XLII.) Paris, 1947.

MILLET, G. *La Dalmatique du Vatican: Les élus, images, et croyances.* (Bibliothèque de l'École des Hautes Études. Sciences religieuses, LX.) Paris, 1945.

———. *Recherches sur l'iconographie de l'Évangile aux XIVe et XVIe siècles, d'après les monuments de Mistra, de la Macédoine et du Mont-Athos.* (Bibliothèque des Écoles Françaises d'Athènes et de Rome, fasc. 109.) Paris, 1916.

NORDSTRÖM, C. O. *Ravennastudien: Ideengeschichtliche und ikonographische Untersuchungen über die Mosaiken von Ravenna.* Stockholm, 1953. (Figure, no. 4.)

SELECTED SPECIAL STUDIES:

Babić, G. "Les Fresques de Sušica en Macédoine et l'iconographie originale de leurs images de la vie de la Vierge." *Cahiers archéologiques: Fin de l'antiquité et moyen âge* (Paris), XII (1962), 303–39.

Thierry, N. and M. "Église de Kizil-Tchoukour: Chapelle iconoclaste, chapelle de Joachim et d'Anne." *Monuments et mémoires* ([Institut de France.] Académie des inscriptions et belles-lettres. Fondation Eugène Piot) (Paris), L (1958), 105–46.

TEXT:

Nilus, St., of Mt. Sinai. *Epistula* LXI: *Ad Olympidoro Eparcho.* In: Migne, *PG*, LXXIX, 577 f., q.v.

INDEX

Index

Numbers printed in italic type refer to the illustrations: roman numerals for the color plates inserted in the text, arabic numerals for the monochrome section at the end of the book. Manuscripts are indexed under place (city) and library.

ILLUSTRATIONS

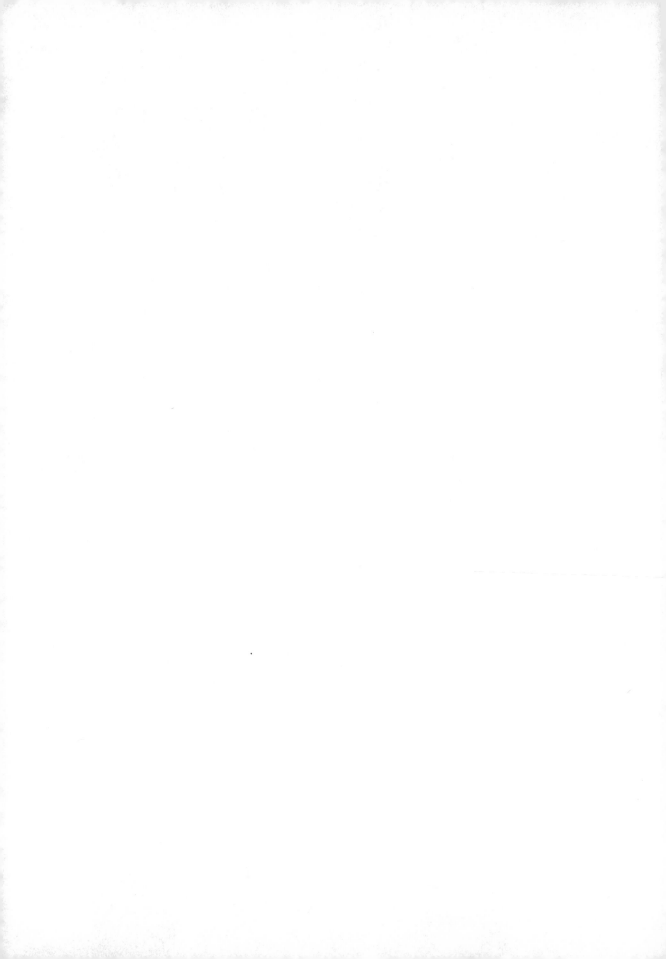

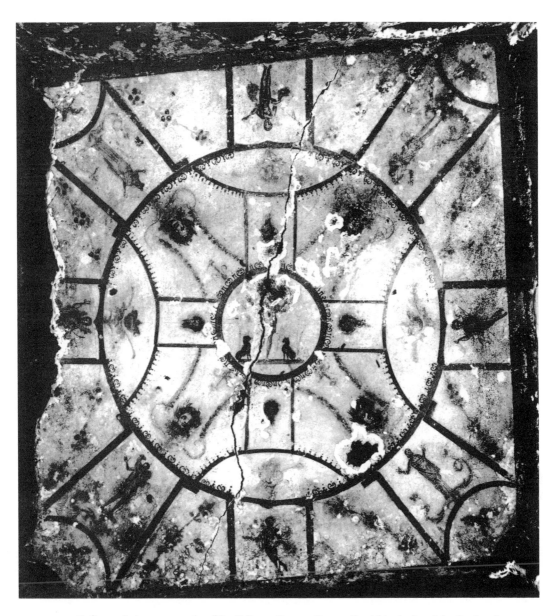

1 Ceiling painting, catacombs of St. Calixtus, Rome. Center: Daniel in the lions' den [7, 8, 10]

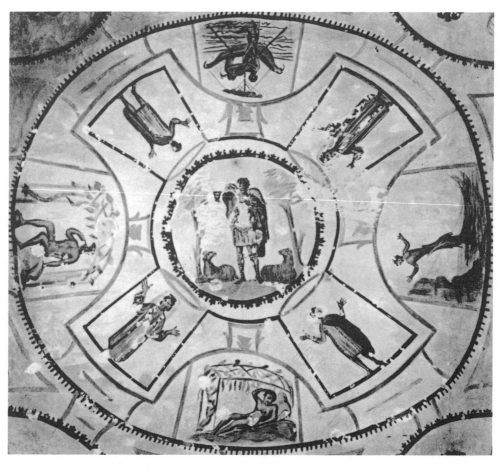

2 Ceiling painting, catacombs of SS. Peter and Marcellinus, Rome. Center: The Good Shepherd.
Four quarters: The story of Jonah [7, 8, 10]

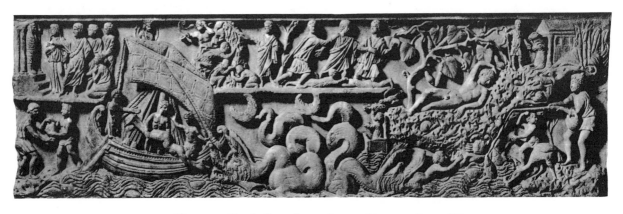

3 The story of Jonah. Sarcophagus, Lateran Museums, Rome [8]

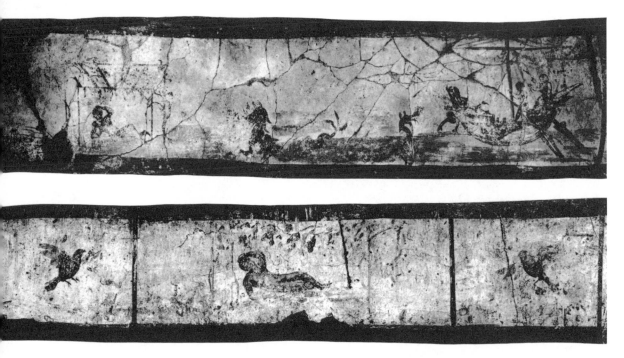

4　The story of Jonah. Wall paintings, catacombs of St. Calixtus, Rome [7, 8, 32]

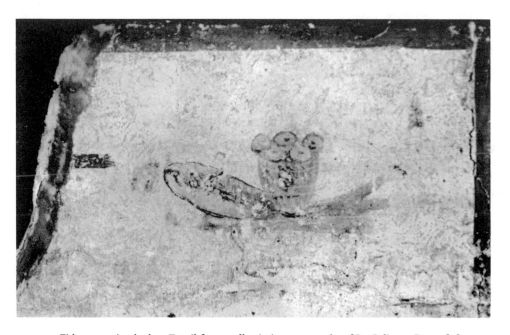

5　Fish supporting basket. Detail from wall painting, catacombs of St. Calixtus, Rome [8]

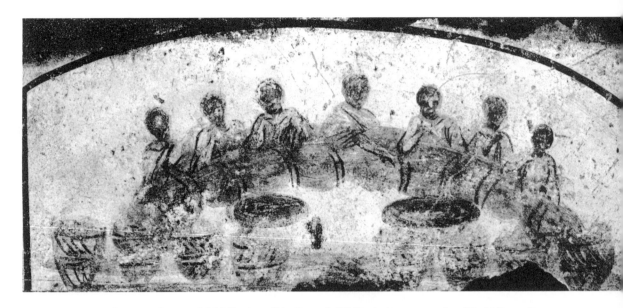

6 Communal repast (Multiplication of the Loaves). Wall painting, catacombs of St. Calixtus, Rome [8, 9]

7 Communal repast (The Last Supper). Wall painting, catacombs of St. Calixtus, Rome [8]

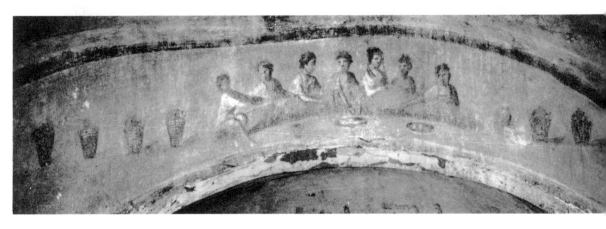

8 Communal repast. Wall painting, catacomb of Priscilla, Rome [8]

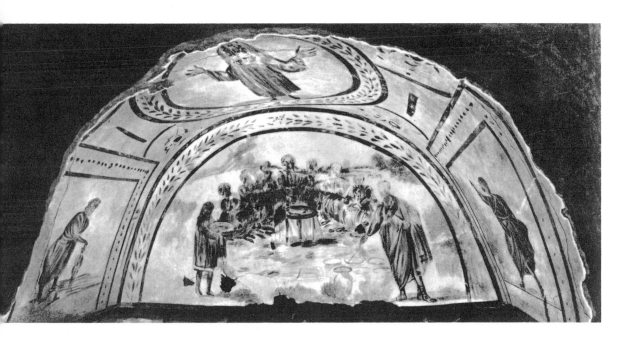

9 Communal repast (The Miracle of Cana). Wall painting, catacombs of SS. Peter and Marcellinus, Rome [8]

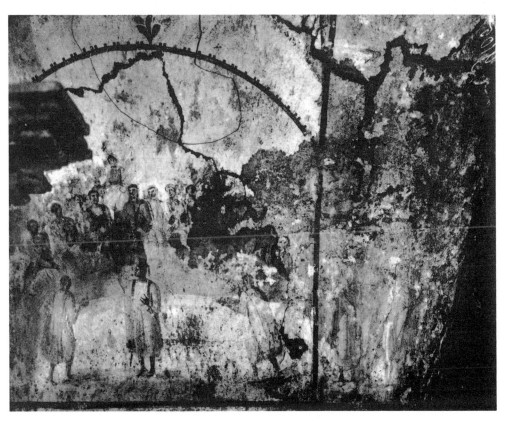

10 Unidentified scene. Wall painting, hypogeum of the Aurelii, Rome [9]

11 Unidentified scene. Ceiling painting, catacombs of the basilica of S. Sebastiano, Rome [9]

12 Unidentified scene. Wall painting, catacomb of Priscilla, Rome [9]

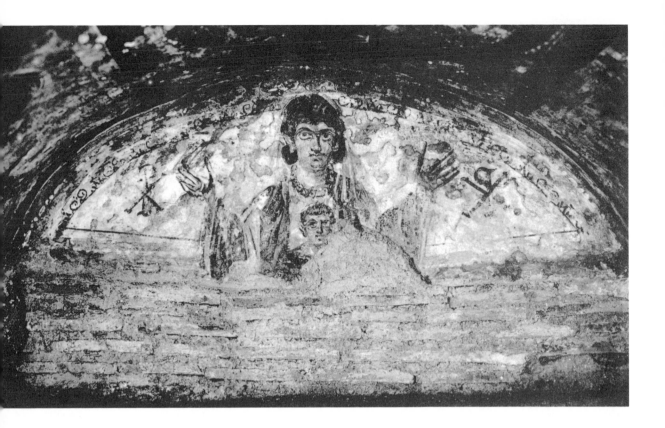

13 Unidentified figures. Wall paintings (above) in the tympanum and (below) on the surrounding
arch, catacombs of the Cimitero Maggiore, Rome [9]

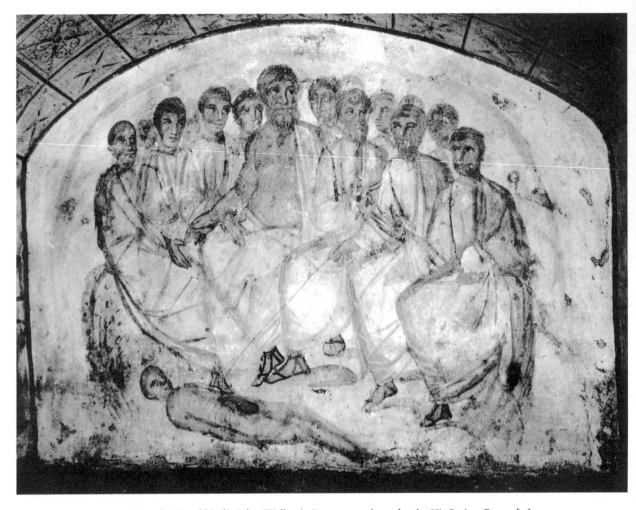

14 Aristotle (?) and his disciples. Wall painting, catacombs under the Via Latina, Rome [9]

15 Orant. Wall painting, catacomb of Domitilla, Rome [10]

16 Orant. Wall painting, catacomb of Vigna Massimo, Rome [10]

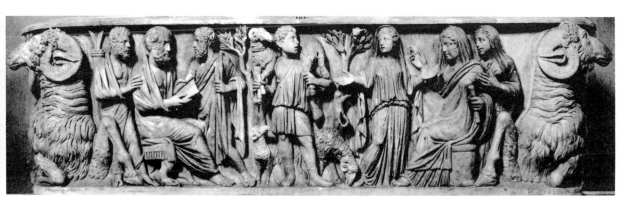

17 Sarcophagus, Lateran Museums, Rome. Center: Shepherd carrying the lamb [10]

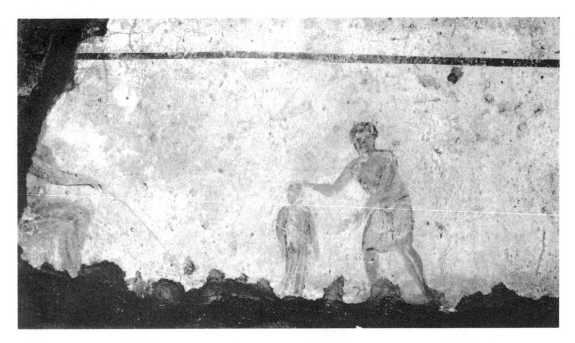

18 Scene of baptism. Wall painting, catacombs of St. Calixtus, Rome [10]

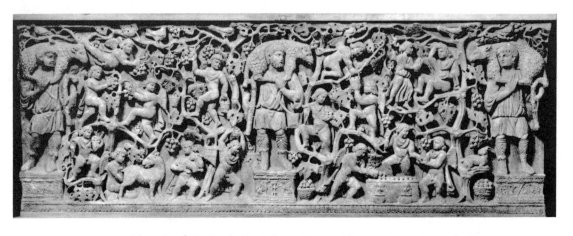

19 Three Good Shepherds. Sarcophagus, Lateran Museums, Rome [10, 11]

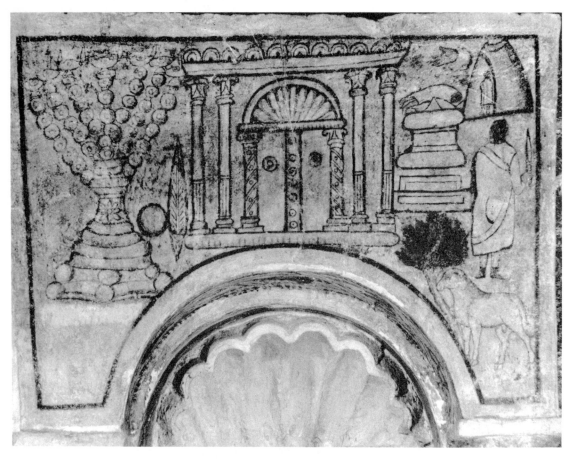

20 Upper panel of the Torah shrine, Dura synagogue. National Museum of Damascus.
Right: The sacrifice of Isaac [11]

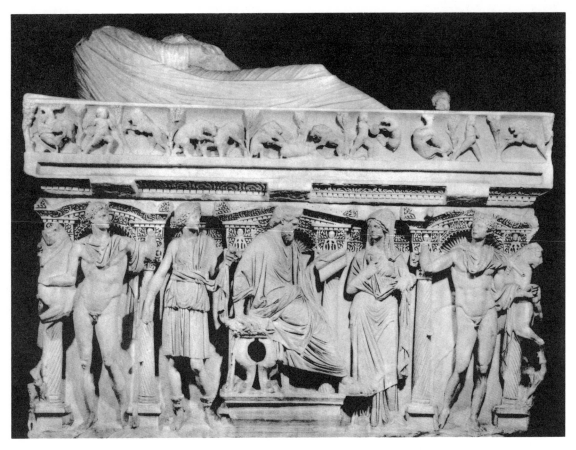

21 Pagan sarcophagus from Sidamara, Anatolia. Archaeological Museums, Istanbul.
Seated figure: A philosopher [32]

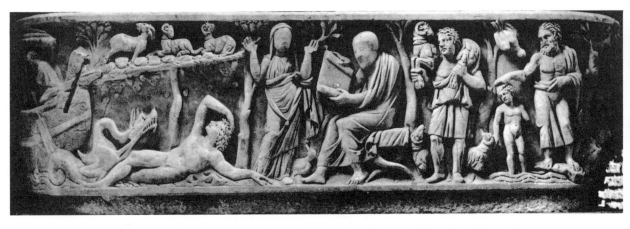

22 Sarcophagus, Forum, Rome. Center (seated figure): The true philosopher. Left: Jonah.
Right: The Good Shepherd [10, 12, 32]

23 Job. Wall painting, catacombs of St. Calixtus, Rome [12, 32]

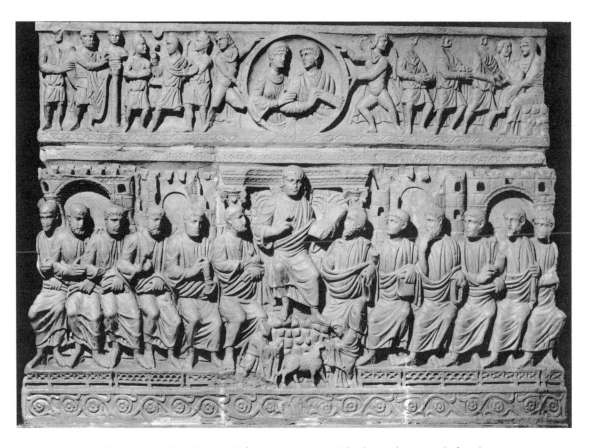

24 Sarcophagus, S. Ambrogio, Milan. Bottom center: The deceased stooping before the true philosopher [12, 32]

25 The resurrection of Lazarus. Wall painting, catacombs of SS. Peter and Marcellinus, Rome [12]

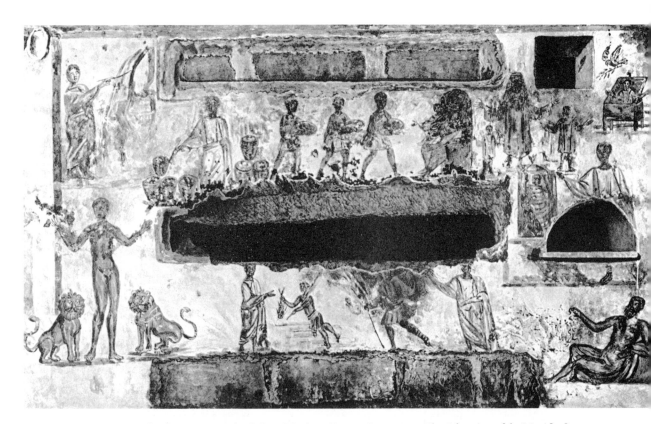

26 Wall painting, catacomb of Vigna Massimo, Rome. Center, top: The Adoration of the Magi [12]

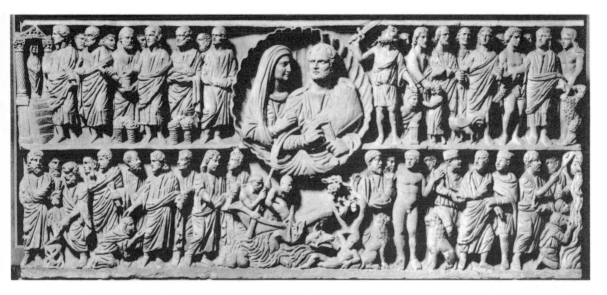

27 Sarcophagus, Lateran Museums, Rome. Extreme left: The resurrection of Lazarus [12]

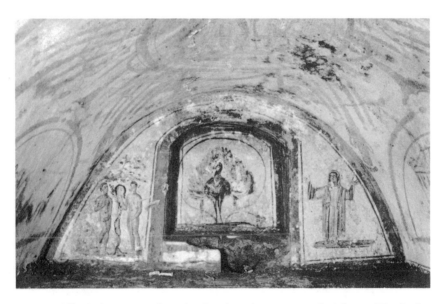

28 Wall painting, catacombs under the Via Latina, Rome. Left: Adam and Eve [12]

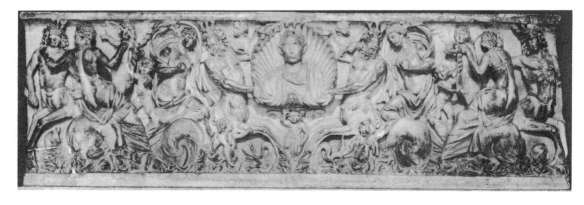

a b c d e

f g h i j

29 Sarcophagus of Junius Bassus, Vatican Grottoes [13]

a	The sacrifice of Isaac	*f*	Job
b	The judgment of Peter	*g*	Adam and Eve
c	Christ as judge between Peter and Paul	*h*	The entry into Jerusalem
d	Christ before Pilate	*i*	Daniel in the lions' den
e	Pilate washing his hands	*j*	The judgment of Paul

30 The deceased transported to the happy isles. Sarcophagus, Louvre, Paris [14]

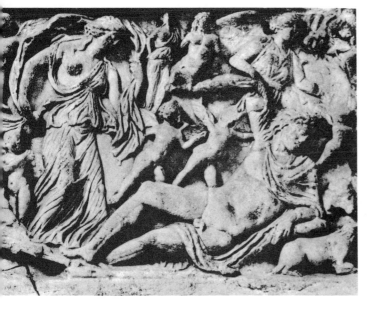

31 Death of Endymion. Detail from pagan sarcophagus,
 Museo Nazionale, Naples [14, 32]

32 Deceased led to Paradise by a saint.
 Wall painting, catacomb of Domitilla,
 Rome [15]

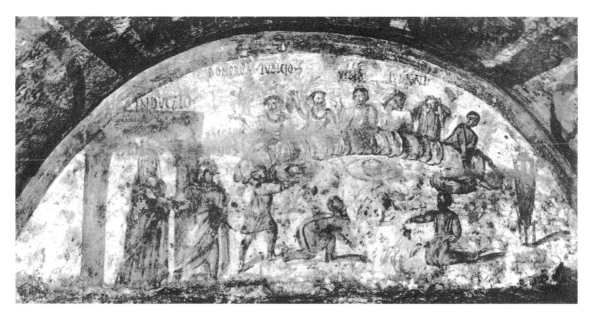

33 Wall painting, hypogeum of Vibia, Rome. Left: Deceased led to Paradise [15]

34 Hercules slaying the hydra. Wall painting, catacombs under the Via Latina, Rome [15]

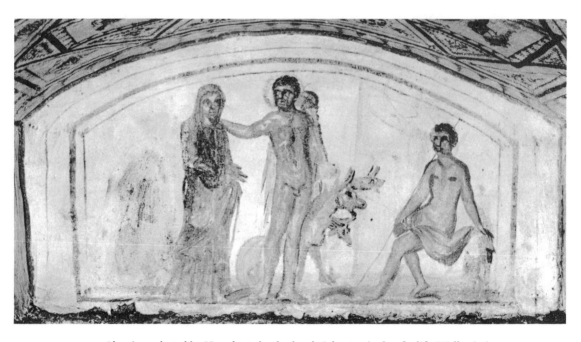

35 Alcestis conducted by Hercules to her husband, Admetus, in the afterlife. Wall painting, catacombs under the Via Latina, Rome [15]

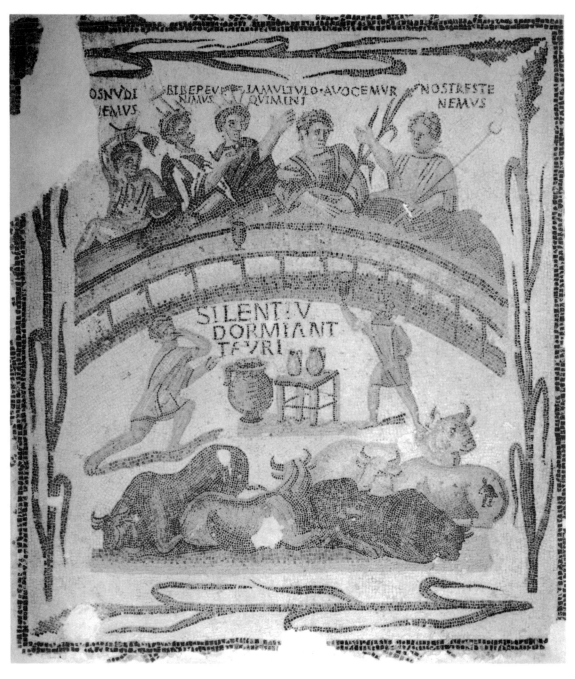

OSNVDI
IEMVS

BIBEPEVE IAMVLTVLO AVOCEMVR NOSTRESTE
NIMVS QVIMINI NEMVS

SILENTIV
DORMIANT
TEVRI

36 Banquet of five circus fighters. Pavement mosaic from El Djem. Musée du Bardo, Tunis [16]

37 Gladiator surrounded by acclamatory inscriptions. Pavement mosaic from El Djem.
Musée du Bardo, Tunis [16]

38 Personification of Ananeosis. Pavement mosaic from Antioch [17]

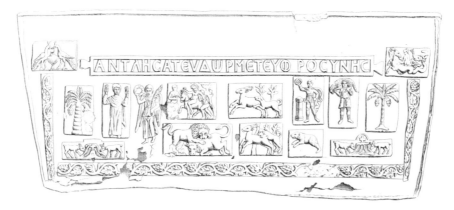

39 Decoration, with mingled Christian motifs and those of the arena, on
a Paleo-Christian lead vessel found in Tunisia (now lost; drawing) [18]

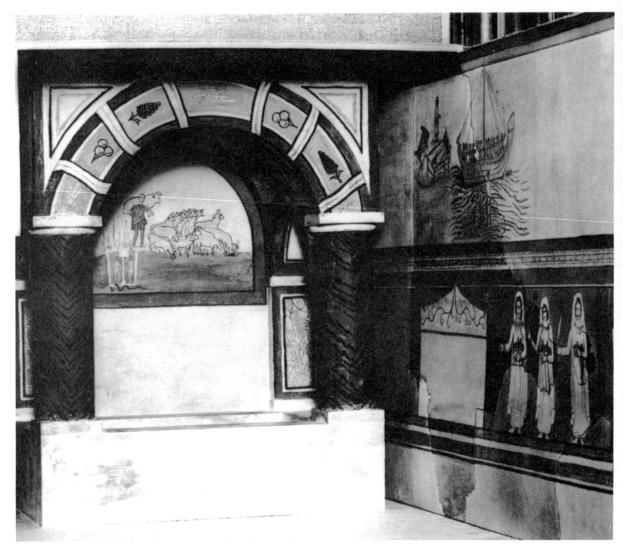

40 Small-scale model of the baptistery from the Christian chapel, Dura. Yale University Art Gallery [19, 20]

41 Good shepherd and his flock. Wall painting, Christian baptistery, Dura. Yale University Art Gallery [19, 20]

42 The Samaritan woman at the well. Wall painting, Christian baptistery ,
Dura. Yale University Art Gallery [19, 20]

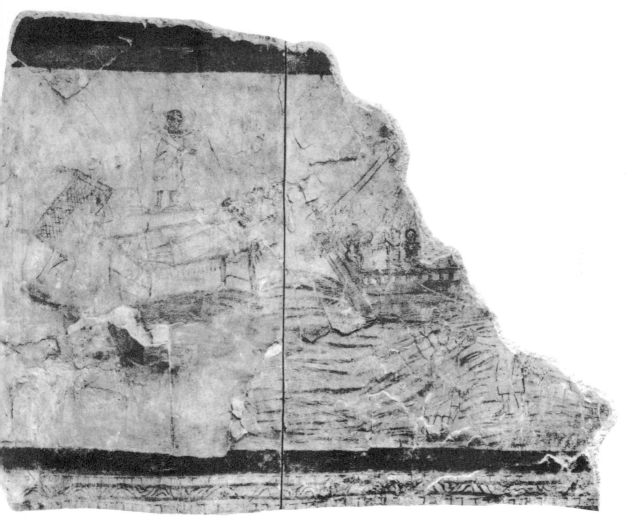

43 Wall painting, Christian baptistery, Dura. Yale University Art Gallery. Left: The healing of the paralytic. Right: Christ walking on the water [19, 20]

44 Wall painting, Christian baptistery, Dura. Yale University Art Gallery. Right: The Holy Women at the tomb of Christ [19, 20]

45 Wall painting, pagan hypogeum, Kerch, Crimea (water-color copy) [21]

46 Seven-branched candlestick flanked by stars. Lintel relief from a synagogue at Jaffa (drawing) [24]

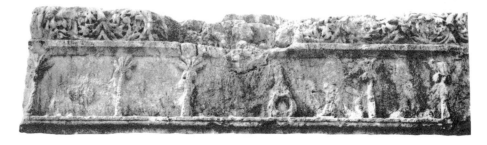

47 Palms of paradise and creatures. Lintel relief from a synagogue at Capernaum [24]

48 Noah and his wife beside the Ark. Bronze coin from
Apamea, Phrygia. Bibliothèque Nationale, Paris [24]

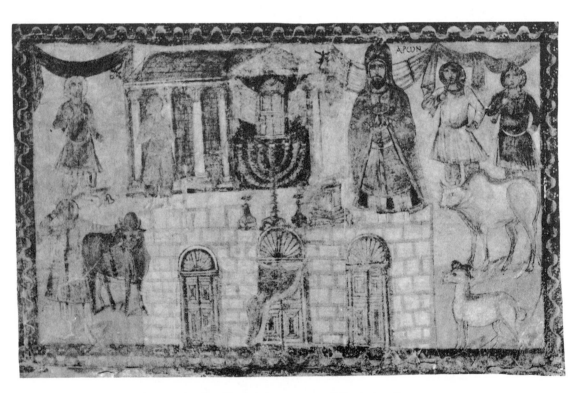

49 The Temple where the Ark came to rest. Wall painting, Dura synagogue.
National Museum, Damascus [26]

50 The wall above the apse, Dura synagogue. National Museum, Damascus
(copy by H. Gute, Yale University Art Gallery).
Top: David as the ideal king of Israel. Bottom: The lion of Judah and
Jacob's two benedictions [26]

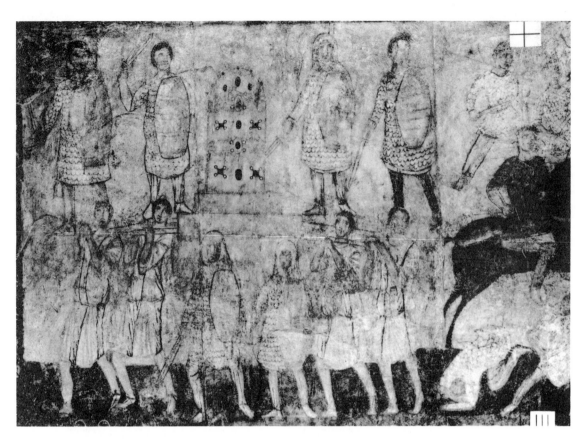

51 The return to Jerusalem of the Ark of the Covenant. Wall painting, Dura synagogue.
National Museum, Damascus [26]

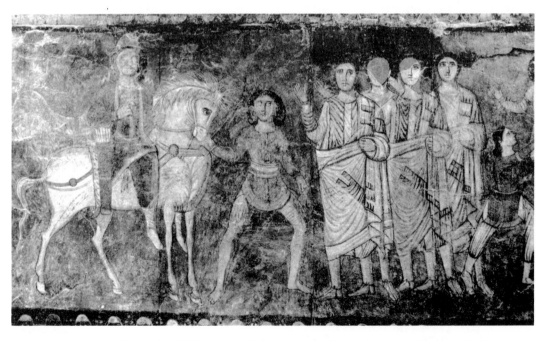

52 Mordecai's triumph. Wall painting, Dura synagogue. National Museum, Damascus [26]

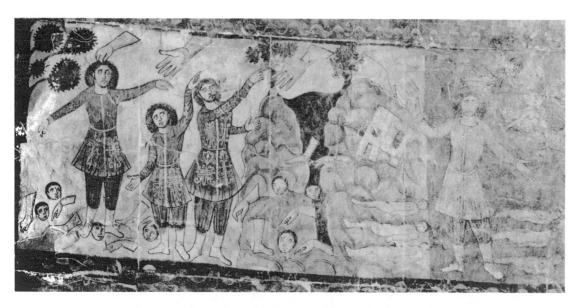

53 The resurrection of the dead before Ezekiel. Wall painting, Dura synagogue.
National Museum, Damascus [26]

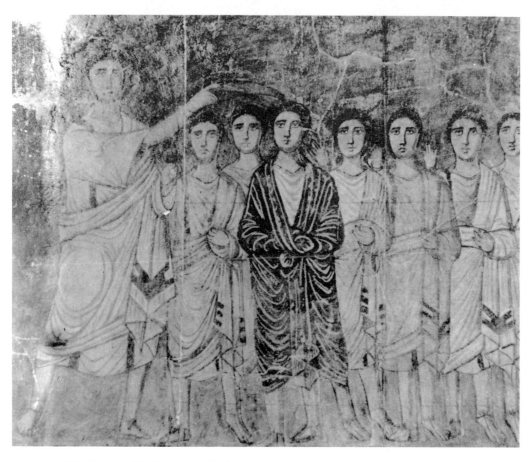

54 David anointed by Samuel. Wall painting, Dura synagogue. National Museum, Damascus [26]

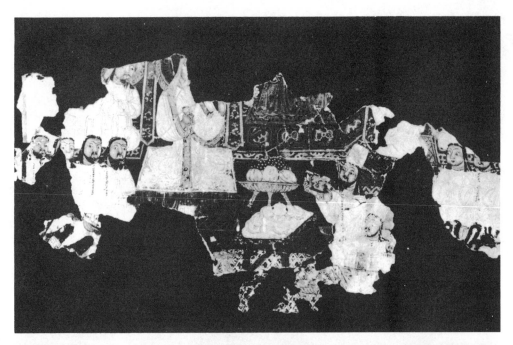

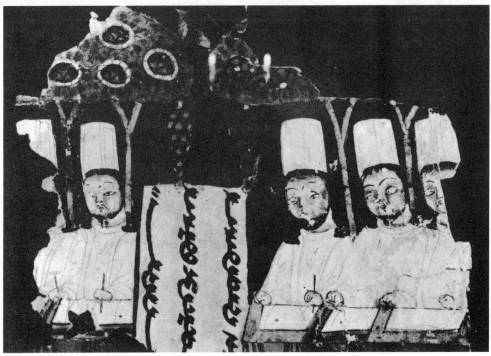

55 Manichean miniatures. Above: A liturgical celebration of a feast.
Below: Scribes and ornaments. Museum für Völkerkunde, Berlin [28]

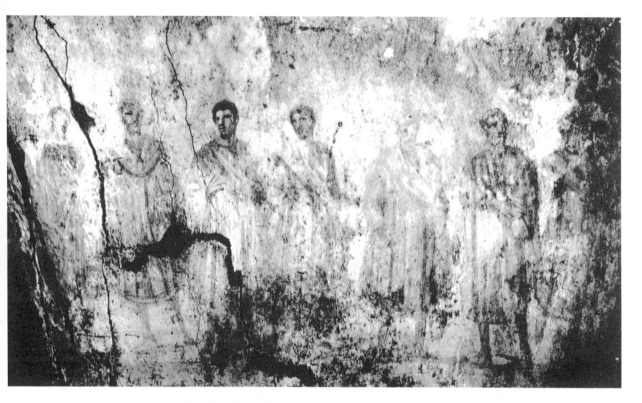

56　A row of standing figures. Wall painting, hypogeum of the Aurelii, Rome [32]

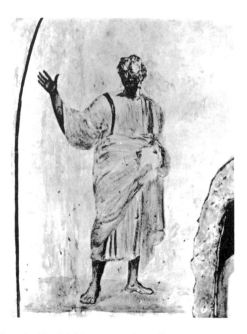

57　Apostle (?) with his arm raised. Wall painting, hypogeum of
the Aurelii, Rome (water-color copy) [32]

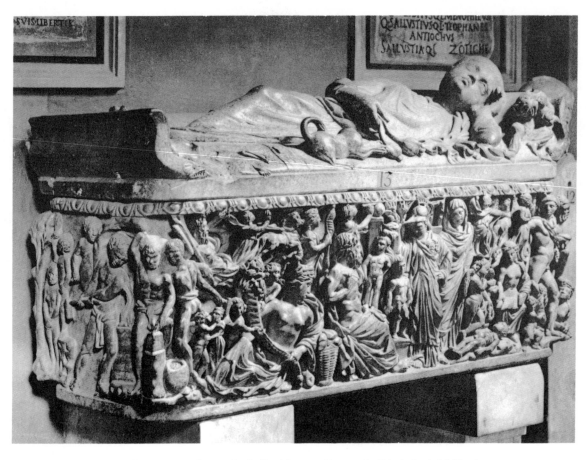

58 Roman sarcophagus, Capitoline Museum, Rome. On lid: A dead child [32]

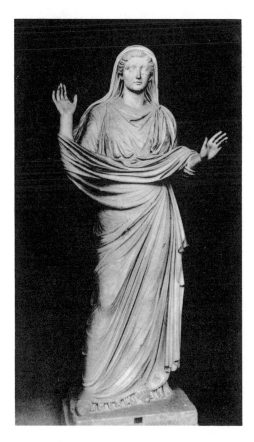

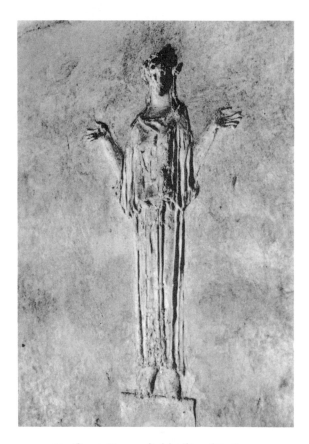

59 Orant. Statue, Vatican Museum [32]

60 Orant. Stucco relief, basilica of the Porta
 Maggiore, Rome [32]

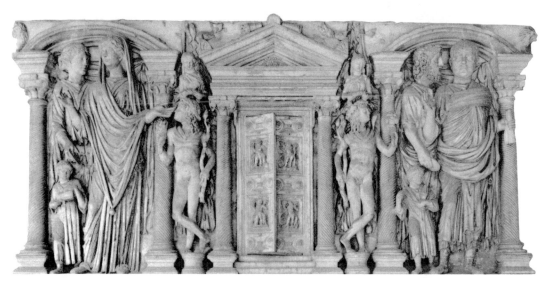

61 Orants. Pagan sarcophagus, Vatican Museum [32, 33]

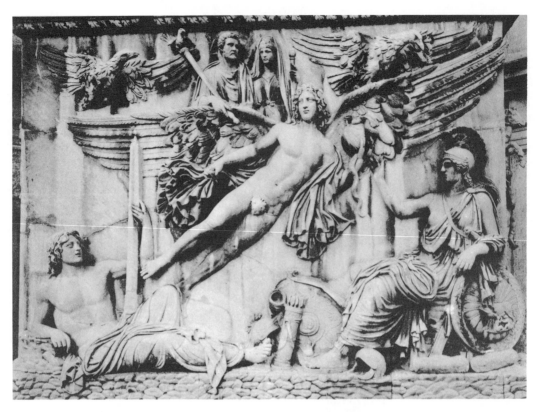

62 The apotheosis of Antoninus and Faustina, with (right) the personification of Rome in a gesture of piety. Base of column of Antoninus Pius, Rome [32]

63 Seated consul with the personifications of Constantinople. Diptych of the consul Magnus, right wing (detail), Bibliothèque Nationale, Paris [32]

64 Detail from a fragmentary leaf of the Alexandrian Chronicle. Center: The Mother
of God carrying the Child. Pushkin Museum of Fine Arts, Moscow [32]

65 Christ healing a blind man, with a prophet as witness.
Ivory carving, throne of Maximian,
Museo Arcivescovile, Ravenna [32]

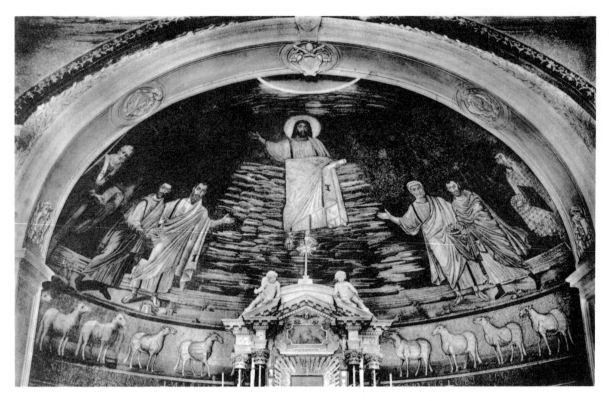

66 Christ with saints. Mosaic, SS. Cosma e Damiano, Rome [32, 33]

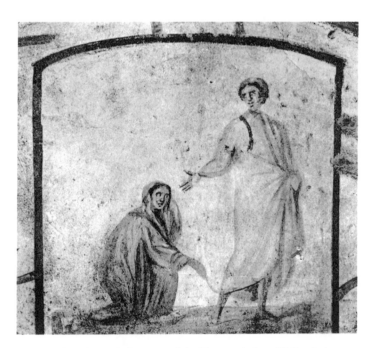

67 Christ in pose of orator and the Haemorrhoissa. Wall painting,
catacombs of SS. Peter and Marcellinus, Rome [32, 33]

68 Mosaics, S. Apollinare Nuovo, Ravenna. Flanking window: A saint and a prophet [32, 33]

69 Heads of St. Peter and a soldier. Sarcophagus of Junius Bassus (detail; see 29 *b*), Vatican Grottoes [33]

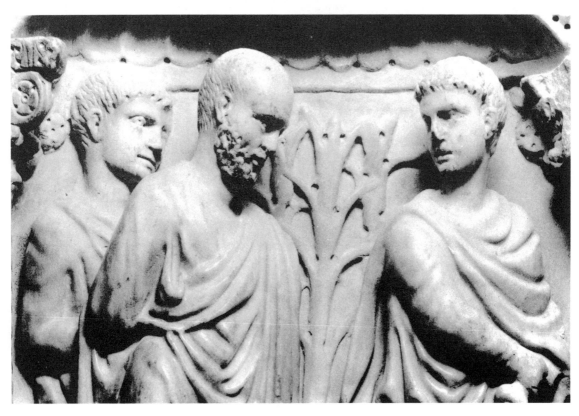

70 Heads of St. Paul and a companion. Sarcophagus of Junius Bassus (detail; see 29 *j*), Vatican Grottoes [33]

71 A figure of the philosopher type.
Wall painting, hypogeum of the Aurelii,
Rome (water-color copy) [33]

72 Two famous doctors. Detail from miniature,
Treatise of Dioscorides, Nationalbibliothek,
Vienna [33]

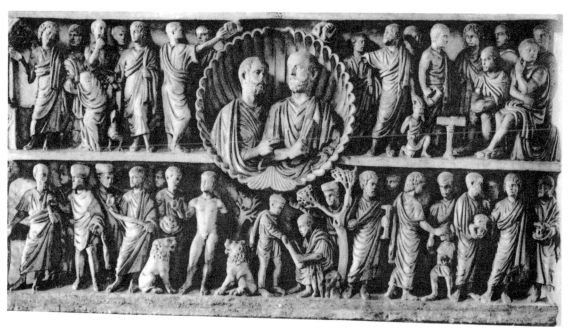

73 Christian sarcophagus known as that "of the two brothers," Lateran Museums, Rome.
In background: Biblical personages represented as young beardless men [34]

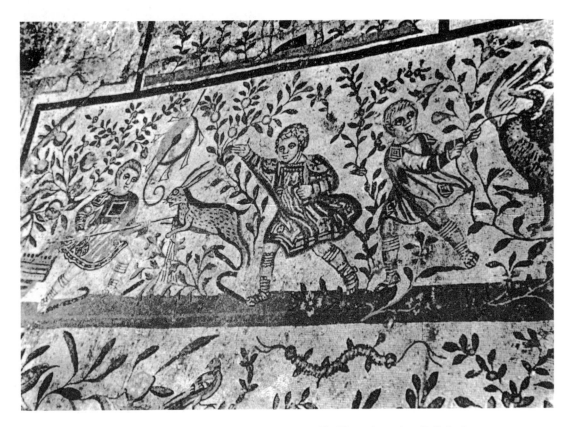

74 *Putti* hunting. Pavement mosaic, Roman villa, Piazza Armerina, Sicily [34]

75 *Putti* harvesting grapes. Pavement mosaic, Roman villa, Piazza Armerina, Sicily [34]

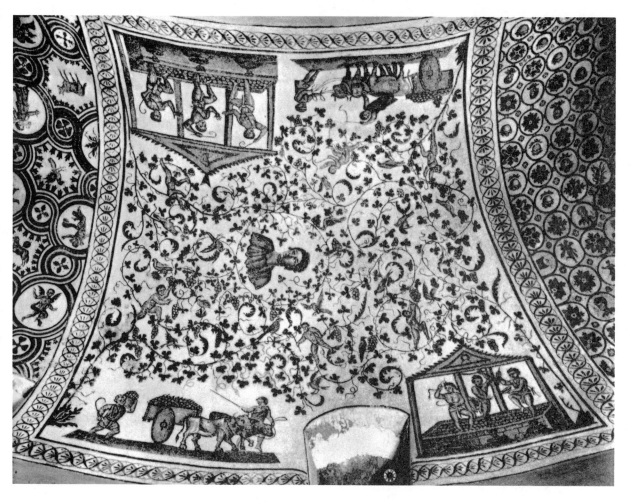

76 *Putti* harvesting grapes. Mosaic, S. Costanza, Rome [34]

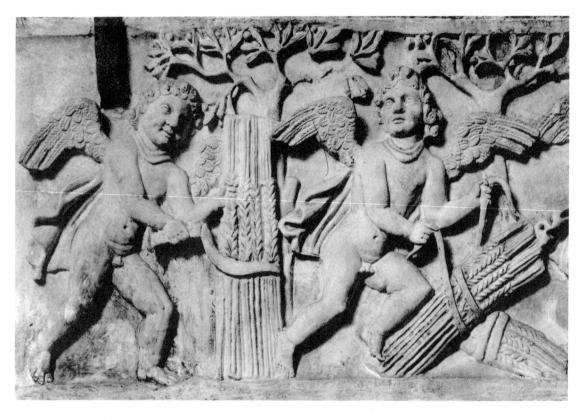

77 *Putti* harvesting wheat. Detail from end panel, sarcophagus of Junius Bassus, Vatican Grottoes [34]

78 *Putti* as Cupid and Psyche. Wall painting, catacomb of Domitilla, Rome [34]

79 Unidentified scene with *putti* in tunics. Wall painting, catacombs under the Via Latina, Rome [34]

80 Christ in majesty. Mosaic, S. Pudenziana, Rome [34]

81 Christ as lord of Universe.
Wall painting, catacomb of Commodilla,
Rome [34]

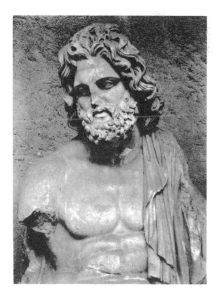

82 Jupiter. Detail of a statue
from the Villa dei Quintili.
Museo Nazionale Romano,
Rome [34]

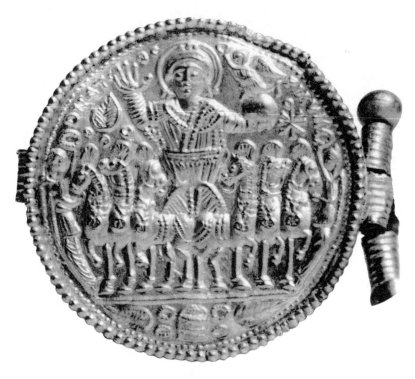

83 A victorious emperor in a triumphal chariot. Bracelet plaque,
Dumbarton Oaks, Washington, D.C. [35]

84 Wall painting, Bawit, Egypt. Above: Ezekiel's vision of God. Below, details: (left) Ezekiel; (right) Wheels of the chariot [35]

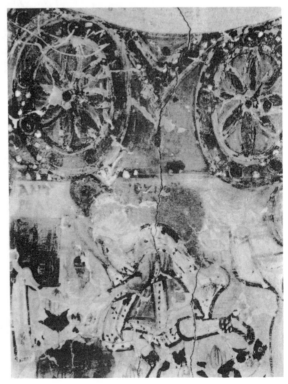

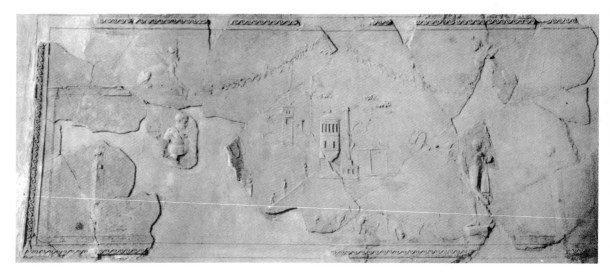

85 Stucco decoration from a house found at the Farnesina. Museo Nazionale Romano, Rome.
Bottom: Pastoral scene [35]

86 Pastoral scene. Wall painting, Museo Nazionale, Naples [35]

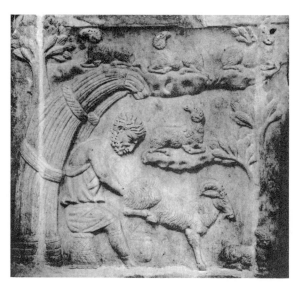

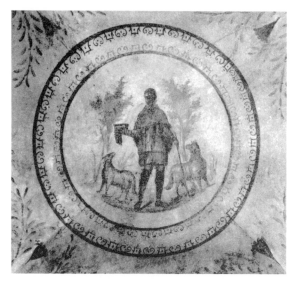

87 A shepherd and his sheep. Detail from Christian sarcophagus, Museo Nazionale Romano, Rome [36]

88 The Good Shepherd and his sheep. Painted ceiling, mausoleum of Trebius Justus, Rome [36]

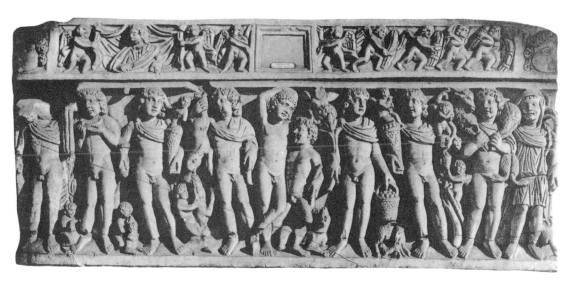

89 Pagan sarcophagus, Museo Nazionale Romano, Rome. Second figure from right: The Good Shepherd [36]

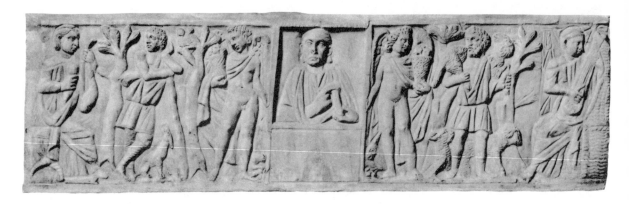

90 Christian sarcophagus, Lateran Museums, Rome. Second figure from left: A shepherd
leaning on his staff. Second figure from right: The Good Shepherd [36]

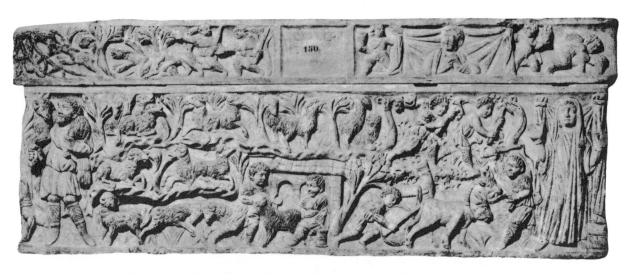

91 Christian sarcophagus, Lateran Museums, Rome. Extreme left: The Good Shepherd [36]

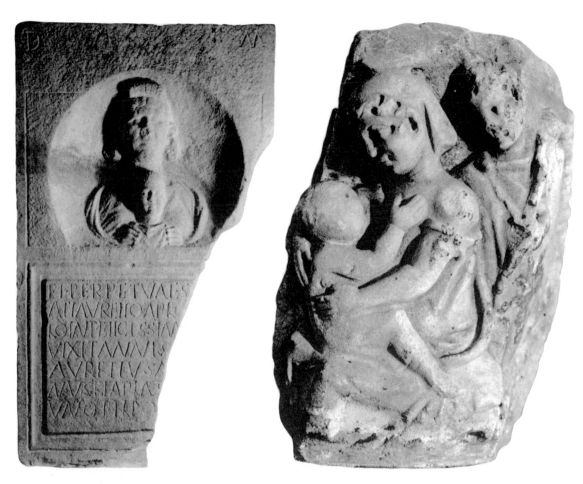

92 Mother and child in a medallion. Funerary stele, Archaeological Museum, Aquileia [36]

93 Shepherdess holding child. Fragment of a pagan sarcophagus, S. Sebastiano, Lapidary Museum, Rome [36]

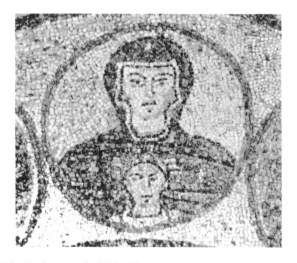

94 The Madonna and Child (Nikopea). Mosaic, S. Zenone, Rome [36]

95 Figure holding the labarum, the Imperial standard bearing the monogram of Christ. Cast of a coin, Bibliothèque Nationale, Paris [38]

96 Another figure holding the labarum. Cast of a coin, Bibliothèque Nationale, Paris [38]

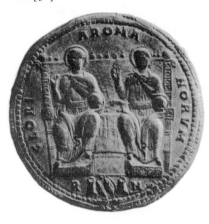

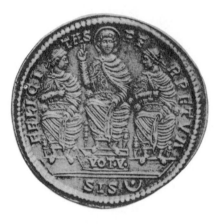

97 Two emperors sitting on a dual thone. Medal, Kunsthistorisches Museum, Vienna [40]

98 Constantine and his sons enthroned. Medal, Bibliothèque Nationale, Paris [40]

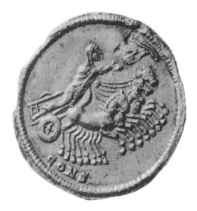

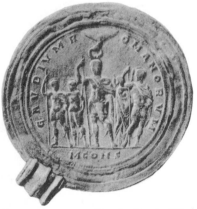

99 The apotheosis of Constantine with the Hand of God. Coin, Bibliothèque Nationale, Paris [40]

100 Constantine crowned by the Hand of God. Medal, Kunsthistorisches Museum, Vienna [40, 115]

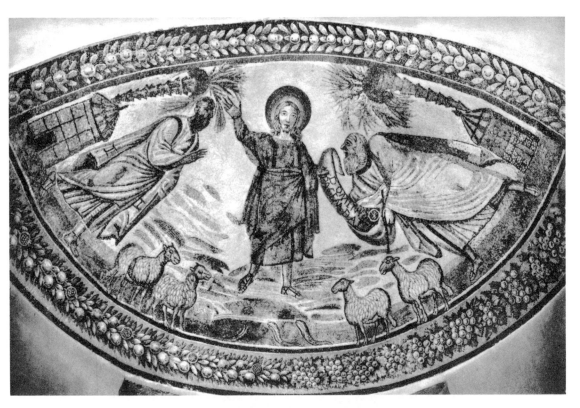

101 *Traditio legis*. Mosaic, S. Costanza, Rome [42]

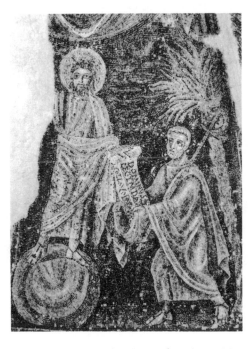

102 *Traditio legis*. Mosaic, S. Gennaro, baptistery of S. Giovanni in Fonte, Naples [42]

103 The Emperor, one of the Severi, crowning a victor in front of a temple. Cast of a coin of Apamea, Phrygia, Bibliothèque Nationale, Paris [42]

104 The Emperor Alexander Severus as cosmocrator enthroned on the sphere of the universe. Coin of his reign (222–35), Bibliothèque Nationale, Paris [42]

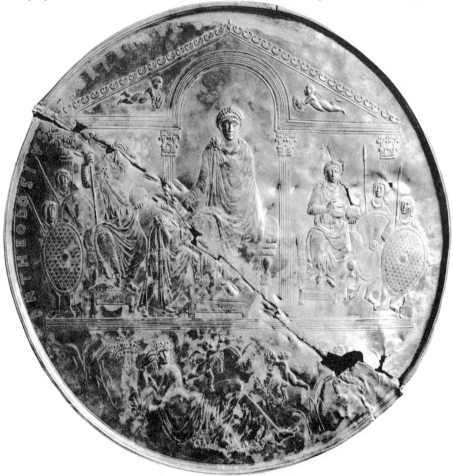

105 The Emperor Theodosius I, enthroned in majesty, hands a scroll of authority to an official. Silver plate, Academia de la Historia, Madrid [42]

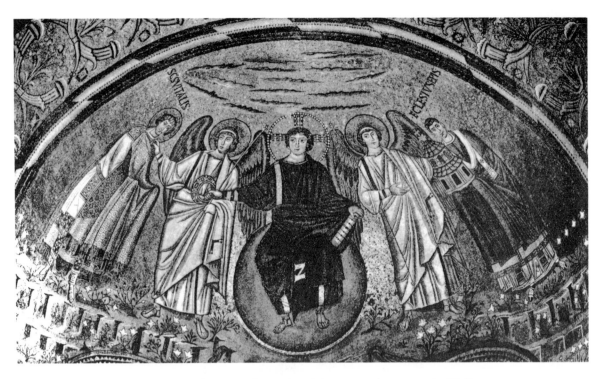

106 Christ as the universal sovereign giving a martyr's crown to St. Vitalis.
Mosaic, S. Vitale, Ravenna [43]

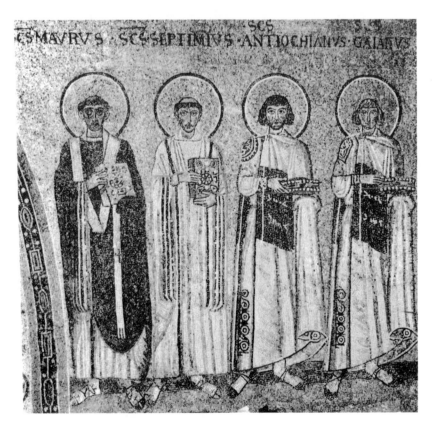

107 Four saints, two holding martyrs' crowns. Mosaic, chapel of
S. Venanzio, S. Giovanni in Fonte, Rome [43]

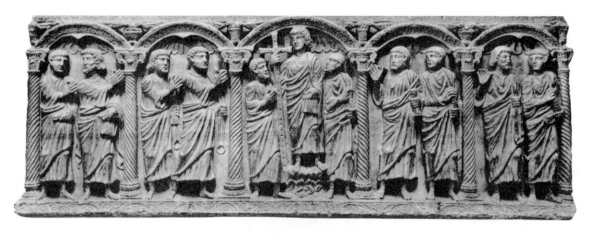

108 Sarcophagus of Sextus Petronius Probus and his wife, Vatican Museum. Center: Christ holding the cross in the pose of a lance-bearing emperor [43]

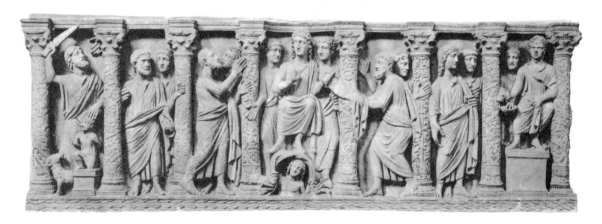

109 Sarcophagus. Lateran Museums, Rome. Center: Christ enthroned as the universal sovereign [43]

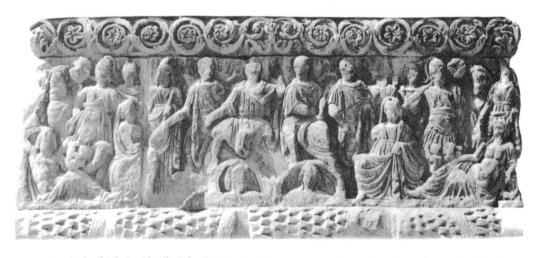

110 Arch of Galerius (detail), Salonika. Center: Two emperors enthroned as universal sovereigns [43]

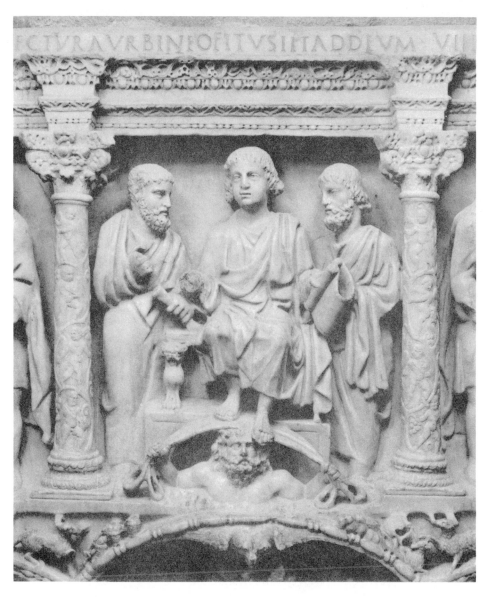

111 Christ enthroned as the universal sovereign. Sarcophagus of Junius Bassus (detail; see 29 *c*),
Vatican Grottoes [43]

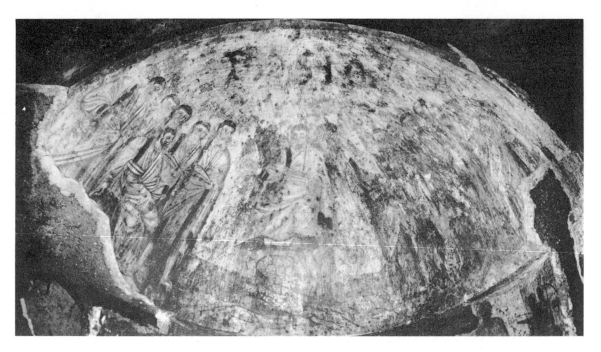

112 Christ seated, in an assembly of standing apostles. Wall painting, catacomb of Domitilla, Rome [44]

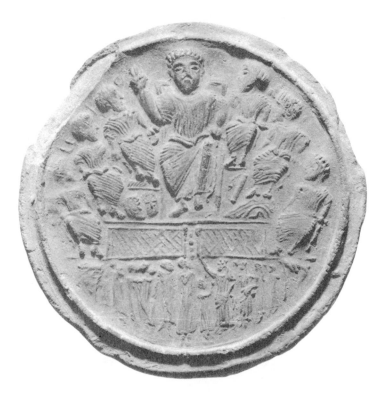

113 Christ as magistrate presiding over a council of apostles (The Last Judgment). The Barberini terra-cotta plaque, Dumbarton Oaks, Washington, D.C. [44]

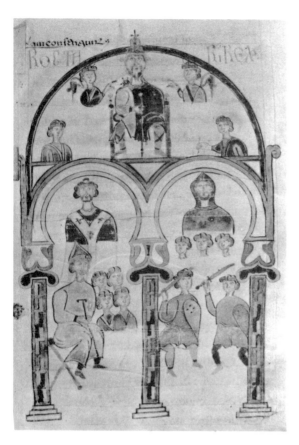

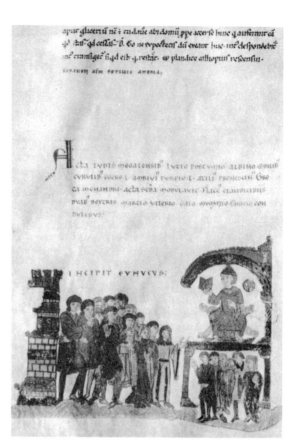

114 Scenes of judgment, with Christ as supreme
judge. Miniature, Lombard Laws, Biblioteca
Nacional, Madrid [44]

115 Scene of judgment. Miniature, Terence's
Eunuchus, Bibliothèque Municipale,
Tours [44]

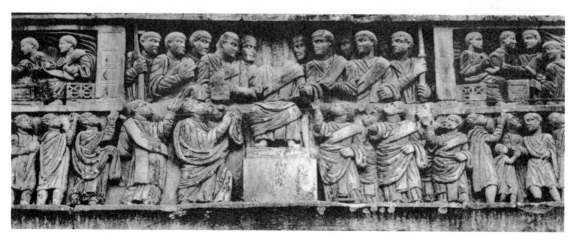

116 Arch of Constantine (detail), Rome. Center: Constantine distributing gifts of money,
the *largitio* [44]

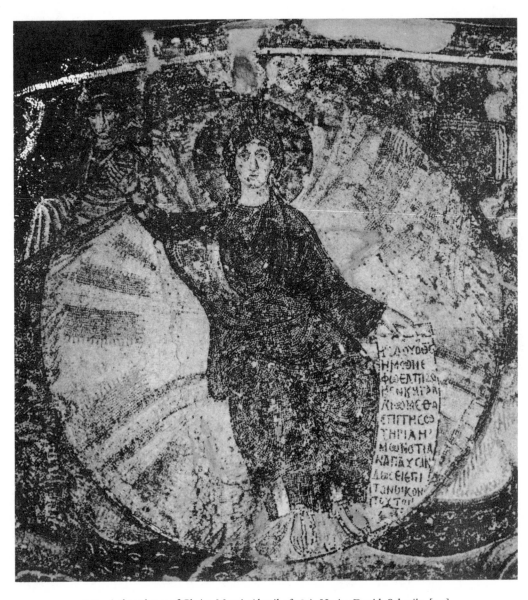

117 A theophany of Christ. Mosaic (detail of 280), Hosios David, Salonika [44]

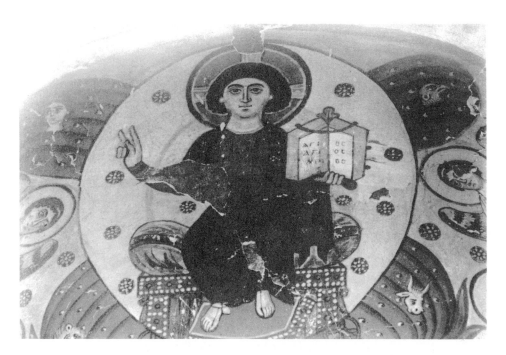

118 A theophany of Christ. Wall painting (detail of 323), Bawit, Egypt [44]

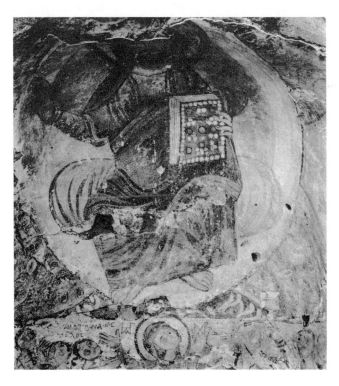

119 A theophany of Christ, with the Virgin and apostles below.
Wall painting, Bawit, Egypt [44]

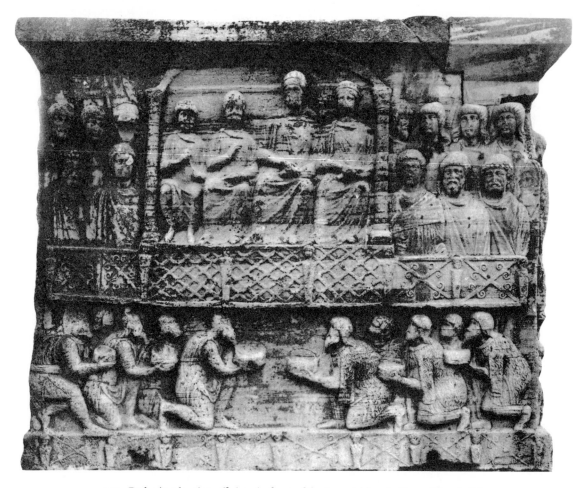

120 Barbarians bearing offerings in front of the Imperial loggia. Base of the obelisk
of Theodosius I, Constantinople [45]

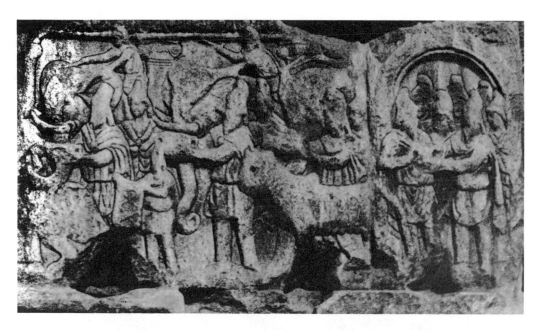

121 Parthian prisoners presenting offerings. Arch of Galerius (detail), Salonika [45]

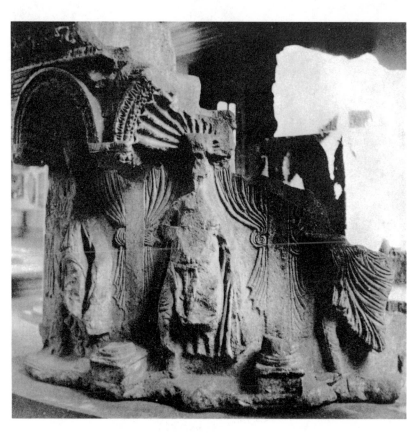

122 The Adoration of the Magi. Detail of ambo from St. George's Church, Salonika. Archaeological Museums, Istanbul [45]

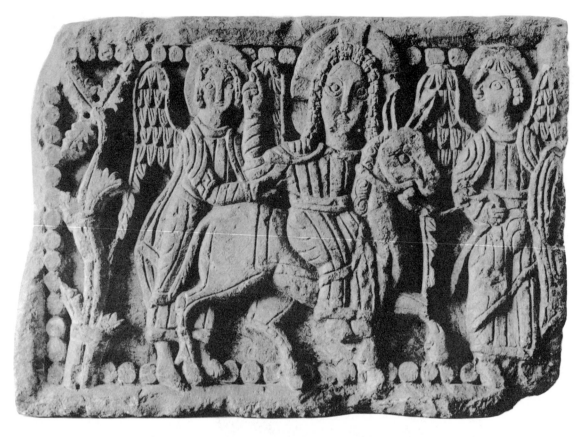

123 The Entry into Jerusalem. Coptic relief, Staatliche Museen, Berlin [45]

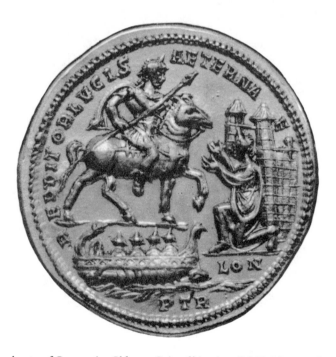

124 The *adventus* of Constantius Chlorus. Coin of his reign, British Museum, London [45]

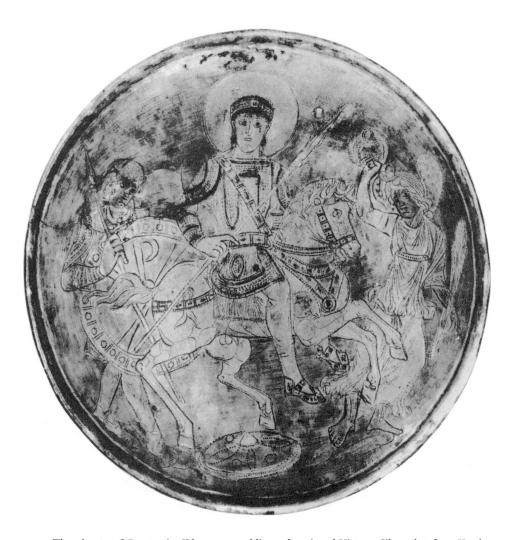

125 The *adventus* of Constantius II between a soldier and a winged Victory. Silver plate from Kerch,
State Hermitage Museum, Leningrad [45]

126 Column of Arcadius, Constantinople (now destroyed). Sketch by Melchior Lorichs dated 1559 (now lost; engraved copy by Reymond) [46, 47]

127 Column of Arcadius, upper portion, south side. Detail from one of three drawings by an unknown artist *c.* 1574. Trinity College, Cambridge [46, 47]

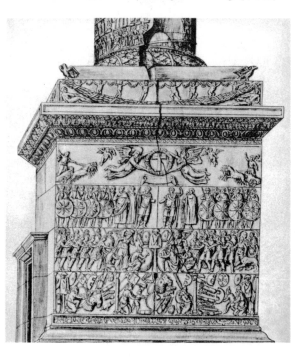

128 Column of Arcadius, south side of base [46]

129 Column of Arcadius, west side of base [46]

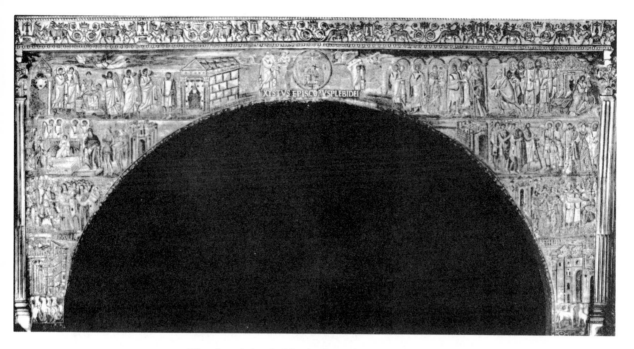

130 The triumphal arch. Mosaic, S. Maria Maggiore, Rome [46]

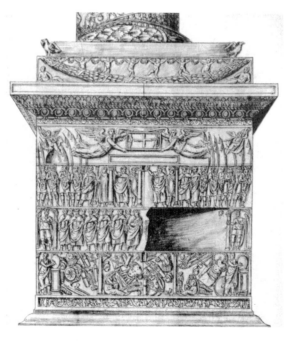

131 Column of Arcadius, east side of base [46]

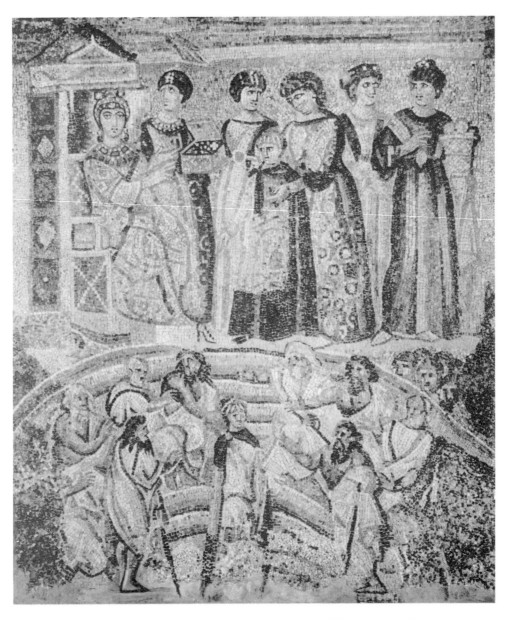

132 Mosaic, S. Maria Maggiore, Rome. Top: The childhood of Moses [47]

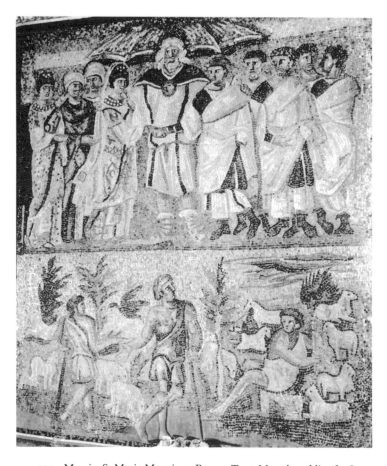

133 Mosaic, S. Maria Maggiore, Rome. Top: Moses' wedding [47]

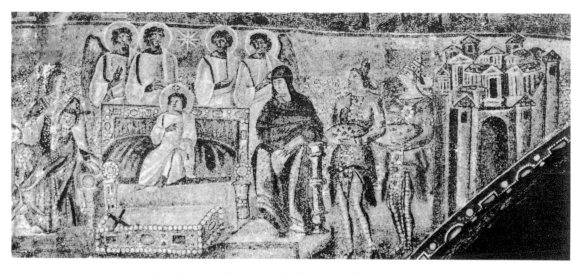

134 The Adoration of the Magi. Mosaic, S. Maria Maggiore, Rome [47]

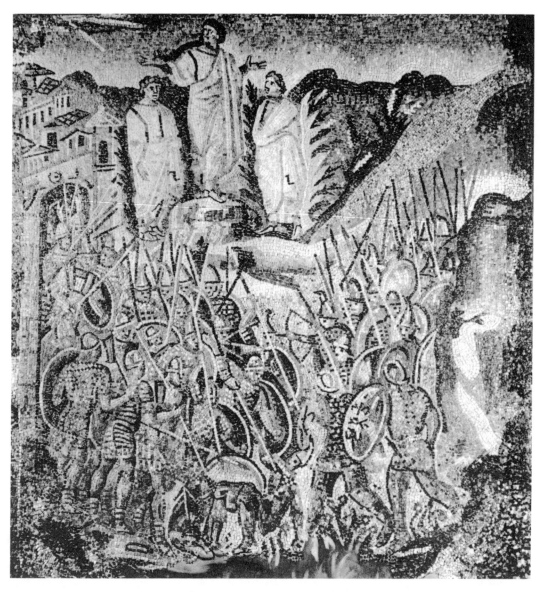

135 The defeat of the Amalekites. Mosaic, S. Maria Maggiore, Rome [48]

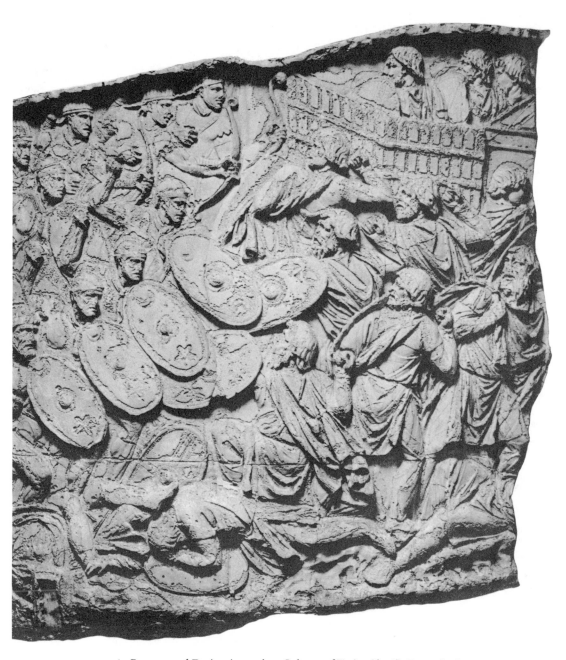

136 Romans and Dacians in combat. Column of Trajan (detail), Rome [48]

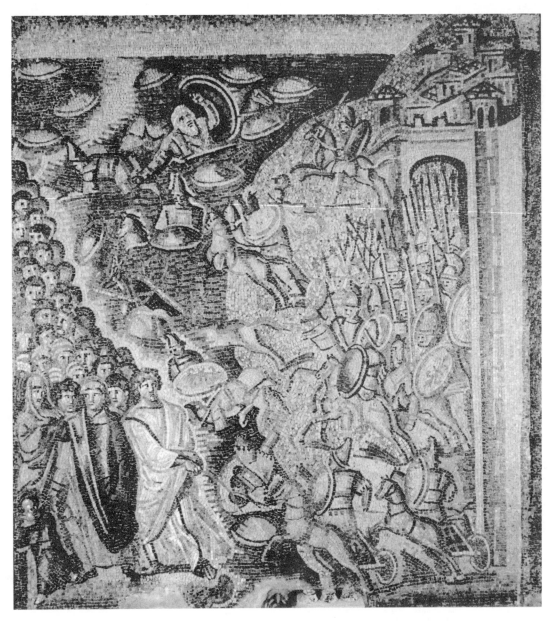

137 The crossing of the Red Sea. Mosaic, S. Maria Maggiore, Rome [48]

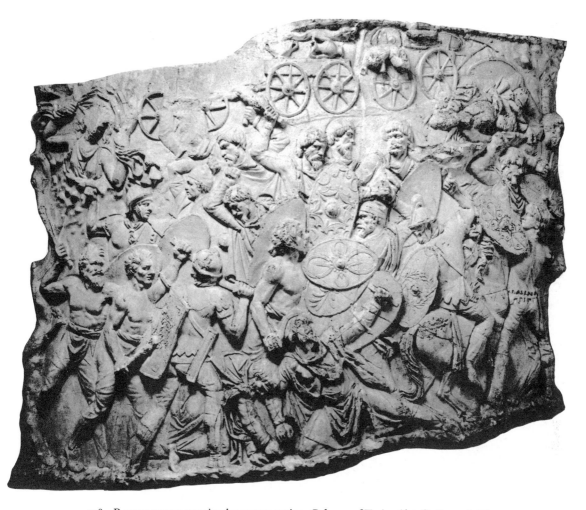

138 Roman troops surprise the enemy resting. Column of Trajan (detail), Rome [48]

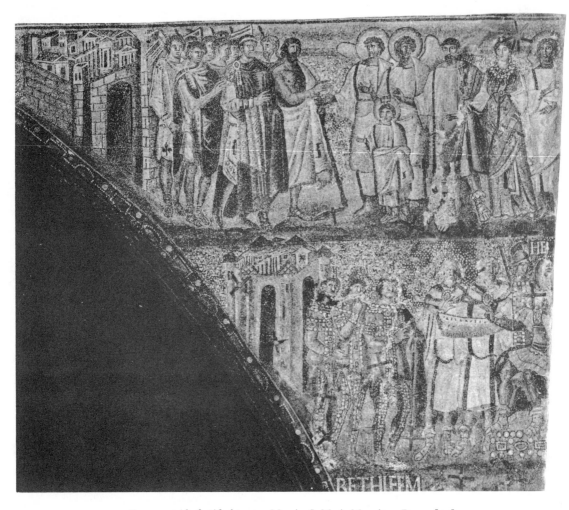

139 Scenes outside fortified towns. Mosaic, S. Maria Maggiore, Rome [49]

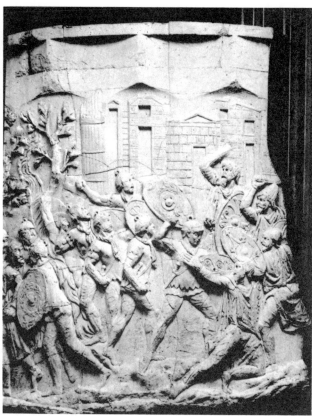

140 An engagement outside a fortified town. Column of Trajan (details), Rome [49]

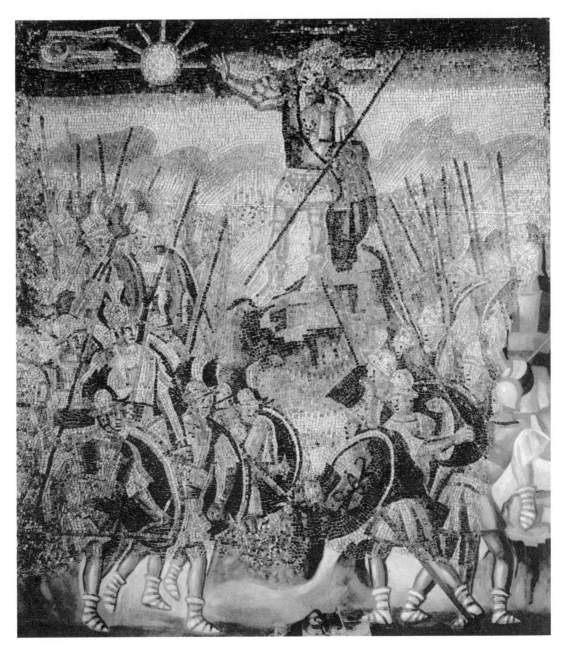

141 Joshua stopping the sun. Mosaic, S. Maria Maggiore, Rome [49]

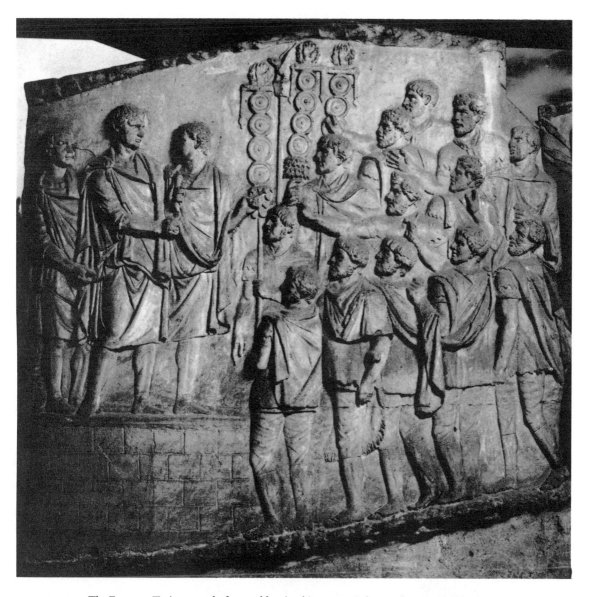

142 The Emperor Trajan on a platform, addressing his troops. Column of Trajan (detail), Rome [49]

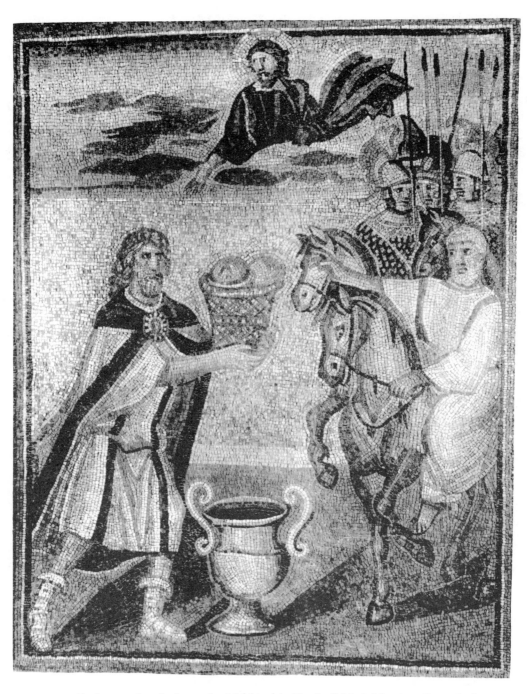

143 Abraham, on horseback, meeting Melchizedek. Mosaic, S. Maria Maggiore, Rome [49]

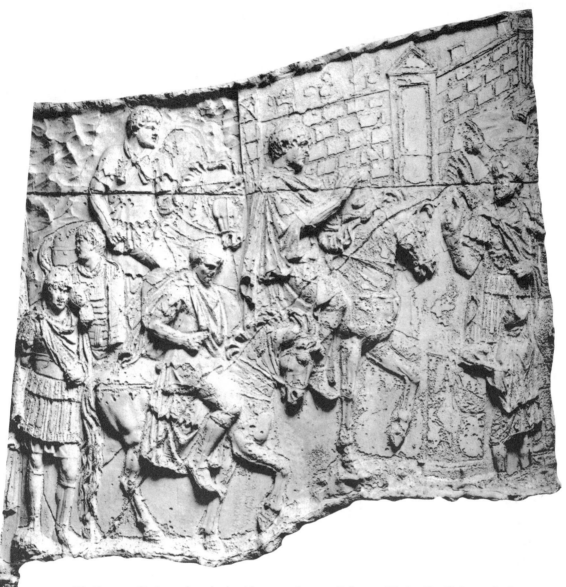

144 The Emperor Trajan on horseback with mounted escort. Column of Trajan (detail), Rome [49]

cui ALLeLuiA
CONFITCMINIDNO TESTAMENTISUI UERBI NOCERFELS ETCORRIPUIT

TIETQUARETRISTISINCEDO IUUENTUTEMMEAM TAREUULTUSMEIETDSMS
DUMADELICITMEINIMICUS

145 Manuscript illustrations for Psalms 105 and 44, Utrecht Psalter, Utrecht University Library [49]

146 Tribunal scenes. Wall paintings from a Roman house found under the Farnesina, Museo Nazionale Romano, Rome [49]

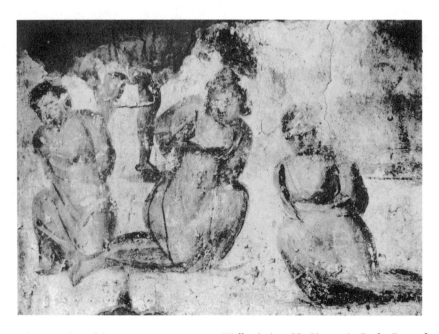

147 The execution of three anonymous martyrs. Wall painting, SS. Giovanni e Paolo, Rome [50]

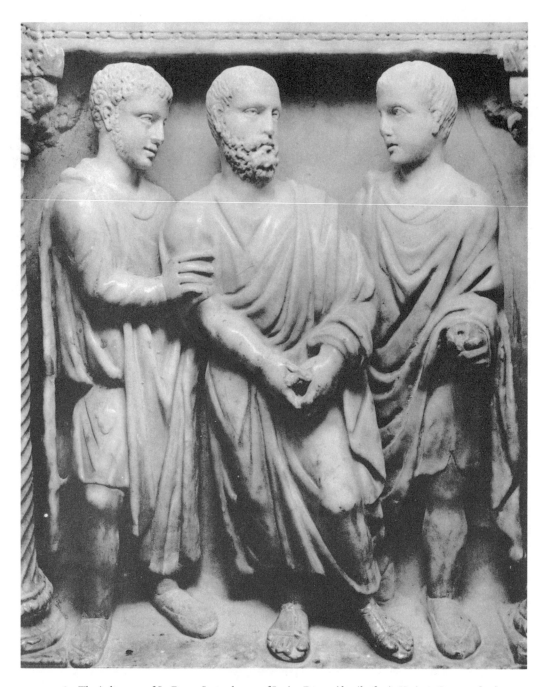

148 The judgment of St. Peter. Sarcophagus of Junius Bassus (detail of 29), Vatican Grottoes [50]

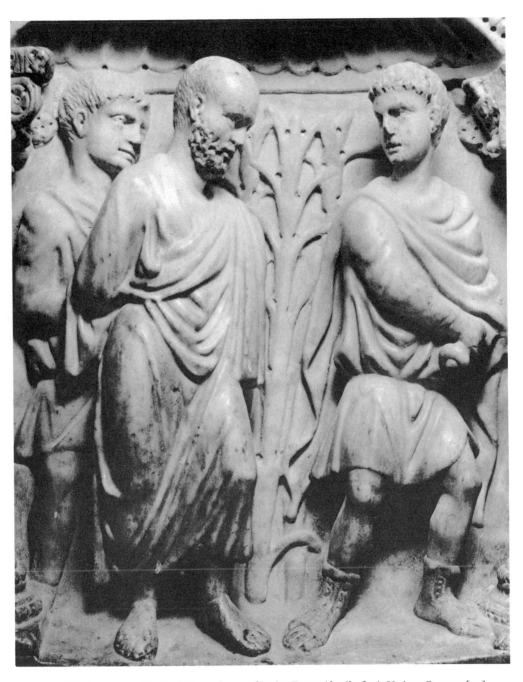

149 The judgment of St. Paul. Sarcophagus of Junius Bassus (detail of 29), Vatican Grottoes [50]

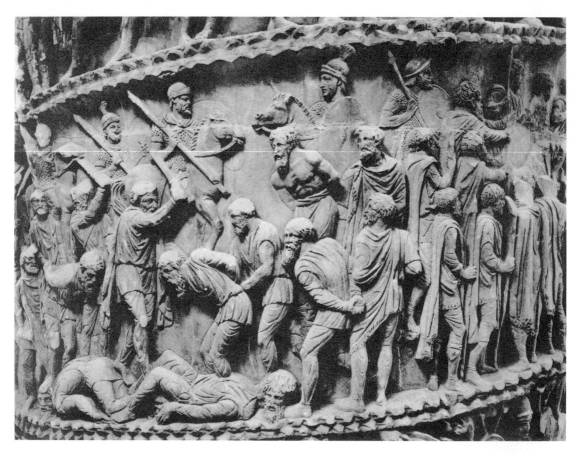

150 The decapitation of the Quadi rebels. Column of Marcus Aurelius (detail), Rome [50]

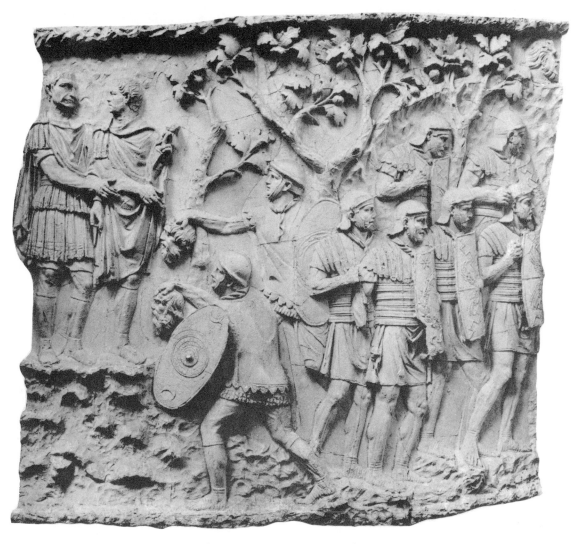

151 Roman officers mounted on an eminence to receive spoils, here the heads of enemies. Column of Trajan (detail), Rome [50]

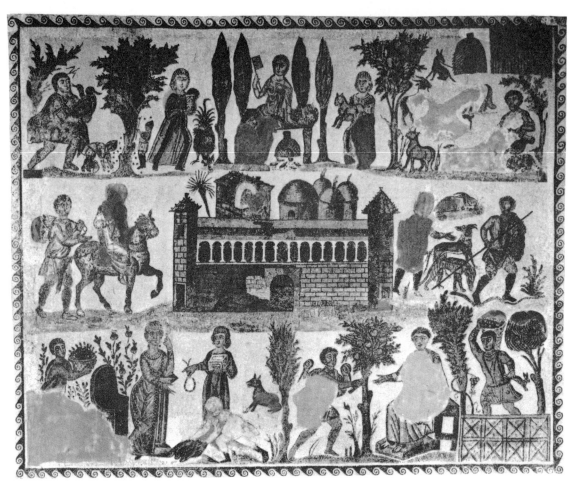

152 Pavement mosaic from Carthage, showing the estate of Dominus Julius.
Musée du Bardo, Tunis [51, 52]

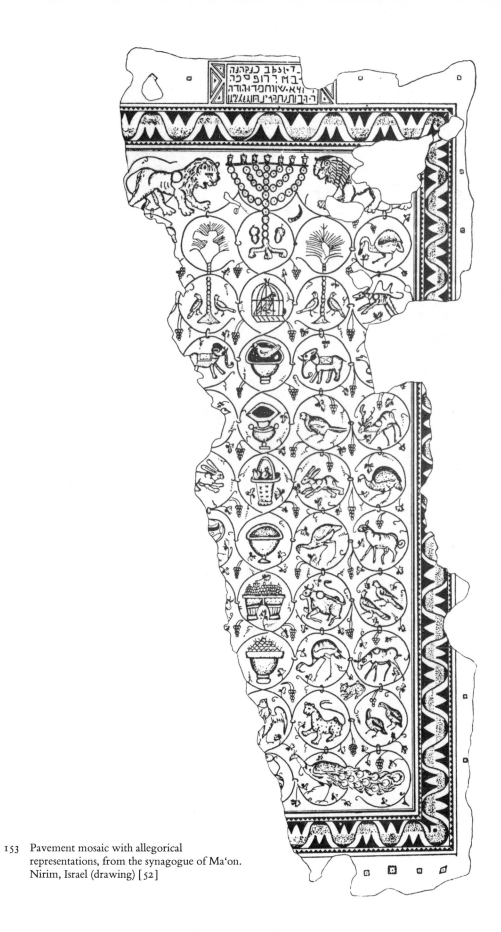

153 Pavement mosaic with allegorical
representations, from the synagogue of Maʻon.
Nirim, Israel (drawing) [52]

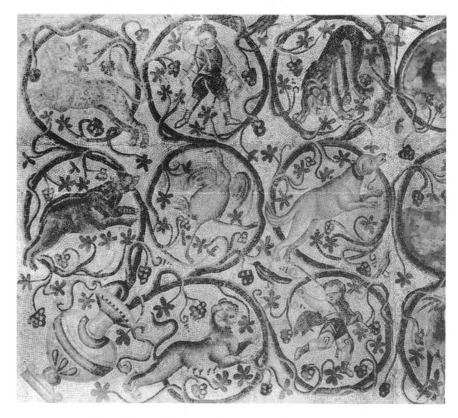

154 Mosaic from a church at Kabr-Hiram, Lebanon. Louvre, Paris [52]

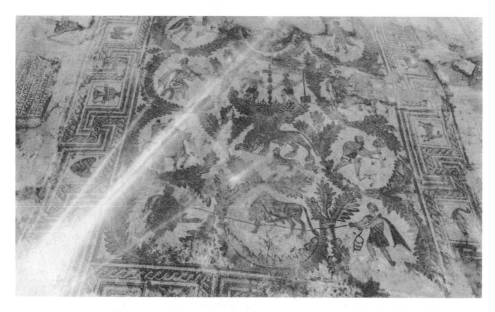

155 Pavement mosaic in the church of St. George, Mt. Nebo, Jordan [52, 53]

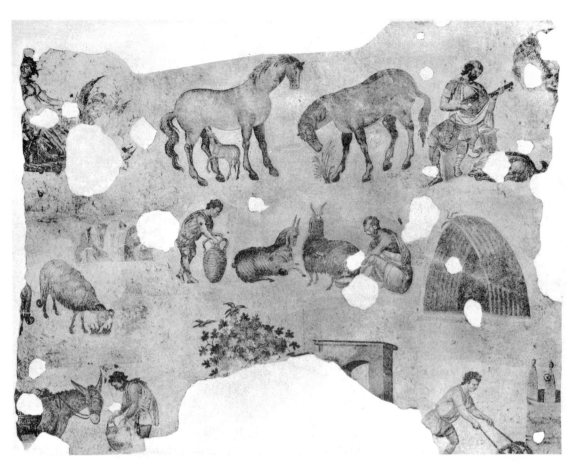

156 Pavement mosaic in the Great Palace, Istanbul [53]

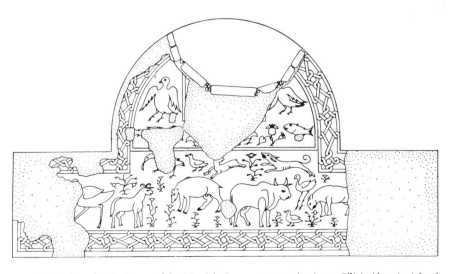

157 Animals under the Peace of the Messiah. Pavement mosaic, Ayas, Cilicia (drawing) [54]

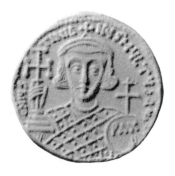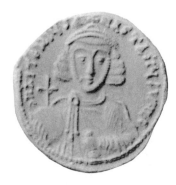

158 The Byzantine emperors Philippicus (r. 711–13), Justinian II (r. 685–95, 705–11), and
 Anastasius II (r. 713–16) represented on coins (here, casts). Bibliothèque Nationale, Paris [64]

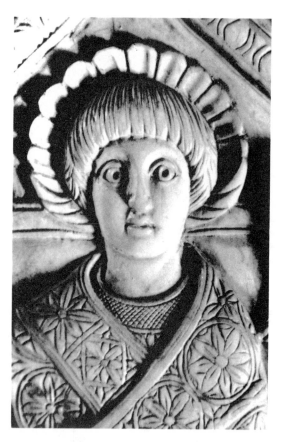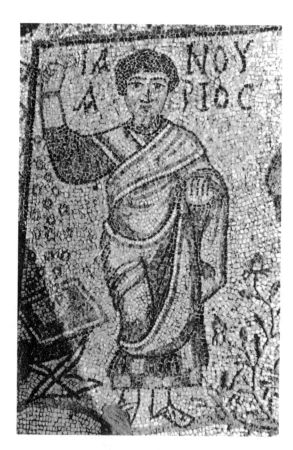

159 The consul Anastasius in a conventionalized
 representation. Ivory diptych (detail; see 196),
 Bibliothèque Nationale, Paris [64]

160 A consul. Pavement mosaic,
 Museum, Argos, Greece [64]

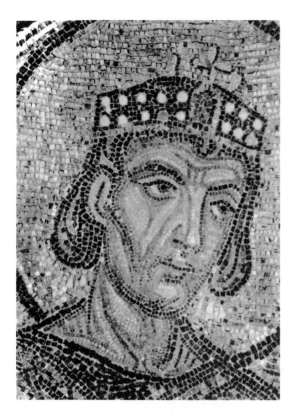

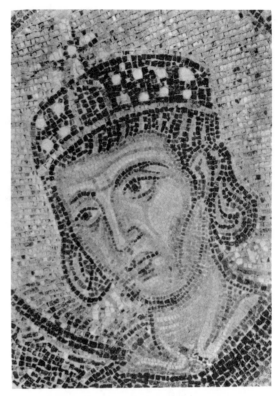

161 Head of Justinian. Mosaic,
 S. Sophia, Istanbul [65]

162 Head of Constantine. Mosaic, S. Sophia,
 Istanbul [65]

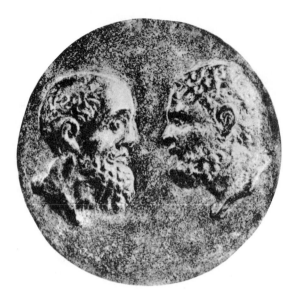

163 SS. Peter and Paul. Bronze medal, Museo Sacro, Vatican [68]

164 Heads of two emperors. Roman coin,
Bibliothèque Nationale, Paris [69]

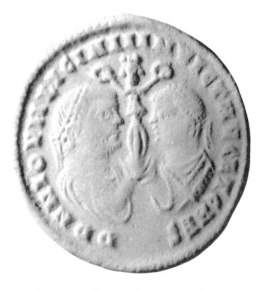

165 Heads of two emperors and a Victory.
Roman coin, Bibliothèque Nationale,
Paris [69]

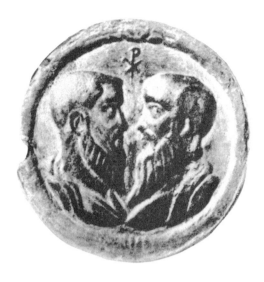

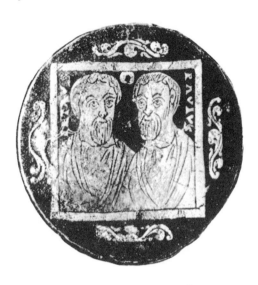

166 SS. Peter and Paul with the monogram
of Christ. Bronze medal, Museo Sacro,
Vatican [69]

167 SS. Peter and Paul. Gilded glass
fragment, Museo Sacro, Vatican [69]

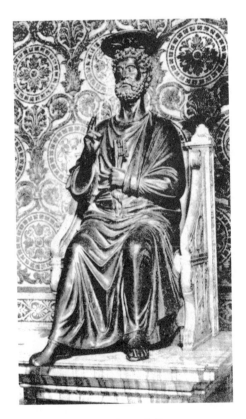

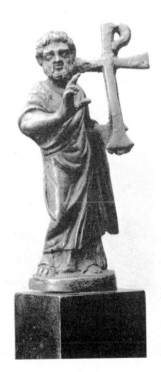

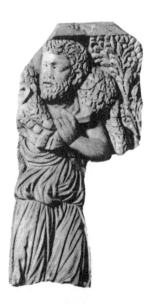

170 St. Peter as the Good
Shepherd. Detail
from a Christian
sarcophagus,
catacomb of
Domitilla, Rome
[70]

168 St. Peter enthroned. Bronze statue,
basilica of St. Peter, Vatican [70]

169 St. Peter bearing cross and
monogram of Christ. Bronze
statuette, Staatliche Museen,
Berlin [70]

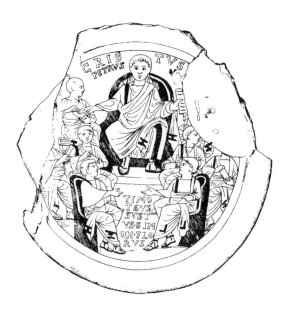

171 Christ, as Master Catechist, among the apostles. Gilded base of a glass vase,
 Pusey House, Oxford (drawing) [72]

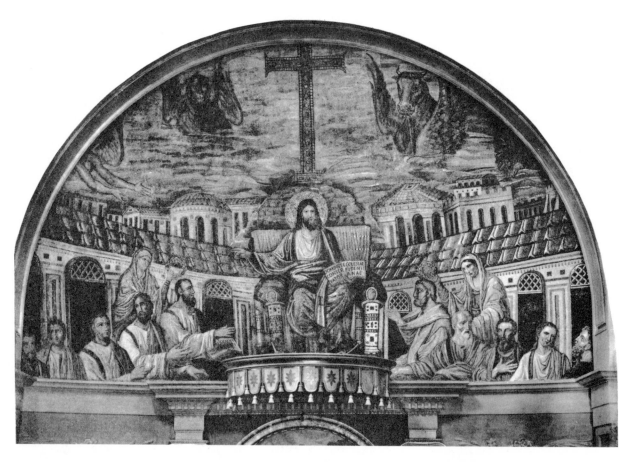

172 Christ in majesty, with apostles. Mosaic, S. Pudenziana, Rome [72]

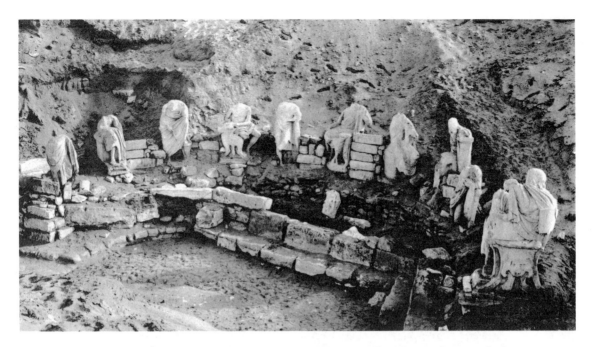

173　Remains of a Hellenistic exedra with statues of sages and poets. Memphis, Egypt [72]

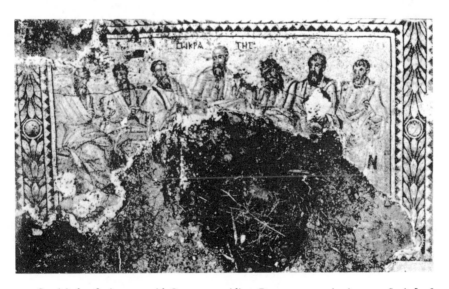

174　Semicircle of wise men with Socrates presiding. Pavement mosaic, Apamea, Syria [72]

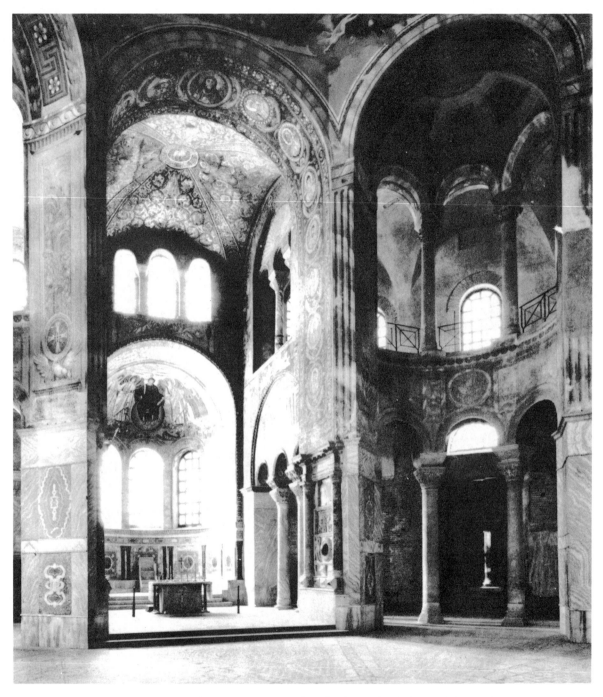

175 Mosaics, S. Vitale, Ravenna. On intrados of arch: Heads of Christ and the apostles
enclosed in medallions [73]

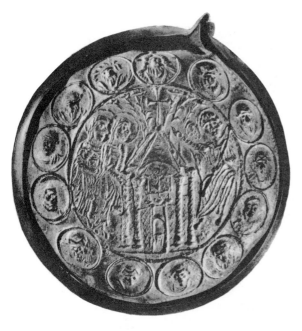

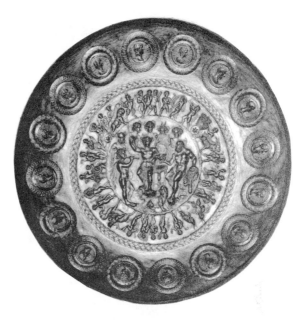

176 Palestinian ampulla, Treasure of the Collegiale, Monza. On rim: medallions of Christ and apostles [73]

177 The triumph of Dionysus, with Imperial medallions. Roman gold plate, Bibliothèque Nationale, Paris [73]

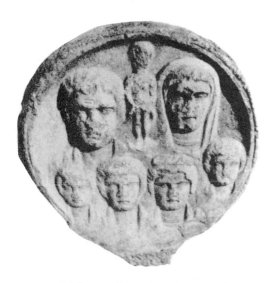

178 Medallion with portraits of an entire family. Fragment from Roman funerary stele, Museum, Sofia [73]

179 St. Prosdocimus. Alabaster sarcophagus panel, S. Giustina, Padua [73]

180 St. Victor. Mosaic, S. Vittore chapel, S. Ambrogio, Milan [73]

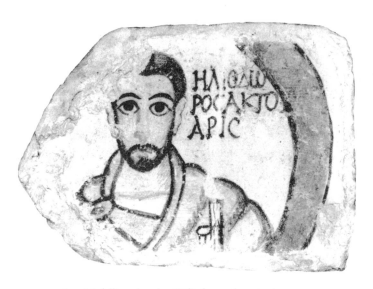

181 Medallion showing Heliodorus, the *actuarius*.
Ceramic tile, Dura-Europos, Syria. Yale University
Art Gallery [73]

182 Medallion showing a portrait of a pope.
Wall painting, S. Crisogono, Rome
[73]

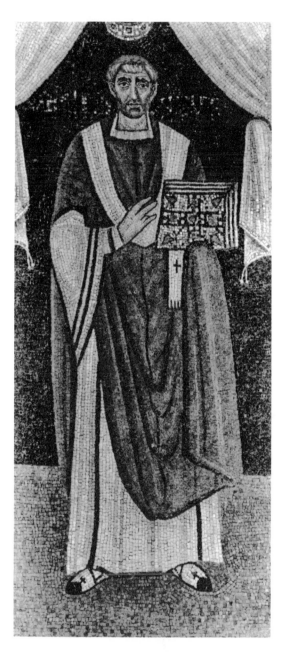

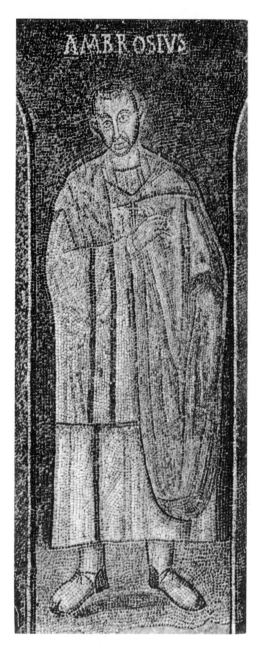

183 An archbishop. Mosaic, S. Apollinare
 in Classe, Ravenna [74]

184 St. Ambrose. Mosaic, S. Vittore chapel,
 S. Ambrogio, Milan [74]

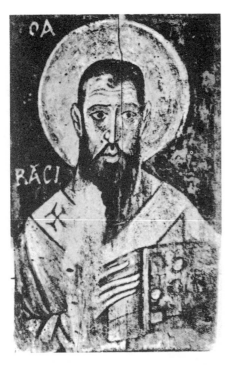

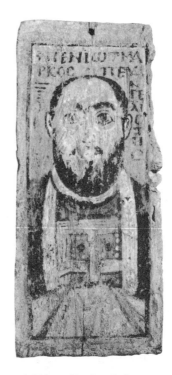

185 St. Basil. Icon on wood, part of a
 triptych, Mt. Sinai (detail of 217) [74]

186 A bishop. Coptic painting on wood,
 Bibliothèque Nationale, Paris [74]

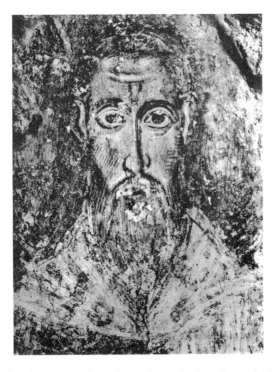

187 St. Basil. Wall painting, S. Maria Antiqua, Rome [74]

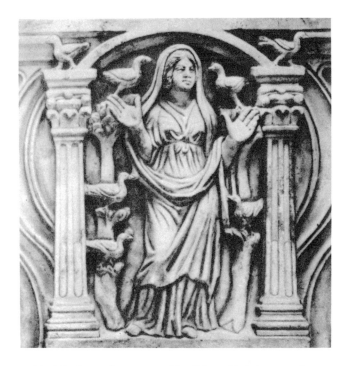

188 The deceased as an orant. Detail from Christian sarcophagus
called "della Lungara," Lateran Museums, Rome [75]

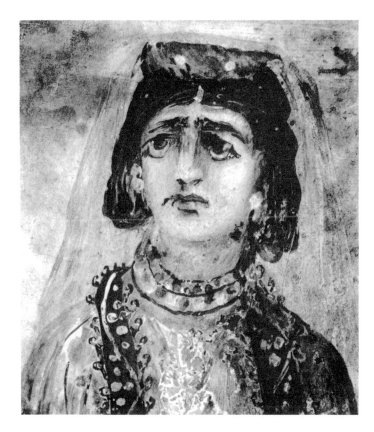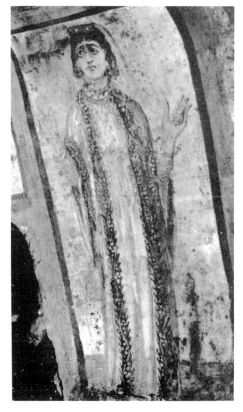

189 Portrait of a girl as orant. Details from wall painting, catacomb of Thraso and Saturninus,
Rome [75]

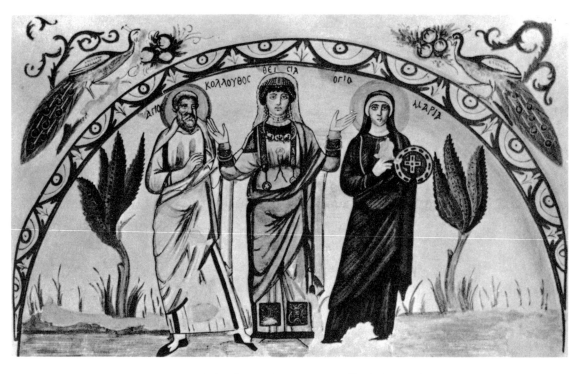

190 An orant named Theodosia with two saints. Wall painting, Antinoë, Egypt
 (copy by M. Salmi) [75]

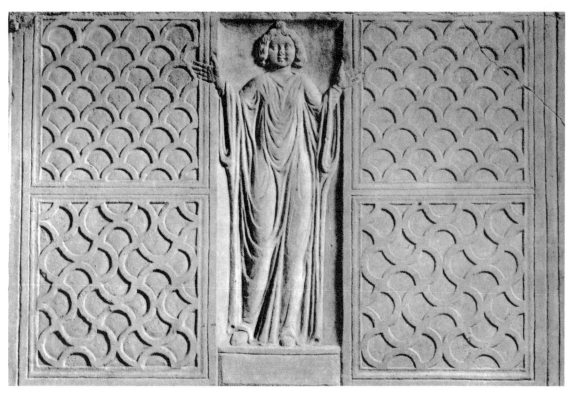

191 St. Agnes. Altar relief, S. Agnese fuori le Mura, Rome [75]

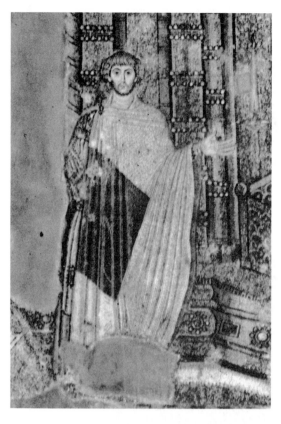

192 A martyr as orant. Mosaic, St. George's
 Church, Salonika [75]

193 St. Demetrius as orant with donors.
 Mosaic, St. Demetrius, Salonika [75]

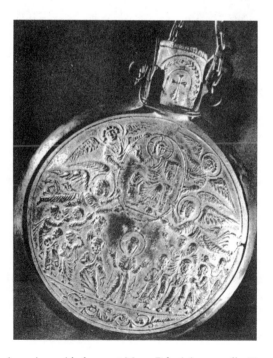

194 The Ascension, with the orant Mary. Palestinian ampulla, Treasure of the
 Collegiale, Monza [76]

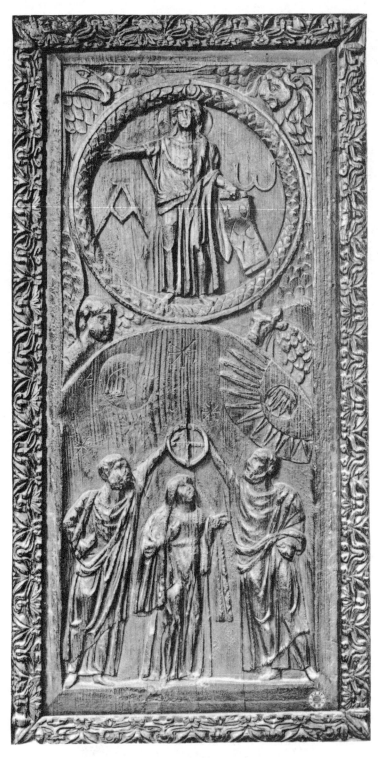

195 Carved panel of the door, S. Sabina, Rome. Bottom: The orant Mary [76]

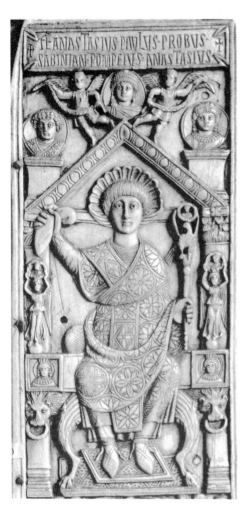

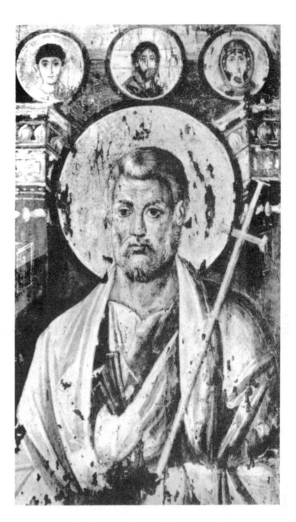

196 Ivory diptych of the consul Anastasius
(right wing), Bibliothèque Nationale,
Paris. Top: Medallion portraits of
the emperor, empress, and (probably)
a colleague [77]

197 St. Peter, with medallion portraits of
Christ, the Virgin, and an apostle. Icon
in encaustic, Mt. Sinai [78]

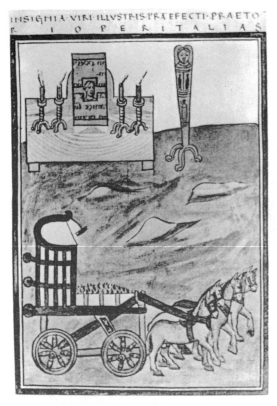

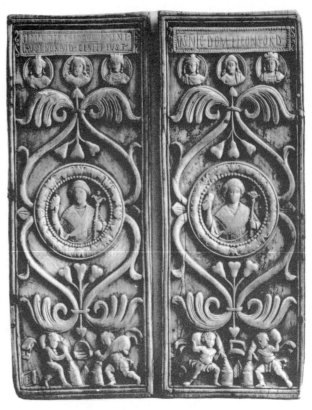

198 Folio from the *Notitia dignitatum*,
Bibliothèque Nationale, Paris. On the
table: An official portrait of a Roman
emperor [79]

199 Ivory diptych of the consul Justin, Staatliche Museen,
Berlin. Above the consul, as in 197: three medallions,
here representing Christ, the emperor, and the
empress [79]

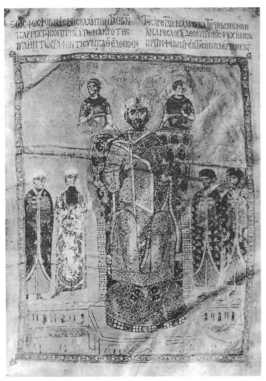

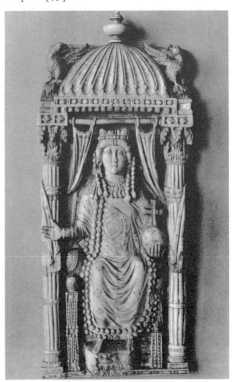

200 The Emperor Nicephorus Botaniates
enthroned, with dignitaries of his court.
Miniature, Codex Coislin 79,
Bibliothèque Nationale, Paris [79]

201 The empress enthroned. Ivory panel,
Kunsthistorisches Museum,
Vienna [79]

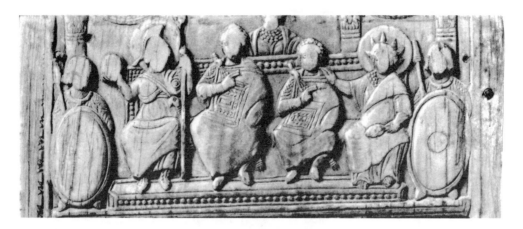

202 Two coregnant emperors on one throne, with other personages. Detail from diptych of the consul Constantius III, Cathedral Treasury, Halberstadt [79]

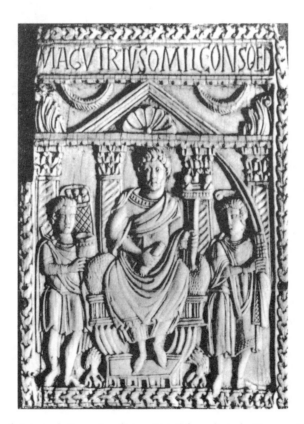

203 The consul Asturius between two lictors. Detail from diptych, Museum, Darmstadt [79]

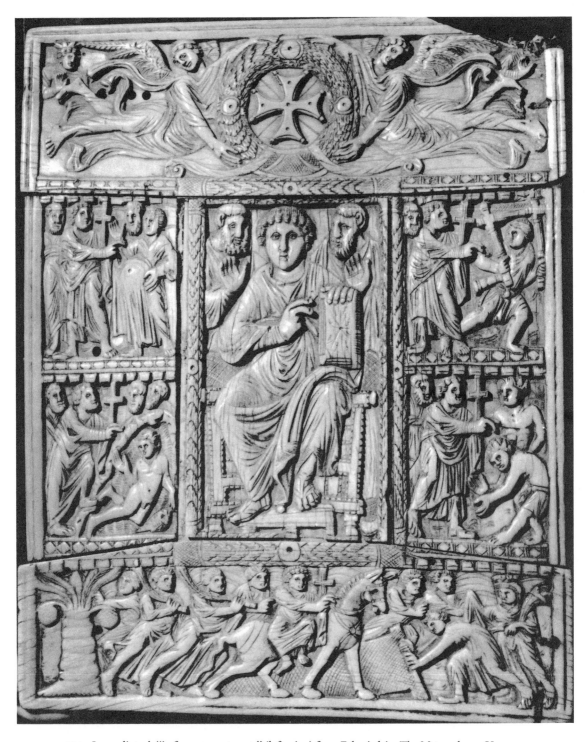

204 Ivory diptych "in five compartments" (left wing) from Echmiadzin. The Matenadaran, Yerevan, Armenia. Center: Christ enthroned, between two apostles [80]

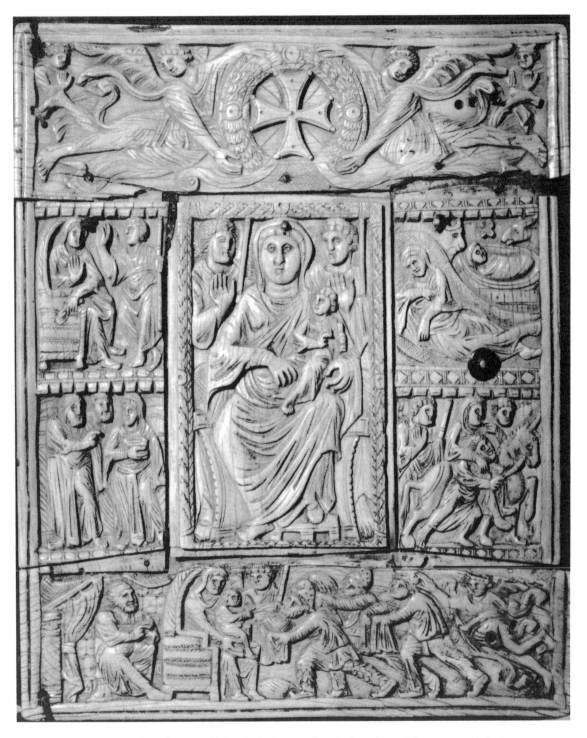

205 Ivory diptych, as 204 (right wing). Center: The Virgin enthroned, between angels [80]

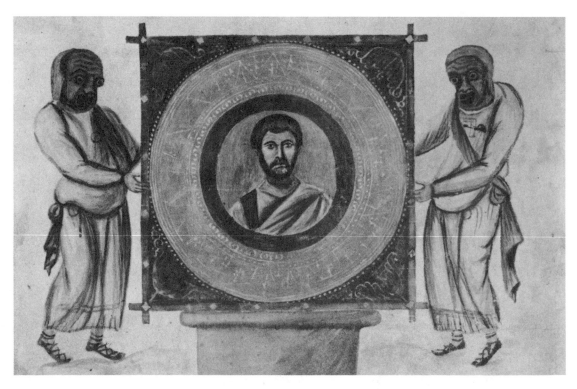

206 Portrait of Terence. Detail from the frontispiece of a manuscript of Terence, Vatican Library [81]

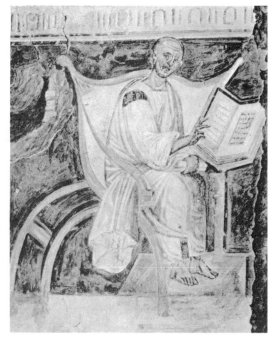

207 Portrait of the monk St. Anthony. Frontispiece in a tenth-century Gospel, monastery of Stavronikita, Mt. Athos [81]

208 St. Augustine at his desk. Wall painting, Old Library, Lateran Museums, Rome [81]

209 The Adoration of the Magi and of the Shepherds. Palestinian ampulla.
Treasure of the Collegiale, Monza [81]

210 Jupiter, or Zeus, enthroned with attendant deities. Illustration in
a sixth-century manuscript of Virgil, Vatican Library [81]

211 Gods or military chiefs seated on a curved bench. Illustration in a sixth-century manuscript
of the *Iliad*, Biblioteca Ambrosiana, Milan [81]

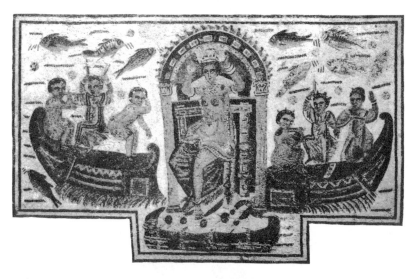

212 The coronation of Venus-Ariadne. Mosaic from Carthage. Musée du Bardo, Tunis [82]

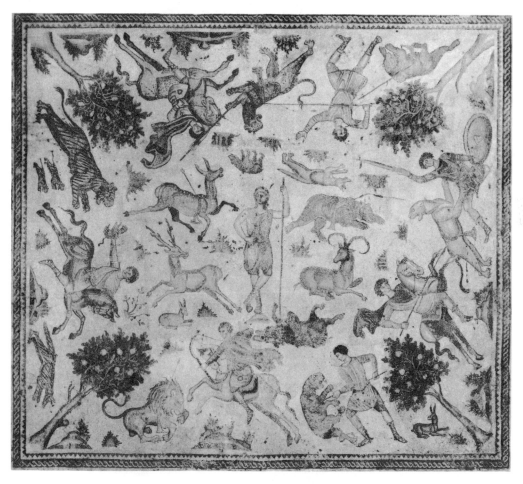

213 Dionysus-Bacchus with trophies of the chase. Pavement mosaic from Antioch (Daphne).
 Worcester Art Museum [82]

214 Harpocrates enthroned. Wall painting from Karanis, Egypt.
Kelsey Museum of Archaeology, University of Michigan [82]

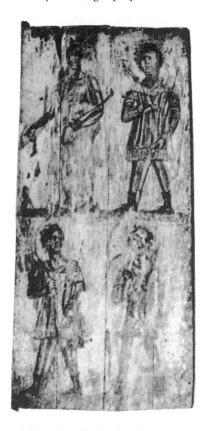

215 Images of Palmyrene gods. Central portion (left) and one leaf (right) from a
• pagan triptych. Staatliche Museen, Berlin [82]

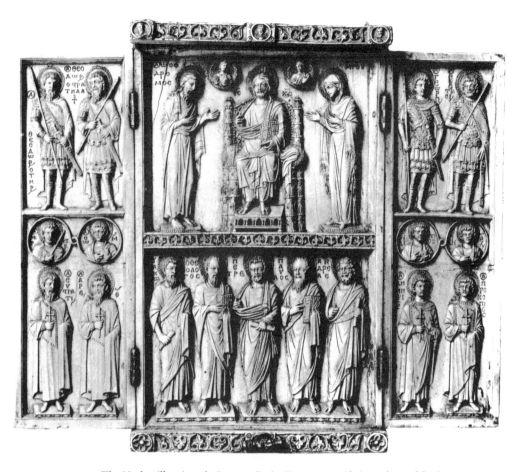

216 The Harbaville triptych, Louvre, Paris. Top center: Christ enthroned [82]

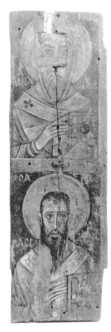

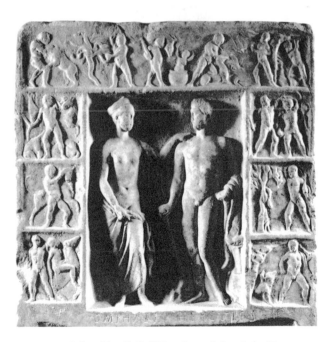

217 Images of saints. Leaf from
a Christian triptych icon,
Mt. Sinai [82]

218 Stele with relief of Hercules and Omphale. Museo
Nazionale, Naples [83]

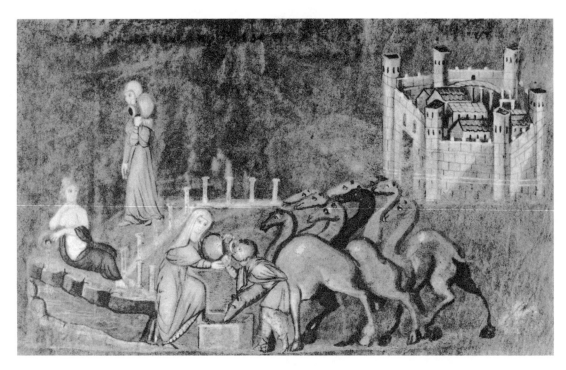

219 Rebecca and Eleazar. Miniature, Genesis in Greek, Nationalbibliothek, Vienna [88]

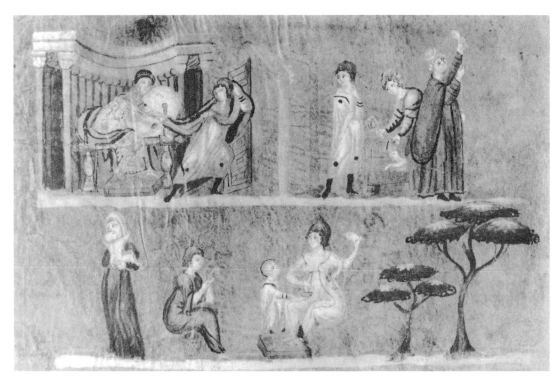

220 Joseph and Potiphar's wife. Miniature, Genesis in Greek, Nationalbibliothek, Vienna [88]

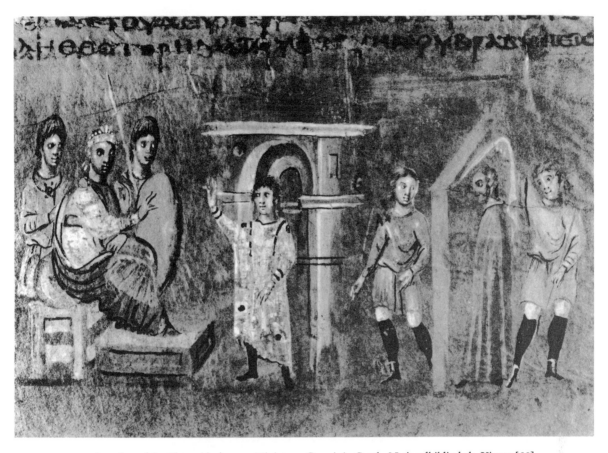

221 Joseph explains Pharaoh's dreams. Miniature, Genesis in Greek, Nationalbibliothek, Vienna [88]

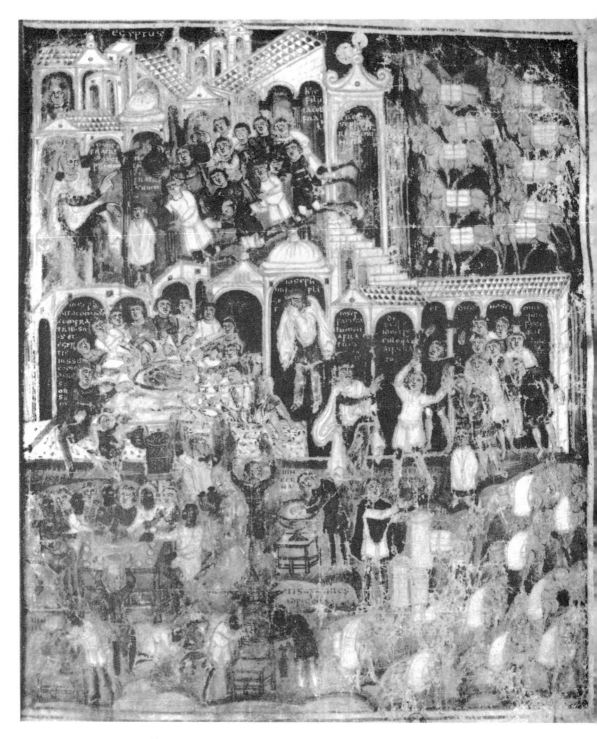

222 Joseph's story. Miniature, Ashburnham Pentateuch, Bibliothèque Nationale, Paris [88]

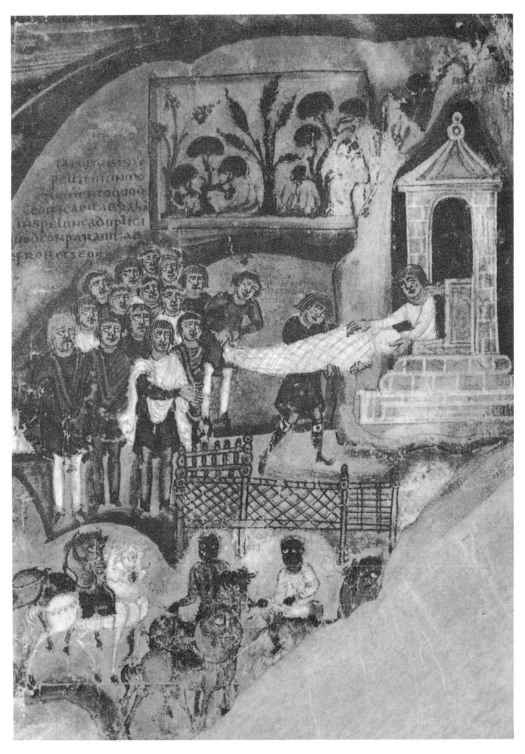

223 Joseph's interment. Miniature, Ashburnham Pentateuch, Bibliothèque Nationale, Paris [88]

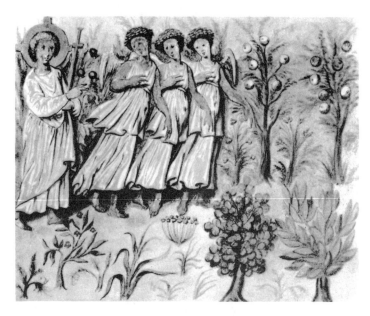

224 The third day of creation. Miniature from Cotton Bible, after a copy prepared for Peiresc, Bibliothèque Nationale, Paris [88]

225 Oedipus' story. Fresco from Hermopolis West (Tuneh el Gebel). Egyptian Museum, Cairo [89]

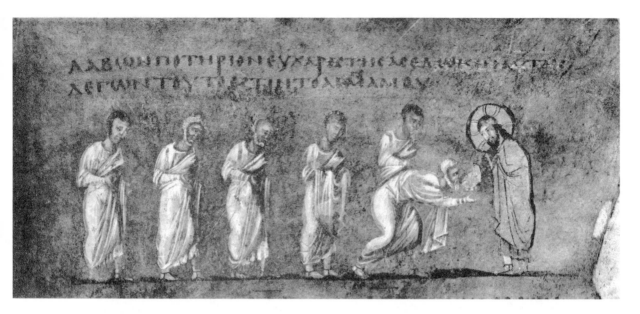

226 The communion of six apostles. Miniature, Greek Gospels, Cathedral Treasury, Rossano [89]

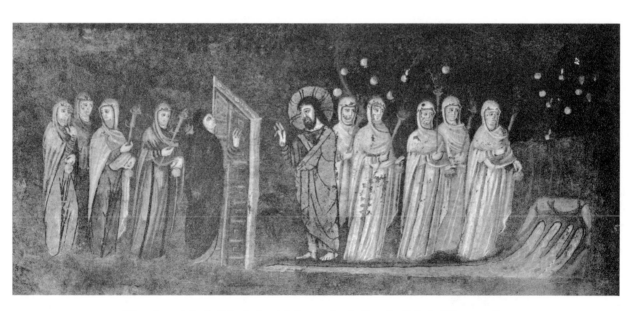

227 The wise and the foolish virgins. Miniature, Greek Gospels, Cathedral Treasury, Rossano
 [89, 90]

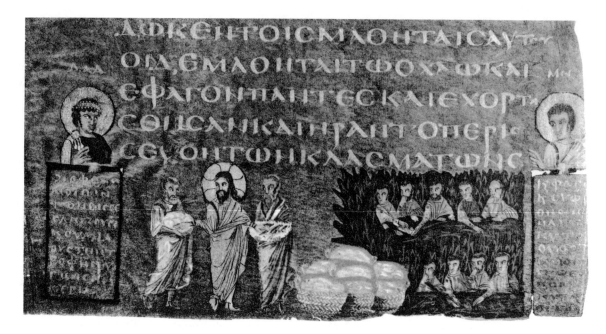

228 The Multiplication of the Loaves and Fishes. Miniature, Sinope Gospel,
 Bibliothèque Nationale, Paris [90]

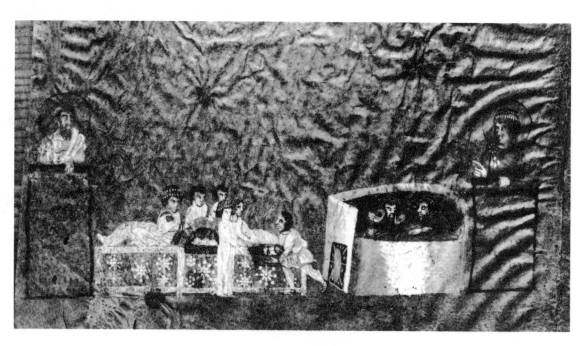

229 The presentation of St. John the Baptist's head at Herod's feast flanked by prophets holding
 scrolls. Miniature, Sinope Gospel, Bibliothèque Nationale, Paris [90]

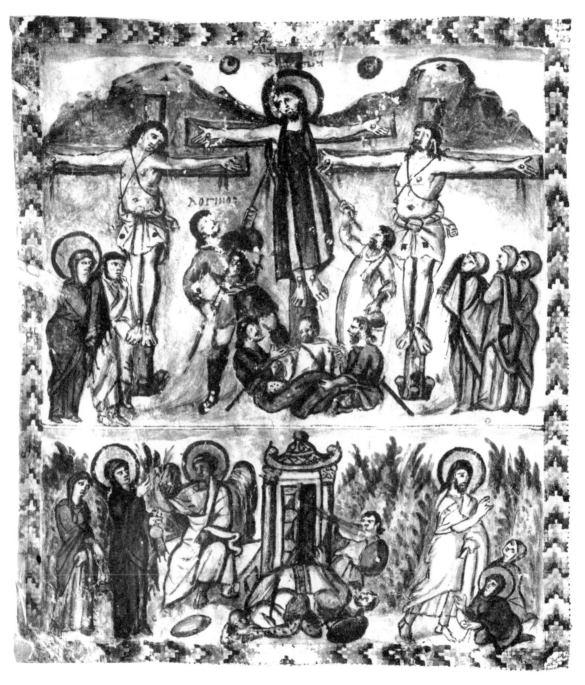

230 The Crucifixion (top) and the Holy Women at Christ's Tomb (bottom). Miniature,
Rabbula Gospels, Biblioteca Medicea-Laurenziana, Florence [90]

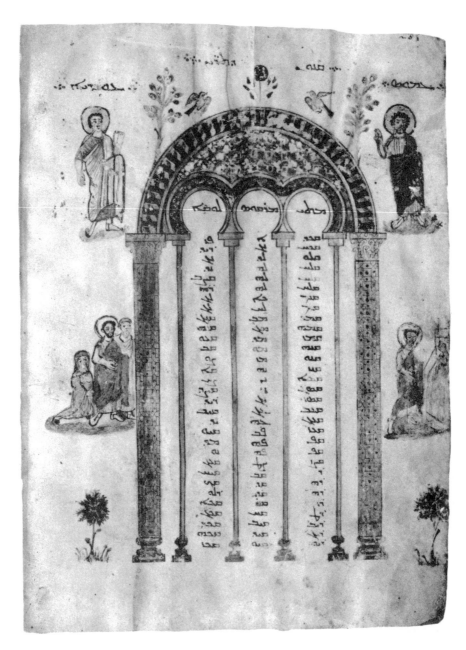

231 Prophets and evangelical scenes. Canon table, Rabbula Gospels, Biblioteca Medicea-
Laurenziana, Florence [90]

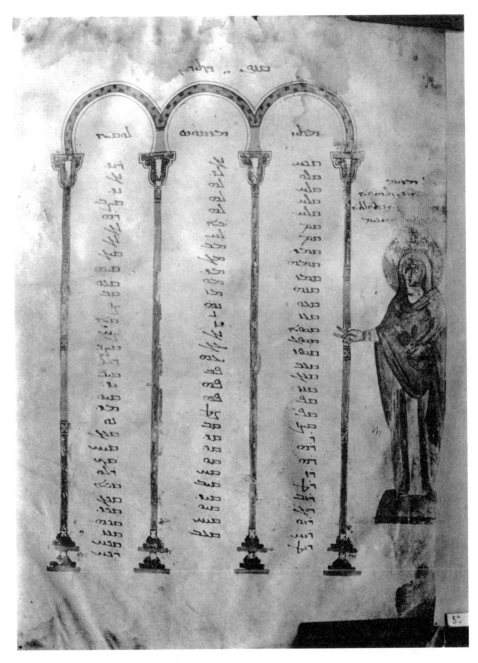

232 The Virgin of the Annunciation. Canon table, Syriac Gospels, Bibliothèque
Nationale, Paris [91]

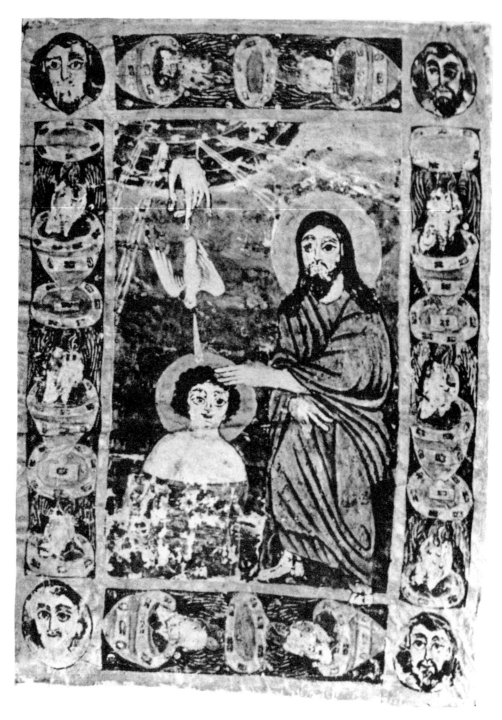

233 The baptism of Christ. Miniature from an Armenian Gospel, The Matenadaran, Yerevan, Armenia [91]

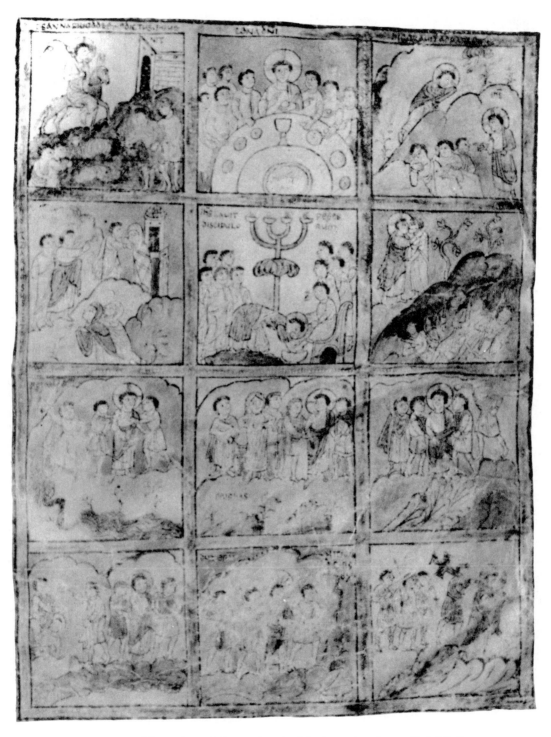

234 Scenes of the Passion. Miniature, Gospels of St. Augustine, Corpus Christi College, Cambridge [91]

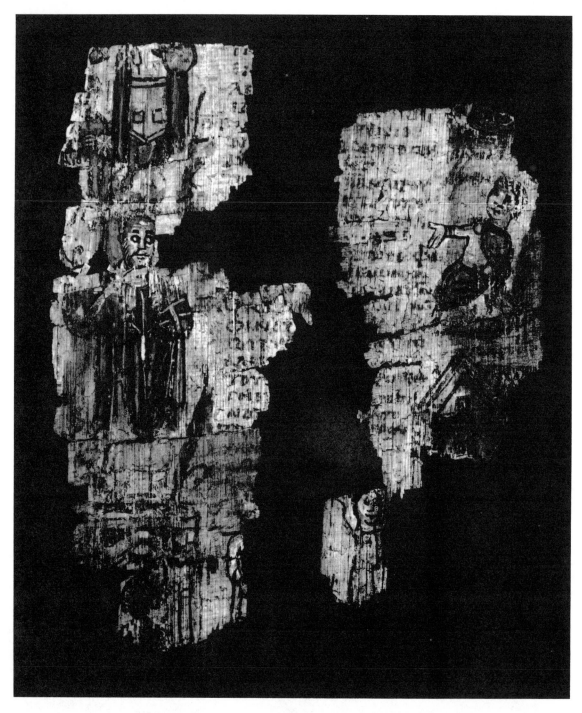

235 Portraits and Biblical scenes. Alexandrian Chronicle, Pushkin Museum of
Fine Arts, Moscow [92]

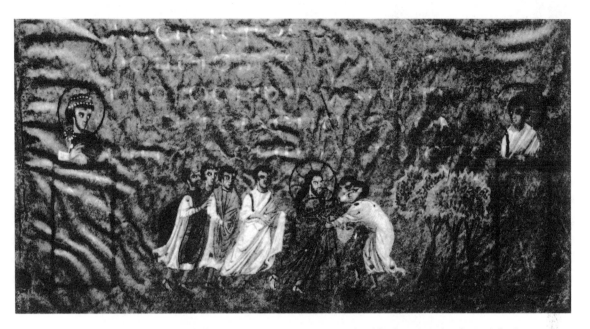

236 The healing of two blind men. Miniature, Sinope Gospel, Bibliothèque Nationale, Paris [93]

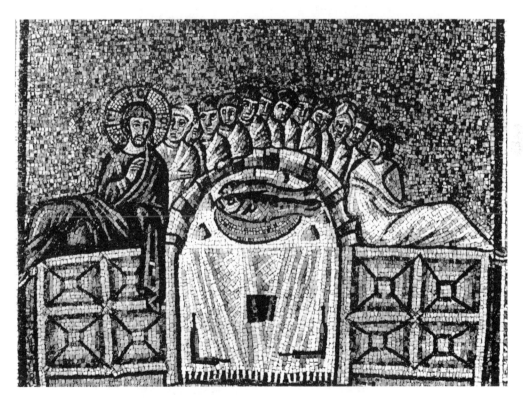

237 The Last Supper. Mosaic, S. Apollinare Nuovo, Ravenna [95]

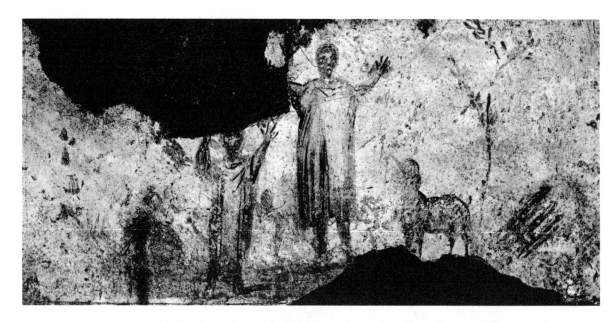

238 Abraham's sacrifice. Wall painting, catacombs of St. Calixtus, Rome [95]

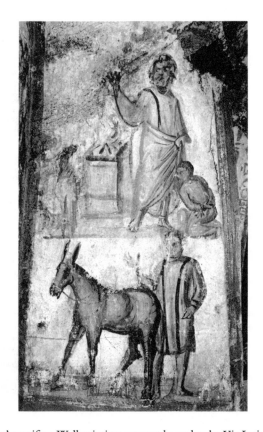

239 Abraham's sacrifice. Wall painting, catacombs under the Via Latina, Rome [95]

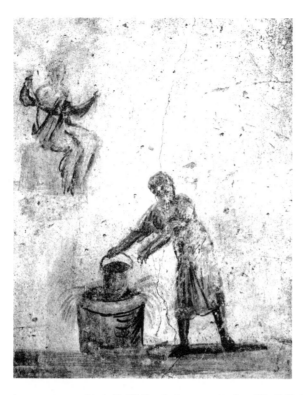

240 The Samaritan woman at the well. Wall painting, catacombs of St. Calixtus, Rome [95]

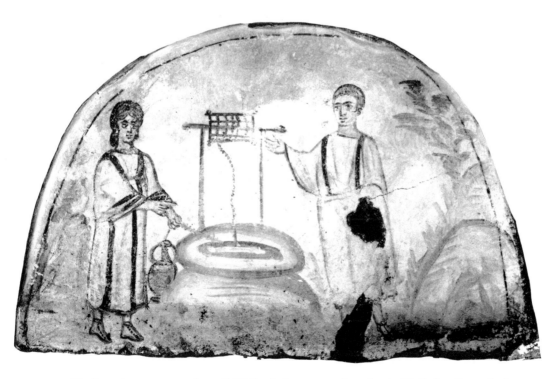

241 The Samaritan woman at the well. Wall painting, catacombs under the Via Latina, Rome [95]

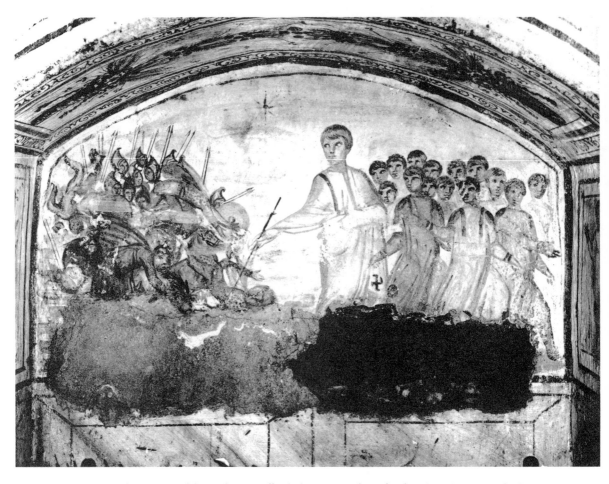

242 The crossing of the Red Sea. Wall painting, catacombs under the Via Latina, Rome [95]

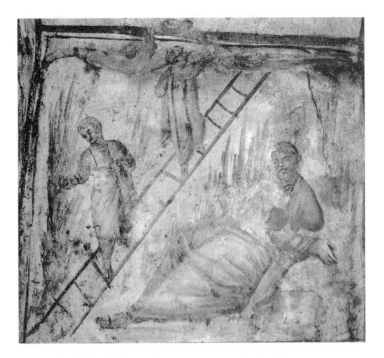

243 Jacob's ladder. Wall painting, catacombs under the Via Latina, Rome [95]

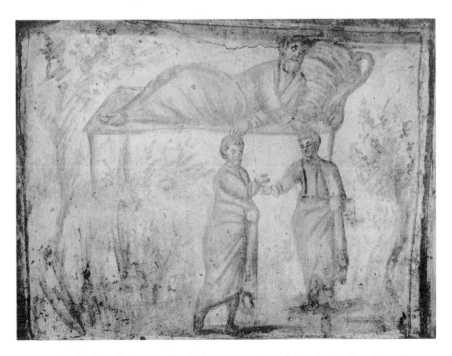

244 Jacob's benediction. Wall painting, catacombs under the Via Latina, Rome [95]

245 A crowd of people in an architectural landscape. Wall painting, hypogeum of
 the Aurelii, Rome [96]

246 Christ healing a blind man. Ivory box for medicaments, Museo Sacro, Vatican [97]

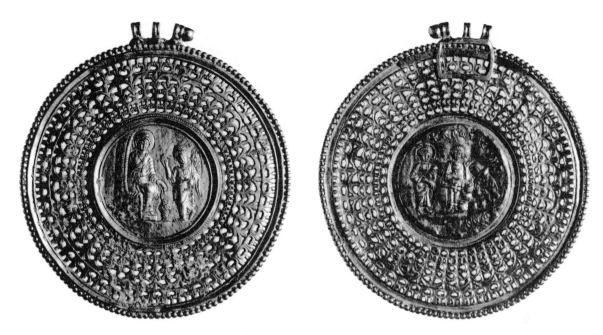

247 Left: The Annunciation to the Virgin. Right: The Miracle of Cana. Gold medallion, Staatliche Museen, Berlin [97]

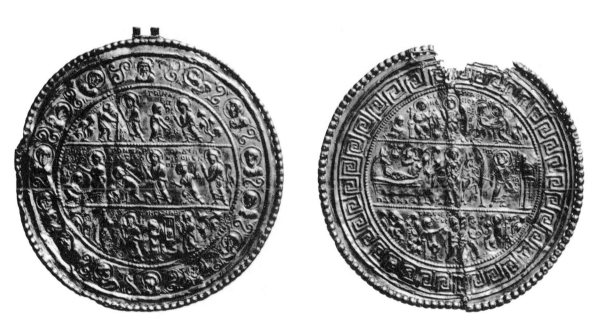

248 Left: Miracles of Christ. Right: Scenes from the life of Christ. Two gold amulets from Adana. Archaeological Museums, Istanbul [98]

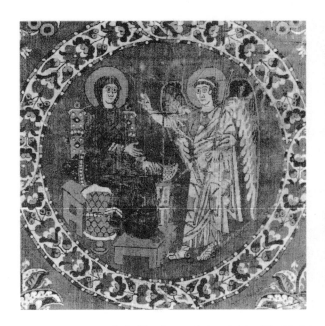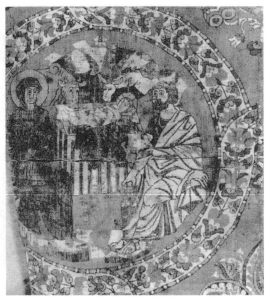

249 Left: The Annunciation. Right: The Nativity. Silk fragments, Museo Sacro, Vatican [99]

250 Textiles represented in wall painting, S. Maria Antiqua, Rome [99]

251 Textiles represented in wall painting, S. Maria Antiqua, Rome (reconstruction by W. de Grüneisen) [99]

252 The Adoration of the Magi in the woven decoration of a ceremonial robe worn by the
Empress Theodora. Mosaic, S. Vitale, Ravenna [99]

253 Portrait of the Emperor Augustus, wearing an ornamental robe. Miniature, Roman
Calendar of 354, Vatican Library (copy by Peiresc) [99]

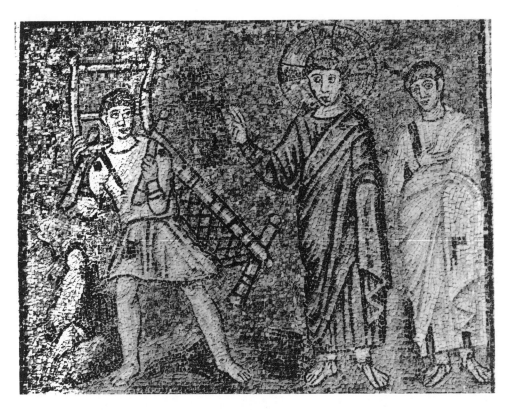

254 The healing of the paralytic. Mosaic, S. Apollinare Nuovo, Ravenna [99]

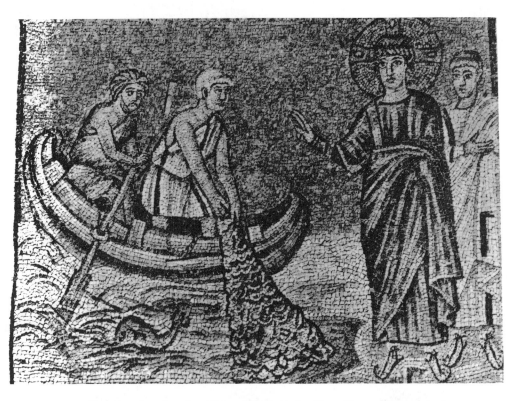

255 The miraculous draught of fishes. Mosaic, S. Apollinare Nuovo, Ravenna [99]

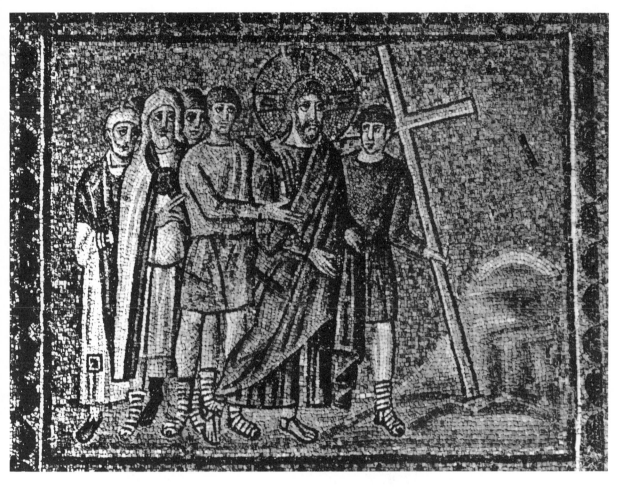

256 Christ on the way to Golgotha. Mosaic, S. Appolinare Nuovo, Ravenna [99]

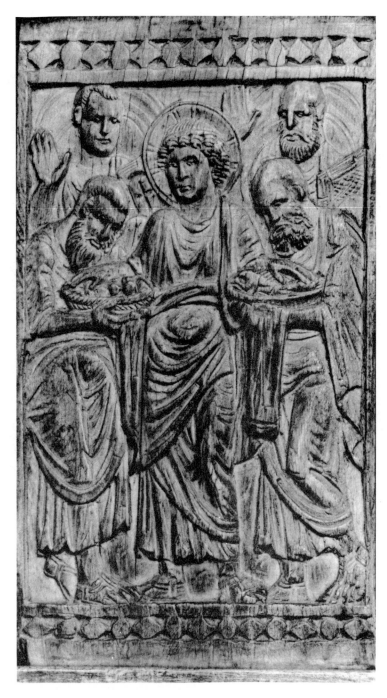

257 The Multiplication of the Loaves and Fishes (first part). Ivory carving, throne of Maximian,
Museo Arcivescovile, Ravenna [101, 102]

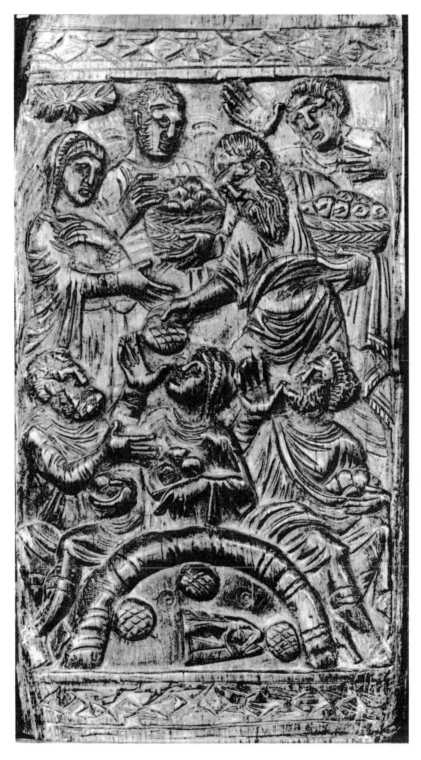

258 The Multiplication of the Loaves and Fishes (second part). Ivory carving, throne of Maximian, Museo Arcivescovile, Ravenna [101, 102]

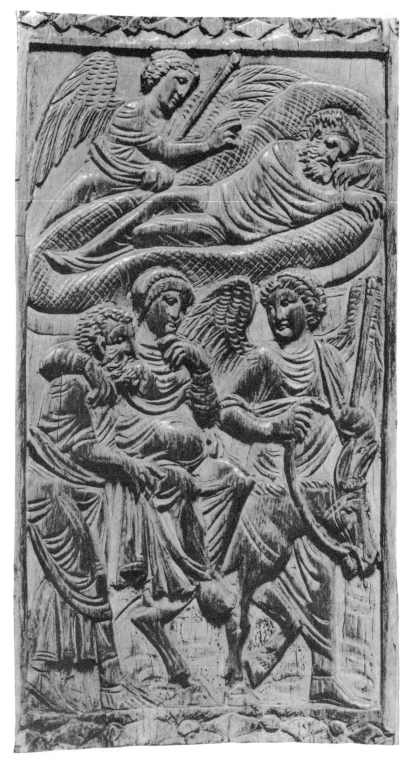

259 The Journey to Bethlehem. Ivory carving, throne of Maximian, Museo Arcivescovile, Ravenna [101, 102]

260 Episodes from the Gospels. Icon on wood, Museo Sacro, Vatican [102]

261 Episodes from the Gospels. Icon on wood (left half), Mt. Sinai [102]

262 "Biography" of Dionysus. The "veil of Antinoë," printed silk, Louvre, Paris [103]

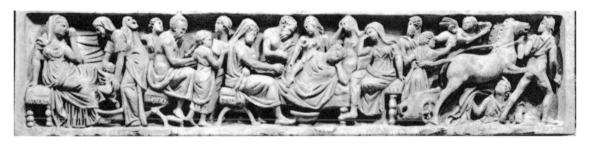

263 The life of the deceased. Pagan sarcophagus, Museo Torlonia, Rome [103]

264 Birth scene. Fragment of a pagan sarcophagus, Museum, Ostia [103]

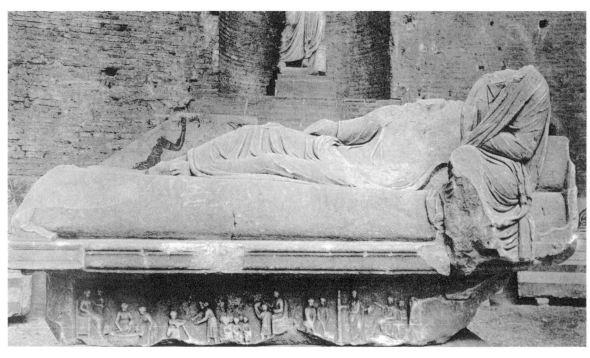

265 Pagan sarcophagus, Museo Nazionale Romano, Rome. Below: The typological cycle
of childhood [103]

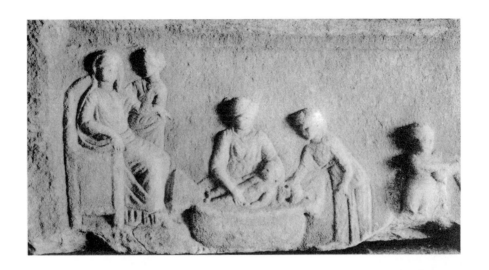

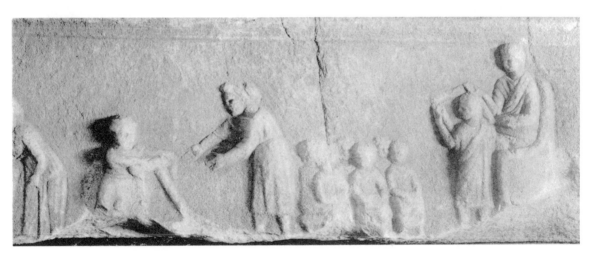

266 Above: Bath of newborn. Below: First steps and scene in school. Pagan sarcophagus (details of 265), Museo Nazionale Romano, Rome [103]

267 Unidentified scenes from early youth. Pagan sarcophagus (details of 265), Museo Nazionale Romano, Rome [103]

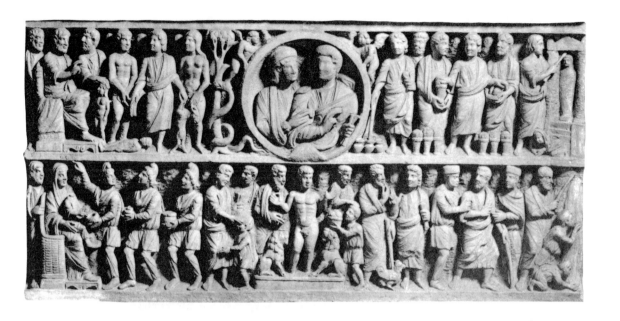

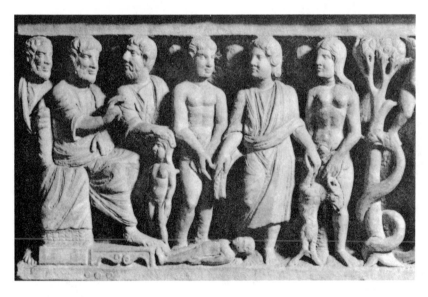

268 Above: Christian sarcophagus. Lateran Museums, Rome. Below (enlarged detail): The Trinity [112]

269　The eagle image of the Trinity. Wall painting, Bawit, Egypt [112]

270　Consular scepters with the busts of one, two, or three coregnant emperors. Details from ivory
　　diptychs of consuls: (left) Anastasius, from Bibliothèque Nationale, Paris (see 196),
　　(center) Constantius III, from Cathedral Treasury, Halberstadt; (right) Anastasius, from
　　Staatliche Museen, Berlin (see 271) [113]

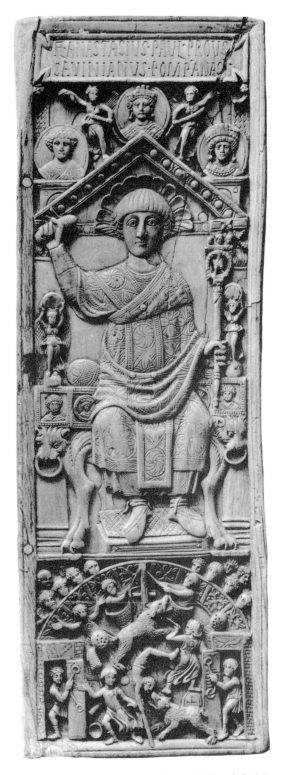

271 Ivory diptych of the consul Anastasius (right wing), Staatliche Museen, Berlin [113]

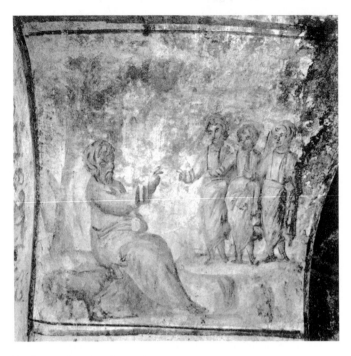

272 Abraham welcoming three celestial visitors. Wall painting, catacombs under the Via Latina, Rome [114]

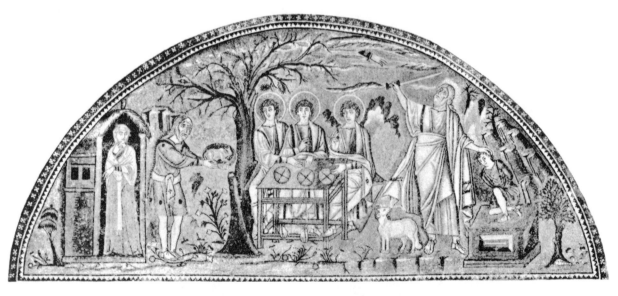

273 Abraham welcoming three celestial visitors (at right, his sacrifice of Isaac). Mosaic, S. Vitale, Ravenna [114]

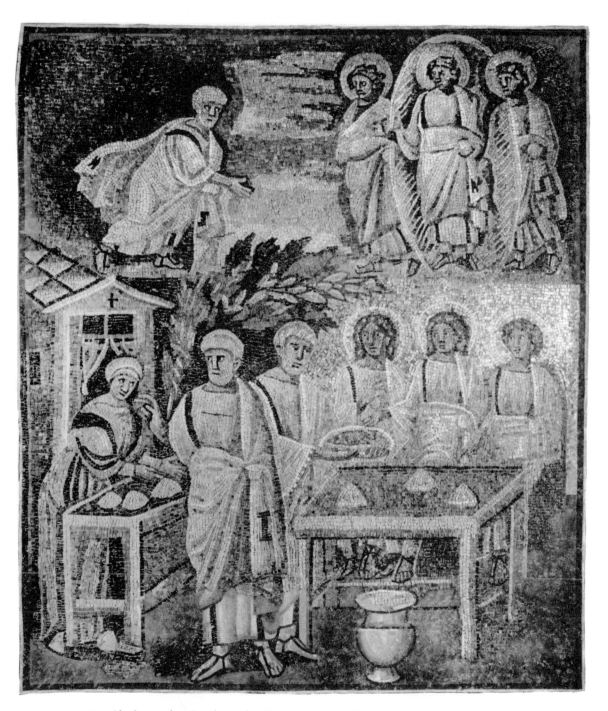

274 Abraham welcoming three celestial visitors. Mosaic, S. Maria Maggiore, Rome [114, 117]

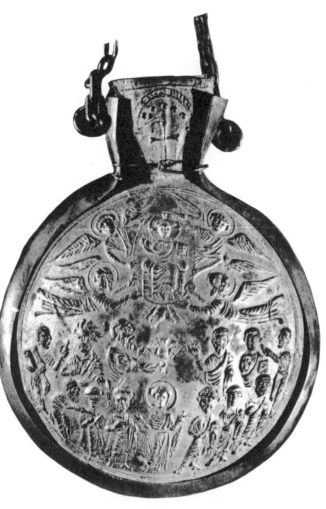

275 Ascension combined with the Pentecost as a Trinitarian image.
Palestinian ampulla, Treasure of the Collegiale, Monza [114]

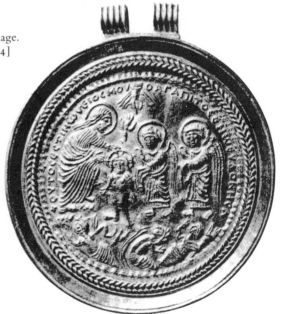

276 Baptism of Christ, with the Hand of God
and the Holy Spirit. Gold medallion from
Cyprus. Dumbarton Oaks, Washington,
D.C. [115]

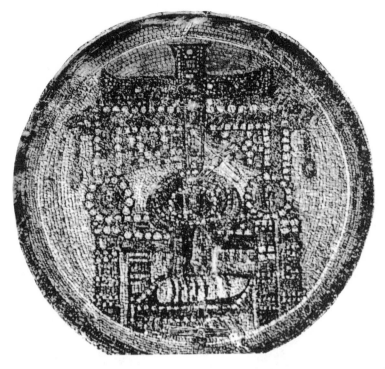

277 The Throne of God as a Trinitarian image. Mosaic (detail of 130), S. Maria Maggiore, Rome [115]

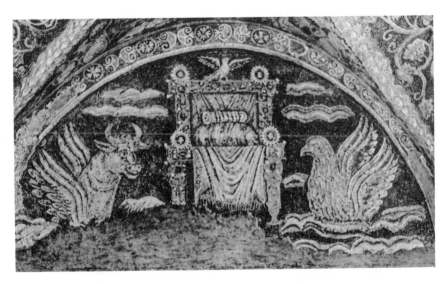

278 The Throne of God as a Trinitarian image. Mosaic, S. Prisca, Santa Maria Capua Vetere [115, 122]

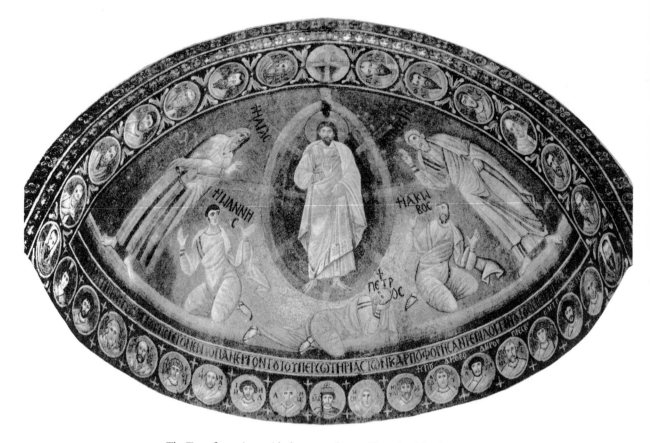

279 The Transfiguration, with three apostles as visionaries. Mosaic, Mt. Sinai [117]

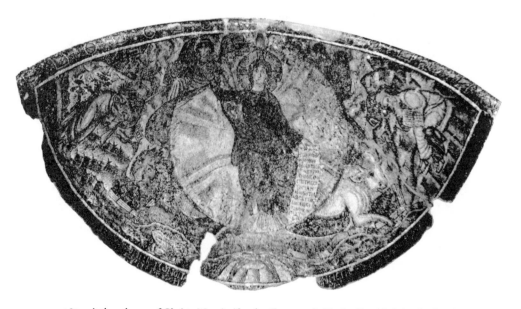

280 A theophany of Christ. Mosaic (for detail, see 117), Hosios David, Salonika [117]

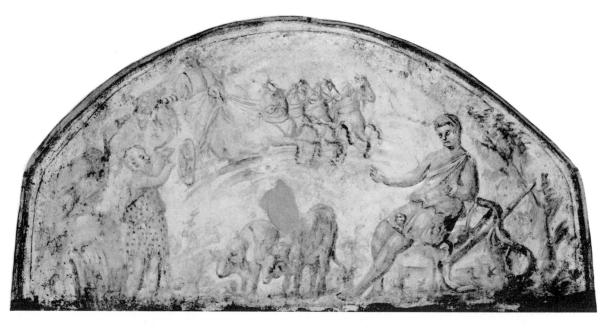

281 The ascension of Elijah, with a figure of a shepherd. Wall painting, catacombs under the Via Latina, Rome [117]

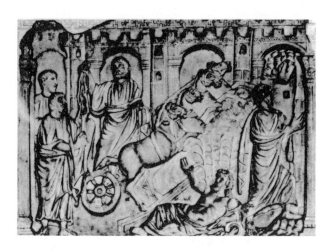

282 The ascension of Elijah. Sarcophagus relief, Louvre, Paris [117]

283 The apotheosis of the Sun. Cast of a coin of Septimius Severus, Bibliothèque Nationale, Paris [117]

284 The apotheosis of the emperor. Coin of Septimius Severus, British Museum, London [117]

285 The Sun (Christ) in his chariot. Mosaic, Vatican Grottoes [117]

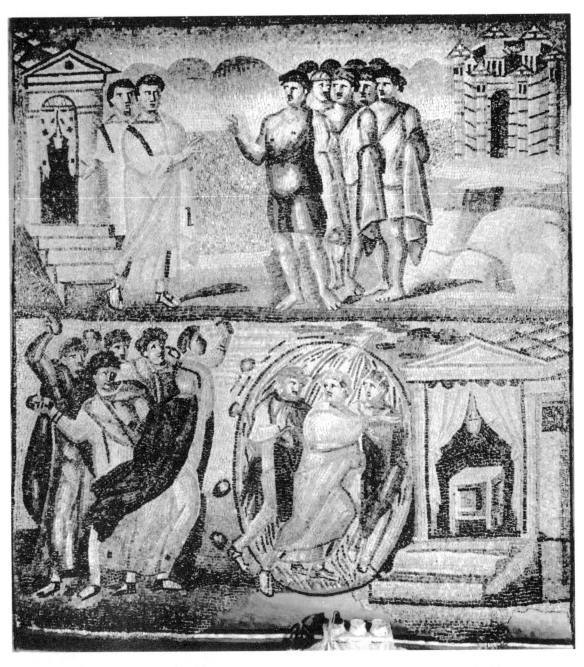

286 Mosaic, S. Maria Maggiore, Rome. Bottom: Aaron and his companions in a cloud of dust [118]

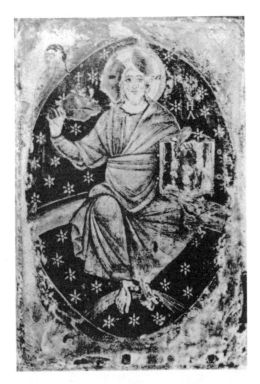

287 Christ with white hair. Icon, Mt. Sinai [120]

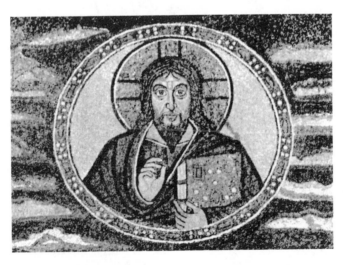

288 Christ with a beard. Mosaic, S. Apollinare in Classe,
Ravenna [120]

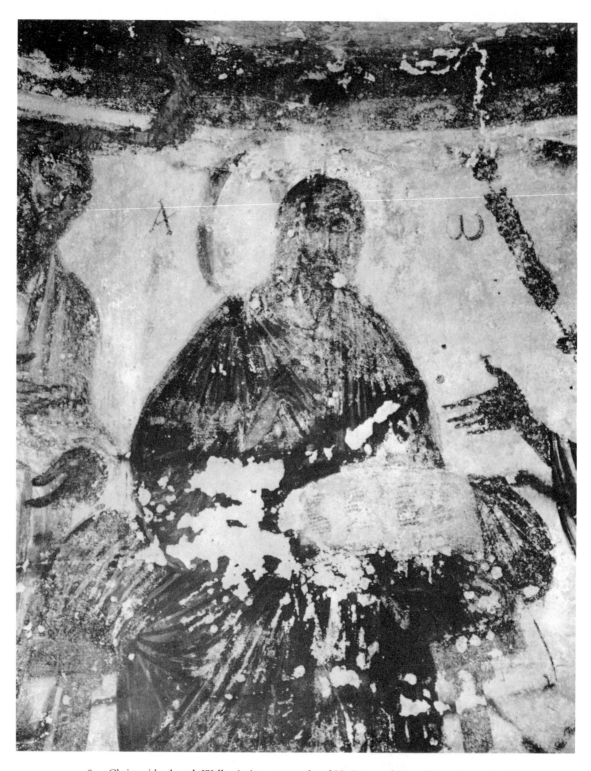

289 Christ with a beard. Wall painting, catacombs of SS. Peter and Marcellinus, Rome [120]

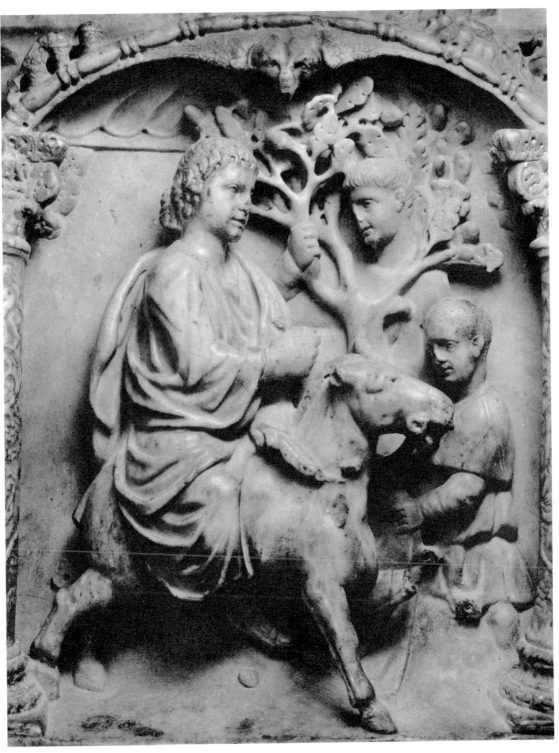

290 The Entry into Jerusalem, with youthful Christ. Sarcophagus of Junius Bassus (detail; see 29 h),
Vatican Grottoes [119]

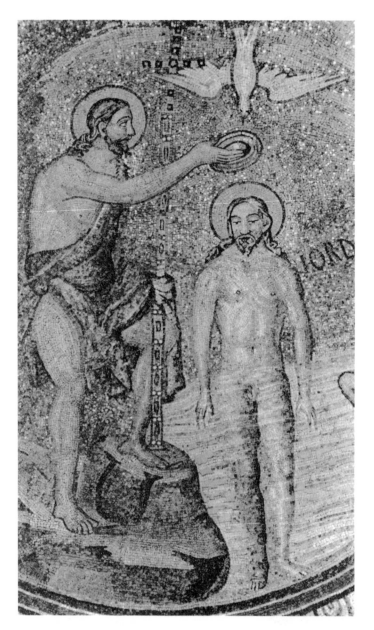

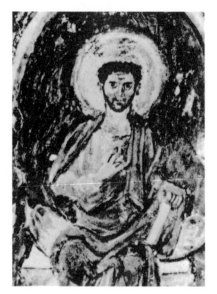

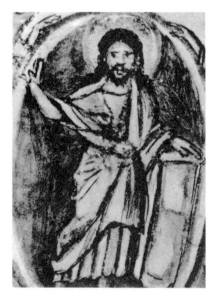

291 The baptism of Christ, with the dove of the Holy Ghost.
Mosaic, Orthodox Cathedral, Ravenna [122]

292 Christ (above) as a youth and
(below) as an adult. Miniatures,
Rabbula Gospels, Biblioteca
Medicea-Laurenziana,
Florence [121]

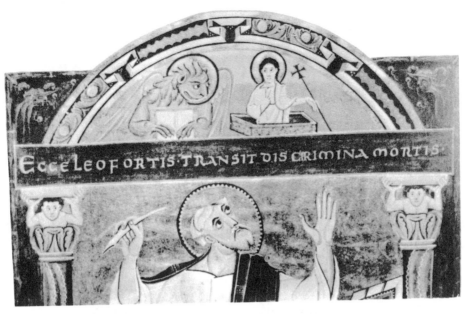

293 The Resurrection, with the symbol of St. Mark. Miniature, Ottonian Gospels, Cathedral Treasury, Bamberg [123]

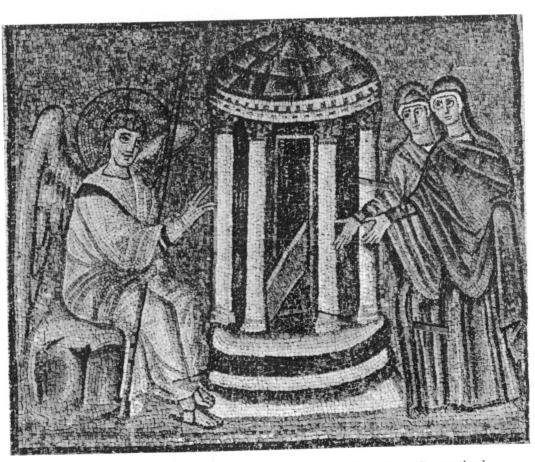

294 The Holy Women at the Tomb of Christ. Mosaic, S. Apollinare Nuovo, Ravenna [124]

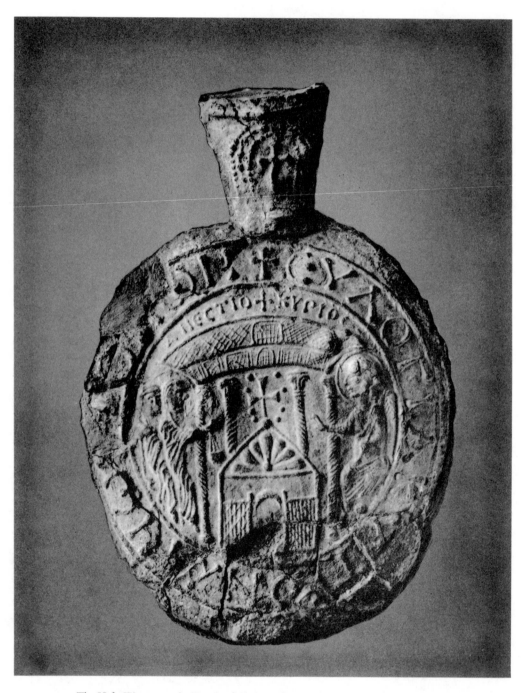

295 The Holy Women at the Tomb of Christ. Palestinian ampulla, abbey of St. Columban, Bobbio, prov. Piacenza [124]

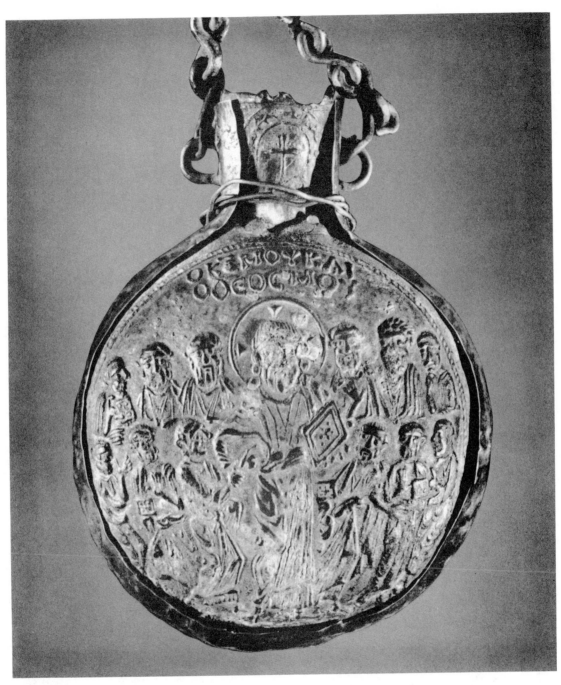

296 The incredulity of Thomas. Palestinian ampulla, Treasure of the Collegiale, Monza [124]

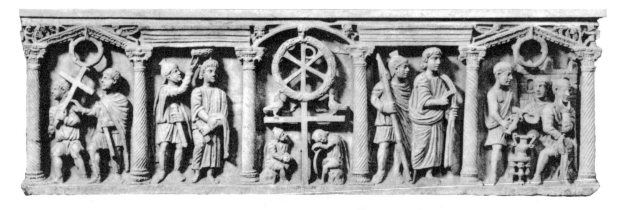

297 Symbolic iconography of the Resurrection. Sarcophagus, Lateran Museums, Rome [125]

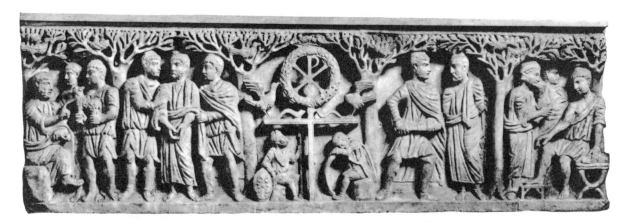

298 Symbolic iconography of the Resurrection. Sarcophagus, Lateran Museums, Rome [125]

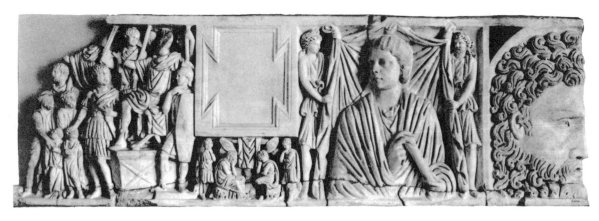

299 Fragment of a pagan sarcophagus, showing a trophy with barbarian captives. Römisch-Germanisches Zentralmuseum, Mainz [125]

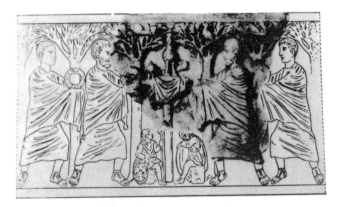

300 The Cross with a triumphal crown and (below) two sleeping soldiers. Fragment of a Christian sarcophagus, Lateran Museums, Rome (with reconstruction) [125]

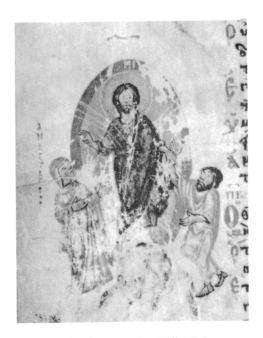

302 Christ's Descent into Hell. Miniature, Chludov Psalter, State Historical Museum, Moscow [125, 126]

301 Three Roman coins showing the Roman emperor with figures of the conquered: iconographical schema of the Descent into Hell. British Museum, London [126]

303 The Annunciation. Detail from
a Palestinian ampulla, Treasure of
the Collegiale, Monza [128]

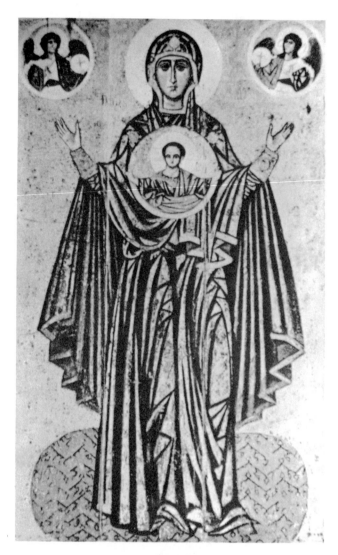

304 The Incarnation of Christ. Icon of the Virgin, known
as the Znamenie "of the Sign," State Tretyakov
Gallery, Moscow [128]

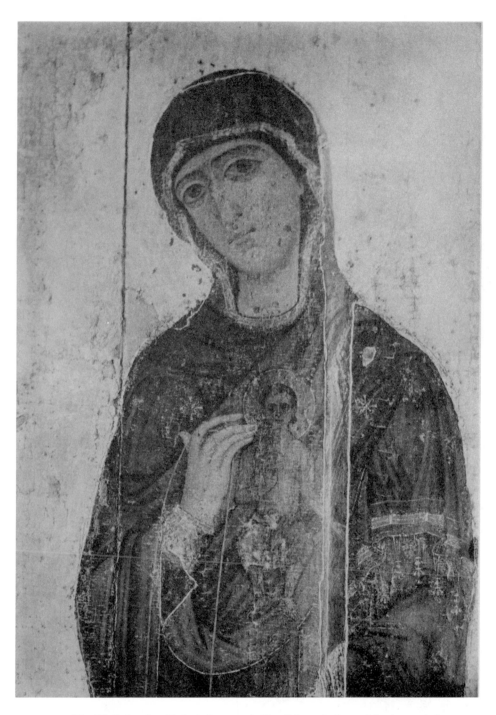

305 The Virgin bearing Christ in her womb. Detail from the icon of the Annunciation, State Tretyakov Gallery, Moscow [128]

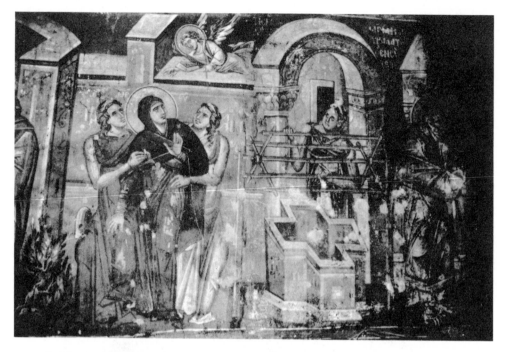

306 The Annunciation, with Mary supported by two girls. Wall painting, St. Clement, Ohrid, Yugoslavia [129]

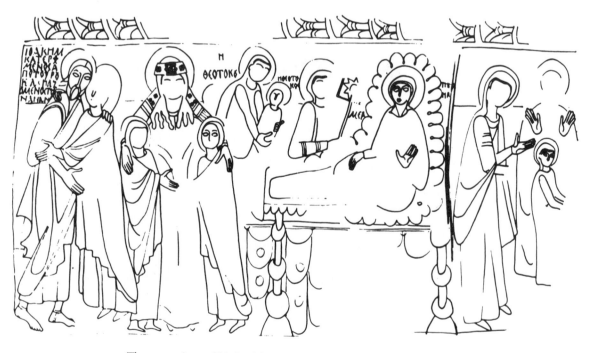

307 The conception and birth of the Virgin. Wall painting, Kizilçukur, Cappadocia (copy by M. Thierry) [129]

308 The confinement of Rebecca. Miniature, Ashburnham Pentateuch,
Bibliothèque Nationale, Paris [129]

309 The conception and birth of a Biblical king. Miniature,
 The Book of Kings, Vatican Library [129]

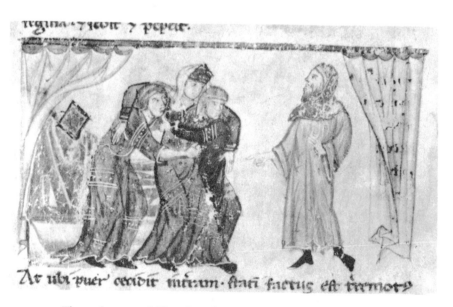

310 The confinement of Olympias, Alexander's mother. Miniature, Romance of
 Alexander, Stadtbibliothek, Leipzig [129]

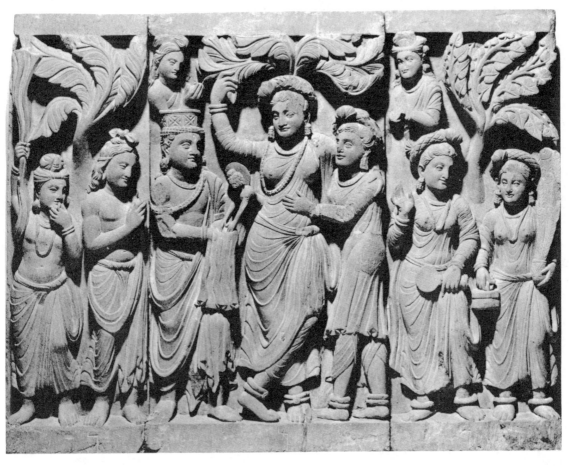

311 The birth of the Buddha. Frieze from the region anciently known as Gandhara, Freer Gallery
of Art, Washington, D.C. [129]

312 The Nativity. Wall painting, S. Maria di Castelseprio, Milan [130]

313 The Nativity, with Joseph turning away. Wall painting, Geledjlar Kilisse, Cappadocia [130]

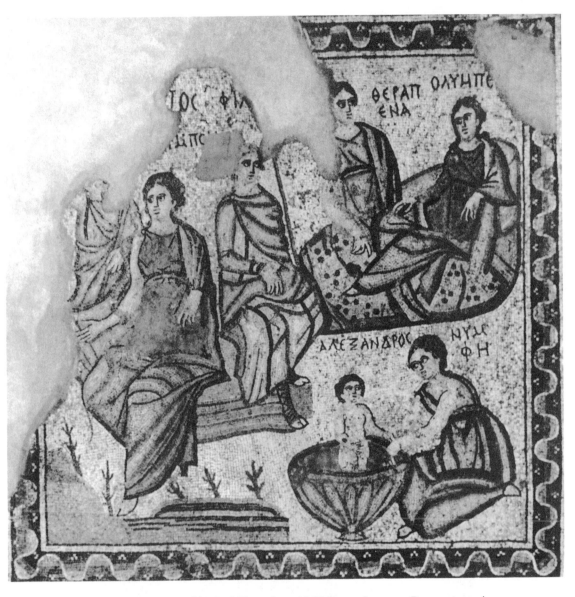

314 The conception and birth of Alexander, with Philip turning away. Pavement mosaic, Baalbek Museum, Beirut [130]

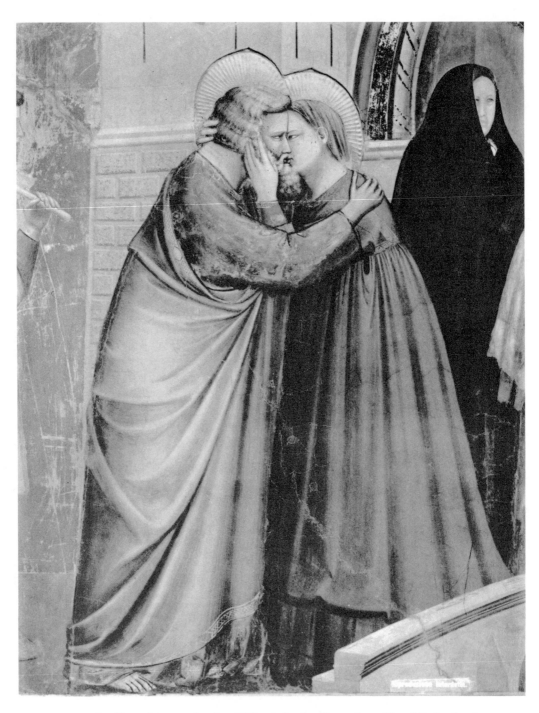

315 Joachim and Anna embracing. Wall painting by Giotto, Arena Chapel, Padua [130]

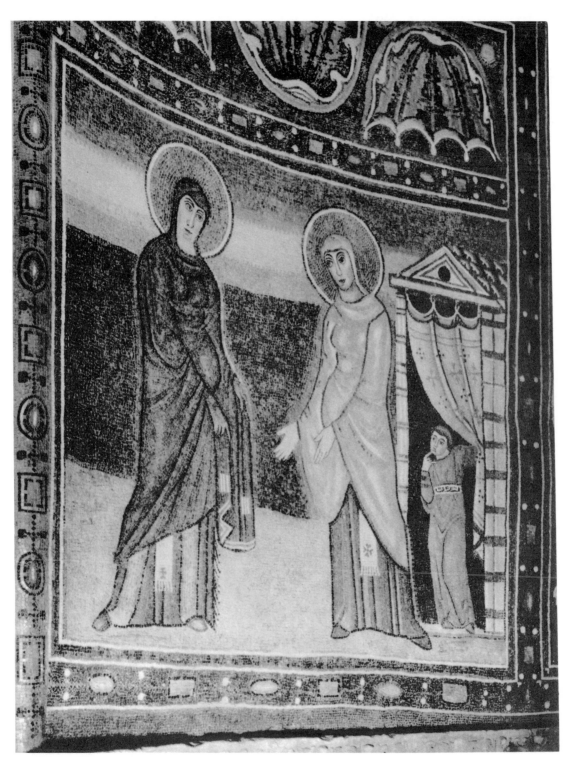

316 The Visitation. Mosaic, basilica, Parenzo [131]

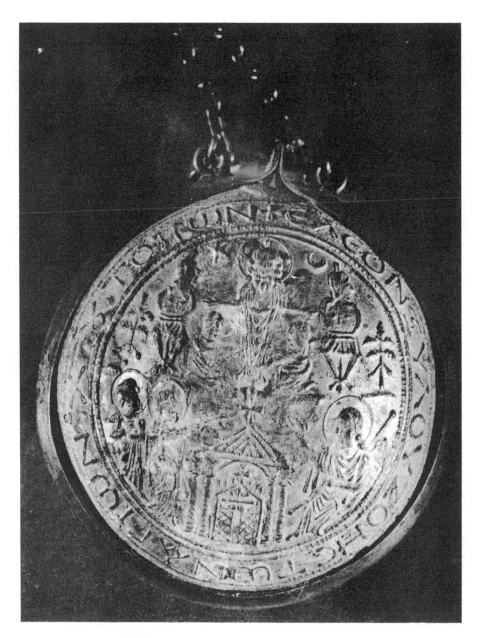

317 The Crucifixion. Palestinian ampulla, Treasure of the Collegiale, Monza [132]

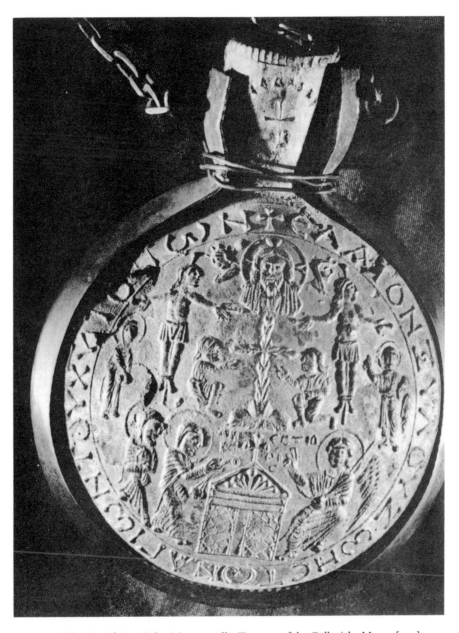

318 The Crucifixion. Palestinian ampulla, Treasure of the Collegiale, Monza [132]

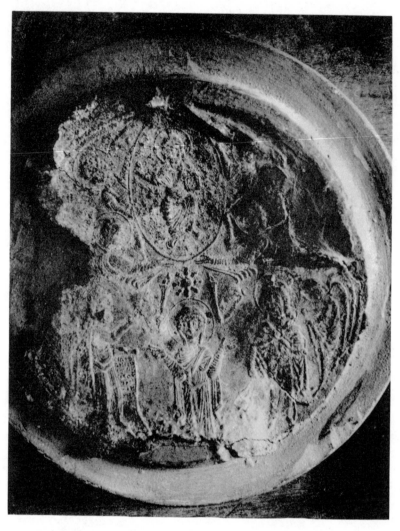

319 Symbolic scenes, evoking the Incarnation. Palestinian ampulla, abbey of
St. Columban, Bobbio, prov. Piacenza [132]

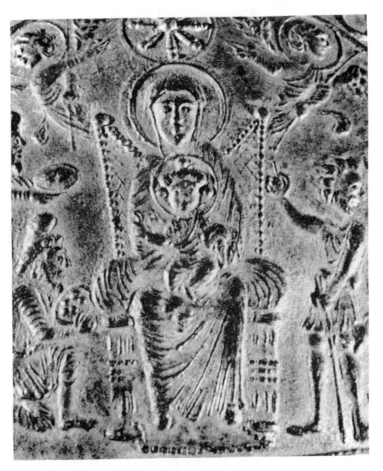

320 The recognition of the Incarnation by the Magi and shepherds.
Palestinian ampulla (detail of 209), Treasure of the
Collegiale, Monza [132]

321 Star above the emperor. Cast of a Roman coin,
Bibliothèque Nationale, Paris [132]

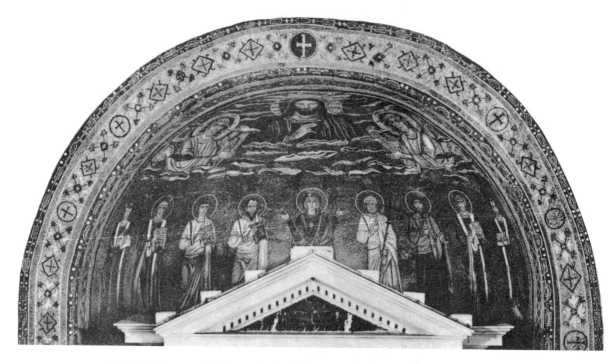

322 Christ in Heaven with Mary and saints below. Mosaic, chapel of S. Venanzio, S. Giovanni in Fonte, Rome [133]

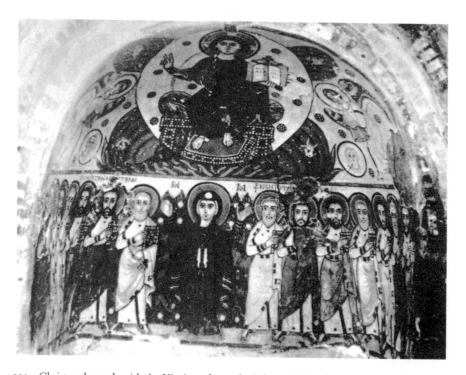

323 Christ enthroned, with the Virgin and apostles below. Wall painting, Bawit, Egypt [134]

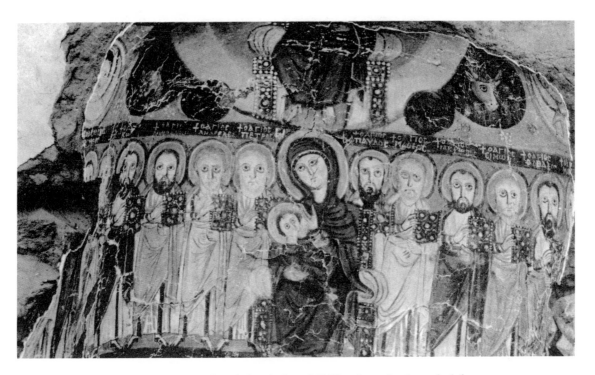

324 Christ enthroned, with the Virgin and Child enthroned and apostles below.
Wall painting, Bawit, Egypt [134]

325 Christ enthroned, with the Virgin and apostles below.
Wall painting, Bawit, Egypt [134]

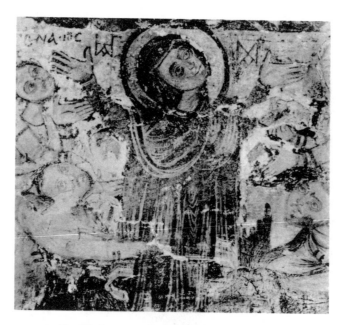

326 The Virgin orant (detail of 325). Wall painting, Bawit,
Egypt [134]

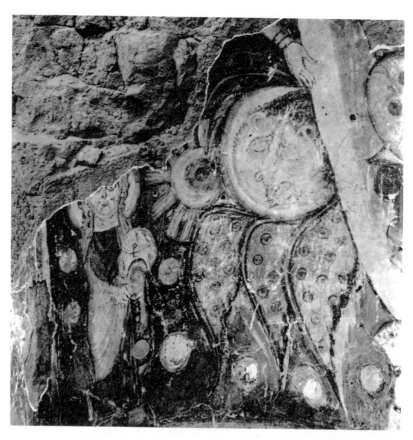

327 An apostle holding the chalice and Eucharistic bread. Wall painting,
Bawit, Egypt [135]

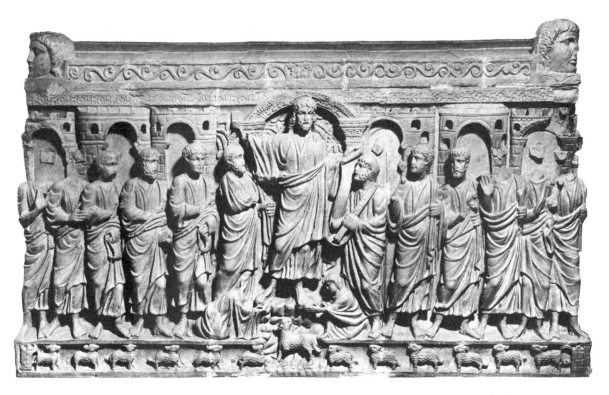

328 Christ with the apostles; the Lamb flanked by sheep. Sarcophagus, S. Ambrogio, Milan [135]

329 Christ with the apostles; the Lamb and sheep.
Ivory box, Museo Civico, Pola (Pula), Yugoslavia
[136]

330 Denarius of Hadrian with a pietas:
Juno with her peacock. [136]

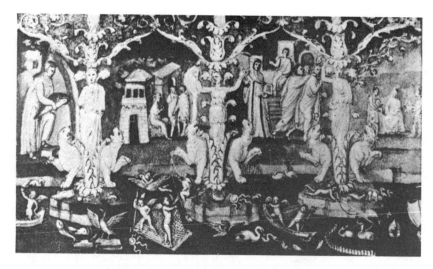

331 Decoration formerly in S. Costanza, Rome (water color by F. d'Ollanda, in the Escorial). Old Testament scenes [137]

332 Another portion of the mosaic decoration formerly in S. Costanza (drawing by Antonio San Gallo the Elder, Florence). Two registers: (top) the miracle of the centurion; (bottom) the sacrifice of Elijah [137]

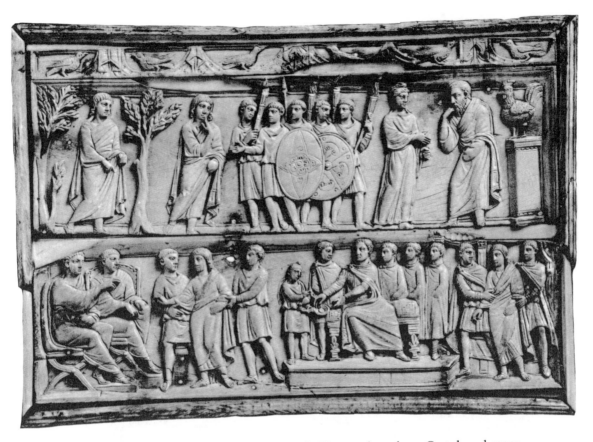

333 Cover of lipsanotheca, Museo Civico, Brescia. Upper register: doves. Central panel, upper part, left to right: Christ in the garden of Gethsemane, the taking of Christ, Peter's denial. Central panel, lower part: Christ before Caïphas, Pilate washing his hands [137]

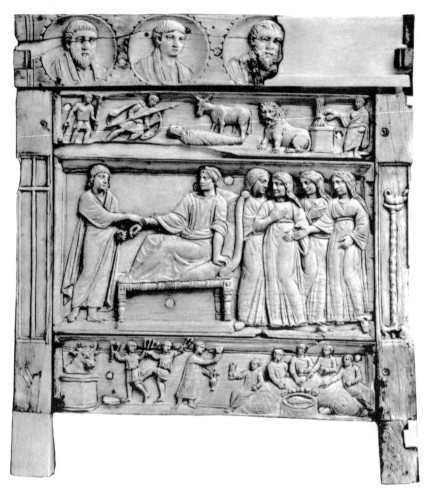

334 Left end of Brescia lipsanotheca. Edge of cover: medallion portraits of
apostles. Upper border: David and Goliath, the story of the disobedient
prophet who was slain by a lion, Jereboam at the altar extending his
withered hand (Kings 13:2ff.). Central panel: Christ and the
Haemorrhoissa. Lower border: the worship of the Golden Calf with
(?) an attendant feast [137]

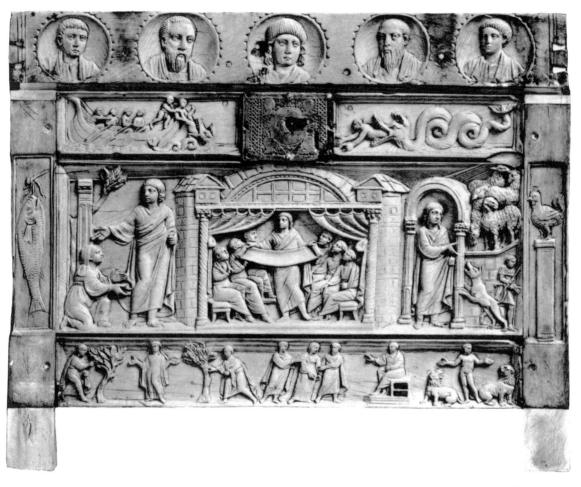

335 Front of Brescia lipsanotheca. Edge of cover: medallion portrait of Christ, flanked by those of
apostles. Upper border: scenes of the story of Jonah. Central panel: *Noli me tangere*, Christ
teaching, Christ at the entrance to the sheepfold. Lower border: Susanna and the elders,
Susanna before Daniel, Daniel in the lions' den [137]

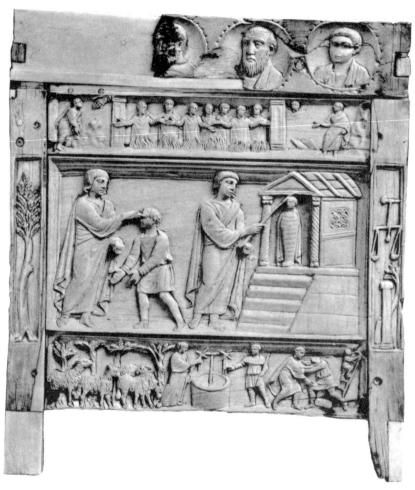

336 Right end of Brescia lipsanotheca. Edge of cover: medallion portraits of
apostles. Upper border: the calling of Horeb, the Israelites in the Furnace,
Moses receiving the tablets of the Law on Sinai. Central panel: miracles of
Christ: the healing of the blind man; the raising of Lazarus.
Lower border: Jacob's meeting with Rachel, Jacob wrestling with
the angel, Jacob's ladder [137]

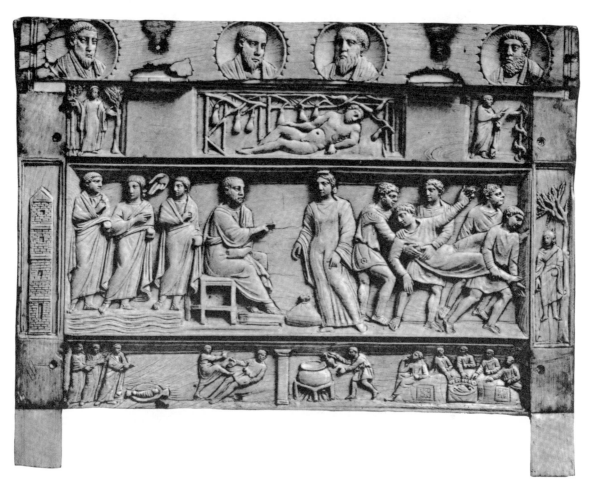

337 Back of Brescia lipsanotheca. Edge of cover: medallion portraits of apostles. Upper border:
Susanna giving thanks, Jonah under his bower of gourds, Daniel and the serpent. Central panel:
unidentified Christological scene, Saphira before Peter, the dying Ananias carried off to burial.
Lower border: the finding of the infant Moses, Moses slaying the Egyptian, Moses in the house
of Jethro. Right leg: Judas hanged [137]

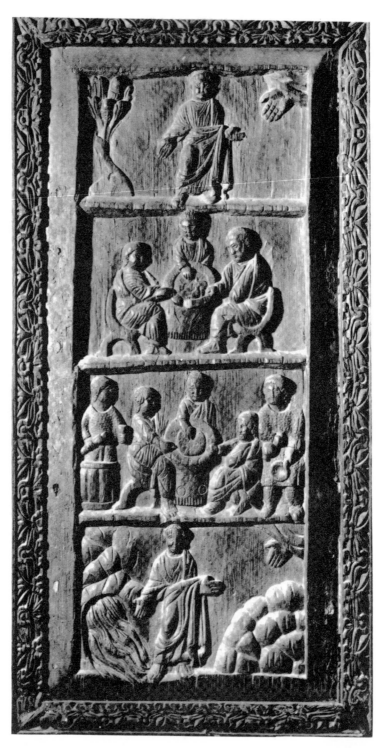

338 Four miracles of Moses. Panel of the wooden door, S. Sabina, Rome
[142]

339 Three miracles of Christ. Panel of the wooden door, S. Sabina, Rome
[142]

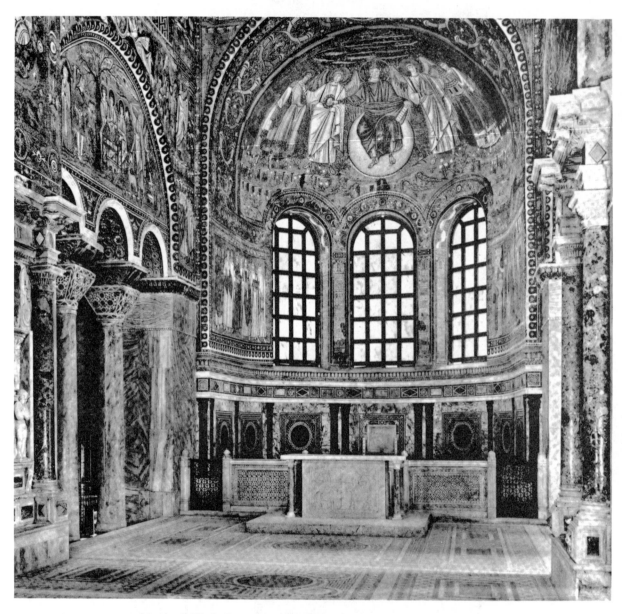

340 Mosaics, S. Vitale, Ravenna. Left: Old Testament scenes (for detail, see 273) [144]

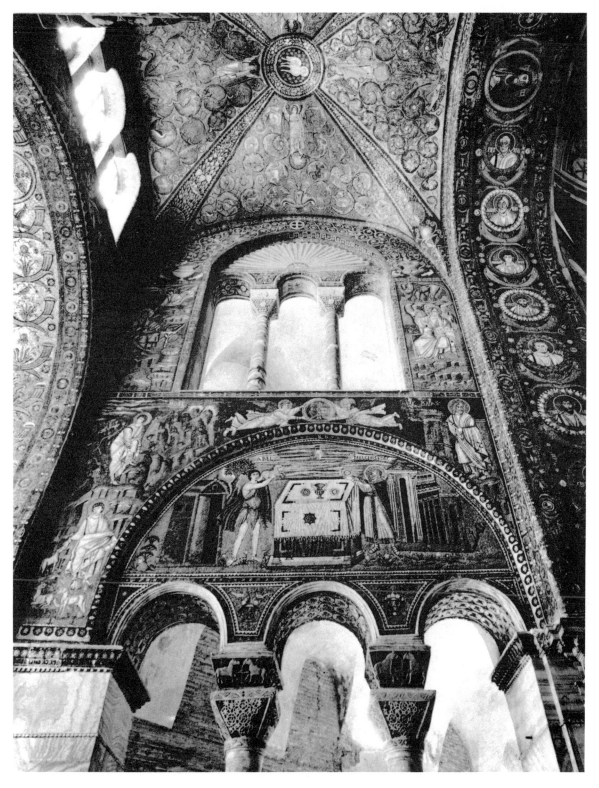

341 Mosaics, S. Vitale, Ravenna. Old Testament scenes and, in vault, Agnus Dei [144]